The
CHALLEN
of DRAWI

AN INTRODUCTION

The
CHALLENGE
of DRAWING

AN INTRODUCTION

ALEXANDER RUSSO

Hood College, Frederick, MD

PRENTICE-HALL
ENGLEWOOD CLIFFS, NJ 07632

Library of Congress Cataloging-in-Publication Data

Russo, Alexander.
 The challenge of drawing.

 Bibliography: p.
 Includes index.
 1. Drawing—Technique. II. Title.
NC730.R87 1987 741.2 86-12240
ISBN 0-13-124520-1

Editorial/production supervision: Sylvia Moore
Interior design and page layout: Maria Carella
Cover design: Ben Santora
Manufacturing buyer: Ray Keating

©1987 by Prentice-Hall, Inc.
A Division of Simon & Schuster
Englewood Cliffs, New Jersey 07632

Printed in the United States of America

10 9 8 7 6 5 4 3 2 1

ISBN 0-13-124520-1 01

Prentice-Hall International (UK) Limited, *London*
Prentice-Hall of Australia Pty. Limited, *Sydney*
Prentice-Hall Canada Inc., *Toronto*
Prentice-Hall Hispanoamericana, S.A., *Mexico*
Prentice-Hall of India Private Limited, *New Delhi*
Prentice-Hall of Japan, Inc., *Tokyo*
Prentice-Hall of Southeast Asia Pte. Ltd., *Singapore*
Editora Prentice-Hall do Brasil, Ltda., *Rio de Janeiro*

CONTENTS

Part I The Pleasures and Challenges of Drawing

Introduction: The Pleasures and Challenges of Drawing 1

1 Objectives and Methods 4

2 The Creative Attitude 11

ILLUSTRATIONS

PREFACE

This book was started four years ago—actually, much earlier, if one considers the incubation process. It is the result of much introspection and objective evaluation incorporating many years of professional experience.

Although it has "how to" aspects, the book is meant to be much more than a series of exercises on how to draw. It is intended to be a useful means whereby one may achieve not only heightened skills and some degree of mastery in drawing, but also much personal enjoyment and creative development.

One of the unique aspects of the book is its references to contemporary developments and research in creativity and learning advanced by neurologists and psychologists. Recent research has indicated the value of understanding the functions of the brain in relation to creative activity. Some of these ideas are used in the book to strengthen the possibilities of artistic growth.

It is equally important to realize how certain techniques can be enployed to sustain creative thinking for greater productivity. Somehow, the analytical portion of the brain must be put gently aside to enable the creative process to take place. Then it is necessary, at a later stage, to utilize analytical thinking.

During my own creative efforts I have learned to suspend linear, analytical thinking so as to better proceed with work, unencumbered by constant interference or "static" from a roaming mind that wants all the answers right away. Years ago, unknowingly, I was applying some of the principles now advanced by science that I believe are useful for creative endeavor. Perhaps artistic creativity and scientific research are finally meeting on common ground; the artist learning from the scientist, and vise versa. Feedback from the artist not only reinforces the validity of scientific research, it strengthens the artist's intuitive awareness. The developing art student, especially, is immensely aided by such knowledge, relying less on faith and more on assurance of results.

A good amount of difficulty in drawing can be eliminated by the methods presented in this book. Students are made aware of how to achieve, at the very outset of their work, a creative posture that will enable them to

proceed with a minimum of difficulty. Steady growth, conviction, and assurance result, which help to create a positive self image.

Some of the problems and studies are not unique, but are "common coin" in many art programs. However, I have included only those that have proven successful in my teaching experience and others of my own invention that have stood the test of time. Above all, I have tried to present material in a manner that I feel is personal and uniquely integrated.

Fortunately, some of the insights I have gained by much trial and error can be utilized to prevent similar occurences for students. Thus the student can advance more quickly, avoiding many of the artistic pitfalls which I and others have experienced in our development. This is not to say that there are no challenges, or that all will go smoothly. Indeed, the challenge to change one's views and to accept new methods and procedures can be a painful experience.

Stereotyped notions of "how to draw" and "what drawing is" may have to be sacrificed to obtain the benefits the book offers. For example, deep breathing and relaxation exercises may seem to be out of place in a book on drawing; yet I believe that they can result in greater control and creativity, which are prime objectives. Visualization is also important, if often misunderstood, but it is seldom used in a text of this kind.

Finally, the book will be of value to professional art students as well as to those with nonprofessional interests. Learning to draw well does not only contribute to attaining professional goals, it can also result in acquiring a new form of self-expression, a heightened state of awareness, and a new creative outlook.

Alexander Russo

ACKNOWLEDGMENTS

There are many to thank who were directly or indirectly involved in the development of this book.

The prime *raison d'etre* for creating the work directly relates to teaching students in professional art schools and college and university art departments. At best, this is not an easy task. While I aided them, the students I taught helped to point out some of my shortcomings in communicating material. How to grasp and translate concepts to students of various backgrounds and varying talents; how to suggest the interrelationships of media, emotional states, cognitive functions, and creative processes; how to do all this and more by means of the written word and not by verbal delivery, eye contact, and exuberant gesture is indeed a challenge. Hence the title of the work has a double meaning, since I too have tried to meet the challenge of communication. I offer profuse thanks to my students for provoking me into it. I have learned much in the process.

I also wish to thank my students for the examples of their work included in the text. Many artists whom I hold in high esteem have been generous in this regard as well. The Corcoran Gallery of Art, the Hirshhorn Museum, and the Medieval Institute of The University of Notre Dame were most generous in making their resources available, as were the Parasol Press, Ltd., the Robert Miller Gallery, the Marlborough Gallery, the Pace Gallery, the Sidney Janis Gallery, the Leo Castelli Gallery, Brooks Alexander, Inc., the Odyssia Gallery, and the Combat Art Gallery of the Navy Department.

A special bow to the many fine teachers with whom I had the privilege to study. They have lurked in my subconscious, providing me with much needed patience and inspiration.

Finally, a special note of thanks to Norwell Therien, whose enthusiastic response to the development of this book was stimulating and encouraging. His perceptive grasp of the value and meaning of the work deserves special mention. Without the keen scrutiny of the text provided by Sylvia Moore redundancies would have abounded and the smooth flow of thought, indeed, would have been less smooth. The art production team have my congratulations in making the visual material so effective and appealing, without which a book of this kind would be rather pointless.

INTRODUCTION: THE PLEASURES AND CHALLENGES OF DRAWING

When I was a student at Pratt Institute, I was provoked by a statement that my design instructor made to the class. He proclaimed "I can teach anyone to draw!" I was greatly surprised by this absolute claim. First of all, I was attending a design class and not a drawing class. Why had Alexander Kostellow made such a sweeping statement? What was his objective?

As his lecture developed, however, it became apparent that he was less concerned with developing drawing skills—these would come in time—than with helping students to acquire the essentials of design. He stressed the importance of making "inner responses" to elements such as shape, form, texture, color, and space, and the methods by which these elements could be made to be expressive. One could learn to improve one's drawing, but without some grasp of the design of form in space one would be "putting the cart before the horse." This premise became a subject of my concern for some years to come.

I derived much benefit from the design class and from the many challenges that Pratt afforded me. However, after many years of constant work, I realized that design is *intrinsic* to drawing. After students acquire a sense of freedom in drawing, they become very sensitive to how things are placed and of certain interactions within the working surface (the picture plane). In time, one becomes aware of the total context of the work and understands that each drawn form has an essential relationship to other drawn forms on any given surface. One learns to compose with whatever elements are there to work with.

I believe that drawing is a skill that can be taught, and that an awareness of design in drawing (or by means of drawing) is an essential phenomenon that develops by intuition and by other artistic insights that we already have, but are not fully conscious of. This consciousness develops as we become more involved in the drawing process. It is experiential unfolding. In a sense, we are all artists, but don't know it. This is a rather simplistic statement, which, perhaps, parallels Alexander Kostellow's claim. Yet, I am convinced that this is so. We all have the capacity to become artists, although not all who become aware of their inner artistic potential will become outstanding artists. Developing latent talents can give much pleasure to the individual and can also serve as a source of inner discovery of untapped levels of awareness. Vision and imagination become active in the process of drawing; perhaps not at first, but relatively soon. This book provides many opportunities for developing such capacities.

Drawing is a challenge, as well. It is a challenge to understand that an important part of the process involves the ability actually to see what is out there. In other words, to learn to draw is to learn to see. This process is critical and is stressed throughout this book. There are also opportunities for other kinds of drawing experiences that rely on discovery brought about by a "playing" with materials, and by other means that are equally important. Essentially, the critical, formative stages of drawing should incorporate careful observation of natural phenomena (the ability to see "correctly" and to record what one sees), as well as departures which permit the exercise of the imagination and the possibility of personal innovative experiences (the ability to externalize, or objectify, the internal).

The pleasures and challenges of drawing are often interrelated in the process of one's development. The child, for instance, does not question why it draws things as it does. It simply draws them. A circle with two marks for eyes becomes "daddy" or "mommy." A crude rectangle with four circles at the bottom becomes a car or a fire engine. Children take great pleasure in drawing these symbols. They are meaningful and produce the delight of achievement. Creating "pictures" is also a storytelling process. The child is telling us something about its family, its friends, or its neighbors. These can be fascinating fantasies that we find amusing or astonishing. And we are often impressed by the child's ability to design. Where to place things on the paper is a conscious process for the child, who exercises this innate ability with candor that is admired by some mature artists. But as the child develops, it wants to achieve more. The child becomes more conscious of its environment and of the challenge of extending its drawing abilities.

Young teenagers feel the need to surpass their childhood abilities. They want their drawings to look more "lifelike." At this age, individuals become even more influenced by their environment. They are more attentive to work they see in exhibitions and in reproductions of art. But when they attempt to draw realistically, they are usually disappointed at not being able to get the results they desire. Their *pleasure* in drawing often diminishes as they present themselves with the *challenge* to draw better. It is at this stage that a good teacher is most crucial. A "good" teacher is one who will help the student understand basic problems of perception and how carryovers of symbols from childhood may interfere with perception. "Seeing" the symbol instead of the object is a common occurrence. It is not simply a mistake which some people make, but one which many make because of a psychological preconditioning to see by means of a previous mental set. This subject is discussed more fully in Chapter 2.

It is lamentable that often even a good teacher, not being able to cope with the teenager's desire to draw realistically, encourages self-expression. Failure to cope with a student's problem may lead to the encouragement to "do your own thing," and a pat on the back for getting "nice" lines, or "pretty" color. The intention is not to deny self-expression, but to base it on a more solid footing, which is enhanced by learning to see correctly. More rigorous standards have been (and are being) set in many states to correct lacks in art education at the secondary level. Teacher training programs in colleges and universities are now requiring studies in secondary art education that include basic drawing disciplines, such as perspective, the use of light and shade, proportion, and other essentials. Adults who have not been exposed to such well-rounded programs at earlier levels often shy away from art courses when they attend colleges or universities. They think that studio art may be fun, but not serious enough to be useful college pursuits. In addition, not having had good preparation at earlier levels, such individuals often feel inadequate and lacking in talent. They do themselves a disservice. Even some academicians, though broadly based in many ways, suffer from misconceptions about art that can create havoc on college campuses when budget time comes around, with the consequence that art programs are poorly funded. The greatest amount of the budget usually goes to the sciences, while art struggles to survive. Fortunately, the situation is changing. The Rockefeller Report, studies in creativity by neurologists and psychologists, and other research have done much to present the value of art activity in an all-inclusive educational perspective. Aside from its obvious value in professional programs, studio art is becoming better understood for its vital role in the education and development of the total individual. Recognizing that art activity is a right brain cognitive function which complements the analytical left brain cognitive function, educators are more inclined to reconsider its importance in the education process at all levels. Some college "core" programs now include studio courses with such titles as "visual thinking," or "studio orientation." Such courses often involve problem-solving approaches that stimulate the ability to see and to express, as well as to enhance the student's ability to comprehend works of art from various cultures and time periods better.

Whether you are studying art formally or are working on your own, whether you plan to make art a profession or simply an enjoyable pursuit, you can profit from this study. It will help you to develop important drawing skills, sharpen your powers of observation, and provide the opportunity for unique self-expressive visual statements. The *pleasure* of drawing will take on added dimensions as you pursue the *challenges* this book offers. Perhaps Alexander Kostellow was right after all: anyone *can* learn to draw, and a perceptive teacher can assist the process.

1

OBJECTIVES AND METHODS

The objectives of this book are planned to meet the needs of a large, diversified audience. Consequently, the book is addressed to those who are attending college or professional art schools, as well as to those working on their own. It is also addressed to various age levels beyond those of the secondary school stage, though it can be useful in secondary art school programs for gifted students by means of careful and selective adaptation.

Regardless of age differences, many people face similar problems or obstacles in learning how to draw. Inherited symbols from previous years, inherited stereotypes, preconceptions, and other factors and conditions often present limitations that hinder artistic development. Hence, the scope of the work includes a variety of drawing experiences that will provide information suited to various needs.

Learning to see creatively is certainly among the main objectives, and the creative attitude is so essential that the entire next chapter has been devoted to it.

The sequential manner in which work is presented should be of much help to the beginner. Becoming aware of the importance of gesture at the outset is critical. Experiments with tools and mediums provide an integral way of getting involved with expressive possibilities before attempting the more demanding work of considering concepts and specific subject matter. The former activity enhances the latter.

Although work is presented sequentially, the student may develop a personal focus that would suggest a selective use of material better adapted to individual needs. That is, someone with previous exposure to certain drawing experiences may wish to skip some portions and go on to others. The planning of the book allows for such possibilities.

The methods used in the book are based on the results obtained from a considerable period of teaching and professional experience as a practicing artist. The translation from "live" teaching into book form is a challenging

endeavor. The teacher becomes an abstract body of information conveying suggestions on procedures, explanations of technical data, promptings, critical evaluation, and other instructional devices. The student is encouraged to become his/her own critic, to evaluate work on the basis of objectives presented, comparing one's work to instructional illustrations and the work of established role models. Self-evaluation is encouraged, in group situations whenever possible.

Because many who use this book may have had little, if any, previous drawing experience, the topics that follow may prove useful.

Terminology

It is obvious that many terms used throughout the book may need clarification. Hence, a glossary of terms is provided. Although nebulous jargon has been avoided, there are some basic words and terms with which the layman should become familiar. Words such as value, symmetry, asymmetry, and tension form a natural part of the artist's vocabulary which should be understood in context, rather than as non-artistic terms.

The section titled "The Figure in Depth" in Chapter 8 includes the study of anatomy. The skeleton and significant portions of the musculature of the figure are presented in such a way as to eliminate unnecessary and complex terminology. Basic descriptions and functions of selected anatomical portions are considered. Such simplification is useful in the book's context, but is not all-inclusive for those who wish to make the study of anatomy a specialization, nor is the material suited for those whose interest in anatomy may relate to medical illustration or other professions requiring greater specifics.

Drawing Materials

A great variety of drawing materials are available to the artist, both of a conventional and unconventional nature. Some of these are explored in Chapter 4. Brand names have not been used, but specific types of materials are suggested in many of the problems and exercises for important reasons that will become evident as you proceed with the work. Whenever possible, purchase materials that are suggested and get good quality brand names. Art supply stores often have catalogues of well-known brands that you can use for comparative purposes. Friends or teachers may also be helpful in suggesting good materials at relatively low cost, though it is often wise to pay a bit more when in doubt. Art supply stores have periodic sales, offering good materials at large discounts, and many stores offer students a 10 or 15 percent discount. Be on the alert for such opportunities.

Experimentation

The value of experimentation is stressed throughout the book. Chapter 4 contains a special section, "Experiments with Media and Surfaces," which should be fully explored by the beginner. Although much of the book is devoted to specific drawing problems of a representational nature, some

portions deal with expressive concerns. Both rely on a sound grasp of materials and surfaces brought about by a preliminary "getting acquainted" phase. In fact, the representative and the expressive are never completely separated, but interrelate on many levels from early attempts to later, more sophisticated visual statements. Knowing what your materials can do is, therefore, essential. Preliminary experiments of a broad, exploratory nature provide much-needed insights that strengthen performance in later sections. For instance, the most advanced portion of the book, Chapter 9, presents a series of drawing projects that require inventive, experimental approaches. The reader is required to engage in a personal kind of selective experimentation to arrive at unique solutions. Early experimentation provides a foundation for more advanced excursions.

Subject Matter

Subject matter ranges from still life through nature studies to the figure. There are also opportunities for imaginative applications in which one invents one's own imagery. Some problems present possibilities for nonobjective work—drawing which does not rely on realistic representation, but permits an option to deal with abstract elements and relationships. This broad range makes it possible for students with some experience to concentrate on whatever portions of the book meet their needs.

It may be helpful to beginners to know why subject matter has been presented in a certain sequence. After the presentation of experiments with media in Chapter 4 and basic material on picture plane and perspective in Chapter 5, the main subject of study is still life. Although still life has been and continues to be a major subject of interest to many artists, it may not have as direct appeal to the beginner. Hence, an explanation of "Why still life?" is necessary.

Since all drawing involves a "right brain mode response," which we shall consider more fully in "Learning to See Creatively," certain drawing procedures can be learned more rapidly when working with still life than when working with other subject matter. Perhaps this is the reason that still life is often the first subject that is utilized in many formal drawing programs, although the rationale may differ. That is, still life may be selected for its primary nature, as perhaps the easiest of subjects to first consider, rather than because of left brain/right brain theories that are of more recent origin. After all, artists have been studying the still life for centuries without the benefit of scientific theories on creativity. Yet, the correlation of previous rationales with more recent, scientific evaluations is instructive and useful.

Simplicity is one of the strongest arguments. A few objects can be arranged to afford the student an opportunity to apply some basic concepts of drawing. Simple shapes *are* easier to draw than more complex ones. Learning to make assessments of shape, form, and space (with a minimum of the naming process) hastens the development of a right brain mode response, rather than a linear, analytic one, which is the most prevalent due to previous instructional patterns established throughout one's education. Later, the still life arrangement can become more complex, and present some of the challenges of other subject matter, such as landscape and the figure.

Objectivity is another important premise. One can develop and maintain more detachment when drawing a bowl of fruit than when drawing a

portrait of one's relative or friend. There is no need to capture a likeness or character. Anxiety is diminished. One is more likely to make necessary changes and adjustments with a sense of greater ease.

Gesture, proportions, tonal aspects, spatial and compositional potentials— to mention only a few essentials—can be dealt with in still life. Other advantages are presented in Chapter 6. The beginner is urged to study thoroughly and complete the problems in the still life section, as well as to grasp the essentials presented in "Picture Plane and Perspective" (Chapter 5).

Learning To See Creatively

This was touched upon in the introduction and needs to be considered more fully here, since it is one of the most critical aspects of the drawing process.

In recent years scientific experiments conducted by neurologists and psychologists have come into focus in relationship to the educational process. Artists and educators are adapting such findings in various ways to stimulate creativity and increase the rate of learning. By now, *Drawing on the Right Side of the Brain* has already become a classic reference in the teaching of art, especially useful on the secondary art level. Betty Edwards has presented the material with a clarity and conviction that makes her book outstanding. I recommend it for its useful insights to both beginners and to educators who wish to have a better understanding of the creative process as it relates to artistic activity. Some of the methods she employs, however, are not entirely new. Many artists and teachers of art have long been aware of the necessity to make nonverbal assessments in the development of studio art. In fact, the artist and the art educator have long pursued methods that by nature are basically holistic, form and space oriented, rather than linear in character. What Betty Edwards has done, however, has been to strengthen such procedures by means of scientific references that are extremely useful to clarify some of the mystery and ambiguity that is associated with the creative process—and with drawing, per se.

Another who has been engaged in pioneering efforts in creativity is Dr. Win Wenger. He has developed a concept called "psychegenics" (psyche means "mind," genics means "derived from"). He has made appearances on college campuses as a visiting lecturer and has been a participant in the Creative Problem-Solving Institute, sponsored by the Creative Education Foundation, State University College, Buffalo, New York, originators of "brainstorming" and other methods for evoking creativity. On several occasions I have seen work done by his students that was accomplished in a surprisingly short time—a matter of days—equal to drawing and painting by beginning students that usually takes several months to achieve. Dr. Wenger is mentioned again in Chapter 10, in the section "How to Overcome Creative Blocks."

Yet another pioneer of creativity is Dr. Jean Houston, whose *Mind Games* may be familiar to many readers. Much of her research (and that of her husband, Robert Masters) has been directed toward enhancing the work of the artist and increasing artistic productivity. Her unique methods have also produced astonishing results: inducing trance, or semi-trance, states has led artists to telescope many hours, even days, of effort into minutes, whereby skills have been increased tremendously. Correlating such altered states of consciousness with so-called "normal" states has resulted in highly beneficial

results in which various kinds of learning have been enhanced and strongly reinforced. Dr. Houston is also referred to in the section "How to Overcome Creative Blocks" (Chapter 10).

These individuals have done much to make us aware of the importance of left brain/right brain correlations. They emphasize the need to understand creativity as stemming primarily from a right brain source and have demonstrated their theories by numerous impressive experiments.

It may be useful at this point to refer to left brain/right brain study in relation to our concern to see creatively. Simply stated, the brain can be divided into two hemispheres—left and right. The connecting cable between the two hemispheres is the *corpus callosum*, which provides communication between the two and thus allows for the transmission of memory and learning. Neurologists, who before the 1960's considered the left portion of the brain to be superior to the right portion, changed their views when studies indicated that both portions, or halves, are involved in higher cognitive functioning. Left brain functioning complements right brain functioning, although each functions in a different "mode" of thinking.

The usual pattern of learning in school situations stresses a left brain mode: we are taught in a linear sequential manner. Verbal and mathematical (analytic) skills are stressed, while nonverbal (art-aesthetic) skills are generally given less importance. Further, the left brain is logical, drawing conclusions based on an ordered sequence of things, while the right brain is intuitive, using insights, feelings, and visual images. Obviously, it is imperative that we combine both capacities (left and right), and we manage to do so somehow, despite emphasis on left brain procedures.

Those who are investigating creativity are concerned not only with the creative aspect of right brain modes, but are also involved with the subject of how right brain modes can function best without left brain interference. Various studies and methods have been developed which give us valuable insights into the situation. Obviously, getting the left brain "out of the picture" while creating—for instance, while drawing—is an important consideration. Yet, since the whole person is involved, the left brain must be consulted with the findings of the right brain. It has been found that this is best done *after* some creative work has been achieved by the right brain.

In my own experience, both in my creative work and in my work with students, I have found it necessary to stress that verbal and analytical activities be set aside while one is in the process of working. Of course, it is necessary to formulate a general plan or objective before one begins to work. This serves as a guide, a skeletal logic which forms a point of departure that the right brain pursues. As one gets deeply into creative work, a unique shift takes place in consciousness that typifies getting into a right brain mode. In this state one does not question each line drawn, each tone applied, but, rather, moves with the process. Afterwards, the logic of the effort is clear and becomes acceptable to the left brain that sits in judgement.

The method employed in this book takes into consideration the value of utilizing techniques that will enhance right brain activity, followed later with left brain analysis. Objectives are given for each problem or exercise. Materials are specified. Approaches and procedures are clarified. One is encouraged to work until a project or assignment is completed, with minimum analysis in the process. It is only *after* the work has been completed that thorough analysis of what one has done is encouraged. In some cases, however, when work involves separate stages, assessing results at different points is necessary. It should be understood, nonetheless, that work of short duration should be done without ceaseless inquiry, which can completely defeat the process. This method has worked well in class situations

in which students are encouraged to verbalize the results they have achieved—and even their lacks—in general classroom critiques. They are asked to describe how they achieved solutions, what problems they encountered along the way, and, in general, to give a total and honest assessment of the results obtained. A person working alone may employ the same process of verbalization after completing a drawing problem. This may be done with or without the aid of a tape recorder, though using the latter has the advantage of playback for further reflection and study. By use of tapes one can keep track of personal development—a tape log of experiments and studies. Making written notes of results is another alternative to verbalization, but is perhaps more laborious and less spontaneous. It may be of interest to know that after using this verbalizing technique for over twenty years, I recently read of a method, "The Principle of Description," coined by Dr. Wenger. He recommends the use of verbalizing things visualized in many different types of situations. This may include describing almost anything one might observe by direct vision, or by the process of visualization (inner, imaginary experience). He claims that by doing so, one is making an important transference of activity from a right brain mode to a left brain mode, thus integrating the two forms in a conscious manner. He further claims that by engaging in this crossover, one's I.Q. can be dramatically increased. If this claim is true—and it is my understanding that Wenger's theory has not yet been disproved—there are important benefits to be gained by the verbalization process in addition to a better grasp of one's own creative efforts.

Several examples come to mind which relate to the crossover of left brain/right brain modes in the experience of well-known artists. We know, for instance, that Leonardo da Vinci kept elaborate sketchbooks in which he made drawings accompanied by detailed written documentation. Such work suggests that written descriptions and explanations were used to clarify or support visual statements, perhaps as an after-the-fact type of performance. As another example, we are aware that Jackson Pollock, though he first worked in the expressive style of Thomas Hart Benton, made a complete break with realism when he embarked on what was to become known as "Abstract Expressionism." This was a completely new form of expression for him, relying largely on automatic responses. It is known that he had to engage in a "get acquainted" period with his new form of expression. He had to analyze (left brain mode) what he had done by a new visual means (right brain mode). He would accept or reject his work only after such analytical scrutiny. His acceptance would be predicated upon a realization of the value of the work, its inherent organic qualities, its sense of unity, its "rightness"—it "worked," as artists say when we don't feel the need to change anything. Of course, he also destroyed or worked over some of his unsuccessful canvases, which is a good indication that they failed the critical test he put them to by means of disciplined maturity of vision and judgment (the use of both halves of the brain).

It is evident that learning to see is critically involved with a right brain mode response. An essential part of one's artistic development relies on the ability to see correctly what is out there and to reject what may be a previously learned symbol which is no longer adequate for one's needs. Also, the linear, verbal description of visual phenomenon must follow and not precede or intrude upon the development of a visual statement. For instance, in considering the drawing of a "head" (verbal description) which is foreshortened, one's recollection of a flat, frontal face (symbol) may intrude upon the vision of the way such a head actually looks from a given point of view. Procedures given in this book will help to eliminate such confusion and will enable one to perceive what is actually there.

Among such procedures, gesture is of the utmost importance. It enables one to capture the total *gestalt* of a subject with minimal applications right at the outset and engages one in a direct right brain mode response. That is the reason it is stressed throughout the book in various problems.

Visualization is another ingredient in learning to see creatively. We use this faculty constantly, but many do not understand its relationship to drawing or how to apply it for creative purposes. One can visualize imaged forms as well as actual forms; It is done constantly, and it is easy to direct the process into productive artistic channels. If one analyzes the process of drawing from life, it is apparent that one is transferring bits of information that are internalized and then recalled. We look at the object and then look at the paper, drawing what has been recalled. Beginners often do this fragment by fragment. More advanced students *look less and draw more*, which indicates a greater use of the visualization process. Some students eventually draw more from imagination than from actual life, which is a sure indication that they have developed a *concept* of drawing that can be channeled into many creative adaptations, without constant reliance on "things out there." Visualization, therefore, is encouraged in doing the problems, exercises, and projects in this book. No matter how simple or complex the drawing, one can advance more quickly by visualizing what one wants to do *before* doing it. Visualization presents the prospect of successful results even before one begins to work. This is a valuable tool that lessens the sense of apprehension often encountered by beginners. It may also provide a means whereby one may overcome past failures to draw because of inadequate procedures; "getting over that hill" is more assured by a more positive kind of preparation.

Another important consideration in learning to see creatively is the role that deep breathing and relaxation play in the process. They are interrelated in ways that bring about receptive states that enhance learning skills, as well as meditative states. Some artists claim that when they get into a creative state, it is very much like meditation (and some psychologists are of the same opinion). Scientific studies have indicated that deep breathing and relaxation, critical to the process of meditation, are also highly desirable in the learning process. Learning to breathe deeply and to relax before beginning to work—and to recall its importance as you work—lessens the tension that is common for most beginners and for others, as well. It is a common experience to hold one's breath in many situations. This is largely an unconscious process—perhaps you are doing so as you are reading this sentence—but in the process you are taking in less oxygen, which in turn decreases blood circulation to the brain. In Dr. Wenger's book *Your Limitless Inventing Machine* (page 13), reference is made to Ron Jevning and colleagues at the University of California, Irvine Medical Center in Orange, California, who found that blood circulation to the brain increased by 65 percent over ordinary rest or sleep by means of relaxation techniques. They observed that by age 30 most people lose at least 100,000 brain cells every day due to retreat of circulation. And, more importantly to our immediate concern, better circulation to the brain enables our *preceptor system* to work much better. Therefore, deep breathing and relaxation are considerations that should not be underestimated. These are mentioned again under "Helpful Hints and Procedures," in Chapter 11.

2

THE CREATIVE ATTITUDE

Before you begin to work, I would like to call your attention to some important considerations which will greatly assist the development of a creative attitude. Supported by some helpful hints this should serve to make your work more rewarding and enjoyable, as well as to make you more productive.

It is regrettable that more teachers and authors of books on drawing and other studio arts do not seem to be concerned with the importance of the creative attitude. They simply set the student to work as soon as possible, as if the preoccupation of work alone will engender a creative state. While one should become immersed in the language of one's craft as soon as possible, it is equally important to be aware of how to prepare oneself for maximum performance.

A creative attitude consists of several attributes: the proper mental set or predisposition; the proper physical state—an alert, but relaxed condition, free of anxiety; a state of openness and responsiveness. These various states are nurtured by having the proper ambience and suitable working conditions. Let us consider each of these in some detail.

Mental Set

Often a person with little or no previous experience has a poor self-image as an artist. People who have not yet learned how to draw are extremely apprehensive when they begin, thinking that they should already know "how to." I have found this notion to be typical of students in a Drawing I class. They claim that they "can't even draw a straight line," as if such precision were the basis for judging talent and ability. It would be unkind simply to say "use a ruler," as I have been tempted to do on some occasions. Instead, I encourage the person to realize that one must begin somewhere,

and that drawing, like any other "language," requires the development of understanding and skills. Almost inadvertently, I have at times stated Alexander Kostellow's contention that "anyone can learn to draw."

Another obstacle that gets in the way of the proper mental set is the stereotype that an artist must be a strange kind of person, subject to moods and flashes of inspiration. The image of Vincent Van Gogh may come to mind, suggesting the tortured artist trying to adjust to an unsympathetic society at odds with his creative genius. The average, fairly well-adjusted person may feel quite incapable of experiencing those moods and flashes. Furthermore, one may not want to! It is important to realize that drawing is a skill to be learned, after which one can then express attitudes and responses to life, the joys and the sorrows. Learning is not predicated upon being unusual, but *receptive*.

Entertaining an image of successful efforts, on the other hand, can prove to be very beneficial. A self-confident image based on one's sincere motivation to learn and a healthy expectation to win some and to lose some prepares the way for responsive learning. All the work will not go smoothly, but with proper application and persistence, inevitable gains will be made. The use of visualization is helpful and will be dealt with under "procedures" at the end of this chapter.

Being prepared to make a mental shift when engaging in the drawing exercises is highly advisable. As you work, you will become deeply immersed in the process of drawing. Your state of consciousness will become somewhat altered from its usual state when attending to the mundane affairs of life. Time will seem to stop—or rather, time does not seem to exist. You experience this state in watching a movie or in daydreaming; you are "taken out of yourself," transported. It is important to learn to recognize this state when it occurs and to cultivate its occurence in drawing. Doing so will make it easier to develop the proper mental set when you work on exercises. After a while it will be quite easy and automatic to enter the kind of creative condition that makes work most rewarding and successful.

Physical State or Condition

In addition to the proper mental set, a proper physical state or condition is most important. In fact, mental and physical conditions are closely interwoven in the creative state. Artists usually feel relaxed but alert as they work. It is a pleasurable experience that enhances one's total feeling of well being. Of course tension sometimes occurs due to some mental or physical problem. Usually an artist stops when this occurs, and resumes work after achieving the desired state of composure and relaxation. I am not suggesting that one does not continue to have personal problems that may cause anxieties, only that such things can be set aside with discipline and effort. Knowing how to deal with such situations that restrict creativity is important. Hence, having some technique of relaxation is most useful. Here's one of my favorites.

Technique for relaxation *Anxiety and stress usually create muscular tensions throughout the body. One gets tense and tight. A feeling of restriction tends to "tie the body into knots." Even mild muscular tensions can impede the proper relaxed state that is desirable for creative activity. Try the following. If you are seated, stand up and stretch your arms outward and upward. Stretch as far as you can. While doing so, take a few deep breaths. Lower your arms slowly, finally letting them go limp at your sides. Continue to breathe deeply as you resume a seated position. Feel how limp your arms are, how relaxed your hands are. Be*

aware of that feeling of complete relaxation in those parts of your body. Compare that relaxed feeling with the feeling in other parts of your body. If you notice a tenseness anywhere, tense those portions even more and then let go, feeling your muscles go limp. Continue breathing deeply as you do so, a calm, steady, deep breathing. Examine the rest of your body for any additional tension and continue the process until you feel deliciously relaxed. Noise should be reduced, if possible, since loud sounds tend to create mental and physical responses that might interfere with your desired state. You may wish to turn your radio down or completely off. This is especially important before you begin to work. After you have achieved a relaxed but alert state, you may find music a pleasant stimulus. Outside stimuli, however, should not interfere with your concentration.

With some observation you may find that while working you tend to hold your breath. If this happens, take a few minutes to relax and breathe deeply. A sense of effort usually makes one hold one's breath, and in the process much energy is wasted.

Although the above technique is one I have developed, I am indebted to Dr. Win Wenger for his research on breathing patterns. Full reference to his work can be found in the bibliography for those who wish to know more about his various breathing techniques.

Ambience or Studio

Although you need not be fussy about a studio, it is desirable to set a space aside that can be used regularly for your work, especially if you are not attending a drawing class. It is important to have your own space for several reasons. It will be your own personal area where you will develop and grow as an artist. Psychologically, it is closely identified with your creative development and attains a kind of creative aura. Also, the convenience of having your own space permits you to set up your work area to your liking. Your drawing table and an easel can be situated for greatest convenience— you need not shift or remove these things as you would have to do in temporary quarters.

If you have a north light you are fortunate. However, many artists prefer artificial light which is constant, compared to other light sources which are changeable. You need not be fussy as long as you have adequate lighting conditions. Often a spare room, a portion of an attic, or a cellar may provide a perfectly good work space with improvised light of your own invention.

Many artists and art students like to organize carefully their materials, books, and other things associated with their interest in art. They either buy or improvise shelves and work tables or storage units that serve basic needs. They also like to put up on the walls of their studios reproductions of their favorite works, or their own studies and exercises for observation and reflection.

In sum, you will probably find it helpful to establish a studio or work-space that you feel comfortable in, which can serve as your creative base.

Helpful Hints and Procedures

Since most of the rest of the book is devoted to various kinds of drawing problems, it would be well here to consider some general procedures and helpful hints that can be utilized throughout your work. It might be useful to place a marker in this section to which you can refer as you proceed from one exercise to another; this will enable you to quickly refresh your memory of some essentials before you move progressively to another exercise.

1. Before you begin any of the exercises *read the entire section* for maximum clarity and comprehension. It is best to have a thorough understanding of objectives and procedures at the outset.

2. If you come across technical terms that are not clear to you, look them up in the glossary. Although not exhaustive, the glossary is meant to provide you with some essential terms which artists frequently use.

3. When time limits are set for certain problems, please observe them. Some exercises are geared to help you attain a right mode response as quickly as possible. Quick action drawings, especially, make demands that diminish an analytical attitude, thus engaging your right brain faculties more fully.

4. Do not stop every few seconds or so to examine what you have done. Early analysis can be detrimental. It is best to work at an even pace. If you are doing a two-minute drawing, finish it before you examine it. If engaged in a longer study, reflect on form and spatial relationships, rather than on mathematical exactness. Additional ways of making assessments will be given for problems or exercises that require prolonged periods of time.

5. Many examples are provided throughout the text. It is best to consider these examples in terms of the objectives to which they are related. Some are student efforts that are successful solutions to a particular problem, and are not considered to be great works of art, but successful statements in their own right. If you do not like the work of some of the professional artists, try suspending your personal preferences by allowing yourself to enter *their* perceptions and insights. Doing so can increase your inner space and broaden your own potential.

6. It is best to follow the sequence of problems presented, unless you have some special, more advanced purpose to pursue. A beginning student is urged to conform to the given sequence for maximum benefit.

7. Visualization is an important technique to use, as you will note in the exercises. When you visualize you are using a right mode response. You are reminded to exercise the faculty of visualization in connection with much of the work you will do. If you have difficulty visualizing, try this: Begin with something simple that you can see nearby. It might be an apple, a lamp, a clock, or some other rather uncomplicated form. Take a good look at it, then close your eyes and picture it in your mind's eye. With a little practice this should become easy to do. After you gain this ability, apply it to the work at hand. Look at whatever it is that you are asked to visualize. Close your eyes and see it as clearly as you can. Then proceed as directed in the particular exercise. You will note how your powers of observation will increase and how your drawing will improve.

8. Don't forget the importance of relaxation and deep breathing. Make it a regular practice to get into a relaxed, alert state before you begin to work. Make deep breathing a natural part of your physical condition before and during your work sessions. Any stress that you develop as you work can be eliminated by reminding yourself of the importance of relaxation and deep breathing. These techniques, together with the proper use and application of visualization can increase your learning rate to a surprising degree. Don't take my word for it, experience it for yourself.

3

SKETCHBOOK CHALLENGES

The Sketchbook

Sketchbooks come in different sizes for different purposes. For instance, the small 8″ × 11″ sketchbook can be used in crowded situations on a bus, train, or subway, or whenever you wish to work without being too obvious. It can be held comfortably, as one would hold a regular book, a feature which can be particularly useful when working in a situation that presents the pressure of movement and close contact with an active environment.

Sketchbooks approximately 14″ × 22″, 18″ × 24″, and larger can be adapted as circumstances and conditions dictate. Medium and large sketchbooks are useful for nature studies, general outdoor work, and work from the figure. It is generally more desirable to have a comfortable setup and adequate space when you use a sketchbook that exceeds the 8″ × 11″ format. But there are no set rules, and common sense should prevail.

Inexpensive newsprint pads are excellent for quick gesture studies. There are many other types of pads and sketchbooks, ranging from bond to all-purpose papers. A heavier paper is better suited to sustained work in watercolor and certain mixed mediums. The majority of sketchbooks that seem to be most popular are "mixed media" types (usually identified on the cover). These are preferred for the latitude they offer, and are recommended for general use.

Some artists and art students supplement regular sketchbooks with one of their own design. These can be made quite easily by inserting the desired kinds of paper into a spring binder that can be purchased at stationery and art supply stores. It is often useful to work with a combination of papers—for instance, newsprint, bond, charcoal, and vellum, all of which can be placed in any sequence in the spring binder. Later the drawings can be stored and fresh papers added.

Sketching Materials

Sketching materials, too, vary with one's intents and purposes. The most common are pencil, charcoal, crayon, pen and ink, ink and wash, and ink and watercolor. It is also possible to sketch on paper with some painting mediums, such as acrylics or oils. Usually, such works are considered studies, in which permanence of materials is not an essential consideration. The artist may also employ unconventional materials, such as twigs, sticks, plastic straws, and other improvised tools. Chapter 4 provides important experiments with various surfaces and media which can be adapted to many sketching needs, as well as for other drawing purposes.

The Sketchbook Vision

I use the term "sketchbook vision" for special reasons. Let us consider some of them.

The sketchbook provides the tool for making first impressions of your inspiration, or some special stimulus that sets your creative imagination into action. Artists of various periods, from early times to the present, have used the sketchbook (or sketches) to record vital beginnings of the conceptual process. For example, Figure 3.1 is an ink and wash drawing by Jacopo Negretti of a religious theme. It indicates conceptual aspects dealing with Christ carrying the cross, Christ's descent into limbo, Christ and the Virgin, and Christ with angels in glory. It is important to realize that even in this early conceptual statement, the artist has conceived his composition, with Christ being the dominant foreground figure, repeated in smaller scale in the background (with angels). Essentials of action and gesture have been captured, almost as if the artist had actually seen the subject. This ability to visualize and conceptualize was mentioned in relationship to learning to see creatively. In addition, it is apparent that Negretti has a well-developed sense of anatomy and figure drawing, which enables him to draw with seemingly little effort but with much conviction. From a technical point of view, the artist has combined parallel strokes with cross hatching, short broken curved lines, and wash in shadow areas. Portions of this study were used as the basis for several paintings Negretti subsequently developed.

Sometimes quick impressions and inspirations consist of both visual and written statements, as found, for instance, in the magnificent sketchbooks of Leonardo Da Vinci.

The sketchbook is one of the most essential tools that the artist can use. It's versatility permits the artist to record all sorts of impressions that may interrelate in a number of ways. Later the artist can sift through these impressions and select those that seem most promising for further development.

It is interesting to relate Negretti and Leonardo to contemporary concerns with left brain and right brain modes. It is obvious that the internal recorded imagery of Negretti relates primarily to a right brain mode (the creation of visual images in the imagination), and that of Leonardo to both modes (visual and verbal-written analysis). It would appear that the artist need not limit himself to a purely right brain mode (visual) as he develops. However, a right brain mode is to be encouraged for students while they are in the *process* of developing their artistic skills in drawing, to avoid the confusion of left brain promptings.

We should mention some of the more obvious uses of the sketchbook

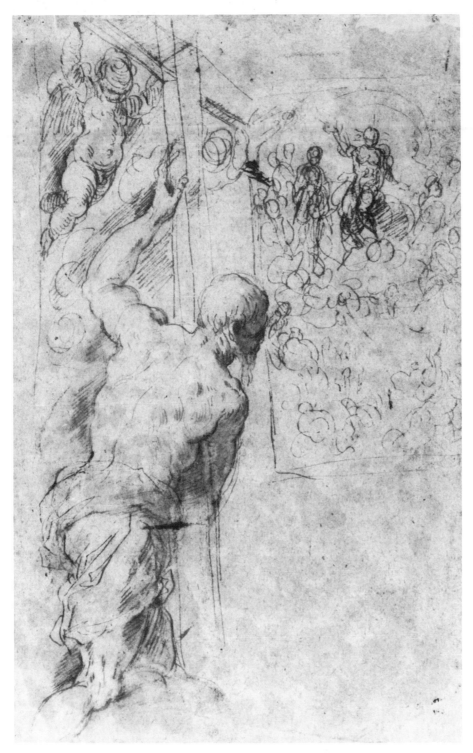

FIGURE 3.1
JACOPO NEGRETTI (1548–1628)
Simon of Cyrene and Putti Supporting the Cross (CA. 1573)
(Study for *The Descent into Limbo, Christ and the Virgin, with Angels in Glory*)
Pen, brown ink, and wash on brown paper. 12¾ × 8¼ in.
Medieval Institute, Univesity of Notre Dame. Reproduced by permission.

in recording life situations. The study of nature, for example, is among the most important pursuits of the artist—beginner and advanced alike. Also, the artist may wish to record some event that has dramatic impact. Many artists have found work as documentary artists, or visual reporters. Television and newspapers constantly utilize the artist's quick sketches in situations that are less suitable (or prohibited) for photography. We might recall that although photography and films were used to document World War II, artists were also commissioned to record their impressions. The

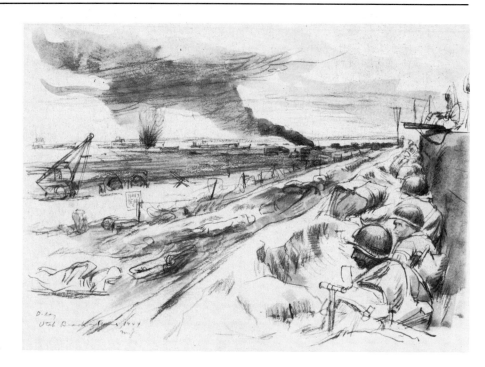

FIGURE 3.2
MITCHELL JAMIESON
D-Day on Utah Beach, 1944
Pencil and wash. 22 × 28 in.
Courtersy Navy Combat Art Center, Washington, D.C.

FIGURE 3.3
MITCHELL JAMIESON
*Transferring wounded from Minesweeper
to LST (1944)*
Pen, ink, and wash. 28 × 22 in.
Courtesy Navy Combat Art Center, Washington, D.C.

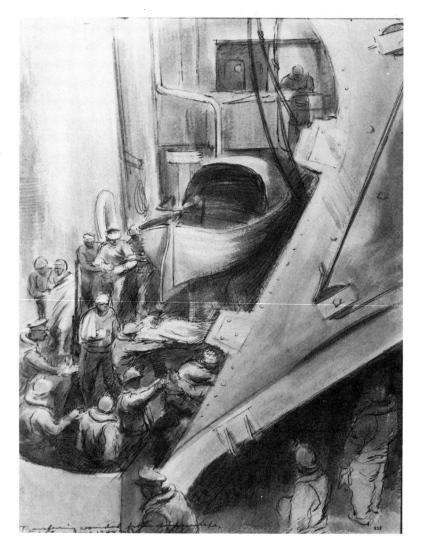

United States Armed Forces commissioned some of its major artists to record the invasions of Sicily and Normandy, not simply to get the facts, but to capture the human drama by means of the particular, creative focus of the artist. Some examples of the work of the combat artist are provided in Figures 3.2, 3.3 and 3.4.

It should be evident from the foregoing that the sketchbook vision may refer to any number of possible visual statements that serve as a basis for future work. Some may be purely imaginative, using invented imagery. Other work may be based on reactions to something in one's immediate environment—something essential that the artist wishes (or has been commissioned) to capture. At times there may be a fusion of the two, as in the work of the Surrealists—a blending of unlikely associations that are meaningful on a psychological level.

Entering the kind of inner space provided by the sketchbook vision is an important, progressive experience for the student. And those who wish to make the most progress are encouraged to sketch as often as possible. Making quick sketches of almost anything, whether seen or imagined, provides vital experiential learning that has no substitute. It is not how well you depict such images—at least not at first—but rather that you make some brief visual statement of your response. The *act* of transferring the image from the "vision" onto paper is the important thing, providing an

FIGURE 3.4
ALEXANDER RUSSO

Underground, London (1944)
Wash. 14 × 18 in.
Courtesy Navy Combat Art Center, Washington, D.C.

excellent opportunity to engage in right brain mode thinking and its objectification onto a graphic surface.

When you transfer your "vision" onto paper, you will soon realize that it is best to capture the *entire* aspect of that vision (whether from "inner" or "outer" sources). In order to do this quickly and effectively, it is necessary to capture the *gesture* of the impression, the totality of it. Gesture, therefore, is the cornerstone, a vital core upon which you will build your work and cultivate your creativity. Let us consider gesture more fully.

Gesture

Although you may have a fairly clear idea of what gesture means from the foregoing, the beginner will profit from a direct, experiential understanding. Those who have done gesture work may wish to skip this section, or simply to scan it for correlation purposes (there is always the possibility of expanding one's insights).

To proceed with these exercises, you will need the following materials: a sketchbook (newsprint or bond paper), approximately 18" × 24", black conté crayon, or soft lead pencil (B grade).

Your model will be a piece of cloth, approximately 2' × 4'—preferably white.

Get set up in your chosen environment: use a drawing table, or a drawing board, and have your drawing materials handy. Tack or fasten your piece of cloth to some supporting surface close by—perhaps a wall or a chair. Now you are ready to begin to draw.

You should spend from three to five minutes on these exercises. A timer (watch, clock, etc.) would be useful.

Exercise 1. *Since this may be the first drawing for beginners, I will carefully outline the procedure to follow.*

1. *Assume a comfortable position and be ready to work. Study the piece of cloth that you will draw, noting its* entire *configuration—see it as a* single *unit. Then study its intricacies: what areas seem taut, limp, curvilinear, angular, and so forth. Close your eyes and try to visualize its form, essential character, and action. Then check your visualized impression by again observing the actual piece of cloth. Now set your timer for five minutes and begin to work.*

2. *Hold your drawing tool comfortably, not rigidly, and move your arm and hand swiftly and freely. Look for a movement that seems to run through the entire form of the cloth, or search out the major movements and other counter movements that characterize the form. As you do this, work lightly and do not lift the drawing tool from the surface of your paper. If you are inclined to stop and observe more critically, do not raise your hand from the surface of the paper. Let it rest there lightly until you are ready to resume work.*

3. *Do not begin to consider small sections or contour too early. Keep in mind that you should be concerned with the general first and the specific afterwards. Only after you feel that you have captured the essential, generalized impression should you consider specifics.*

4. *As you continue to draw vigorously, try to sense which areas seem to recede into shadow and which areas seem to advance into light. Try to feel a kind of push into space as you draw a shadow and a return pull back as the shadow merges into a light*

area. Block the shadows simply and directly with the broad portion of your drawing tool.

5. *Glance at your timer and note the remaining time left to complete the drawing. If you have only a minute or less left, let your eyes roam over the entire form of the cloth and compare the total aspects of it with your drawing. If any portion seems less developed than any other portion, quickly make adjustments so that the entire drawing will have the same degree of completeness—naturally in brief, relative terms. Completeness here does not mean "finish," but degree of suggestion. Stop work when the timer rings, or sooner, if you have accomplished the objectives.*

6. *Now assess what you have accomplished. The result should be simply the expression of gesture, with some generalized effects of light and shade to give some all-over semblance of the subject. It should be characterized by its direct, bold quality, and the feeling of what the material is doing. At this point refer to Figure 3.5, A and B. Compare your drawing for added insights.*

Make four or five more drawings, following the same procedure you used in the first drawing. Change the position of the cloth each time for an entirely new configuration. See Figure 3.5 C.

Don't forget to relax and to breathe deeply if you find that you are becoming tense or anxious about your work. You may wish to review the technique for relaxation given earlier if you feel that the work is not going well, or if you are noticeably tense.

FIGURE 3.5A FIGURE 3.5B

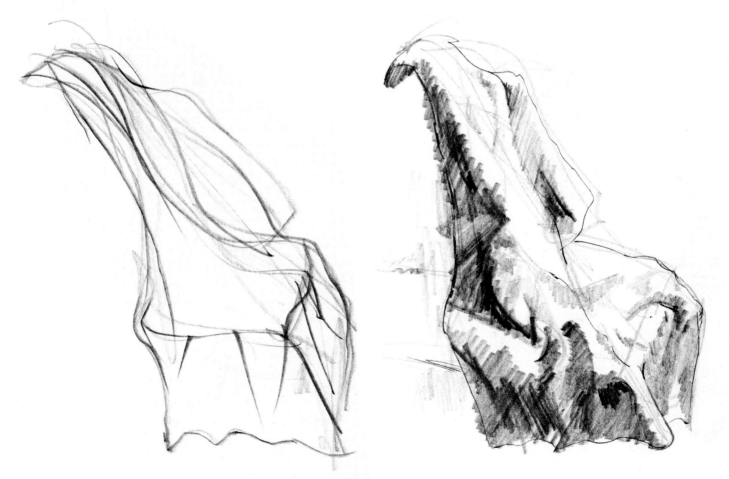

FIGURE 3.5C

FIRST STAGE:
QUICK GESTURE INDICATION—LINES
INDICATE *MAJOR* MOVEMENTS AND
COUNTER MOVEMENTS. ONE MINUTE
DRAWING.

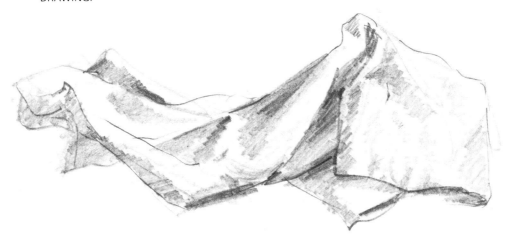

SECOND STAGE:
SHOWS SIMPLE BLOCKING IN OF
SHADOWS, FOLLOWING BASIC
GESTURE—SOME ATTENTION TO
CONTOURS. THREE MINUTE DRAWING.

Working in the way described should be both a relaxing and a stimulating experience. If you approach the first exercise in the spirit of adventure, or as a challenge, a bold assertion should dominate. Experiencing apprehension or timidity—constantly questioning whether or not the exercise is valuable—is a left brain response. Try to avoid letting this happen, as it could result in considerable frustration. Instead, let your mind playfully review the objectives of the exercise. Were you successful in getting the qualities of movement and gesture? Observe and study what you have done in the light of the objectives, not in terms of some preconceived notion. Don't force a preconceived idea of what a drawing should be into your mental evaluation. The drawing you have made is exactly what it is and nothing more. It is an exercise with its own intrinsic qualities, based on your present abilities and understanding. Patiently witness the development of your work as you proceed with other studies that follow.

Exercise 2. *This time you will consider a number of objects on a table, a floor, or some other supporting surface. These objects may be household items, furniture, clothing, shoes—almost anything will do. Arrange four or five such objects in a clustered composition. Refer to Figure 3.6 which diagrammatically suggests a typical composition.*

You will use the same materials as before and follow the same working procedure. Again, you should plan to spend from three to five minutes on the drawing. Set your timer for three minutes and try to finish the work in that period of time. Extend it to five minutes if you have to. Be sure to look at Figure 3.7 A, which is an example of what you should try to achieve in your own drawing, using your own subject matter and your sense of empathy for what you are drawing.

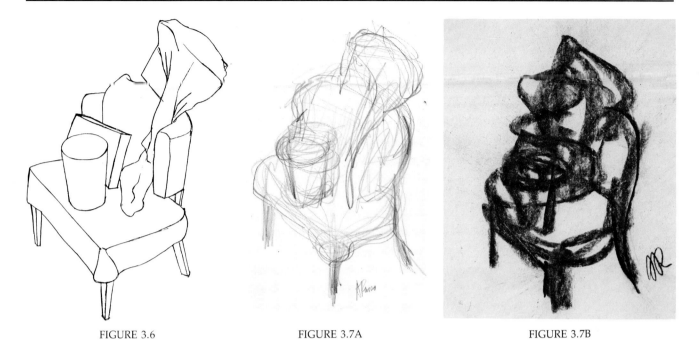

FIGURE 3.6 FIGURE 3.7A FIGURE 3.7B

Before you begin to draw, consider the following new aspects. You will be concerned with establishing the gesture of all the objects in the composition, seeing each separate form as part of a single totality. When drawing the piece of cloth in the previous exercise you were concerned with a movement that seemed to run through the entire form. Here, too, seek out visual relationships that are continuous (or can be related in a continuous linear movement). Do not lift your drawing tool from the paper as you go from one object to another. Instead, though you may pause at times to make quick assessments, keep a light pressure on the drawing tool, and then move it more affirmatively as you go from one object to another. Keep your observation generalized, moving from top to bottom, left to right. These shifts should be as continuous as possible, keeping your drawing hand on the surface of the paper.

This kind of continuous searching, meandering activity may resemble a scribble effect. There is no particular emphasis on any object or part of the composition. In a sense, the composition is the "object" or subject of your total concern.

After you have finished your drawing, compare it to Figure 3.7 A. If you find that you have been sidetracked into drawing contours instead of action (which might run through contours and other portions of form), make another gesture drawing using the blunt side of your pencil or conté crayon. The resultant heavy, massive line will make it almost impossible to be preoccupied with contour or edges. Figure 3.7 B presents and example of the more massive, broader gesture treatment.

Make several other such compositional gesture drawings before going on to the next exercise.

This exercise builds on the previous two and involves the same subject matter as the last exercise. However, your concern will be with establishing a more selective emphasis toward the end of your drawing. Materials will be the same as in the previous work.

Exercise 3.

Assuming that you have understood and successfully developed the previous gesture studies, you will now concentrate on emphasizing certain portions, some descriptive contours that seem essential. Again, you should try to complete the drawing in about five minutes.

Make your first all-over indications light and tentative, after you have spent a half minute or so studying and visualizing the subject matter. This should be a kind of hazy general pattern of lines, which should take a minute or so to draw. The hazy indication should then be followed by more emphatic lines (use medium pressure) that indicate important aspects of objects in the composition, as well as some visual forces created by

FIGURE 3.8

the relationship of parts of one form with parts of another form. In Figure 3.8, for instance, the edge of the chair in the right side of the composition is related to the upper edge of the material in the left side of the composition. This similarity of visual emphasis creates an important visual tension that tends to unify the drawing and, at the same time, portray something equally important about the forms. Several minutes should be devoted to such concerns.

In the remaining time work with still greater emphasis, bearing down more heavily with your drawing tool. You may find that in the process of a more affirmative indication, you should make adjustments of shape or proportion. You are inclined to become more sensitive to portions of the work that need to be corrected in one way or another. However, don't erase. Simply make corrections by using a more affirmative line. Stop when the time is up. Again compare the drawing with Figure 3.8. There should be a similarity of intent in expressive gesture and expressive description, though, of course, the subject matter may be entirely different, as mentioned earlier.

You are urged to make more drawings in the nature of all three types of exercises explained above. The more experience you have in these progressive stages, the deeper your perceptions will become.

Let us now turn to a consideration of the kind of assets that the study of gesture affords.

Gestural Assets

The following are some of the assets that gesture affords.

1. In doing the previous exercises, you have become aware of the importance of capturing the essence of the total subject matter, whether that be of a

single image, like the piece of cotton cloth, or of a composition consisting of a number of objects. Gesture is the means by which you quickly grasp the essentials, and hence the essence.

2. You may realize, also, that gesture is the means by which you obtain the first few important aspects or indications of an entire drawing. It becomes the *structure*, the underlying basis for more complex and detailed work. This aspect will become even more evident as you proceed with additional studies and more detailed work.

3. Gesture can be related to visualization, which should precede actual drawing. When you combine the two, you have much greater potential for better drawing. The preliminary visualization experience prepares you *to see the essentials first*, which you can then translate more easily to paper when you draw.

4. It is apparent that visualization and gesture are related closely in right brain functions. After a while you will become used to experiencing a shift from your previous, analytical mode (left brain) to the artistic, or visually expressive mode (right brain). Being aware of this shift is essential. You are encouraged to become sensitive to it and to utilize it in *as conscious a way as possible*. Doing so will enable you *to sustain* your creative efforts, which might otherwise be unnecessarily subjected to the arguments of the left brain. Getting into your work quickly by means of gesture, therefore, is a great asset.

5. In the third exercise you may have become aware of how your interest was drawn to proportion and scale in a rather effortless manner, even if you experienced some difficulty achieving correct proportions. Working very quickly did not permit slow, careful analysis—which would not have been in keeping with the primary objective. Rather, your attention might have been directed to proportion and scale in broad, essential terms. By quickly relating objects to each other you were, in a sense, everywhere at the same time; the tendency to see things in relationship to each other was a built-in perception. Working from one object to another without the all-over, essential concern which gesture affords leads to bad proportions and ineffective drawing.

6. Gesture greatly aids your ability to consider generalities first, and specifics later. This procedure is emphasized throughout the book and is stressed by many teachers, regardless of what medium or form of art they employ. As you progress, your concern with details and elaborations will be predicated on a sound foundation made possible largely by your knowledge of gesture.

4

TOOLS AND EXPERIMENTS TO HELP YOU MASTER THEM

Having realized the importance of capturing gesture at the outset of your work, it is equally important that you have a basic understanding of the tools and materials at your command. Some of you may have had little or no experience working with various media and supports (drawing surfaces) to which they are applied. The exercises that follow have been planned to be exploratory for maximum benefit to the beginner. More advanced students may wish to skip this section, or to use only portions of it.

Surfaces and Supports

We have already considered various sizes and types of sketchbooks. A variety of surfaces from smooth to rough is useful to experiment on, either in sketchbook form or by means of single sheets of paper. Some highly technical works on drawing present elaborate information on various paper stocks and their durability, and other data of interest to those desiring such information. Several such references are mentioned in the list of suggested readings, but we need not deal with such technical matters here.

Drawing Media

In the section on sketchbooks, we mentioned basic media: pencil, charcoal, crayon, pen and ink, and ink and wash. Ink and watercolor will be touched

upon in relationship to ink and wash. If you wish special instruction in the use of watercolor or other mixed media, you are encouraged to explore more complete references in the list of suggested readings.

Basic Considerations

Drawing materials should never stand in the way of one's expressive concerns. Rather, they should serve as vehicles for expression. But to gain some sense of freedom and mastery with materials, it is essential to explore them to some extent. Some instructors make their students practically destroy their materials before they begin to work; students are required to crush their drawing paper, stamp on it, and in other ways devalue it. Calvin Albert, a highly respected sculptor and professor, requires students in his drawing class to devalue materials in just such ways, so that the student has a "direct release of freedom" and achieves a sense of dominance over his or her materials. The student loses the awe of materials, which in turn allows for a more relaxed attitude when he or she begins to work.

I do not suggest such drastic procedures, but I encourage the student not to be intimidated by materials. One way to achieve a relaxed attitude with materials is to explore them without trying to draw specific objects or things. Such preliminary, free exploration is directed solely to finding the inherent expressive potential of materials without additional encumbrances. One soon discovers by such a process that both surfaces and media react and interrelate in a variety of ways. The technical limits and extents of each are appreciated for their various potentials.

The possibilities of exploration cannot be exhausted; there are so many variables that one could spend endless hours just scratching the surface of an infinite number of combinations. We shall be concerned, therefore, with a few essential exercises, the style and quality of which can be adapted to the study of many other media and surfaces. We shall relate to media first, and then to surfaces and the interrelationship of the two as we proceed in our exercises.

Experiments with Media and Surfaces

"Head of a Woman" by Hans Holbein the Elder, a sensitive linear study in silverpoint on white chalk ground, resembles a precise drawing with an H pencil. Note the simple yet strong structural quality, as well as the convincing foreshortening of eyes, nose, lips, and chin (Figure 4.1).

PENCIL

Materials to have on hand include H, HB, and B pencils; newsprint, a sheet of both medium bond (all-purpose type will do) and a rougher type (such as heavy watercolor paper), approximately 11" × 14". If you do not have these materials, try to use counterparts that are similar: three pencils, hard, medium, and soft; papers that range from smooth to medium to rough. There are no time limits for these exercises.

Begin work with an H pencil on a smooth type of paper. Start by making some scribbles. **Experiment 1.** *Notice how the pencil behaves on the particular surface you are using. These scribbles*

FIGURE 4.1
HANS HOLBEIN THE ELDER (CA.
1465–1524)
Head of a Woman
Silverpoint on white chalk ground.
5¼ × 3¹⁵⁄₁₆ in.
Medieval Institute, University of Notre Dame.
Reproduced by permission.

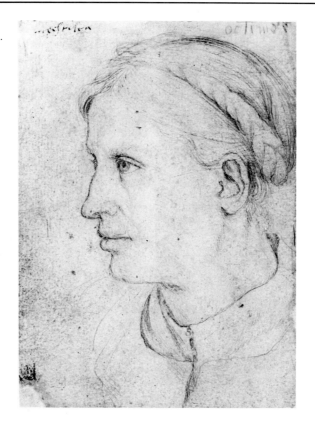

are an exploratory exercise in how the pencil responds to your hand pressure—which you
should vary as you draw—and to the drawing surface. After you have covered a few
square inches with scribbles, move to another area of your paper. Here make some tonal
gradations. Begin with light pressure, moving your pencil up and down in a series of
closely placed strokes. Try not to let any of the blank paper show through as you achieve
a transition from a very light tone to the darkest tone you can achieve. After you have
covered a few square inches of paper, stop and observe the results. You will notice that
although you increased the pressure of your pencil for dark tones, the difference between
light tones and dark tones is minimal. The hardness of the graphite does not permit more
than a limited tonal range in a light tonal key.

Move to another section of your paper and experiment with various graphic marks.
Touch the surface lightly, tentatively, barely making a mark. Then try making some dots.
Bear down with a sharp staccato effect, as if your arm were a woodpecker. Next, try
working with the broad side of your pencil. Drag the pencil across the paper. Then
make it race across the paper. Vary other applications as your imagination dictates until
you have achieved a variety of effects, using about one third of your paper.

Finally, in the remaining area of your paper, attempt to combine all the various kinds
of effects you have achieved. There is no prescribed way to do this. Let your imagination
and sensitivity suggest desirable sequences. Stop when you feel you have achieved an
interesting and varied combination of effects. Figure 4.2 will give you some idea of what
your first experiment might look like.

If some object has been suggested in the last portion of your study, it is most likely
a by-product of the chance manipulations of materials. Study this suggested or implied
image in terms of the kind of feeling it might produce. It is quite likely that instead of
finding an image in your chance effects, you will find an indication of some mood or
feeling. Spend a few minutes adding greater clarity to the implied image, or to establishing
a stronger mood indication. Students using this approach come up with surprising results.
Never having intended an image or any particular feeling or mood at the outset, they have
often come up with sensitive projections resembling people, nature scenes, underwater
scenes, and other references to life.

One of the most important aspects of the study is the expression of some image or
mood in terms of the inherent possibilities of the particular type of pencil used on a

FIGURE 4.2
Experiments using "H" pencil on
bond paper.

2. TONAL GRADATION

1. "NONSENSE" SCRIBBLE

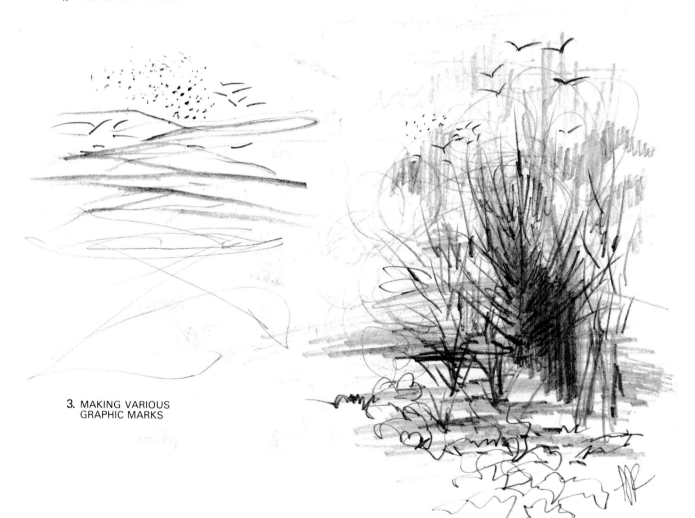

3. MAKING VARIOUS
GRAPHIC MARKS

4. IMAGINATIVE COMBINATION OF ALL
THE OTHER THREE APPLICATIONS

particular type of paper. However, if your last study does not seem to suggest anything—neither person, place, thing, or even mood—do not think that you have not done the assignment correctly. Remember that any suggested subject matter or mood would be a by-product of the study and not the objective. You will have ample opportunity in work that follows to seek out suggestions of various kinds that stimulate the imagination and allow for more elaboration of subject or mood.

Experiment 2. *This time use your H or hard lead pencil on a medium bond paper. You may follow the same procedure as in the previous experiment, or you may change the sequence of application. The important thing is to try different applications on different areas. After having done so, try to combine all the various kinds of effects you have achieved in a single composition in a clear area on the same sheet of paper.*

Examine your last attempt for suggestions of subject matter or mood. Allow your imagination to roam over the possibilities. Look at what you have done, close your eyes, and try to see the results in terms of what might emerge from it. This can afford good imaginative stimulation with beneficial right brain results. Spend a few minutes allowing for the possibility of a creative situation. If something emerges, try to amplify it and make it explicit; emphasize it by additional applications of pencil. However, don't spend more than five minutes elaborating on it, since you should move on to the next experiment. Figure 4.3 A suggests one possible result. Your results may be completely different. Just remember, this is process, not finality.

FIGURE 4.3A

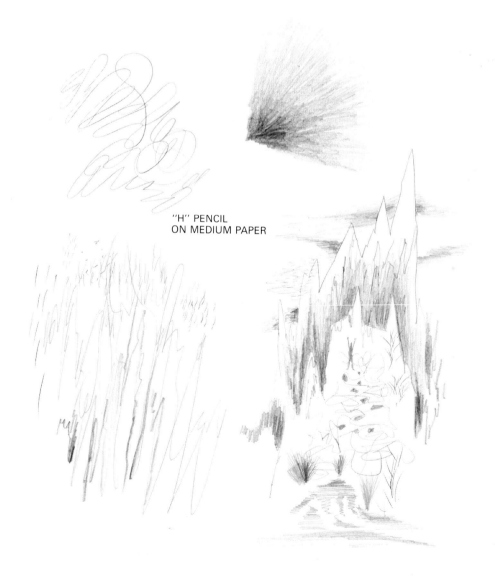

"H" PENCIL
ON MEDIUM PAPER

The final experiment with H pencil should be done on a rough-surface paper. If you have done the first two experiments as directed, you should have no difficulty with this one. Make it even more exploratory, if you wish, by changing the sequence of applications. However, don't forget to put it all together in a final composition. One final observation: you may have experienced a certain degree of frustration when working with the H pencil on a rough surface. One quickly learns the limits of materials on surface by this process— or, perhaps, realizes some hitherto unsuspected aesthetic quality. Example 4.3 B might be worth considering in this regard.

Experiment 3.

Procedural note for work with HB and B pencils: Since a detailed method for work with H pencil was given in the preceding exercises, the same method may be used for work with HB and B pencils. Use these pencils on different types of paper stock (smooth, medium, and rough). The objectives are the same: to become aware of how your materials respond to your use of them and, in turn, how you respond to the results obtained. Examples of experiments with HB pencil on bristol board are provided in Figures 4.4 and 4.5.

Individuals will prefer some results over others, even at this highly experimental stage. Be aware of these preferences, though there is much more work to be done before you can make definitive decisions of this kind.

FIGURE 4.3B

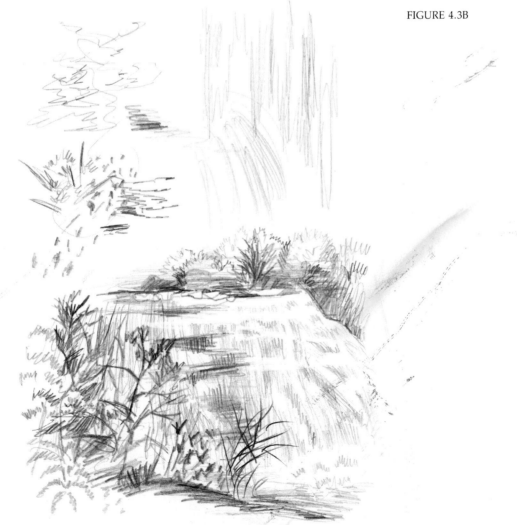

"H" PENCIL ON ROUGH PAPER

FIGURE 4.4
(top section)

FIGURE 4.5
(bottom section)

"HB" PENCIL ON SMOOTH
BRISTOL BOARD

Although the beginner has yet to apply experiments in a personally directed way, with specific objectives in mind, yet, like one's handwriting, a personal inclination will be evident at the outset.

Study the work you have done so far and allow yourself a break before beginning the next section. You may find that getting away from your work for an hour or longer may help you start the next project with a fresh vision and a relaxed attitude. A change of pace may be useful, as many college students have found when switching from one kind of discipline to another. One often complements the other and leads to enrichment.

CHARCOAL

"Reclining River God" (Figure 4.6) by Sebastiano del Piombo is a chalk drawing with the tonal and textural quality of a charcoal study. This drawing will be helpful as anatomical reference in the anatomy section, Chapter 8.

The two basic types of charcoal most used are (1) vine charcoal and (2) compressed charcoal. But for more detailed work, charcoal pencil is most

desirable, since it has some of the better properties of graphite (a more controlled fine line, for example). Powdered charcoal is also used by some artists to achieve large tonal areas by sprinkling it directly from its container onto the drawing surface; it may then be smudged by fingers or cloth (such as chamois or tissues) to produce an overall gray tone. For these experiments you will need vine charcoal, compressed charcoal, a chamois, tissue, or soft cloth, and a paper stomp. You may use charcoal pencil, as well. However, if this is your first attempt with charcoal, you are advised to work with vine and compressed charcoal first, since they provide the essentials. Working with a charcoal pencil may lead to a preciseness that should be avoided at this time, and powdered charcoal may create the opposite effect: being lost in a cloud or nebulous tonality. Charcoal paper or slightly rough drawing paper should be used, though the former is preferable. Since most single sheets of charcoal paper are fairly large in size (18″ × 24″), you will need only one for the experiment that follows. Be sure to back it up with a sheet or two of smooth paper (such as newsprint) before tacking it to your drawing board or drawing table, to prevent the grain of the board from showing through.

This will be an exploratory exercise using vine charcoal. Since charcoal is used primarily to render tonalities (often referred to as values, or gradations from light to dark), start the experiment by working for a sensitive change in tonality from very light through medium to dark. Work within about one quarter of your paper. As you manipulate the rectangular edge of your charcoal stick, notice how the edge wears away very quickly. Rotate the charcoal as the edges wear away until you finally have a rough point. However, don't work with the point, but continue to work with the edge slightly slanted, so that it continues to provide a broad tonal effect. Bear down more heavily as you proceed, to achieve darker and darker tonalities. Try to make smooth, even changes in tonalities until you have gone from light to dark.

This experiment tests your ability at tonal discrimination. Do you notice any interruptions in the flow from light to dark? If so, try to adjust them by additional applications, or by some smudging with your finger or cloth. In another section of your paper, apply the charcoal more roughly, trying for general gradations from light to dark. Here, use your chamois to achieve a smooth gradation. You may find it useful to apply additional

Experiment 1.

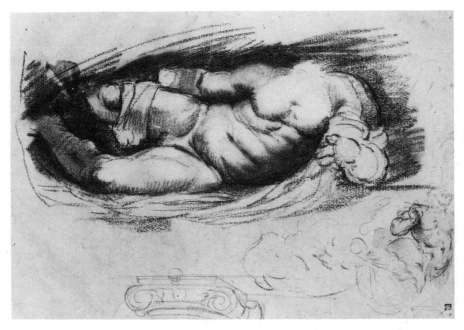

FIGURE 4.6
SEBASTIANO DEL PIOMBO (CA. 1485–1547)
Reclining River God (CA. 1512)
Chalk. 10¾ × 16⅝ in.
Medieval Institute, University of Notre Dame. Reproduced by permission.

charcoal and repeat the smudging with the chamois until the desired effect is achieved.

In the third section of your paper, use the point or edge of the charcoal to achieve a linear quality. Draw some simple forms, such as circles, rectangles, or odd shapes, if you wish. These do not have to represent specific objects, though, of course, they will be specific shapes. Try also to indicate a variety of lines, or linear effects.

The tonal portion of this exercise should not take more than five to ten minutes. The linear portion should take even less time.

Finally, in the last section of your paper make an experimental composition, without any preconceived plan. Having done the previous experiments with pencil, you should have developed some insight into this process. Be playful about it, and don't tense up. In a free, spontaneous fashion, combine various lines, shapes, and tones. Let them overlap randomly. The results may surprise you. They may suggest an abstraction resembling some work of art you have seen in a gallery or museum. By this process you should gain more insight into works of art in which the "play" of materials is essential; for instance, a work by Jackson Pollock. Figure 4.7 serves to indicate the possibilities of this experiment.

FIGURE 4.7

VINE CHARCOAL

This time you will become acquainted with the possibilities and properties of compressed charcoal. Compressed charcoal is made from powdered vine charcoal, combined by pressure with a binder. There are various grades of it from very soft (#.00) to hard (#5). It is useful to experiment with both soft and hard types. Either round or square sticks may be used. Compressed charcoal tends to be more permanent and does not smudge as easily as vine charcoal, nor is it as easy to remove with a kneaded eraser as the latter. Hence, it is advisable to use this kind of charcoal only when one has gained more assurance. However, experimenting with it is helpful at this stage to assess its use for future work.

In addition to two sticks of compressed charcoal (one soft and one hard), you will need a chamois or soft cloth and a paper stomp. As before, work on a sheet of charcoal paper backed up with one or two sheets of smooth paper.

The purpose of this exercise will be first to explore a range of effects and then to develop a spontaneous composition. This will be similar in many ways to the work done with vine charcoal. However, you will become aware of some noticeable differences as you proceed.

Divide your paper roughly into four sections, with the largest section set aside for a compositional study (you may make light indications of such divisions with any convenient pencil).

First, develop tonal gradations from light to medium to dark. Do this first with the hard stick, then with the soft stick. Since the compressed stick is pointed, work with the point to achieve these gradations. This work will take longer than the work with vine charcoal, and hand pressure will have to be established at the outset—light at first, then a gradual increase in pressure as you proceed to darker tones. Take your time and be relaxed. After finishing a tonal gradation, notice how the gray tones differ from those developed by vine charcoal. The medium and dark tones should be richer. However, the entire tonal exercise may lack a smooth quality throughout. This will be better achieved in the second tonal study.

In the second section of your paper, proceed as before, but use the paper stomp to blend the tonal areas for smoother transition. Work the paper stomp into the tonal areas gradually with some pressure. As you do this, notice how much richer the tones become— more velvety and deeper. You may find that your tones get a bit darker when you work with the paper stomp. If you try to erase a portion of the tone (with kneaded or pencil eraser) it will be more difficult than with vine charcoal. This will make you aware of the more permanent effects achieved by compressed charcoal.

In the third section of your paper, use both the soft stick and the hard stick to develop a series of random lines and shapes. Notice the differences in linear qualities achieved by the two different types.

Finally, in the last section of your paper, develop a composition, utilizing any combination of lines, shapes, and tones. As before, let the composition emerge. As your work develops, notice how this composition will have certain technical qualities which are different from the vine charcoal composition. Although this exercise is meant for the beginner, a person with some drawing experience may automatically draw something from life or from imagination. In either case, the experience of putting something together is worthwhile. Each approach should maintain some essential degree of spontaneity and will be the result of a personal orchestration which is right brain oriented. Figure 4.8 suggests the outcome of this exercise.

If working with charcoal has a special appeal for you and you feel adventurous, do this optional experiment. Use either hard or soft charcoal stick, or both.

Take a sheet of charcoal paper and make lines, dots, shapes (both contour and solid), tones, and other applications you may invent. Be playful, exploratory. No one will make a judgment on what you will do except yourself. You might try slipping some creased paper or cloth under sections of the paper and then work over them: notice the interesting textures that result. Enjoy the various visual results as you would hearing different notes from various instruments in an orchestra. Don't make any assessments until you have finished covering the paper. Then stop and reflect.

Is some mood or quality suggested in the allover result? Can you bring some inner associations to bear on what may be evoked in the composition? If nothing seems to emerge that appeals to you, try this. After spraying your charcoal study with fixative,

FIGURE 4.8

COMPRESSED
CHARCOAL

FIGURE 4.9

CHARCOAL COLLAGE

randomly tear the sheet into various pieces, some small, some large. Then reassemble them on a fresh sheet of paper (any kind will do). Keep moving them around until you sense where they seem to be best placed. Spend five minutes or so doing this, until you find an agreeable arrangement for all the pieces; some may be against the backup piece of paper with some blank paper showing, or some may overlap other pieces. When you sense an agreeable composition, attach all the pieces with "Elmer's" glue or rubber cement. (Carefully remove and replace all pieces one at a time to maintain the composition.) You have now created a collage. Congratulations! Figure 4.9 is an example of a charcoal collage.

A reflective note. To the beginner, the optional experiment may be fun or distressing. If one is not inclined toward abstraction, the experience may be less pleasurable. An intermediate or advanced student may enjoy the experiment more than someone solely intent on becoming an accomplished draftsman; that is, one who has been exposed to the many possibilities of artistic expression—at least to some degree—may recognize implicit value in the approach. Spontaneous orchestrations of tones, lines, textures, and patterns bear the imprint of the artist who creates the abstraction. The abstract expressionist artist, for instance, thrives on just such seemingly chance manipulation of elements. The left brain (analytical portion) is held in abeyance as deeper levels of the mind take over in the creative act; then the analytical sense comes in for reflective purposes. And it is possible that one's inner sense of organization plays a great part in what appears to be chance placement. This can be a valuable experiment for one who accepts the challenge.

Another observation at this point may be useful for those who have had some sense of unease in developing the requested compositions. Naturally, *no* instructions have been given on how to develop compositions. The experiments so far have relied on chance possibilities of organization, as discussed in the preceding paragraph. However, much attention is given to compositional aspects in the chapter on "Picture Plane and Perspective." Compositional elements or forces are carefully considered, since they provide a *conscious* basis for pictorial organization crucial to drawing, painting, and other artistic modes. These do not constitute art. They do, nonetheless, support the artistic possibilities of mature expression—that form of expression that relies on certain procedures and acceptable norms of element arrangement to produce desired states of communication. These are learned, then used—or not used—as one wishes. But not to know some form of organization at the outset simply impoverishes one's potential. One can always subtract from what one knows, but one must accumulate a basis, a storehouse, from which that subtraction can take place. No one creates out of a vacuum, and personal development, considered at the end of the book, depends on a synthesis of all one knows—plus the unique vision of one's personality.

A practical note before turning to other media: before putting your charcoal drawings aside, it is advisable to spray them with several light coats of fixative. There are several types available in spray cans: (1) a "workable" type that can be used and drawn over, if necessary, and (2) a "final" type for work that is considered finished. Use your judgment as to which seems best. Some artists "fix" all drawings made with pencil or charcoal (as well as pastel and other mediums subject to smudging if not protected).

CRAYON

"Group of Figures" by Polidoro da Caravaggio is a study in red chalk on paper. A parallel contemporary medium would be sanguine pencil or conté crayon (Figure 4.10).

FIGURE 4.10
POLIDORO DA CARAVAGGIO
(1490–1535)
Group of Figures
Red chalk on paper. 7⅛ × 8½ in.
Medieval Institute, University of Notre Dame.
Reproduced by permission.

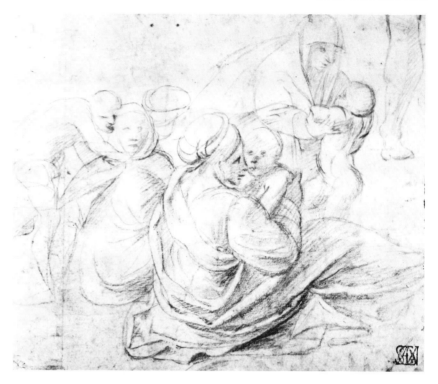

FIGURE 4.11

There are many types of crayons, some of which we shall consider briefly. Conté crayon is perhaps the most extensively used. It is a chalky, waxy substance that comes in stick form. Sanguine is a similar type, but of a reddish color, available in pencil or stick form. There are various grades of conté, ranging from hard to soft, and the visual effects are much like those achieved by compressed charcoal. These crayons are used for sketches as well as for larger, more detailed studies. They can be applied to all types of drawing papers. Sometimes they are combined with wash or watercolor, depending on the objectives of the artist. After work is completed, they, too, should be protected from smudging by the application of a fixative.

Use conté and sanguine like pencil and charcoal. You may wish to increase the range of papers you work with. Try some studies on regular drawing papers (single sheets or pads); if you can afford some tinted drawing stock, include that also.

The beginner should use conté crayon as in the experiments for charcoal studies, especially the compressed charcoal experiments. A conté crayon example is provided, in Figure 4.11.

PEN AND INK

"Studies for a Pieta" by Giulio Cesare Procaccini are pen and ink drawings on white paper. Note the gestural and expressive use of line to evoke mood and emotional impact (Figure 4.12).

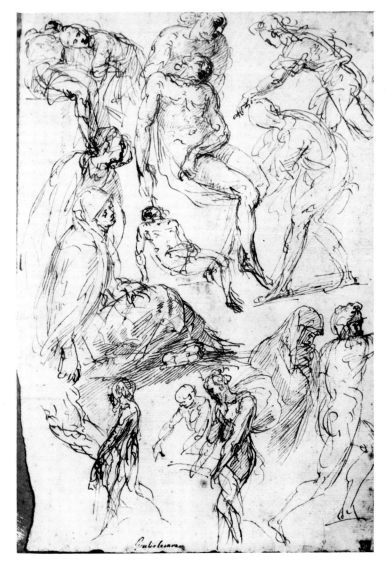

FIGURE 4.12
GIULIO CESARE PROCACCINI
(1574–1625)
Studies for a Pietá for an Altarpiece
(1602–04)
Pen and ink on white paper. 10⅞ × 7⅝ in.
Medieval Institute, University of Notre Dame.
Reproduced by permission.

Work with pen and ink may be intimidating to the beginner, since it has a kind of finality that other drawing mediums lack. You can't erase it; it is there to stay. Our objective is to experiment freely with this medium without trying to capture any specific imagery. You don't have to make it look like life.

There are many types of pens the artist can use. They serve different purposes, and we will not make an exhaustive study of all of them. Rather, we will be concerned with a few that seem to be most useful at this time. Later, as interest dictates, you may wish to explore additional pens for their intrinsic qualities and varied applications. The bibliography will offer more complete sources on this subject.

One way to to overcome any sense of intimidation when working with pen and ink is to begin with an improvised drawing tool: a sharpened stick, a piece of twig, a toothpick, a matchstick, or a similar object not usually associated with drawing. I have found this approach extremely useful in overcoming preconceptions and hang-ups. The results, surprisingly, often resemble those achieved by such orthodox instruments as the crow quill pen

FIGURE 4.13

(a Renaissance favorite), steel-point pens, lettering pens, ball-point pens, and others.

There are primarily two kinds of inks: translucent and opaque. One may obtain these in various colors, and they may be diluted to achieve different tonal effects. Some artists dilute inks for wash effects and apply them with a brush. A few combinations are shown in Figures 4.13, 4.14, and 4.15. Endless combinations are possible utilizing pen or brush, and a variety of tonal and linear effects can be achieved. India ink is probably the most widely used and easiest to work with, though China inks are preferred by some. We shall work with India ink in our exploratory exercises.

Pen and ink lends itself to a linear technique, with its own intrinsic properties. One may achieve a distinctive linear quality with a given pen that differs from those achieved by any other medium. Yet tonal qualities may also be achieved by means of parallel and crosshatched strokes. Another way to achieve tone by means of pen is to use a point or dot effect. You will create some of these effects in the experiments that follow.

(below, left)
FIGURE 4.14

(below, right)
FIGURE 4.15

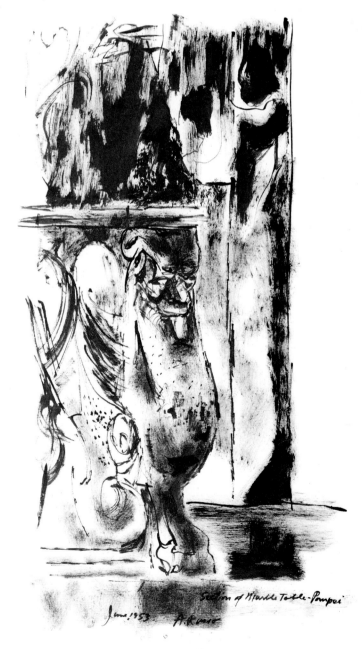

Experiment 1. *Since ink may be applied to almost any kind of paper, use a sheet of paper (a multipurpose pad, for example) of your own choice. Later you may wish to experiment on other papers. For most conventional effects, however, a smooth paper is desirable, and the following studies are suggested with this type in mind. You will also need a smooth supporting surface (a drawing board or pad) in addition to a toothpick or a sharpened twig, and a bottle of India ink.*

 First, on a small portion of your paper, as in previous studies, experiment with different types of lines. Try to get the feel of the possibilities of different types, such as jagged, smooth, or broken. Switch to another section of your paper and make some parallel strokes, then try crosshatched strokes. On still another section of your paper try some dots or points; create open, then closed arrangements of dots, achieving different densities or tonal qualities.

Experiment 2. *If you are inclined toward abstraction, try developing a composition based on the various marks you achieved. You may need a separate piece of paper for this. This need not be an elaborate work; it might simply be a kind of doodle, a spontaneous composition that fills a certain amount of space on your paper. Since this procedure was presented in previous sections, we need not spend time defining how it should be done. Remember, allow your imagination to take over. Figure 4.16 is a student work done from imagination using ink and twigs.*

FIGURE 4.16
TINA PETROHILOS (student)
Stick and ink.

A

FIGURE 4.17
ANONYMOUS (student)
Ink.

B C

Having had the stick and ink experience, you may do this study using the same equipment, **Experiment 3.**
*or you may wish to switch to a fountain, felt-tip, or ball-point pen. Any of these pens
will permit a more continuous line than was possible with stick and ink, and hence will
offer a more extended experience.*

*If you decide not to use stick and ink, spend some time getting acquainted with your
pen. Find out what it can do.*

*This time, try to render some small object, or part of an object, using a technique
you have developed (strokes, dots, crosshatched lines). Some examples are seen in Figure
4.17 that should prove helpful for the beginner. It is best to keep the object simple—a
cup, ball, bottle, piece of fruit, or some similar, uncomplicated form. Later, when working
with still life, for instance, there will be opportunity to use more complicated forms. Don't
get hung up on intricate forms at this stage. It is helpful to visualize the object before
actually drawing it. Have a good look at the object, take a few seconds to frame it in
your imagination—make it look "real" in your imagination first—then proceed to render
it, getting contour and gradations of tone that relate to your experiments.*

This will be an improvised, optional composition for those who enjoyed working with the **Experiment 4.**
*pens suggested earlier. It may be abstract (and perhaps more exploratory for this reason),
or realistic, though you should not be too demanding in terms of achieving lifelike results.
More complete instruction will be given in later sections on how to achieve realistic
qualities; for the present, it is best to try to get the feel of objects in an improvised
composition by imagining forms, or by observing simple forms that may be within one's
range of vision.*

*If working with simple objects, it may also be useful to set them up or view them
so that a strong light source comes from one direction. This will increase the dramatic
impact of form that we will be concerned with later in more carefully outlined problems.
Gesture, as described in "Sketchbook Challenges," will provide a useful method for either
an abstract or realistic composition. Make this a vigorous study, working as spontaneously
as you can. An example is shown in Figure 4.18.*

INK AND WASH

Ink and wash drawing, or perhaps more properly, brush and ink drawing,
has been a popular expressive vehicle for artists of many periods. Renais-

FIGURE 4.18

sance artists such as Leonardo Da Vinci; Baroque artists such as Rubens; the Dutch master Rembrandt; and countless others have found the combination particularly rewarding. Among other things, it permits a quick, conceptual grasp of a situation. "Three Attendants of Europa," a pen and bistre wash study by Giulio Romano, is a fine example of activated figures done with consumate directness and simplicity of tone (Figure 4.19).

Artists often make small, quick ink and wash studies in preparation for larger work, but they also enjoy it for its intrinsic, engaging qualities. A sculptor, such as Henry Moore, will often use linear and tonal effects of

FIGURE 4.19
GIULIO ROMANO (CA. 1499–1546)
Three Attendants of Europa (CA. 1527)
Pen and bistre wash on white paper.
12 × 9½ in.

Medieval Institute, University of Notre Dame.
Reproduced by permission.

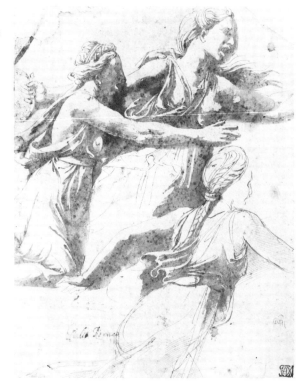

ink and wash to get a quick preliminary indication of a proposed sculpture before working in a plastic three-dimensional medium, such as clay or plaster.

One of the first things the beginner will discover when working with brush and ink is its flexible range of effects. One may achieve a fine line or strokes of varying widths. Edges may be smooth or rough; drybrush effects may be achieved which provide important textural effects of great use in the far-ranging repertoire of the artist.

As with other mediums, sensitive control and method are important factors to develop in using ink and wash. These take time. But a few directed experiments will quickly permit some insights on which to build for future consideration. The following experiments rely greatly on the examples provided, which should be carefully studied before starting to work. In preparation for the experiments that follow, have on hand a Japanese brush (probably the least expensive, but one of the most useful brushes), a sheet of medium or smooth paper (a multipurpose pad will do), a bottle of India ink, a container of water, and three or four paper cups or small trays (plastic or aluminum are good). Japanese brushes range in size from large to small; I suggest you begin with a medium-sized one (approximately a #6). Be sure to clean brushes with soap and water after working with India ink to prevent brush damage.

Hold the Japanese brush with thumb and fingers so that it points down; grasp the end of it, instead of the portion near the hair, as if you were holding a baton. Dip it directly into a bottle of India ink and make some marks, varying hand pressure as you do so. Some lines should be thin, some wide, some smooth, and some rough, as noted in Figure 4.20. After using about half of your paper, devote the rest to drawing some simple objects. Vary your hand pressure as you draw these objects, noting the linear quality that results. Oriental calligraphy and brush drawings have much the same effects that you are achieving in these simple studies. **Experiment 1.**

FIGURE 4.20

Experiment 2. *Pour a small amount of ink in one of the cups or trays, then add a small amount of water to it. Using this solution, repeat Experiment 1. Note the differences in emphasis when comparing this experiment with the first one.*

Experiment 3. *Pour a small amount of ink into another cup, diluting it more than in Experiment 2. Repeat the process explained in Experiment 1.*

Experiment 4. *This is an optional composition, but is recommended for all beginners. Try to get the gestural feel of some imagined or actual situation. Make a rapid compositional study in which you utilize the possibilities of your brush and ink, incorporating some changes in tonality. Remember to be playful and experimental in your approach.*

There are other experiments that could be made, for example, diluting the ink wash even further. Various combinations of different tonalities offer additional expressive possibilities. Brush and ink washes can be combined with pen or pencil. The possibilities are numerous, and you are encouraged to try as many as your interest dictates.

INK AND WATERCOLOR

In the section, "Drawing Media," we stated that ink and watercolor would be touched upon in relationship to ink and wash. This is appropriate because transparent watercolors are not often associated with drawing, with the exception of blacks and some browns (sepia, for instance). Figure 4.21, "Women of Neurenberg," a study by Albrecht Dürer, is done with pen, brown ink, and watercolor on paper. The strong structural linear quality is enhanced by limited wash applications.

Whereas India ink is made of carbon or lampblack pigment combined with a shellac binder, watercolors are made of dry pigments combined with gum arabic as a binder. India inks are waterproof; hence, when an ink drawing is dry, it may be worked over with watercolor tones of black, brown, or any color one wishes. Whereas India ink washes tend to appear granular, watercolor washes appear smooth, with softer edges.

Some liquid, or tube, watercolors are made of dye substances, or a combination of dyes and pigments. These are usually considered concentrates, and are stronger in tinting strength.

One does not usually associate acrylic paints with drawing materials. However, these can be used much like watercolor or diluted inks. There is one important distinction that is necessary to keep in mind in comparing watercolor with acrylics, especially when several applications of different colors are needed. That is, different color washes in watercolor tend to mix, even when one applies a wet wash over a dry one; the result may appear muddy due to the blending process. In the application of acrylic washes this does not happen, since the dry wash over which the wet one is applied is waterproof. It is like laying one clear sheet of colored acetate over another one of a different color: the two blend to form a third wash effect (possibly a third color, as well). These distinctions may prove useful in later work with nature subjects, landscapes, and seascapes.

Many artists and critics claim that there should be no clear-cut distinction between drawing and painting, since many combinations may be found that deny any clear and distinct demarcation between the two. Ultimately, it is the expressive quality of a work of art that counts, and not splitting hairs over whether or not the work is primarily a drawing or a painting. For our purposes, however, we shall simply consider some basic aspects of watercolor as they relate to drawing. In the chapter on "Personal Development," such considerations may be more profitable in terms of following some unique direction or developmental program.

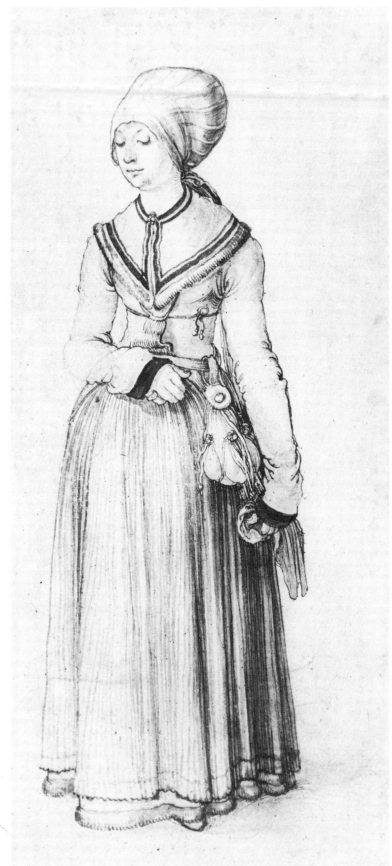

FIGURE 4.21
ALBRECHT DÜRER (1471–1528)
A Woman of Nuremberg, Dressed for the Home (CA. 1500)
Pen, brown ink, and watercolor on paper. 11 × 5 in.
Medieval Institute, University of Notre Dame.
Reproduced by permission.

FIGURE 4.22

JAPANESE BRUSH

FLAT SABLE BRUSH ↗

FLAT BRISTLE BRUSH ↗

Before beginning the experiments, you may wish to acquire a few additional brushes. Figure 4.22 indicates several new additions, including a flat sable brush and a bristle brush. The flat sable brush can be used for large-brush applications where smooth washes are desirable (a greater range than is possible with your Japanese squirrel-hair brush). The bristle brush can be used for scrubbed-in effects; dryer, tonal gradations and variations, sometimes resembling charcoal or chalk applications. It is advisable to wash brushes with soap and water *immediately* after work if acrylic paint is used, since even thin washes of acrylic paint will tend to seal and stiffen hairs of the brush, making them almost useless for future work.

In developing the experiments that follow, you may work with either cake or tube watercolor. If you already have a set of acrylic paints, you may use it instead of watercolor. If you are just beginning to work with a water-based paint, the cake form is adequate and probably the least expensive. The cake type requires some preliminary working with your brush and a small amount of water to soften the top layer of hardened paste (the cake itself). Have some brushes, medium smooth paper (or pad), a container of water, and several small trays on hand, in addition to your watercolor set.

Experiment 1. *Review experiments 1, 2, and 3 for ink and wash. Repeat them, using one or more brushes. Work with any single color or combination of colors. There is no special sequence of color application. Use a random approach with color, brush work, and the depiction of small objects; recall a scene from your imagination, perhaps, or from something that you see from your window. In your final efforts, try to relate brush and color applications to your possible choice of subject matter. That is, if you are working on some small pieces of fruit, try to get the general color of the fruit, with varying tonalities. If you are working on some imagined or real scene, try to get the general coloration (dominantly green, blue, or some other possible allover color harmony). You can use a single brush or several brushes for contour (linear) indications, as well as for all wash or tonal areas. An example is given in Figure 4.23.*

FIGURE 4.23
JANET TAUBE (student)
Ink and watercolor

FIGURE 4.24

Having gained some feel for brushes and color, try another exercise on another sheet of paper. This time you will work with pen and ink, as well as with washes of a single color. Try working from any material that seems to interest you, whether imagined or real. This will be what is called a "monochromatic" study (single color), in which only one color of washes is used over a pen and ink drawing. You may also add ink lines over the washes of color for additional emphasis. **Experiment 2.**

This time you will work with pen and ink and the stiff bristle brush. Try some preliminary work with the brush to get the feel of how it responds. Work with any color of your choice, first with wet applications of short, firm strokes, then with dry applications of similar strokes. Get brush end fully saturated with paint, then remove most of the moisture with a cloth or paper towel before working dryly. Next, attempt a simple study which combines ink drawing with tones achieved by stiff, dry brush applications. An example is provided in Figure 4.24. **Experiment 3.**

The experiments for ink and watercolor given in the preceding text are minimal. You may continue to do more, based on your own innovative tendencies. More studies could be made with any of the mediums and tools we have dealt with in this chapter. But keep in mind that the objective has been to provide some basic knowledge and experiential feel for some of the most frequently used drawing tools and mediums of the artist. Later chapters deal with some of these tools and mediums in more specific ways. Those interested in continuing work of this kind may move directly to Chapters 6 and 7. However, the beginner is encouraged to study the next chapter, "Picture Plane and Perspective," in order to gain some essential information which it is best to learn as soon as possible. Such information will provide a stronger sense of self-assurance and a useful grasp of what goes into the drawing process, which will support and enhance final results.

5 PICTURE PLANE AND PERSPECTIVE

In our previous work we were concerned with experiments and explorations without any specific reference to the picture plane. In working with various drawing media the objective was to begin with a "get acquainted" period in which free exploration was encouraged; composition was left to one's individual sensitivities or to chance. However, the artist must have a good understanding of the picture plane, what it represents, and how best to utilize it for its expressive potential. Let us consider a definition that will relate to the work that follows, after which we will consider pictorial forces and essentials of perspective.

Definition of Picture Plane

In the previous studies, our approach was characterized by an identification of materials on the surface of our paper—how to use them and what effects they produced. In one sense, the paper itself was our picture plane. We were less conscious of the surface of the paper as an area in which we would organize elements; *composition* or *organization* was not our prime objective. On a more sophisticated level, in terms that artists use, the picture plane is the area which is *specifically* utilized for pictorial composition and the arrangement of pictorial elements. Several examples of students' work will illustrate this point.

In the student drawing of a seated male figure (Figure 5.1), we are confronted with a single image. Note how the figure takes up almost the entire piece of paper, which is the picture plane. The figure is placed fairly close to the observer, as if it were only a few feet away. There is no reference to any background activity.

FIGURE 5.1 (left)
ANONYMOUS (student)
Pen and ink with wash.

FIGURE 5.2 (right)
BARBARA FARKUS (student)
Acrylic on canvas.

When we consider the single figure in Figure 5.2, we are aware of major differences. First of all, the figure is definitely established in a spatial context. It is placed solidly on the sidewalk, across from which is a building. The figure is holding an umbrella, which suggests a rainy day. The lower part of the woman's dress is being blown by the wind, creating a triangular projection to the left which adds a dynamic quality to the otherwise motionless figure. The shape and tilt of the umbrella gives a feeling of added space and volume over the figure's head, adding to the three-dimensionality of the composition. The slant of the building on the opposite side of the street creates a thrust into space and indicates perspective diminution.

In comparison, we find that the first example lacks additional pictorial elements, except for an ambiguous spatial field. It is a simple statement that emphasizes the attitude or gesture of the figure and nothing more. In the latter case, special attention is given to a number of objects and the manner in which they are organized or related. The eye level is established rather high in the composition, thereby heightening the various tensions that exist between the figure and the umbrella, the boots of the figure and the fire hydrant, and so on.

Another approach is to consider the single figure (or an object) as a vignette; its placement on the paper or picture plane is predicated by the artist's desire for size, scale, and position as a single unit. The result may, in turn, be considered as an allover two-dimensional shape, as seen in Figure 5.3. The image of a vignette sets itself apart from the possibilities of any dynamic interaction, since it exists as an isolated element.

In the student work of the figure with the umbrella, we are aware that the figure cannot be isolated, as in the case of the single figure/vignette. It is critically related to other elements in the composition, making use of various pictorial forces. Let us consider some essential pictorial forces at the disposal of the artist.

FIGURE 5.3

Pictorial Forces

Our main concern here will be to explore various possibilities of pictorial organization from simple to complex. We will later relate these possibilities to drawing and sketching situations. Our objective is to be aware that one does not draw without composing; that any mark on a piece of paper, consciously or unconsciously, is always within the context of the whole. To draw is to be aware of creating a context within which expression takes place. The holistic, right brain mode is active in determining the most effective arrangement of elements, given that an individual has made a preliminary and somewhat comprehensive study of pictorial composition. Stored information can, therefore, be used most effectively when needed for creative purposes. An abundance of information enhances the possibility of effective expression.

Let us first consider the possibilities of some simple formats of composition, basic shapes which have intrinsic qualities even devoid of any realistic elements. We will begin with the two-dimensional surface of a sheet of paper. In Figure 5.4, you will note that three basic shapes have been drawn: a square, a vertical rectangle, and a horizontal rectangle.

The *square* is a resolved picture plane all by itself; that is, the distance *a,b* is equal to the distance *c,d*. The basic symmetry of the form centers our attention by means of equalized tensions. However, when we turn to the *vertical rectangle* something else takes place; we do not feel the same kind of resolution presented by the square. Our eye is made to move from *a* to *b*, or from *b* to *a*. Regardless of any subjective reference, these movements are inherent in the form of the picture plane presented as a vertical rectangle. When we have a *horizontal rectangle* as our picture plane, we are aware of a still different inherent phenomenon. Our eye is made to move from *a* to *b*, or from *b* to *a*. Obviously, the tensions in both the vertical and horizontal rectangles are not equalized, as in the case of the square. This basic example illustrates that the *nature of the picture plane itself* is an important factor to consider in developing any type of pictorial composition. You may wish to draw other shapes and study their inherent picture planes; a circle, ellipse, triangle, and hexagon offer interesting possibilities. But for practical purposes, one generally composes in a picture plane defined as either a square or a rectangle.

Let us turn once again to the square picture plane. In Figure 5.5, we have five compositions utilizing a square within a square. In example A, note that the small, inner square is placed directly in the center of the larger

FIGURE 5.4

FIGURE 5.5

square. The result is that a sense of perfect equilibrium is created; symmetry and flatness are emphasized. The work of Joseph Albers utilizes just this kind of balance or total resolution, although his paintings are far more subtle essays involving various color harmonies. In example B, the square within the picture plane is larger than the inner square of example A, creating the illusion of being closer to us than the smaller square in example A. We tend to read in a sense of scale. It is like the single figure student drawing mentioned under our definition of the picture plane; it, too, seemed to be close to the observer because it occupied a major portion of the picture plane. In example C we are aware of a new pictorial configuration. We no longer have a centralized balance; our attention is strongly drawn to the lower left-hand corner where we feel strong tensions between the small, inner square and the left and bottom portions of the picture plane. Examples D and E provide additional illustrations of tensions created by different placements of the small square within the picture plane.

Figure 5.6 is provided especially for the beginner who may wish to study the possibilities of a more complex reference to the use of square shapes within the format of a square picture plane. Although schematic and basically abstract in character, these studies serve as a valuable orientation to compositional possibilities that will prove useful in later work.

In Figure 5.6 A, a second square creates a new set of visual conditions: (1) both squares contend for our attention—something like a Ping-Pong game with square balls—and (2) both squares seem to be equally far away from the larger parameters of the picture plane. In this case, we have *equalized* tensions between the squares themselves and between the spaces of the picture plane. However, as soon as we shift one of these squares closer to the other, as in example B, there is a sense of movement created in one direction. We sense that the square at the right is moving closer to the square at the left. Correspondingly, the tension between the two small squares is heightened. In example C, the two small squares are still closer together, and we tend to identify them as a pair. The surrounding space,

FIGURE 5.6

especially in the upper areas, seems to be compressing the forms, pushing them together. The tension between the two forms is heightened further than in the previous example. When we look at example D, we find that the right-hand square has been placed to over-lap the left-hand one. Since the squares are line drawings, we are presented with spatial ambiguity: we don't really know which one is in front of the other, or how close or far apart they are in depth. In example E, the dilemma is resolved: we know that the left square is definitely in front of the right one, and we can actually sense some space between the two of them.

Medieval artists utilized just the kind of space seen in Figure 5.6 E. The diagrammatic example, Figure 5.7, clearly indicates how the artist created a sense of depth and dimension by the use of over lapping forms. Medieval artists relied on just such devices to create a sense of reality, resembling a stage setting in which some drama of human or religious experience is enacted. It was only a century or so later that perspective came into existence, reaching a highly sophisticated level in the High Renaissance period with the works of Leonardo Da Vinci and others. Artists of today have the freedom to use either method (overlap or perspective) in their creative work.

Let us return to Figure 5.6 and look at example F. The addition of more squares gives an even greater sense of depth than in example E, like

FIGURE 5.7
Diagrammatic
studies of
Giotto's
Lamentation.

the more extensive use of depth projection by Medieval artists. Note also the unique *curvilinear movement* created by the placement of the squares. Movement is one of the key factors, or *pictorial forces*, which adds *interest* and *unity* to a composition.

In example G of Figure 5.6, additional movements are created by the use of additional squares, all of the same size as in the previous examples.

When we turn to example H, we are aware of a greater sense of depth that has been created by a change in size of the squares. The small square to the right is definitely far away from the one to the left. Here we are not relying on overlap for a sense of depth, as in some of the other examples, but on a suggestion of *implied perspective*. This form of implied perspective was often used by early Renaissance artists before *scientific perspective* came into existence.

Finally, in considering example I of Figure 5.6, we note how additional depth is created by means of overlapping progressively smaller squares that recede into distant space. These squares could be arranged in different ways, creating many variations in pictorial composition.

If we were to substitute actual objects for the squares, we would soon realize that *arrangement* and *scale* are the two key factors which govern the quality of composition, whether the forms are abstract or realistic. Some possibilities can be seen in Figure 5.8.

So far our discussion has centered around the utilization of some basic pictorial forces that have been illustrated by means of simple formats in which the square has acted as the chief protagonist. *Arrangement, scale,* and *movement* received prime consideration; *tension* was also touched upon. Some reference was made to *depth* and *spatial relationships*. Other pictorial forces, such as *repetition, rhythm, contrast, proportion, balance,* and *emphasis* are equally important.

These forces seldom exist in an isolated state, though some may dominate a composition. Rather, it is the orchestration of many of these forces that creates unity and interest in a composition. For additional clarity and simplicity, let us review one of the most important pictorial forces, *tension,* while considering some others not previously illustrated (beginning with repetition). In doing so, we will use a variety of subject matter of a representational or symbolic nature.

In Figure 5.9 A, we no longer have a square, but rather, a "feather" located in the lower portion of the picture plane. The shape of the feather

FIGURE 5.8

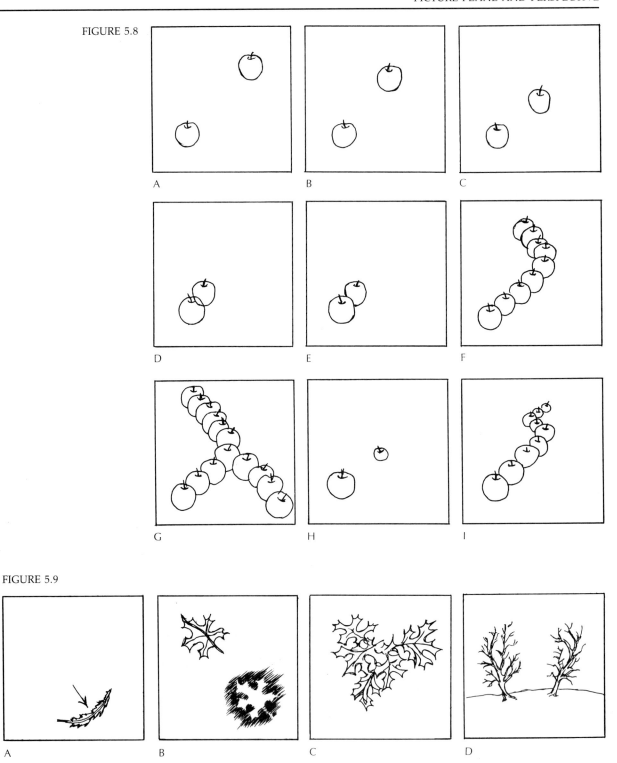

FIGURE 5.9

gives us the sense of a dynamic force pushing us visually toward the lower right-hand corner of the composition. The curve of the feather is a modified arrow shape with a softer thrust. In example B, we are aware of the tension that exists between the two leaves that oppose each other: One is a positive image of the leaf, the other a negative image. The positive-negative relationship creates an *active visual tension* between both units. When we combine several leaves, as in Figure 5.9 C, the various positions of the leaves

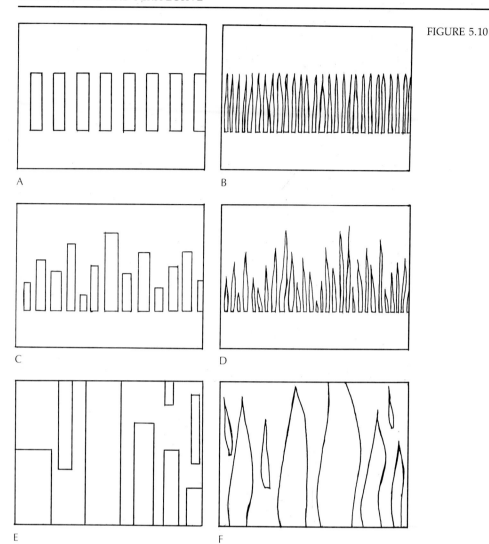

FIGURE 5.10

create opposing thrusts that, in turn, alert us to the tension created by the negative spaces as well as by the positive forms of the leaves and their directional quality. In example D, two trees of the same size, tilted in opposite directions, activate the space between them.

At this point, make several drawings of objects in a room that demonstrate some of the aspects of tension. Choose any kind of drawing pencil or pen and any kind of paper, and spend about ten minutes making some quick studies, seeking to find counterparts for the examples. Be sure to make some brief suggestion of the picture planes in which your studies are to be placed.

Repetition is perhaps one of the most easily understood compositional devices to utilize within the picture plane. But if not used properly, it can produce a monotonous configuration. Let us consider some examples. In Figure 5.10 A, we have a series of rectangular shapes of similar size. Obviously the effect is monotonous. In Figure 5.10 B, shapes that suggest grass also become monotonous because of the sameness of size. However, in Figure 5.10 C, we note that interest is heightened in the geometric composition by a change in size and spatial intervals; in a similar manner, Figure 5.10 D presents us with a more interesting biomorphic configuration than

example B, though both deal basically with the same type of forms. When we turn to Figure 5.10 E and F, we see that interest is heightened to an even greater degree by more pronounced changes in *scale, placement,* and *spatial intervals.*

Rhythm is closely related in character to both repetition and movement; in fact, one might find it difficult to isolate rhythm from the other two. For example, in Figure 5.11 A,B,C, and D, we are aware that the *repetitive* devices utilized also strongly reveal *rhythmic* qualities.

Rhythmic devices can range from the simple to the complex. One can find simple rhythmic elements in the branches of a tree, as in Figure 5.11 A, or in the more complex linear configurations in Figure 5.11 B. In Figure 5.11 C intricate rhythmic patterns are shown in a nature design, with repetitive leaf imagery in both positive and negative formations.

Rhythm can also be a useful device in the relationships that are created by *unlike elements,* such as those in Figure 5.11 D. Here the rhythmic forms of the window panes, leaves of a plant, and folds of the drapery present interesting kinds of contrapuntal relationships, creating both *variety* and *unity.* Some artists use rhythm as the central core and organizational format of the entire picture plane. (See Figure 5.11 E.)

Contrast performs a different function; it serves to *heighten interest,* while rhythm reinforces unity. We have already noted how contrast can be effective in Figure 5.10, especially in examples E and F: a change in scale

FIGURE 5.11

A

B

C

D

FIGURE 5.11E
IBRAM LASSAW
Diagonals (1982)
Ink on paper. 6½ × 6¼ in.
Photo by C. Noel Rowe

E

FIGURE 5.12

A

B

FIGURE 5.13

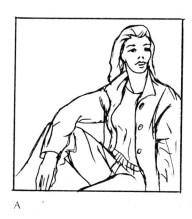

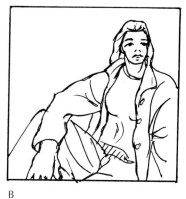

A

B

created contrast among similar elements. However, contrast can be achieved by unlike elements, as well. For instance, in Figure 5.12 A there is contrast between the giant leaves of a plant in the left-hand area and the rhythmic perforations of the background heater cover. Also, note how the tiny plant forms in the bowl echo and contrast with the larger leaf forms in the foreground. In Figure 5.12 B, contrast is achieved by the large foreground forms of cloth and chair against the rhythmic portion of a bookcase in which only the lower sections of books are shown. As we shall see in our applied problems, contrast can be extended to the elements of tone or value, color, line, technique, and other pictorial ingredients.

Proportion is another essential ingredient in developing a composition within the picture plane. We have already touched upon it with regard to squares and simple objects arranged in various sizes. We noted how a sense of scale and distance was created by means of placing one large square close to a smaller square, as in Figure 5.6 H; a large apple next to a small apple, as in Figure 5.8 H, and so on. But proportion can be considered in other terms, as well.

Usually proportion refers to the size of one part of a form in relation to another part, or to the total form. For instance, a complex shape, such as a human figure, may be difficult to render in proportion by the beginner. Someone with little experience often has difficulty in drawing all the parts in correct proportion to each other. The process can become more complex when the beginner tries to relate the figure to other objects within the composition. We shall consider some of these situations in the next chapter devoted to specific drawing problems (still life, nature, and so forth). We have made reference to the importance of gesture and visualization exercises that greatly help to ensure correct proportions. It is useful to compare correct or normal proportions with incorrect or exaggerated proportions. For instance, in Figure 5.13, we have drawings of two individuals; A is in proportion, while B is out of proportion. In A, the parts of the figure relate to each other in a fairly convincing manner, whereas in B, the parts close to the lower part of the picture plane are much too large. This kind of exag-

FIGURE 5.14

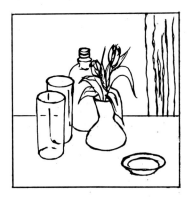

geration may be due to a number of things. The surface on which the drawing is made may not be at right angles to the student's vision; it may be tilted, thus causing a natural kind of distortion in the process of drawing. Usually in such a case the portion of the drawing that is closer to the student is drawn larger in scale or proportion than portions that are farther away. This is an automatic process that happens due to *visual compensation*; it is only when the student holds the work at arms length, or props up the work on an easel or other surface, that he or she becomes aware that something is wrong.

Another reason that beginners might get things out of proportion is that they tend to see parts isolated from the whole. Gesture is an essential means by which one can avoid such a situation; seeing everything at the same time, in the *sweep* of the action of gesture, helps one to avoid seeing only the part instead of the whole.

Sometimes proportions may go off in the process of making a more complex drawing involving a number of objects. For instance, in Figure 5.14, note how the glasses are too large for the bottle, while the vase of flowers seems too small. We will discuss how to avoid such undesirable situations when we deal with still life and other subject matter. Also, we will study the importance of perspective as a device to avoid creating relationships that seem distorted and unconvincing.

Balance is very critical in a work of art. One automatically feels that certain relationships create a desirable distribution of elements. Yet, *learning how* to achieve certain qualities of balance is essential in controlling the pictorial effects within the picture plane. To understand two essential types of balance, let us refer to Figure 5.15.

Figure 5.15 A shows us that the picture plane contains two equal weights of the same substance; both are the same size. This is a simplistic diagram of a *symmetrical* composition. The weights could be blocks of stone or of any substance that will balance perfectly on a fulcrum, being of equal weight. In B of the same figure, we have two forms of different sizes but of equal

FIGURE 5.15

A

B

C

D

E

F

FIGURE 5.16

A

B

weight: one might be a block of wood, the other a box of sawdust. In this case, we have a good diagram of *asymmetrical* balance.

Balance becomes more critical when working with graphic elements. The artist develops a sensitivity to balance in a very sophisticated sense, so that many diverse elements may be combined in a composition. In example C, we have two simple black circles, much like the blocks of stone in example A. There is no substantial challenge in achieving this kind of balance, yet it has its place in conveying certain kinds of visual messages. In a similar manner, two leaves are used in D, with equally uninteresting results. However, in example E we have a more challenging visual experience: the small black square on the left is balanced by the more complex formation of squares to the right. We sense that the visual weights are equal, though the sizes are unequal. The result is a more dynamic kind of balance of an asymmetrical nature. In F, we have a similar situation in which leaves are used. A single dark leaf at left is counterbalanced by the linear configurations in the right-hand portion.

Balance takes on complexity by means of other aspects, such as *tensions*. Tensions do much to create variations of balance throughout the picture plane. The quality of balance is further complicated by other pictorial elements, such as tone, texture, and color. We shall have an opportunity to consider some essential elements in the work that follows.

Emphasis is perhaps one of the most personal and critical of compositional elements. It is the *pictorial directive* of the artist, which, when skillfully used, holds the attention of the observer without destroying the unity of the whole.

In Figure 5.16 A, for example, the artist has chosen to emphasize the central hanging pot of flowers instead of the larger leaf forms to the right. This is achieved not only by placing the flowers in the central portion of the composition, but through the dramatic use of the dark tonal pattern which contrasts strongly against the white areas of the paper and other forms in the drawing. In B, we have a shift in emphasis from the central pot of flowers to the leaf pattern on the right. It is important to note that though the subject matter of the two works might be identical, the artist can choose to emphasize one portion of it over the others by dramatic use of light and shade, by color, or other means. Monet's studies of haystacks, for instance, show how he varied the treatment of his subject matter by depicting it at different times of the day. The artist has the liberty to exercise what is termed *artistic license* in dealing with any kind of subject matter. In this context, it is interesting to reflect that although the camera, invented in the mid-nineteenth century, can capture "reality," it obviously cannot replace the artist, whose objective is to interpret nature and life with a specialized emphasis that *requires*, at times, the rearrangement of nature.

FIGURE 5.17
ALBRECHT DÜRER (1471–1528)
Ruin of an Alpine Shelter (1514)
Metalpoint and watercolor, heightened
with white. 14½ × 10⅜ in.
Medieval Institute, University of Notre Dame.
Reproduced by permission.

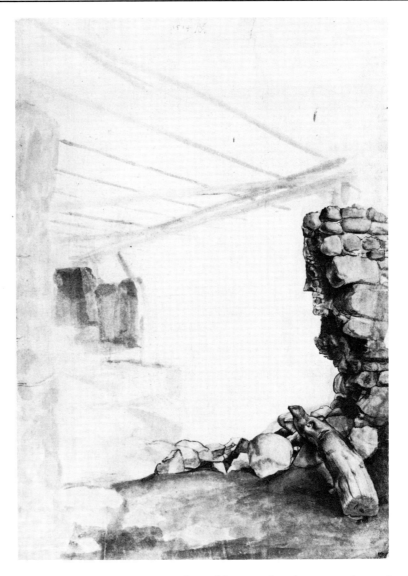

There are many examples of how artists have used emphasis in their work. For instance, in Figure 5.17, a mixed-media work by Albrecht Dürer, the right foreground elements of dark stones are dramatically emphasized, in contrast to the much lighter background forms. This is a rather unusual work for Dürer, whose emphasis is often on central placement of important compositional elements, or is achieved by emphatic expressions and activated gestures. We may be more familiar with Rembrandt's emphatic patterns of dark and light, sometimes at the expense of diminishing the identity of the subjects portrayed. Classical Greek art idealized, and therefore emphasized, special qualities of the human form; Michelangelo did the same in his Sistine Chapel murals.

SUMMARY OF PICTURE PLANE CONCERNS

We have considered some of the essential pictorial relationships and forces that relate to the picture plane. Our study could be extended to a much greater degree; however, for our present purposes we have stressed some of the most critical: *movement* and *direction, tension, repetition, rhythm, contrast, proportion, balance,* and *emphasis.* We have found that it is sometimes difficult to separate these, since they often relate closely to each other as pictorial

forces (repetition and rhythm, for instance). And the artist who has had a sound grounding in these and other elements does not always use such elements consciously. Recall our discussion of left-brain/right-brain modes. Many artists will tell you that they work from *feelings*, rather than from strictly intellectual concepts. However, they may not add that their feelings are essentially grounded on a sound basis earned by means of much work, consciously directed (left brain mode).

Our purpose in this book is to provide you with reliable essentials that you can utilize in your personal statements. A personal statement is greatly enhanced by the absorption of information that will make it possible. Thus, in order to understand the pictorial successes achieved by the artist, we have to use the analytical method (left brain mode). Yet the analytical method neither explains art, nor creates it; it is meant to help us understand a pictorial language, essential process, and development.

In the study of any language, there is first a conscious, awkward stage when large amounts of material are being digested. As the process continues, one gains more confidence and greater freedom. Finally, one reaches a plateau which is more totally integrative and less purely intellectual. At this stage, the right brain mode is dominant. Sufficient material has been absorbed to *allow* an even greater degree of freedom of expression. Work produced, however, is always subject to the analysis of left brain mode activity, but *after the act of the creative effort*.

It would be well to remember that the artist—and one who aspires to be one—aims at a total integration of his or her expression, perhaps of his or her personality, as well. The artist is more than intellect, more than emotion and feeling. The study of art helps one to realize that the artist is a conglomeration of many things, some of which have deep roots in seldom-used areas of the mind. An awareness and utilization of left-brain/right-brain modes will greatly assist one in the development of maximum artistic potential.

Definition of Perspective

Philosophically, perspective can mean any and all visual clues that relate to forms and the placement of those forms in a spatial field. Hence, Medieval artists shared a particular method. So, too, did artists of earlier periods, dating to prehistoric times, as in the work of the cave drawings. Many beginners already use some form of perspective, and they probably know more than they realize about some of the things we shall discuss.

Too great a preoccupation with perspective can be restricting and can produce work which lacks spontaneity and freedom. It must be kept in mind that perspective is merely one of the techniques at the artist's disposal, and not an end in itself. However, one can do many intriguing things with perspective. Our concern will be with developing an understanding and a clarity which will simplify the drawing process. The two principal types of perspective which we shall define are primarily Western concepts, in contrast to Oriental and other systems: the first is *linear perspective*, and the second is *aerial perspective*.

An engaging example of the early application of *linear perspective* is afforded in the ink and wash study by Jacopo Zanguidi, Figure 5.18. The sixteenth century Italian artist has utilized one-point perspective to emphasize his "fantastic" theme. The three figures at the left, extraordinarily elongated, are minimized by the powerful thrust of the architecture in the

FIGURE 5.18
JACOPO ZANGUIDI (1544–1573?)
*Three Figures with Fantastic Architecture
and Landscape* (CA. 1568)
Pen, ink, and wash, with black chalk.
18 × 10½ in.

*Medieval Institute, University of Notre Dame.
Reproduced by permission.*

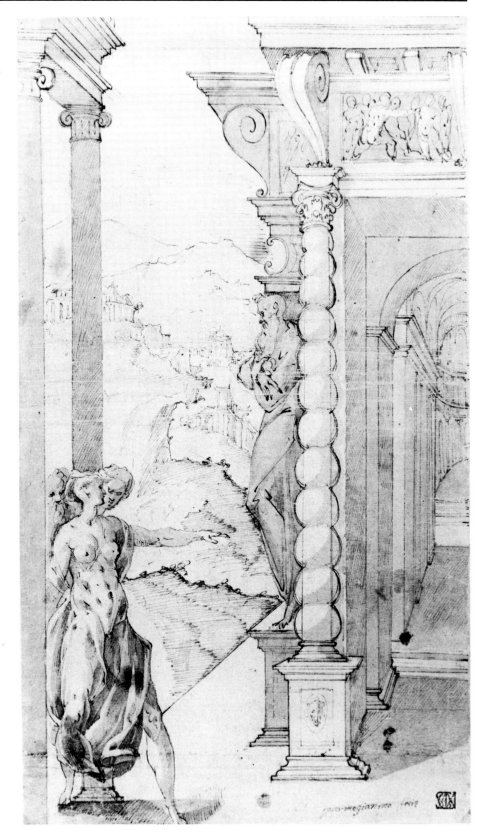

rest of the work. Framed against two columns to the left, the central figure motions to the right, directing our attention to the dominant architectural motif, which recedes dramatically into the far distant background. The landscape element is merely supportive and supplementary in character. Light and shade are used minimally in deference to the strong contour indications of figures and architecture.

Linear Perspective

This helps one to create an illusion of reality from a fixed point of view, as if viewing a scene with one eye closed. Since the camera gives us an absolute kind of linear perspective indication, beginners can be assisted in their understanding of perspective by analyzing photographs. However, a good drawing is based on the artist's *expressive attitude*, rather than on a system of set rules. We must, of course, consider certain essential rules of perspective, but with the understanding that these will become absorbed and utilized for more personal expression later.

Let us turn to our photographic reference and focus on some essential terms which are crucial to our understanding of perspective. Primary among these is *eye level* and *horizon line*, which are synonymous. For instance, when we look at the analyses in Figure 5.19, we will see that the eye levels are placed differently in each of the studies. Whether one is only a few feet off the ground, as in A, or higher, as in B, one's eye level corresponds to the horizon line. Eye level, therefore, represents the height of the observer (or one who is drawing) from the ground level.

Here is another example: If you are in a building with an elevator, first look out a window on the first or second story. Note how buildings, trees, and other objects appear to your vision. Close one eye to assume true monocular vision (imitating a camera). The chances are that what you see will relate closely to the horizon line; things will appear to be quite close to where sky and land meet (horizon). Also, you will most likely see very little of the top surfaces of things. Now take the elevator up to the fifth story and see how the same things appear. They will appear to exist *below the horizon line*, and *below your eye level*. You will also note more of the tops of the various objects and things in the scene. If your building is higher than five stories, continue to glance from successively higher and higher levels . . . and don't forget to take a look from the roof. Make a mental note of how things appear at different levels; *try to visualize these differences in succession, as if each were a link in a short movie film.* This exercise is helpful to gaining a basic grasp of perspective, especially with regard to the two key terms, *eye level* and *horizon line*.

Let us return to Figure 5.19 E. Note that the eye level is about six feet or so above the placement of the fence in the lower part of the composition. When examining the trees and the fence, we can use another important perspective term: *diminution*. Objects become smaller in size (or rather, they *appear* to become smaller) as they recede into space.

Whereas *diminution* refers to a *number of objects* that recede into space, *foreshortening* refers to changes that occur to a *single object*. Specifically, when a form is foreshortened, a portion of it seems to be smaller (that part which is farthest away) compared to another portion (that part which is closest to the observer). Foreshortening is illustrated in C and D of Figure 5.19. In C we are aware of the use of *parallel lines*, which are extended from the sides of the rectangular objects to the eye level where they meet at a common

FIGURE 5.19

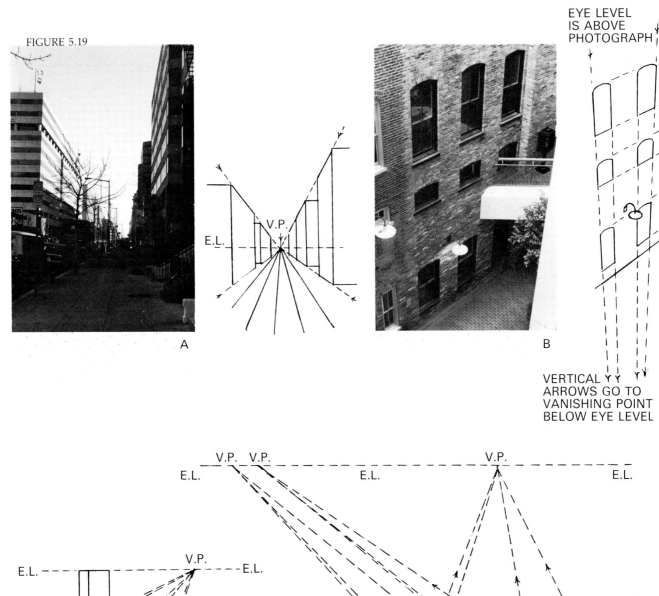

EYE LEVEL
IS ABOVE
PHOTOGRAPH

VERTICAL
ARROWS GO TO
VANISHING POINT
BELOW EYE LEVEL

A

B

E.L. V.P. E.L.

V.P. V.P. E.L. V.P. E.L.

C

D

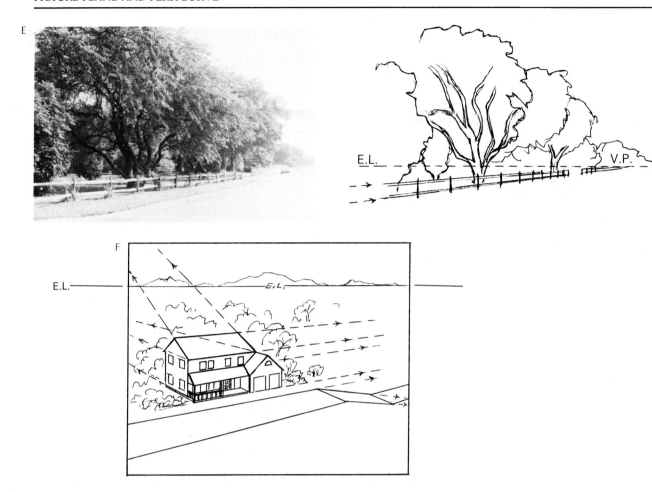

vanishing point. Here, three rectangular objects have separate vanishing points. Also note that a portion of an object that has a surface parallel to the picture plane does not have a vanishing point, since it does not foreshorten; that is, it is seen in its true length relative to the general proportion of the object of which it is a part. The front edge of the large form to the extreme left is a good example.

Parallel lines of objects will always recede to vanishing points at eye level if such objects are resting on a flat, horizontal ground plane. If, however, such objects are not level with the ground plane (table, desk, floor, and so forth) they will have vanishing points either above or below eye level, as noted in Figure 5.19 F. In this example, the roof lines converge upward, while the road lines that slope downward converge to a vanishing point below eye level. The parallel lines of the main portion of the building resting on ground level converge to vanishing points at eye level.

Vertical lines, which are shown in the building in Figure 5.19 F, run up and down and are parallel to the vertical sides of our picture plane; they are also at right angles to the horizon line. These lines *do not* foreshorten to vanishing points unless one is high above them or, conversely, below looking up. The former is usually called a *bird's eye view*, the latter a *worm's eye view*. Both of these are illustrated in Figure 5.20.

Before we go deeper into the subject of perspective, you should do some studies that will reinforce the terms we have considered so far: *eye level, horizon line, diminution, foreshortening, parallel lines,* and *vanishing point.* These will not involve any special materials other than a sketchbook (medium to large), an HB or medium lead pencil, and some photographic references

FIGURE 5.20

BIRD'S EYE VIEW

WORMS EYE VIEW

V.P.

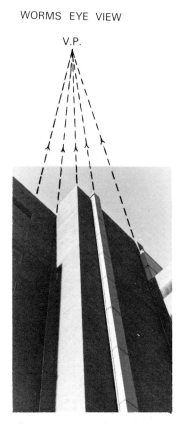

LINES MEET AT V.P.
BELOW EYE LEVEL

from newspapers or magazines. These basic studies were designed espe-
cially for the beginner. If you have had some preliminary work in per-
spective you may skip this section, or briefly review it. Beginners are ad-
vised to attempt the studies that follow.

Study #1. *In the first study, which will be of an analytical nature, use three different kinds of pho-
tographs taken from magazines or newspapers. These should be small enough (approx-
imately 3" × 5") to allow generous surrounding space when placed in the center of sheets
of drawing paper in your sketchbook. It is important that each of the three photographs
represents a different eye level.*

*(1) Select one that represents objects on a table (or other surface) with an eye level only
a short distance above the objects*

(2) Select another with an eye level that is about five or six feet high

(3) Choose a third with an eye level fairly high up, suggesting an aerial view.

*The second reference may be of objects similar in nature to the first; the last reference
should be of buildings, or of a landscape involving buildings.*

*Attach the first photograph (rubber cement works best) to the center of one of your
sheets of paper. The next step is to draw lines over surfaces that are parallel and extend
these lines until they meet at a vanishing point. Do this for as many surfaces as you can
identify. If the extended lines tend to go off your paper, tape on an additional piece of*

paper to achieve the necessary extension. After you have located a number of vanishing points in this manner (anywhere from 5 to 7), connect the vanishing points of objects that are resting on the horizontal plane. This will locate the eye level and the horizon line simultaneously. Remember that surfaces of objects that are inclined upward or downward will have vanishing points that are not on the horizon line, but either above or below eye level. Refer to Figure 5.19 if you have difficulty.

After you feel satisfied with your first study, make two additional studies, repeating the first procedure. After completing these, label the areas that show evidence of diminution, foreshortening, and the extension of parallel lines to vanishing points at eye level and horizon line.

Use a photograph of buildings as seen from a low eye level, looking upward. Locate the photograph in the center of a new sheet of paper. Then draw parallel lines from various planes or surfaces until they converge and ultimately meet at vanishing points above eye level. The result will be an example of the worm's eye view. Refer to Figure 5.20 B for reinforcement of this concept. **Study #2.**

Optional It involves a view of buildings seen from above, looking down. This is a bird's eye view. You may wish to make this study by drawing the vertical lines of buildings which now seem to converge downward to vanishing points well below eye level. Seek out an appropriate photographic reference, and proceed as before. Refer to Figure 5.20 A for clarification if necessary. **Study #3.**

Although bird's eye views and worm's eye views are exaggerated forms of perspective, they are sometimes useful devices in creating a special kind of emphasis. It is interesting and informative to seek out examples of these two kinds of perspective in the work of well-known artists. Advertising artists—both photographers and illustrators—realize how effective such forms of perspective can be in capturing one's attention to emphasize a particular message. Look through newspapers and magazines to find such examples.

MODES OF PERSPECTIVE

The term relates to three principal types of perspective which the artist uses. These are known as *one point, two point,* and *three point perspective.* You may have already become aware of these modes from making the previous studies. Let us now consider them in some detail.

One-point perspective assumes that the artist is centered in relationship to his subject matter, with his line of vision at right angles to at least one main or broad surface of a given subject. Figure 5.21 A is a good basic example. Here we have three views of a box. The center of the box is shown at eye level. Notice that all we can see is one surface of the object, which is at right angles to our vision. The upper view of the box displays two surfaces: the one we see in the center drawing, plus the under surface of the object. We can follow the projected parallel lines of the underside of the box to its central vanishing point. In the lower view, we again see the front surface of the object, plus the top surface. The top of the object can be projected back to the central vanishing point. All three views have a central, common vanishing point. The box showing the underside is above eye level; the one showing the top is below eye level. One-point perspective is the easiest to understand and can be utilized in situations in which a frontal approach seems best. However, when objects or things are not at right angles to the observer or the picture plane, one or both of the other two modes must be used.

Two-point perspective presents us with a situation in which *no* single surface is parallel to the picture plane, though the observer or artist might be exactly in front of the scene depicted. Surfaces of an object (or objects)

FIGURE 5.21

FIGURE 5.22

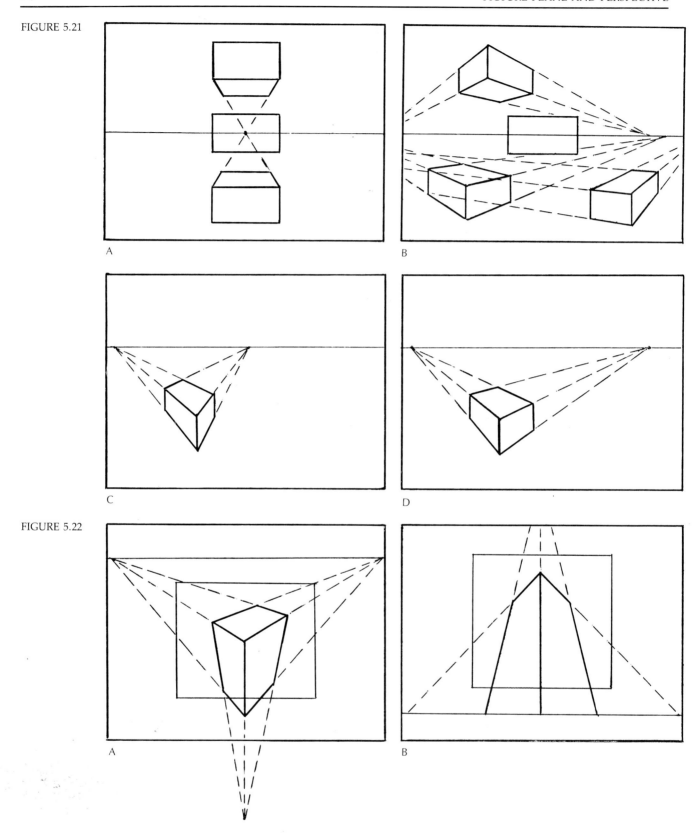

A

B

C

D

A

B

seem to converge on more than one vanishing point. In Figure 5.21 B, for example, we have our original box seen frontally in one-point perspective. But we also have several other boxes, the surfaces of which recede to the left and to the right. A study of this example will reveal that all objects, other than the one presented in one-point perspective, have two vanishing points which meet at eye level. Since each object is in a somewhat different position, each has its separate sets of vanishing points.

In Figure 5.21 C, the box is drawn in two-point perspective, but appears to be distorted. This may remind you of the example of the bird's eye view, even though the vertical lines do not converge. Sometimes drawing an object at close range can create just such a distortion. In Figure 5.21 D, the object is made to look more convincing, simply by changing one of the vanishing points to a distance farther to the right. Alternately, the vanishing point to the left could be moved to provide an equally good solution.

Beginners in perspective are often confused when distortions occur, especially when they are using rules of perspective. This is especially true in freehand drawing. The examples of shifting vanishing points in Figure 5.21 C and D illustrate that one must use perspective to improve one's drawing, and *not* just for the sake of "using perspective." Rules can produce bad work as well as good work. Relying on one's common sense and intuition are good supplements to the use of theory.

With some experience in freehand drawing, the beginner learns either to place the vanishing points at a comfortable distance from each other, or is able to infer where they should be and make a drawing without explicitly indicating them. This is also true in the case of three-point perspective.

Three-point perspective is perhaps the least used of all the modes of perspective in conventional drawing, especially in drawing from the still life and from the figure. However, there are times when it can be useful to achieve dramatic effects. The main difference between three-point perspective and the other two modes is that in this mode vertical lines or edges of objects converge either to an upper vanishing point (as in the worm's eye view) or to a lower vanishing point (as in the bird's eye view). Objects will thus have a third vanishing point, in contrast to a single vanishing point, as in one-point perspective, or two vanishing points, as in two-point perspective. Two illustrations may help to clarify this.

In Figure 5.22 A, an object, such as a tall building, is viewed from some high point well above it. Notice that there are *three* vanishing points, two of which have a place on the horizon line and the third below the horizon line. After one understands this theory, it is not necessary to draw the actual vanishing points; these may be inferred, and with some practice they can be determined to exist somewhere off the paper as shown by means of the smaller rectangle framing a portion of the building in the center. It is obvious that the vanishing points cannot be included within the smaller rectangle.

In B of the same figure, we again have two vanishing points that rest on the horizon line. Note that the horizon line is located low on the paper in this study; the third vanishing point is well above the horizon line and may extend out of the picture plane altogether. Again, one may wish to infer where the vanishing points occur instead of actually drawing them; this condition is illustrated through the smaller rectangle in the center of B. As in the previous example, the smaller rectangle represents a smaller picture plane, in contrast to the larger one, which shows the vanishing points.

Nothing can equal the experience of actually applying theory to freehand drawing problems; you learn best by doing. Let us now do some basic drawing studies, instead of working over photographs.

FIGURE 5.23

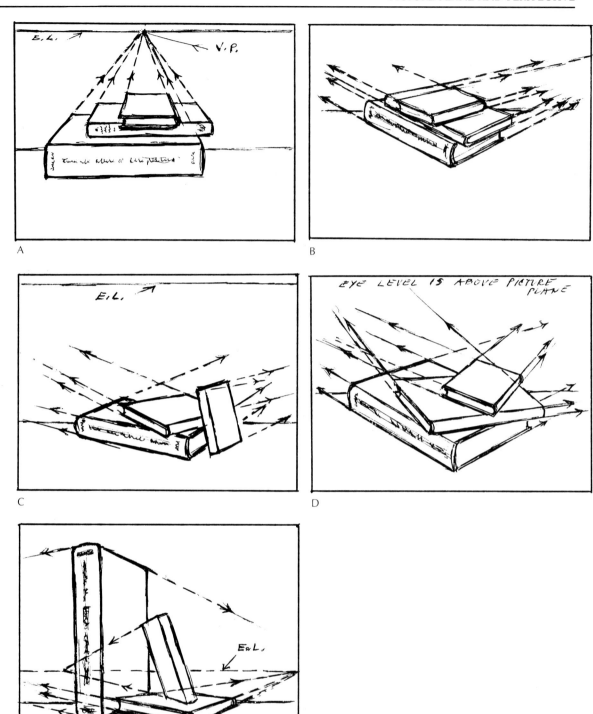

You will need a medium soft lead pencil (an HB will do), an eraser, and your mediumsized sketchbook or some sheets of drawing paper. Since books are usually available, select three which vary in size. For the first study, arrange the books as in Figure 5.23 A. Notice that the books are arranged so that one surface of each is parallel to the picture plane. This will provide you with a good situation for making a one-point perspective drawing.

Determine where your eye level is on the paper by drawing a light line. Somewhere in the central area on that line, locate a central vanishing point. Then make light, tentative indications of the size and shape of each book. Compare the books to each other for correct proportion. Establish all the books in this manner, making sure that the relationships of foreshortening and scale are correct. Once these have been achieved, make your lines more emphatic, emphasizing each book. Drawing straight lines without a ruler is good practice, but you may later wish to check your lines by a ruler or any straight edge—the edge of a piece of paper, for instance. After you have done this, change your location so that you are viewing the same books from an angle that provides a good situation for a two-point perspective drawing. After ruling off your picture plane, proceed as before. Indicate your eye level first, then tentatively draw the books with their vanishing traces to the vanishing points at eye level. If the vanishing points go off the paper, try to assess approximately where they are located without actually indicating them. When your tentative lines are well situated, make them more affirmative. Figure 5.23 B provides a good example.

Study #1.

Rearrange the books in different positions, as in Figure 5.23 C. Proceed as before on another sheet of paper. When you have finished this drawing, make at least two other line drawings such as those illustrated in D and E.

Study #2.

After you have finished your practice in one- and two-point perspective, take your sketchbook and materials outdoors and refer to some large buildings for three-point perspective. As before, establish your picture plane on the paper, then your eye level, and so on. Situate yourself close to a building, so that when you look up you will note the convergence of lines to a point well above eye level. It is important to remember that although you are looking up, your eye level does not change. Your gaze direction changes, but your eye level remains the distance your eyes actually are off the ground. You may refer to Figure 5.22 B for greater clarity or reinforcement.

Study #3.

All of the studies in this section have been basically analytical in nature, dealing with important aspects of the picture plane and perspective. Many teachers and artists claim that there are no shortcuts to learning the basics. However, it is advisable to try to adjust basic information in as personal a manner as possible. Hence, the following suggestions are given with regard to some additional work at this time.

Additional Studies.

1. Apply the three modes of perspective in a number of free-hand drawings. Devote an hour or so at set intervals over a two- or three-day period reviewing these modes.

2. Apply the gestural approach to your perspective work, getting the feel of things even before you begin your perspective analysis of any given subject matter. Work rapidly and boldly, allowing perspective information to influence your work and make it seem more convincing.

3. Use any drawing medium that appeals to you, for instance, crayon or charcoal. Make drawings which illustrate your knowledge of gesture combined with perspective. You might wish to incorporate tone or value if it helps to create a more convincing three-dimensional quality. Although we will consider tone more fully elsewhere, you might wish to make a few experimental studies at this point. Look at good examples of drawings which illustrate application of such concerns.

4. Make drawings of subject matter not mentioned so far. Let your own preferences suggest what material you wish to work from. Glance through this book at various drawings provided, even though we may not have covered or explained such material. Many works will include concerns you have already been exposed to, and you will most likely feel a sense of familiarity with such work. Make copies, then try some original attempts.

FIGURE 5.24

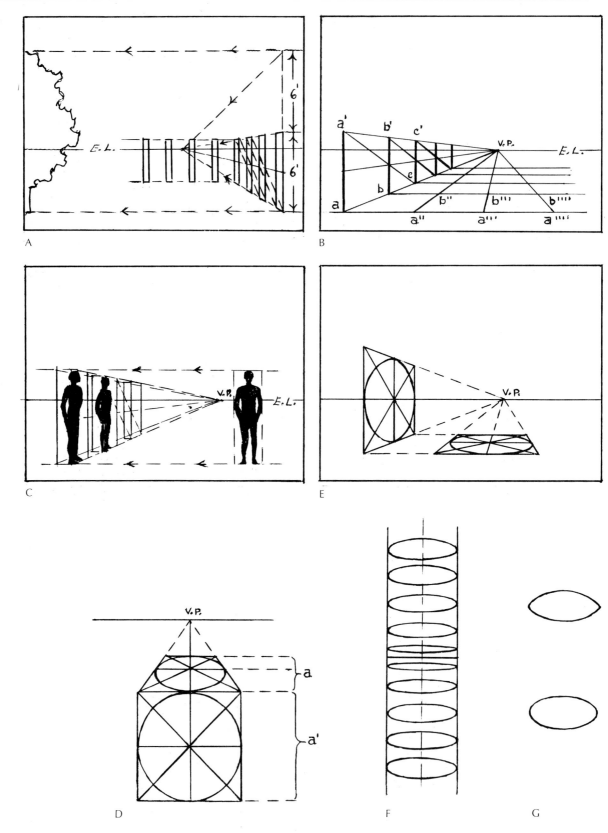

5. *Change your drawing and sketching format often. Make some studies very small, spending only a few minutes on them. Make others larger and work up to a half hour or more, but try to maintain a sense of freshness and spontaneity even in more sustained work.*

6. *Allow inner dictates to suggest new ways of combining the information you already have. Try your own way of doing things, invent your own procedures. Compare your results with examples given in this book. Ask knowledgeable friends, fellow students, and perhaps your art teacher for opinions of what you are doing. Even if your attempts do not all prove successful, you will have discovered some of your strengths and weaknesses and will become more sensitive to the information and suggestions that follow in this book.*

PERSPECTIVE LOCATIONS IN SPACE

In freehand drawing and sketching, it is desirable to have some aids or systems whereby one can make correct judgments of *scale, proportion, diminution,* and *foreshortening.* One of the most useful systems is illustrated in Figure 5.24 A. The following steps should be observed. First, it is necessary to establish the picture plane in a suitable size and relationship to your paper. If you were sketching outdoors, you might use the entire sheet of paper as your picture plane. In any case, you would first determine the amount and size for your proposed drawing in a *total* sense. Next, you should establish your *eye level* and your *first unit of measure,* which can be placed wherever convenient. For instance, you will note that in Figure 5.24 A, a six-foot measure has been marked off in the right hand portion of the composition. This might be where you wish to establish a figure which is six feet high, or some other object, such as a fence post. This is your first unit of measure. Notice how it is related to the eye level on the paper. The unit of measure and the eye level should be thought out at the same time in relationship to other proposed elements one wishes to draw in a given composition. Making the unit of measure too high would limit the possibility of including many more elements; making it too small would suggest the incorporation of many more elements. Hence, the relationship of these two factors is critical to the entire content of the drawing. Therefore, determine a unit of measure that seems best-related to other objects you intend to include in your composition.

To indicate a larger dimension, begin with the already established six-foot (or other) dimension and extend it vertically as shown in the illustration. For a twelve-foot measure, you would simply double the dimension; if you wished to establish a nine-foot height, you would take one half of the six-foot height and add it to the existing six-foot mark. To indicate a smaller dimension you would begin with the known six-foot dimension and divide it into whatever shorter dimension you wish.

Known distances established by means of the unit of measure can be projected horizontally across the picture plane as shown in the same example. Note how in Figure 5.24 A the twelve-foot measure can be projected to the extreme left to locate a tree exactly twelve feet high.

The unit of measure (or any portion or multiple of it) can be projected back into space as demonstrated in the same example. Note how the six-foot measure in this example has been projected back to eye level, thus locating a vanishing point. The top and bottom of the given unit of measure projection can be interrupted at any background distance to establish an equal dimension anywhere along the vanishing traces. In the same example, note how a fence can be created by projecting the six-foot dimension back toward the vanishing point; then one can project it horizontally across the picture plane thus making each horizontal unit of the fence the same height.

If you have followed the above explanation carefully and referred to the example provided, you will see that you can establish known distances and dimensions anywhere within the picture plane. Both vertical and horizontal dimensions, since they are parallel to the picture plane in one- and two-point perspective *do not diminish or foreshorten*. You can add to them or subtract from them; it is only when you wish to establish dimensions farther back or closer up that you project the known dimension back to a vanishing point at eye level, and then stop it where necessary to create smaller units of the same size. Review the explanation and carefully study Figure 5.24 A until you understand the method thoroughly.

Figure 5.24 B further demonstrates the theory. This figure shows the perspective placement of a number of vertical and horizontal units. The vertical units could be posts of a fence, such as those in the previous illustration. To develop the exact repetitive placement of a number of similar units, such as fence posts, lamp posts, telegraph poles, or other objects that are equally spaced from each other, it is necessary *to establish eye level and the first unit of measure*. The first unit of measure in this case is a-a'. Draw lines from this unit to a vanishing point placed so that you will have *the kind of progressive recession that you wish*. You may have to experiment with this until you have located the vanishing point where it best suits your purpose. For instance, if you wish to show more of the surface fronts of the units, your vanishing point would have to be placed *farther to the right of the picture plane* in the particular example shown. If you wish to show less of the surface fronts and more of the side surfaces, placing each unit closer together, then the vanishing point should be moved *closer to the first unit of measure*. Next, visually estimate the distance of the second unit from the first, which in this example would be b-b'. Then draw a center line from a-a' at its midpoint to the vanishing point. Following this, draw a diagonal line from a' through the center of b-b' until it strikes the lower part of the line (from a to the vanishing point). This will give you the location of c, from which you would then extend a vertical line until it touches the upper vanishing trace at point c', giving you the exact perspective location of the third division c-c'. Simply repeat this process as shown in the example to locate as many vertical divisions as you wish.

Horizontal divisions are achieved much in the same way. In our example, the horizontal extensions a-a'', a''-a''', and a'''-a'''' are the same in size, but when projected back to the vanishing point the second series of divisions are equally shorter, as noted in b-b'', b''-b''', and b'''-b''''. This simple method of perspective projection can be very useful in many situations. With some imagination it is possible to use the horizontal division method for cement walks, pavements, and the like.

In C of Figure 5.24, the block to the right enclosing a human form is seen frontally. If the vertical dimension of this block is projected to the left and placed in a perspective situation, it would be possible to draw the block first as a foreshortened unit, after which drawing the *foreshortened* figure within it will be facilitated. Using the method shown in B, this process can be repeated to develop a row of figures receding back into space.

This method is particularly useful to the beginner who wishes to draw a street scene or some other situation calling for a convincing depiction of representational elements located correctly in perspective. More sophisticated applications of this method and other methods may be found in the suggested readings for those who wish to carry their study of the subject further.

DRAWING CIRCLES IN PERSPECTIVE

Drawing circles seems to constitute a major problem for the beginner. The method for drawing circles in perspective is illustrated in D, E, F, and G of Figure 5.24.

In D, we have drawn a cube in perspective, using one-point perspective, and divided the top and front surfaces by means of diagonals which intersect at the centers of each respective square. We can then draw vertical and horizontal lines through the centers of each square, creating four equal divisions. Notice that in the upper square (the one which recedes back to a vanishing point), the front half of the divided square is larger than the back half. This upper square is first drawn by means of a fairly accurate visual estimate: in the example shown, note that the foreshortened dimension marked "a" is about one third of the distance marked "a'." Having located the four equal divisions for each square, it is relatively easy to draw a circle within each of the squares. Note that the frontal circle is a "true" circle with equal divisions; while the upper circle is an ellipse.

In E, we have two ellipses that relate to the perspective situation shown in B. Use the same method as in D for E.

In F, we have an example that can serve as a general guide in drawing freehand ellipses. You might think of this as a plastic cylinder which is scored in equal divisions from top to bottom. The portion that exists above eye level (b) is equal to the portion that exists below eye level (a). It is important to note that at eye level the ellipse exists as a straight line. The ellipses just above and below eye level are very shallow, or thin. Each successive ellipse gets progressively larger at its midperspective center, both above and below eye level, until the very extreme ellipses at the top and bottom of the form are the largest (and in this case, equal).

Example G shows two ellipses: one is drawn correctly, the other incorrectly. The beginner tends to draw pointed ends to an ellipse, which can create the illusion of a *flattened* form, rather than the correct *rounded* ellipse. At first it is advisable to draw ellipses within squares established in perspective, as shown in the examples. Then draw ellipses freehand, without the squares. With practice, the process becomes easier until it becomes automatic to draw ellipses correctly.

APPLIED STUDIES

Figure 5.24 has afforded us with some important references for *perspective locations in space* and *drawing circles*. Now try applying some of these methods to actual drawing situations. Two procedures will be especially helpful for beginners: preliminary work from photographs and work from actual scenes and objects.

The camera was invented in the nineteenth century. The French Impressionists and other artists since that period have used photographs for various reasons. A purist may object to the use of photographs on the basis that one should learn to draw directly from nature itself. However, I believe that photographs present us with the opportunity for better understanding such things as perspective and certain aspects of realistic drawing. Hence, the photographic study applications that follow should be considered as useful *adjuncts to a better understanding of how to draw correctly*, rather than as *substitutes for how to draw correctly*. Just as perspective can be a useful tool for better drawing, so, too, an understanding of how to use photographs in a constructive, informative fashion should contribute to better drawing. It

is not inconceivable that if the camera had been invented earlier, it would have provided extremely useful data for such masters as Leonardo Da Vinci and Michelangelo, without any sacrifice of their outstanding abilities. It must also be remembered that the monocular eye of the camera presents us with aspects of perspective that are critical to better comprehension of the subject. Some may wish to skip the portion dealing with study from photographs and go directly to the work from actual scenes and objects. Nonetheless, the beginner may profit from engaging in both forms of study. A further rationale for the constructive use of photographic references may be surmised from our previous discussion concerning left brain/right brain modes. Obviously, the left portion of the brain, being the analytical sector, eagerly seeks out data that can be stored and relied upon for the insight developments of the right portion of the brain. In doing so, all kinds of pertinent data can be utilized, and the richer and fuller the battery of data, the more and greater potential is provided for the right portion. We are assured from our studies that an abundance of stored information is much better than a lack of it.

Study 1. *You will need an HB pencil, rubber cement, and a medium-sized sketchbook.*
 The first photographic reference that we shall use should correspond in general character to Figure 5.24 A. This may be selected from any newspaper or magazine. Attach the photograph in the center of your paper and consider that it represents your picture plane. Next, draw your eye level. Now identify some major form in terms of its height. Use this one unit of measure, as was done in example A, to indicate the approximate height of other objects in the composition. Do not spend more than half an hour on this drawing and do not try to determine the heights for everything in the photograph if it is complex. Make indications for only a few forms to assure yourself that you can apply the principle involved.

Study 2. *Go outdoors and find a scene that corresponds to the previous situation, or as close to it as possible. Repeat the procedure for establishing picture plane, eye level, unit of measure, and other devices for constructing the drawing. The objective is to concentrate on establishing heights, distances, and proportions of objects in the scene. Do not attempt any kind of complex drawing at this time. Work in line alone and draw freely, but exercise control in determining all of the important relationships. Spend about half an hour on this drawing.*

Study 3. *Switch to a photograph of figures in an outdoor scene that has a good feeling of depth. Then proceed as before to establish all essential perspective devices, referring to Figure 5.24 A, B, and C.*

Study 4. *Go outdoors and find a reasonable counterpart for Study 3. Use a medium or small sketchbook. Apply all the devices you have used in the previous work. You may wish to make several of these drawings, but do not spend more than half an hour on each. The important thing is the application of theory, not the development of a finished drawing. Again, work in line for simplicity and directness.*

Study 5. *Find a good photographic reference of an interior scene, one that has only a few objects in it; for instance, a living room that might show only a table, a few chairs, a lamp, some pictures on the walls, and possibly a window or two. Search out the important relationships as in the previous four examples.*

Study 6. *This will be a drawing based on insights gained in Study 5. Use an interior situation which lends itself to the purpose. Study the example in Figure 5.25. Draw a freehand sketch, searching out relationships until you have established the main spaces and objects.*

It might be helpful to think of the room as part of a large box. In the example, note how the walls recede to vanishing points at eye level and how the objects conform to the established perspective context of the walls and floor. Spend half to three-quarters of an hour on this drawing.

Here we turn to ellipses, using photographic references for careful study and practice drawings. Newspapers and magazines contain many advertisements which show glasses, bottles, and other cylindrical forms. You will find it especially helpful to trace many different types of ellipses, representing views from different eye levels. Draw some of these in your sketchbook. Place some inside squares in perspective so that you will have a comprehensive understanding of the theory presented in Figure 5.24 D, E, F, and G. Develop at least twelve studies of various ellipses to familiarize yourself with a broad range of perspective situations. Some ellipses should be practically flat (eye level, or near eye level), while others should be thin (slightly above or below eye level). Avoid drawing pointed ends. Some ellipses should be well-rounded (a noticeable distance above or below eye level). Spend up to three-quarters of an hour on such studies. **Study 7.**

In this study, draw ellipses from actual objects which you may arrange in different positions relative to your established eye level. For instance, place some objects on the floor, some on a chair, and some on a table; place at least one object in line with your eye level. Naturally, the objects placed on the floor will present the widest ellipses, since they are considerably below eye level whether you are standing or sitting. The top or bottom portion of an object that is at eye level will present an ellipse as a straight line. Fill one or two pages of your medium-sized sketchbook with such drawings, spending about half to three-quarters of an hour on them. **Study 8.**

Aerial Perspective

We shall consider this kind of perspective in more detail when we work with landscape drawing and sketching. Here we shall be concerned primarily with a useful working definition and some supportive reference.

Aerial deals with atmospheric changes that influence the tonality (or value) of forms in nature. The farther back forms are, the lighter they appear due to the intervening layers of air, and the less clarity they have in contrast to forms that are in the foreground. Hence, objects like distant mountains, trees, and houses are not only *smaller in scale* than objects closer to the observer, they are correspondingly *lighter in tone* as well.

Sometimes the artist will force a sense of lighter tonality in background areas even when such tonalities do not exist. For instance, on a clear day

FIGURE 5.25

TO V.P. AT RIGHT

TO. V.P. AT LEFT
E.L.

V.P.

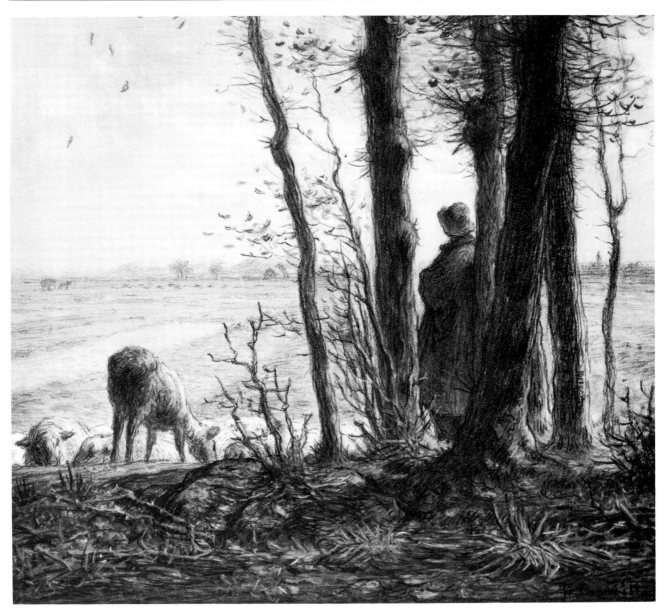

FIGURE 5.26
JEAN FRANÇOIS MILLET (1814–1875)
Falling Leaves (1866–67)
Pastel. 14½ × 17 in.
Corcoran Gallery of Art, William A. Clark Collection.

far objects may appear to be almost as sharply defined and as dark as close objects, but the artist, wishing to stress the illusion of deep space, will often make such objects lighter than they actually are.

Figure 5.26 is a poetic example of the use of aerial perspective. It is a pastel drawing by the French artist Jean François Millet, titled "Falling Leaves." It is important to be aware that the artist has developed the drawing in terms of a strong foreground plane, darker in tonality than the rest of the composition. The slight play of light over foreground forms—trees, figure, and sheep—enhances their three-dimensional qualities, though they appear to be almost silhouetted against the lighter midground and background areas. The background terrain and sky illustrate aerial perspective by being much lighter in tonality than the foreground objects, suggesting intervening layers of atmosphere. The pastel strokes have been applied in the foreground more affirmatively, creating a luminosity and vividness that strengthen the sense of reality.

Those who find aerial perspective particularly engaging may wish to make a few studies at this stage, perhaps using the Millet drawing as a reference. Soft lead pencils, conté crayons, or charcoal would be suitable drawing materials. The next chapter will provide ample opportunities for landscape and other nature studies.

6

STILL LIFE

In the previous chapter we discussed some of the essentials of basic drawing. We shall now utilize these essentials, together with other concerns, to extend our challenge to draw.

The still life will be our subject of study at the outset. It will enable us to probe the various expressive possibilities of line and tone; it will give us the opportunity to test our grasp of perspective; and it will present us with the challenge to get deeper into the art of drawing, giving us new insights into this fascinating and totally absorbing activity.

If you encounter difficulties in this chapter, review the relaxation and deep breathing techniques mentioned in the first section of the book. Since much of the work is analytical in nature, you may find that you are holding your breath as you study the various explanations and instructions. As we proceed, try to visualize all the material presented (explanations, applications of theory, and various stages of drawing). Most of us unconsciously visualize whatever we are studying or are concerned with; descriptive words and explanations naturally stimulate imagery. Take advantage of this natural tendency and build upon it. To visualize in creating art is indispensable. Let us now discover why still life is such an important subject of study for the artist.

Western artists have been having an ongoing love affair with the still life for centuries. In the eighteenth century, for example, Jean Chardin (1699–1779) had recognized the poetic beauty of pitchers, cups, boxes, glasses, pipes, and other three-dimensional forms that were in common use. He endowed such objects with a vibrant luminosity that only a sensitive artist can convey.

Near the end of the nineteenth century, Paul Cézanne utilized the still life to produce a revolutionary art form that departed from the traditional concerns of the past. In the twentieth century, such artists as Piet Mondrian, Juan Gris, Pablo Picasso, and Georges Braque carried the still life into new dimensions of innovative pictorial organization and aesthetic concerns. In more recent times, Andy Warhol, Claes Oldenberg, Jasper Johns, and others have used still life objects to heighten our awareness of the beauty and uniqueness of mundane objects. Artists continue to work with still life for

many reasons, and you, too, may find still life an indispensable subject of study.

Let us consider some of the advantages still life material offers. Still life is stationary; it does not have the annoying habit of moving just when you are about to capture some essential line or relationship. It will not change in tone or color, unless you are working with such perishables as apples or leaves, which in any case are easily replaced by new ones. (Wax and plastic forms—if you are not a purist—offer almost indestructible stability.) Still life material can be selected for its *variety* in color, size, form, and maneuverability.

Still life can provide a variety of *textures*, another important quality that adds interest to a composition. Also, one can easily set up a still life in the most desirable lighting situation; *controlled light* is an essential factor in our study of *chiaroscuro*, or our concern with tonal aspects of drawing. Extreme changes in temperature will usually not affect still life material. If your studio is not well-heated, you need not worry about your pitcher getting a chill, nor will heat unduly affect most of your subjects. Still life has the desirable aspect of allowing you to work with things you are fond of, things you have gathered in your travels, perhaps, or which have particular significance to you. Such associations can heighten the emotional responses you will transfer to your work, giving it a more personal quality. You may think of other advantages. Our concern here is to consider still life in terms of drawing fundamentals and of personal innovations that stimulate the imagination.

Expressive Possibilities

Figure 6.1 shows five still life studies made by a student. These clearly indicate how various drawing materials can produce various *expressive states* or *qualities*, even though they deal with the *same* subject matter. You have already had some exposure to expressive possibilities in an earlier section when you were experimenting with drawing materials; therefore, the examples that follow should be of particular interest.

In 6.1 A, for instance, the drawing has been made with vine charcoal, applied in such a way as to achieve a light tonality. Portions of the drawing have been smudged and then erased. The result has a lightness and a delicate quality that suggests a particular kind of music that can be produced by the guitar. The instrument, itself, is presented in a somewhat fragile context, indicative of heightened notes and tones that can be produced in the upper tonal register of the instrument. The work was produced by a woman student who plays the guitar and loves music. She is therefore appreciative of the potential to express emotional qualities. Note that the artist has organized the composition to emphasize light playing over the instrument, the drapery, and several small, subordinate forms. The main object is centralized, emphasizing its importance. It is also larger in scale than the other objects, which also stresses its importance as the dominant object.

In B, we have the same objects drawn with vine charcoal; however, the effects differ from the first study for several reasons. The drawing is made on charcoal paper, in contrast to the previous work made on newsprint paper. Charcoal paper, having a rougher tooth and a corresponding rougher surface, produces a different kind of textured line and tone. Also, though some smudging has been employed, crosshatch strokes serve to activate the

FIGURE 6.1
CINDY BENDIX (student)

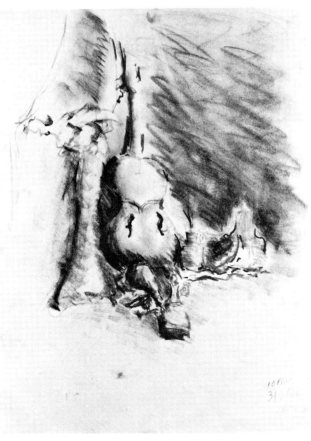

A

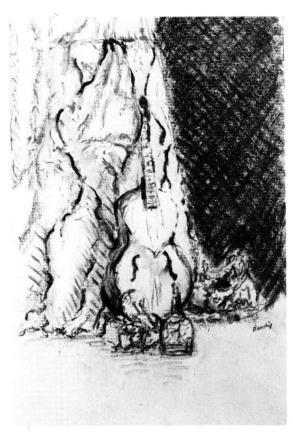

B

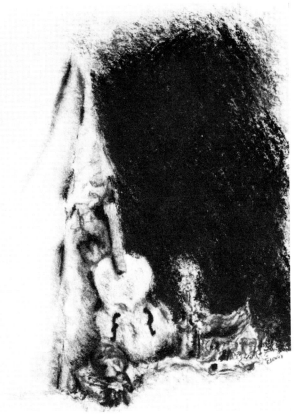

C

surface, producing, in turn, a vibration which is stronger than the relatively muted effects of the first study.

In C, the dramatic effects have been further heightened by the use of compressed charcoal on newsprint. Compressed charcoal has an oil base and will not powder like vine charcoal, permitting even more permanent and stronger qualities of tone.

In D, on the other hand, we are brought back to a more subtle statement as in example A. However, these subtleties have been achieved primarily by the use of black ink and sepia wash on newsprint. The even tonality of washes is only slightly accented by the ink lines drawn with a crow quill pen.

Finally, in E we have a powerful and expressive statement of the same subject matter. An assortment of mediums has been used: pen and ink, charcoal, magic marker, and black construction paper applied in collage fashion. This is a highly innovative statement, differing completely from all the others. Although we may have some difficulty identifying the guitar, it is still in its central position. The black construction paper plays a major role by being placed in various positions throughout the picture plane. This creates a dramatic pulsation of light and dark intervals, suggestive of the deep beat of the instrument. This effect is supplemented by the application of other media to heighten the dramatic and decorative qualities.

The student has been successful in achieving different emotional qualities in these studies, and thus has stimulated the observer to respond in correspondingly different ways. We might compare the first study to a classical approach, where the identity of the objects is portrayed with much sensitivity. The last study is a significant departure from the subject matter *per se*; it evokes a dramatic quality in which powerful visual forces are at

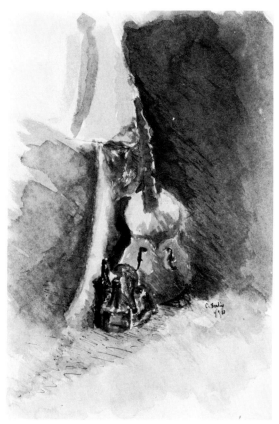

D E

work. The successful artist, like the successful actor, should have the ability to control the medium's expressive language to achieve the particular message or content of a work.

This *overview of expressive possibilities* will serve as a basis for the studies that follow. We will be primarily concerned with an *emotional response*, which will rely heavily on your personal attitudes to the subject matter that you choose to work with. Therefore, it is advisable to work with objects that have some special meaning to you, keeping in mind that variety of sizes and a basically centralized type of composition is desirable.

Study 1. *Select three to five objects. They should vary in size, one of them being dominant. Intricacy of form, design, pattern, color, and tone are not desirable at this time; rather, simple objects are preferable at the outset. After you have achieved a desirable degree of control, you may wish to work from different materials. Arrange these objects against a large piece of drapery, similar to the arrangements shown in Figure 6.1, so that there will be one principal light source. The light source should be strong, coming from either left or right and slightly above. Avoid frontal lighting as it tends to flatten out forms, which would be contrary to our purpose.*

Carefully select an assortment of drawing mediums to allow the possibility of far-ranging tonal effects for each work you will develop. You may improvise with different materials, if you wish; however, they should lend themselves to a variety of emotional statements.

In addition, make a selection of five different types of paper. If you have not developed a sketchbook (approximately 18" × 22") that has an assortment of papers which range from smooth to rough, you may improvise with single sheets of paper, cut to fit a spring-bound sketchbook. However, don't be fussy about these aspects; the most important thing is to utilize five different types of papers. Now you are ready to begin.

Your objective will be to make five separate drawings. It does not matter which of these you choose to begin with; let your own preferences determine which should come first. However, since this may be an entirely new experience for you, certain general procedures are suggested. These will not necessarily constitute a step-by-step, "do-it-by-numbers" process. You yourself can determine how you will achieve the range of emotional statements. A review of Figure 6.1 may be desirable before you begin.

1. Determine the allover composition by a few preliminary gestural indications, working lightly. This should assure you of relative sizes, proportions, and spacing of objects and folds of material in the composition. This work is to be done in a predetermined picture plane, even if your picture plane is the total sheet of paper. Tentative indications are best at first, even though you may intend a more forceful statement for the work in question. You are mapping out your territory.

2. Don't let principles of perspective bog you down. This suggestion may seem paradoxical, but it is necessary that your initial approach be free—more of a sensing approach than a measuring approach. It will be sufficient to sense perspective relationships, without actually drawing perspective lines to vanishing points. You should, however, be aware of your eye level and how objects are related to it.

3. Next, decide which quality you wish to develop by means of the most appropriate materials. This is really the key to the whole process, as we found when analyzing the studies in Figure 6.1. Your emotional intent is paramount; all other procedures should contribute to this aspect. Don't be afraid to make a mistake. This is not a precious work of art that has to be framed and exhibited; it is a study aimed at learning to express yourself. If you get off to a bad start, don't hesitate to tear up your paper and begin again. On the other hand, don't analyze each stroke of the pencil or charcoal so that your progress is extremely slow and intellectualized. Remember, we are extending the challenge, not minimizing it. Try to be confident and work with assurance, and don't forget to relax if you find yourself tensing up. Take a few deep breaths and continue.

4. *If you are a beginner, make all five drawings of the same subject matter. In the last study, improvise with collage materials, principally limited to black and white papers.*

5. *Time yourself so that you will not spend more than half an hour of work without a short break. You must get away from what you are doing every so often so that when you return to work you will see it with a fresh eye. Remember: While you take that break, your right brain is at work* planning the rest of it for you. *Gaining this insight will give you the assurance you need to make rapid progress. When you know you have spent sufficient time analyzing your approach, then it is time to shift into the right brain mode and to work with confidence and a minimum of interruptions.*

6. *After you have finished one or more of your studies, refer to Figure 6.1 for comparisons. Were you successful in achieving your objectives? If not, determine why. You may wish to repeat one or two studies before proceeding further. The important thing is that you analyze what you have done* after *you have completed the work, not constantly while you are developing it. Use this procedure for all of the five drawings, repeating those that do not meet your expectations.*

This study will be a further reinforcement of the various possibilities indicated in Study 1, but with a special focus on you and your preferences. The objective is to determine how you feel about the above studies. Which of those seemed to strike the most personal kind of response? If you cannot determine which emotional approach was the most significant from a personal point of view, invent one of your own. **Study 2.**

 Consider making one major study that will sum up or personalize the information contained in the previous applications. Perhaps you were moved by materials that presented a light, delicate statement, or conversely by those which presented the possibilities of rich, dramatic effects. Determine which direction you wish to pursue. Think out the problem in all of its details. Visualize how it will look when it is complete. *Try to create a vivid visual image of what the work will be like, in as complete detail as possible. Spend a few minutes in this preliminary planning and visualization, then begin to work and continue for as long as you feel comfortable. The value of this approach is twofold: It will make the information of the above studies more meaningful to you because of your personal preferences and it will provide the opportunity for a totally integrative utilization of* left brain/right brain modes. *Remember: The left brain mode will assure you that you have assimilated* meaningful *information* necessary to pursue the problem; *the right brain mode will provide you with the feeling or inspiration to pursue the problem in a way in which* time will seem suspended. *You may work for half an hour or longer without feeling any sense of discomfort, which would be a certain indication that you are deep into the subject from a right brain mode response. Test yourself now. If you do not succeed, you will have other opportunities in the work that follows.*

We shall now turn to a consideration of line and tone in still life.

Linear Considerations

In much of our previous work we have limited ourselves to line drawing. This was to simplify work that required an analytical approach in which tone would have been an added complication. An artist usually combines both line and tone, especially in drawing, to achieve the most complete, expressive statement possible. We will continue to work with line and tone separately, but will combine them from time to time as needed.

 Contour drawing, which is a form of linear drawing, can be an intensely expressive kind of drawing, in addition to providing us with a valuable technique of study. Some artists have become identified with their special use of contour or linear drawing—Jean-Auguste-Dominque Ingres, for in-

stance. This neoclassic artist developed many portraits in a linear style that was later admired and emulated by Pablo Picasso. William Hogarth, the nineteenth-century English satirist, developed many fine etchings in line. Vincent Van Gogh, who lived only thirty-seven years, was a prolific draftsman, constantly perfecting his craft; his paintings took on the quality of linear ribbons of color, perhaps revealing an unconscious concern with the power of line. Joan Miro, Piet Mondrian, and many others have utilized line in terms of their own particular idioms.

It should be understood, however, that line is an abstract device: *it does not exist in nature.* That is, all forms exist *as volumes* of one sort or another, even forms we might consider to be linear, such as thin wires, fine branches, wrinkles, and folds in material. Line is an *artistic invention* which forms an integral part of the artist's *visual vocabulary.* We shall study line drawing in the light of its contribution to the richness of the artist's language of expression, its descriptive nature, and its plastic relationships which assist perceptual comprehension.

Some of the studies that follow may at first seem to be a repetition of work presented in the chapter on picture plane and perspective. However, most of these studies are planned to help the beginner gain added information, building on what had been done earlier. The more advanced student may wish to scan this section, making only those studies that seem useful. The beginner, on the other hand, should make all of the studies to understand the concepts thoroughly.

The following group of studies develops from the simple to the complex. All you will need will be an HB (or similar) pencil, a fairly smooth type of drawing paper (sketchbook or single sheets of middle-weight bond), a drawing board, if you wish, and an eraser. You may combine several studies on the same sheet of paper, especially if you are working in a sketchbook or on paper which measures 14″ × 22″ or larger.

Study 1. *Draw a simple form, such as a vase containing some leaves or flowers. (See Figure 6.2 A.) You may work from an easel standing up, or prop your drawing board or sketch pad against the table on which you have placed the vase. If you plan to make several drawings on the same sheet of paper, indicate your picture plane in line before you work.*

FIGURE 6.2

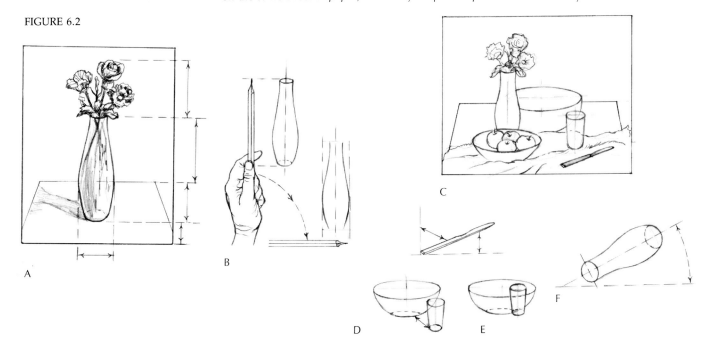

The next step is to locate eye level, then establish the table and the ellipses of the vase in perspective. If you wish, review the chapter on picture plane and perspective. All of this work should be done very tentatively, subject to the directions that follow.

We shall now use a device not previously used in our studies. This will be a visual sighting procedure which will supplement the unit of measure concept presented in an earlier chapter. You will recall that our unit of measure was predicated on the application of basic mathematics in which actual measures were determined by means of a single, predetermined dimension projected into a spatial/perspective-oriented context. Our present method relies on visual assessments that are made by means of the utilization of a sighting device, aided by considerations of vertical, horizontal, and diagonal references.

The device has been used by countless artists. You may have noticed how artists will hold up a pencil or a paintbrush and squint at an object or a scene they wish to depict. In Figure 6.2 B, we have a drawing which demonstrates the essential process: a hand holding a pencil. Assume that the artist is the person holding the pencil, held at a certain distance from his or her point of vision. Note also that the pencil is adjusted to the height of the vase. When the pencil is turned to a horizontal position, and held at the same distance from one's vision, it will be possible to assess the width of the object in relation to the height of the object. It may be one-half, one-third, or some other portion of the height of the object as noted on the pencil itself. This visual sighting is best done with one eye, and the pencil must remain the same distance from the eye.

It is advisable to check how accurate you were in your first, tentative indications in setting up the drawing you started, using the sighting procedure. For instance, you might sight along your pencil to check the height of the vase in terms of the vertical distance of the table from the point where the vase is established. In example A, it is somewhat larger than twice the noted distance. Do the same for the height of the leaf or flower formation. Also check the width of the vase in relationship to it's height, using the same procedure. What is the distance of the portion of the table that extends in front of the vase in relation to the vase itself? After checking your first indications in the manner explained, make your drawing more definite and affirmative, erasing portions that seem off or need adjustment. Note how the center line drawn through the vase in B helps one in getting a symmetrical shape and in centering the ellipses correctly.

We shall complicate the previous subject matter by the addition of more forms, up to about six, as seen in Figure 6.2 C. The vase is on a larger table on which have been added a bowl of apples, a taller bowl, a glass, a knife, and a piece of cloth. **Study 2.**

In developing this drawing, follow the earlier procedures of establishing the picture plane, eye level, and tentative positioning of all objects, then apply the visual sighting method.

There are some supplementary explanatory drawings associated with C of Figure 6.2. Note how the tilt of the knife can be determined by imagining vertical and horizontal lines as shown, or by holding a pencil up to the knife in vertical and horizontal positions which form the angles.

The still life has been complicated not only by additional forms, but also by the spatial relationships that exist between the forms; it is necessary to sense and draw the spaces that exist between the forms so that the forms will have space in which to exist. Figure 6.2 D and E provide correct and incorrect solutions, respectively. In the former, the undersides of the objects are drawn, clearly indicating how much space they occupy. We see that there is a comfortable amount of space between the objects. In the latter, the undersides are drawn so that they overlap, indicating insufficient space in which to exist on the table surface. Some adjustment will have to be made.

If you have an object that is resting on its side, as in F of the same figure, first determine the angle of its centerline in relationship to an imagined horizontal line. Then draw the long axis of the ellipses at right angles to the centerline to establish correct relationships.

Objects that are foreshortened, as in Figure 6.3 A, B, C, may be drawn as shown by first constructing a simple geometric box in two-point perspective. Following the procedure explained in the perspective section for establishing ellipses, draw the most

FIGURE 6.3

FIGURE 6.4

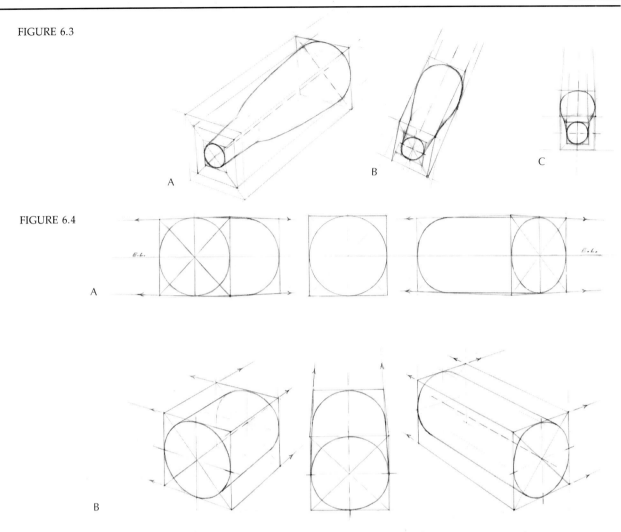

A

B

important ellipses within the boxes; then carefully sketch the contours, making necessary adjustments until the form looks correct.

Spend as much time as needed making the kind of visual assessments described above. When you feel that all the various components have been correctly established, work more affirmatively. But keep all your work in line for the present. This will permit you to study your work at this stage with the utmost clarity. Remember, the objects should be correctly located in relationship to each other; proportions should be accurate; spaces between objects should be convincing; angles of objects should be correct; and finally, ellipses should have rounded ends.

Study 3. This study is planned to provide you with more experience in drawing ellipses. You now have a chance to apply theory to still life objects, such as an ordinary drinking glass, as shown in Figure 6.4 A. If you wish, arrange three glasses in positions similar to those in the line drawings of three glasses at eye level shown in A. These can be drawn on a sheet of paper without any indication of the picture plane, but it is necessary to suggest eye level with a faint line. As in the illustration, you may find it useful to develop some preliminary indications of basic squares and rectangular forms before you draw your ellipses. In studying A, observe that the central form is drawn as a circle, since it is seen head-on, and only the front surface is visible. The drawing to the left shows a slight modification of the circle into an ellipse. The drawing to the right shows an even greater modification of the circle into a more pronounced ellipse. In example B of the same figure, the glasses are shown below eye level; note the corresponding modifications of preliminary indications (squares, intersecting diagonals, etc.). Notice, also, that a portion of the long axis for the glass becomes the short axis for each ellipse. The long diameters,

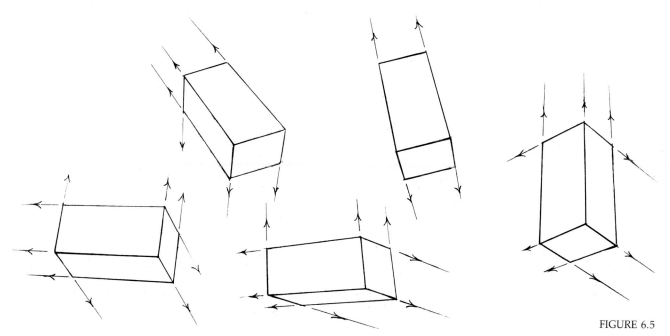

FIGURE 6.5

or the long axes of the ellipse, are at right angles to the short axes. Make drawings that correspond to those in Figure 6.4. It would be good practice to make free-hand drawings of glasses in different positions, or to draw cups, bowls, and other forms.

This study is intended to reinforce your understanding of drawing simple rectangular shapes. **Study 4.** *Use some simple form, such as a brick, or a block of wood. In Figure 6.5, a simple solid is shown in various positions, none of which are parallel to the horizontal plane; each is tilted or angled away from the horizontal surface. Since the forms are turned in different positions, they have correspondingly different vanishing points, indicated by vanishing traces (the short arrows). Place the form of your choice in different positions, corresponding to those shown, and make a separate drawing of each position. Do this by using vanishing traces, instead of actually locating vanishing points.*

This is a further application of the concepts and theories used in developing a contour **Study 5.** *drawing. We will be concerned with both inner and outer contours. Figure 6.6 is a typical situation for study. Note that all of the material is below eye level. There is a step in the right foreground, in front of the side arm of a couch with two pillows and a folded blanket. Beyond, there is a table on which an ashtray and a cylindrical vase of flowers are placed. Note how inner contours in most of these forms create a three-dimensional quality, though tone has not been used.*

FIGURE 6.6

Try to select and arrange material that is fairly close to the example. This study is in the form of a vignette, hence a picture plane has not been indicated. However, it is assumed that the eye level is fairly high above the arrangement, since one can peer into the most distant ellipse in the vase of flowers. Use whatever aids you desire when making this drawing. If necessary, review the previous explanations. In general, it is best to establish large forms first, then smaller ones. Remember that it is advisable to begin all preliminary work in a light, tentative fashion. Once you are sure that forms are correctly established in relation to each other in the setting, reinforce your contour work, strengthening inner as well as outer contours for the maximum amount of three-dimensional form.

Additional Studies. *Figures 6.7, 6.8, 6.9, and 6.10 provide examples of additional studies that should be made. Figure 6.7 depicts a piece of material drawn with a crow quill pen. You may wish to switch to pen and ink at this stage to increase the challenge through a more direct approach. However, if you feel hesitant, stay with pencil. Notice how important inner contours are in this example; they serve to create directional movements that articulate the form of the material and make one aware of its particular shape characteristics and modifications. Also, the outer contour at the top of the material creates the appearance of being farther back than the lower contour, which corresponds to the actual situation. Heavy lines tend to advance, light lines tend to recede. Since drapery forms an important part of most still life drawing, make several pencil and pen drawings similar to the example. These studies do not require picture plane or perspective indications, but they do require a sensitive, searching-out attitude of attentive vision.*

There are many variations to this kind of contour work. For instance, one can benefit greatly by making a very slow contour drawing of some subject. As one draws, it is essential to feel one's way along with the direction and character of the line. Is it thick or thin? Does it move backward or forward? What kind of a directional curve does it create? How can you make one line seem to exist in front of another? These are some of the questions you might ask yourself as you develop a slow contour drawing.

Another variation is a fast or quick contour study. This was touched upon briefly in the section on gesture work. Getting the allover mass established in terms of a quick contour indication helps you sense the whole, without getting lost in detail. As a change of pace, make a few quick contour studies of a subject of your choice. Spend ten to fifteen minutes making a few quick contour drawings, using whatever drawing material you wish.

Figure 6.8, a crow quill pen and ink drawing, takes us back to the subject of a vase with flowers and illustrates the importance of preliminary structural (perspective and proportion) considerations. The small sketch to the left is an analysis of the drawing of the vase, showing a centerline and the establishment of essential ellipses. Notice how the flowers have been placed to provide the observer with different views (front, side, back). Such variations heighten the sense of forms existing in space, making the spaces between the forms active, as well as the forms themselves. Notice, also, that portions of the contours have been strengthened to produce a sense of advancing forms and emphasis, while the thinner lines give a sense of recession and less accentuation, adding visual interest. When you make a similar drawing, it is important to sense portions of the forms that you do not see; this will enable you to draw the portions you actually see with more conviction.

Figure 6.9 provides an example of another subject in which inner and outer contours are essential in creating a convincing feeling of form. This was done as a slow contour drawing in which no preliminary guides were used. However, an intuitive sensing of proportions, solids, and directional movements were considered in the process of drawing the camera case and its appendages. The analysis drawn below the contour study suggests the basic solids in which the camera could be enclosed; the beginner may wish to make a similar analysis before beginning the direct, slow contour work, especially if he or she wishes to work with pen and ink.

Figure 6.10 makes us aware that line can describe texture, as well as form. We gain a grasp of the reality of objects through the senses of touch and sight. It is important to be sensitive to this kind of reality dimension when we draw. Is the object of our concern hard, smooth, bristling, furry, soft, or porous? How can you best describe the textural quality of the object you wish to draw? In this figure, two subjects have been drawn using crow quill pen and ink. Notice how in the drawing of a piece of rope, thin lines have

FIGURE 6.7

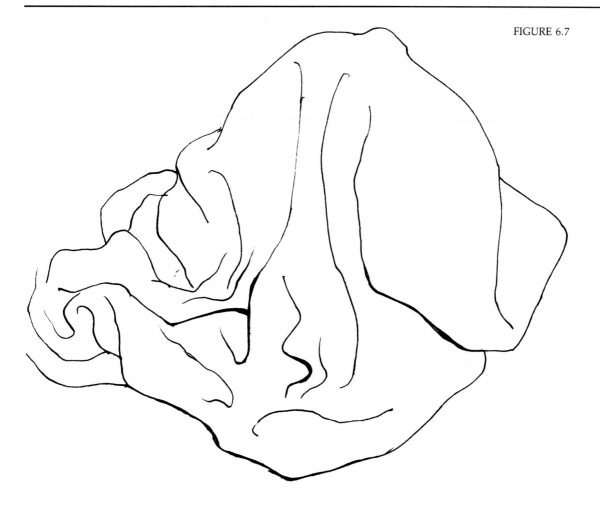

Pen line indication of drapery. Note how the
upper portion seems farther away than the lower,
and how the eye can move in different directions
over the form by means of inner contour lines.

FIGURE 6.8

Linear variations in these inner and outer
contours create interest and describe
form. Notice how darker portions of
lines in the vase seem to advance.

FIGURE 6.9

A complex form like a camera in its case
is easy to sketch in pen if one is aware
of how it relates to simple box-like
shapes.

FIGURE 6.10

Texture of thin rope is suggested by
means of line.

been used, placed close together, to create the sensation of hemp. In the soft form drawn below the rope, a feeling of terry cloth is suggested by fuzzy contour lines, both inner and outer.

SOME FINAL CONSIDERATIONS OF LINEAR STUDIES

The preceding studies are planned to present you with a progressive program which you can adapt as you see fit. Some drawings will take longer than others. Some will call for acute analysis; others will require selective sensing and feeling, based on a sound grasp of essentials. Some studies have no set time limit; use your own judgment of how much time you wish to spend on them. Keep in mind that it is best not to work more than twenty-five minutes without taking a break to get a fresh view of what you have done. Study, analyze, and review as much as you wish, until you feel confident. As you proceed in your work, rely on the sensing process as much as possible, for this right brain mode should be constantly encouraged and developed. Sound analysis in terms of preparation (left brain mode) precedes such activity, and a final wedding of both cognitive aspects is the ultimate goal.

Tonal Considerations

Whereas line is an invention of the artist, tone, or value, quite obviously exists in nature, in what we see around us. We not only see things in terms of their tonal differences, we can make drawings of things in tone only, without line, and get a good representation of an object in terms of tone alone. We see light objects against dark ones, or against a dark background, or vice versa. Objects in a room without light cannot be distinguished unless we employ the sense of touch to determine their volume. Conversely, if objects were illuminated with lights from many angles, we might have such an intense allover light that such objects would be almost equally undistinguishable. Hence, the artist is very sensitive to how light affects subjects and, when possible, presents subjects in the most effective kind of lighting.

Drawings can be made with a minimum of tone, thus producing a light, or flat, tonality. Usually such drawings dominate in line, perhaps of an equally light nature, emphasizing a particular mood associated with lightness. We may associate this kind of quality with a soft, light, nonthreatening voice. On the other hand, a dark tonality is heavy, powerful, and dramatic, like the strong voice of Othello, or someone in a state of rage or anger. Earlier in this chapter, we saw that five drawings of the same subject conveyed different qualities, or moods, not only by means of linear qualities, but also by means of tonal differences.

Try a preliminary experiment showing how we can perceive and depict a form by tone alone, without the use of line.

This will call for an HB pencil (or its equivalent), your all-purpose drawing pad (or a sheet of white drawing paper), and a pencil eraser. You will also need a model, and in this case it will be a piece of paper approximately 2" × 2"; you can cut this directly out of your drawing pad, or use a thin piece of scrap paper. Next, crease and bend your paper model until you have about four or five major surfaces that tilt in different directions (there will most likely be some minor surfaces, or planes, which will add additional interest). Set your model near a lamp, or some other strong light source, so that you will have some contrasts more powerful than others. This will be fairly easy to do in that the surfaces,

Preliminary experiment.

FIGURE 6.11

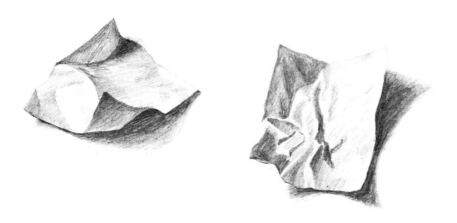

FIGURE 6.12
TINA PETROHILOS (student)
Pencil.

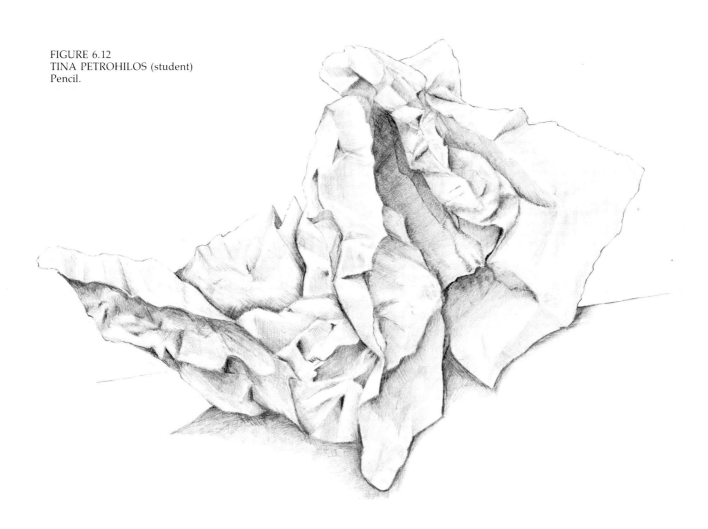

tilting in different directions, will almost automatically provide you with these variations in tone. Now you are ready to draw.

First, lightly indicate the boundaries of your form, which should be about a foot below your eye level. It will not be a flat frontal view, but seen in perspective (refer to Figure 6.11). Keep in mind that these first, few preliminary pencil indications should be very light contours outlining your large shape. Later you should indicate, in the same tentative manner, the divisions within the large shape. This should take only a few minutes.

Now proceed only with tone. Carefully look at all the surfaces in your model— which is essentially a low relief paper sculpture. Compare all the tones with each other. This is a process that brings in a high degree of tonal discrimination; you are carefully comparing one surface, one tone, with another, noting the subtle or high degree of tonal contrasts. Some surfaces may have the same tonal quality. Once you have made such visual comparisons, begin to draw in tones. It is best to begin with the darkest surface, comparing it to the lightest and those tones which are in-between, but keeping the entire form in mind as you draw.

Draw or shade in the surfaces using any technique that appeals to you. You could use parallel, crosshatch, or scribble strokes. Don't rush this study: It should take ten to twenty minutes. An example of what can be produced by this method is shown in Figure 6.11. Notice how important the cast shadow is, and how it helps to give dimension to the study. If you are not pleased with your result, adjust it by erasing or darkening portions, or simply get a fresh start. This is a valuable study that helps you to see tonal relationships in a very objective way, without trying to get a likeness, as if you were drawing a person or some familiar object. Variations of this experiment can be seen in student projects illustrated in Figures 6.12 and 6.13. It is fascinating to see how one's imagination can translate such studies into mountain ranges, rugged terrain, or the like. If you enjoy making this experiment and feel adventurous, try the next one, which is more complex.

FIGURE 6.13
FREDERICA AKINSON (student)
Pencil.

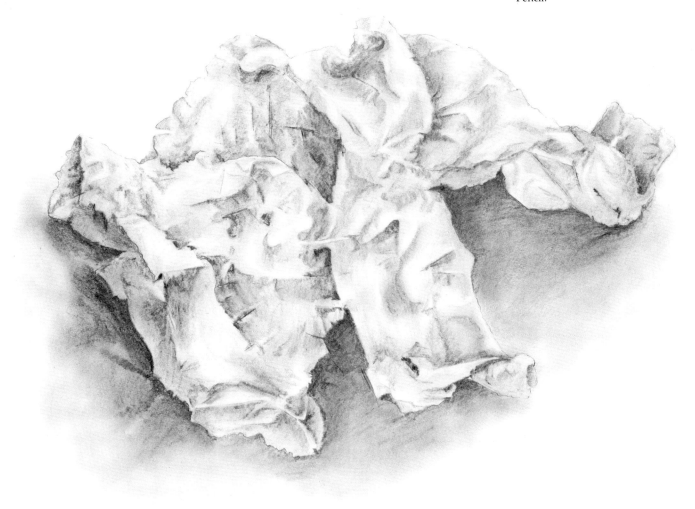

Second experiment. *Drawing an egg is considered a classical means whereby one becomes aware of the most subtle tonal changes, ranging from the very lightest (highlight) to the very darkest (sometimes called "base-tone"). There are also other tones involved (See Figure 6.14). The six tones, or values, shown in the study of an egg comprise all the necessary tones to consider in such objects as spheres, cones, and cylinders. Some objects have fewer tones, such as cubes, and rectangular forms. In all cases, the source of light determines the position and character of shadows and tonal variations. Reflected lights may vary, depending on the surfaces on which objects are placed. A lighter surface will produce a lighter reflected light than will a darker surface. Nearby objects also produce reflected light.*

Set yourself up to make a drawing of an egg. This time, try working with charcoal, taking into account the possibility of a medium-dark background, as shown in Figure 6.14. Work with a paper stomp to smudge tones to get careful tonal gradations. Use your kneaded eraser to lift off the highlight. Make your drawing about twice the size of the actual egg, to provide greater ease in getting the tonal variations. Vine charcoal is preferred to compressed charcoal for this study, since it is easier to lift off highlights and reflected lights. Observe that seldom, if ever, is the reflected light lighter than the highlight. However, sometimes an artist will reverse the process and make the reflected light stronger (lighter) than the highlight. The work of a contemporary artist, Ted Kliman, shown in Figure 6.15 A and B is an example; the result creates a kind of eerie reality, which, though unreal in nature, has a striking presence.

In addition to the importance of the "egg study," other basic forms are stressed in a classical approach. These are the cube, cone, cylinder, pyramid and sphere. Beginners are encouraged to study such forms and the way light playing over them can reveal their volumes. Figure 6.16 indicates forms that are illuminated by only one light source from the right-hand side. It is profitable for beginners to duplicate this group of objects in a practice drawing. If you have access to similar objects, set them up and make an original drawing that follows the objectives of Figure 6.16. Many teachers stress working from such simple objects because these basic forms can be found in many ordinary still life objects (glasses, boxes, bags, and the like) and because they are not intimidating, having a purity that makes the study of tone easy to understand. Later, we shall find that even the human form can be simplified into flat planes, curved planes, or a combination of the two. Artists who are concerned with a sense of structure realize how important it is (especially in their early studies) to be able to break down complex forms into simple flat and curved planes. Also, many accomplished artists who work with the figure believe that structure (here referring to flat

FIGURE 6.14

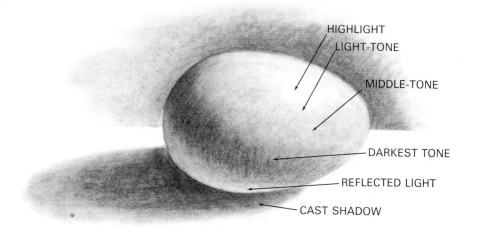

HIGHLIGHT
LIGHT-TONE
MIDDLE-TONE
DARKEST TONE
REFLECTED LIGHT
CAST SHADOW

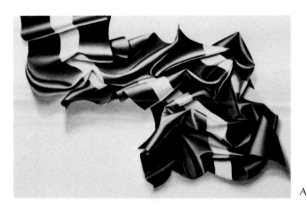

FIGURE 6.15A
TED KLIMAN
Configuration #1 (1983)
Oil on canvas. 35 × 56 in.
Courtesy of the artist.

A

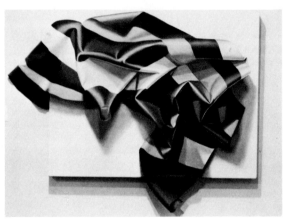

FIGURE 6.15B
TED KLIMAN
Flap Configuration #1 (1983)
Oil on canvas. 30 × 36 in.
Courtesy of the artist.

B

FIGURE 6.16

FIGURE 6.17

FIGURE 6.18

and curved planes) should precede actual anatomical studies, since bone structures and musculature can be extremely complex forms to draw.

It is important at this point to make reference to objects of different tonalities. When you are making the tonal studies in this section, you will *not* be considering the inherent differences of tone that each object may have. For instance, the egg you will draw is basically very light (perhaps white), whereas a cup or a vase may be blue, brown, or a color that has a darker tonality. Our concern is with how light affects all forms, whether or not they are light or dark. For the sake of our tonal work in this section, we are assuming that all objects are of the same tonality (white, or very light). Although this is somewhat of an artificial distinction, it is helpful at this stage. Later, with more experience and sophistication, it will be easier to consider basic tonal differences in objects, as well as how they are affected by light and shade.

Since a good grasp of tone or value is important to the artist at an early stage, the following additional studies are suggested, especially for the beginner. They will provide experience in applying mediums and surfaces introduced in Chapter 4 to actual drawing situations.

Study 1. *Arrange your objects as shown in Figure 6.2. Notice how many of them relate to the basic forms of the sphere, cylinder, cone, and cube. This time you will work with a B grade pencil for simplified, direct, and bold tonal qualities. Use your drawing pad or a sheet of drawing paper. Before you begin to draw, make sure that you arrange strong lighting from the upper left-hand direction. This drawing can be about 12" × 15". After lightly indicating all objects in a rapid, gestural manner, indicate tones, searching out a tonal pattern that will unify the entire composition. Limit yourself to two basic tones: a middle tone and a dark tone. Establish the middle tone first, then add the dark tone. Contours of objects can be indicated by a middle tone line. Figure 6.17 indicates the nature of this study.*

Study 2. *Rearrange the same objects to produce another composition. This time work with a sheet of colored pastel paper, with black and white conté crayon (grade B charcoal pencil and white chalk may be substituted). If possible, select a medium-toned colored paper, so that it will serve as the basic gray tone of all objects drawn. Lighter tones can be achieved by means of the white conté crayon; darker tones by the black conté crayon. Use parallel, crosshatch or some other strokes to produce tones that are lighter or darker than your basic middle tone (the paper). This is an interesting adaptation of previous work with conté crayon, where the white of the paper itself served as the lightest tone of the drawing. Here, the application of white crayon establishes lighter tones. An example of this approach is provided in Figure 6.18. Notice how important it is to have a strong light source for maximum tonal contrasts, and how the tone of the paper provides essential middle tones for the objects.*

Study 3. *This time your concern will be mainly with drapery. Use a B grade or medium soft lead pencil for richness of tones. Again use a sheet of paper or your drawing pad. Drapery is fascinating to study because of its forms, textures, tonal patterns, and sometimes unusual configurations. Many outstanding artists have featured it for its expressive possibilities in still life compositions. Also, it is of critical significance in depicting the action of the human figure; folds and patterns in clothing can emphasize essential activity and motion, as we shall note when dealing with the figure in a later section.*

Arrange a still life so that a few objects take up only a minor portion of the composition, the remaining portion being devoted to drapery. If the drapery seems uninteresting, try pulling a section or two upward, holding such areas by means of objects in the upper portion. When you have achieved an interesting arrangement of folds in the drapery, sketch in the large compositional elements in such a manner that everything is lightly indicated by a simple form and action lines. A basic, gestural approach is best. Working

FIGURE 6.19

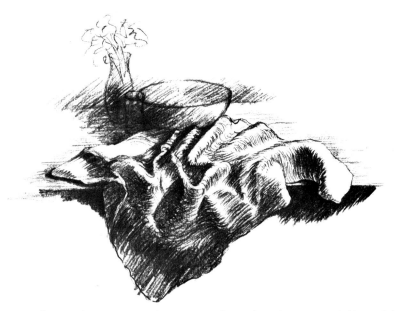

with gesture has made you aware that you need not draw in every wrinkle and fold of cloth. Getting some indication of major surfaces (planes) is what is essential, as well as the directions they take.

Look for areas that suggest major surfaces. With attentive observation, you can simplify complex forms into such simple formations as top planes, side planes, and under-surfaces. Refer to your previous work with "paper sculpture" if you have difficulty with this simplification process.

After finishing the preliminary work described above, begin to work in tone, searching out parallel and near-parallel surfaces that seem to have the same tone. This will ensure you of consistency of tonal effects. Your light source is a critical consideration; one solution is shown in Figure 6.19, while Figure 6.20 is the work of a contemporary artist. In the latter, the drapery of sheets and pillows dominates the pictorial space, opposed in the left hand area by a newspaper and some envelopes. Although the work is a watercolor, the broad tonal patterns and suggestions of folds lend themselves to pencil or charcoal drawing. You may wish to set up something similar as a drawing subject, utilizing ordinary objects in your environment. If you work large the drawing may take up to twenty-five minutes or longer. A small "thumb nail" sketch would provide good preliminary com-positional preparation.

Optional studies of drapery. *A good way to learn more about drawing drapery is to work with a single piece of cloth, arranged in different positions for different drawings. A piece of white sheet, approximately 3' × 3', would be suitable. Tack the sheet onto a wall (or some other supporting surface) to create interesting folds. Make a drawing, then change the position of the tacks, or add a tack or two, to create a different set of folds. Make at least three drawings, using different materials. Spend from ten to thirty minutes on each drawing.*

The drapery study by Federico Barocci in Figure 6.21 is a bold charcoal study in which some portions have been left rather sketchy, while other portions have been more completely developed. White chalk has been used to pull out some of the lighter areas against the ochre-toned paper. Artists often make such studies in preparation for larger, more complex works.

The student work in Figure 6.22 indicates the importance of drapery in a still life. This charcoal study reveals sensitivity to textures and precision in drawing.

In this section, our consideration of tone has been restricted to still life. The beginner should make additional studies of a more personal nature that will build upon what has been offered. How light affects objects of different textures and forms is a fascinating and rewarding study.

The following sections on nature, seascape, and cityscape provide further applications of both line and tone.

FIGURE 6.20
POLLY KRAFT
Village Voice Under Mail (1981)
Watercolor. 29½ × 42¼ in.
Collection of the Corcoran Gallery of Art, Museum
purchase with funds from Centro Corporation.

FIGURE 6.21 (below)
FEDERICO BAROCCI (1526–1612)
Drapery Studies
Charcoal and white chalk on stained
ochre paper. 10⅞ × 16½ in.
Medieval Institute, University of Notre Dame.
Reproduced by permission.

FIGURE 6.22 (overleaf)
TINA PETROHILOS (student)
Charcoal.

7

NATURE, SEASCAPE, AND CITYSCAPE

Nature is a broad term which means different things to different individuals—a landscape, a tree, plants and shrubbery, or the sky and seas. Like still life, nature has been a favorite subject for artists through the ages. The closeness of humans to nature and their reliance on it has made it integral to our way of life. Even in large cities where concrete structures dominate, we rely on public parks and recreational areas to "get back to nature" during leisure hours.

In this section, we shall be concerned with some basic ways of representing nature. We shall consider landscape and some of its most common elements. The value of both quick sketching and long studies will be emphasized. The use of photographic references and compositional devices will be discussed. However, a more advanced emphasis on expressive possibilities and heightened perceptions of nature will be touched upon in some special drawing problems in Chapter 9.

Landscape

The beginner may be confused when facing a landscape, since there is so much to see. It is necessary to develop a selective focus so that one may deal with *only* the broad elements at the outset, putting details aside for later, as in our previous study of still life. Let us consider several landscape approaches in which some portions are dominant and others are subordinate.

Before beginning to work, mention should be made about working

FIGURE 7.1

outdoors, as opposed to working in the studio. For students who have automobiles, problems will be lessened by having a "portable studio." Those who lack automobiles will have to be more selective in the choice and number of materials. A sketchbook or light drawing board with clips or push pins to hold down paper, a few selected drawing materials easily contained in a kit or paper bag, perhaps sun glasses, and proper clothing for the weather are the essentials. The time of day is significant, since light will affect your subject matter in different ways determining certain expressive aspects.

A device that many beginners find useful in working from nature (which could be applied to still life and other subject matter, as well) is a *viewing frame*, made from a thin sheet of cardboard or stiff paper (shown in Figure 7.1). This will help you to establish your general composition and will be a great aid in screening out unwanted portions of the landscape that might otherwise distract your attention. As your senses of selectivity and attention develop further, you will not need this viewer.

Study 1. *This is a study you can make at any time of day. Find a landscape that you can view from a considerable distance, containing distant trees and sky. Work with a soft pencil (B) or vine charcoal. The medium should permit a broad treatment in which masses are established and details are eliminated.*

Hold your viewer up so that you will frame a composition that emphasizes the sky and minimizes the landscape. The sky should take up at least two thirds of the horizontal space. Study the scene, using the viewer, until you have a good sense of what you will draw. Then roughly indicate the general picture plane on your paper. Since the drawing need not be very large—perhaps one half of a sheet of paper—spend only ten minutes or so making the drawing, using the following procedure:

First, study the general shapes of cloud patterns and distant trees. Look for essential tonal differences that relate to aerial perspective, as discussed in Chapter 6. Select only a few general tonal differences, perhaps three or four in the entire scene. There may be many more; simplify and edit. You are looking for general tonal patterns and shapes, both positive and negative. After you have simplified the scene in the manner described, establish general divisions on your paper. These should indicate major portions of sky and terrain. If it is a windy day, the clouds will most likely change as you draw, so indicate an existing formation, framing it in your imagination. Get the gesture of all forms drawn as quickly as possible. Then look for those few differences in tone and indicate them as simply and as broadly as you can. Figure 7.2 provides an example of this approach.

FIGURE 7.2

Since this will be your first landscape drawing, you may wish to repeat the procedure on the other half of your paper, being even more critical of shapes and general tonal patterns. Keep in mind that your aim is to simplify all that you see into large patterns of a few tones.

Study 2.

The second study may also be made at any time of day. It will reinforce the first study by purposefully establishing the tonal depth levels found in the scene. Use the same materials. You may change your composition by having some portions in the foreground, some in the midground, and some in the background (horizon and sky elements). This will allow a definite application of aerial perspective.

Refer to Figure 7.3 before you begin. Notice how the tree, the fence, and a portion of the foreground are rendered with the darkest tone. These are basically on the same plane, closest to the observer (foreground). Next, there is a field which forms the next plane (midground); it is treated with the midground tone. The barn and a few trees comprise a third plane, and since it is farther back it is treated in a lighter tone. Finally, some distant trees in the background form a fourth plane and are treated with a tone that is lighter than the third plane. The sky may be left white, or some faint suggestions of clouds may be made with a correspondingly lighter tone.

Keep in mind that this study is based on the concept of aerial perspective, which is based on the relationship of intervening layers of air—the farther back, the less transparent the air becomes, so that objects and forms become less distinct. Your scene may not conform strictly to the concept, nor to the example provided in Figure 7.3. However, it is the prerogative of the artist to impose aerial perspective to create a more convincing quality of depth.

Study 3.

This study is a departure from the aerial perspective concept, and represents only one of many possibilities. Change your composition. Go to a new site if there are no objects or forms in the foreground that can be treated in a light tone. If you are in the country, it should not be too difficult to locate a house, barn, or some structure that can be seen as a light mass or surface in back of which darker forms exist—trees or hills, perhaps. Figure 7.4 is an example of a composition with a foreground element that is lighter than the background forms (planes). It is also possible to view a tree, or portions of it, so as to see it as basically a light mass against darker tones. A walkway, gravel road, terraced terrain—any of these could be treated in lighter tones, though they are in the foreground. An example of such a composition is provided in Figure 7.5. After studying the example, determine your composition, using pencil or vine charcoal, sketching in general masses. Work simply and boldly, concentrating on tonal areas without becoming involved with details.

FIGURE 7.3

FIGURE 7.4

FIGURE 7.5

FIGURE 7.6
ANDREW WYETH
November Field, Chadds Ford (CA. 1940–45)
Dry brush. 14⁹/₁₆ × 20¹³/₁₆ in.
Collection of the Corcoran Gallery of Art, bequest of Mrs. David Edward Finley.

Figures 7.6 and 7.7 are examples of the work of artists who have utilized landscape in highly personal and interesting ways. You may wish to make studies of them to understand the technique and handling of the medium. It is helpful to the beginner to make studies of other artists' work using materials different than those used by the original artist. This transposition of materials makes demands on the student that stimulate creative adaptation.

Study 4. *As in your first study, your composition should be one in which the sky dominates and the terrain is minimized. Use your viewer to frame the composition. The medium for this study can be pen and ink, stick and ink, or some other improvised tool and ink. Your sketch pad should have a relatively smooth surface. Plan to make four to six small studies on the same piece of paper.*

Your objective here is similar to that in the first study: simplicity; directness; the use of only a few essential values; attention to broad masses (planes); and no attention to details. Get a vigorous start, using the gesture approach. Mass in all areas with appropriate tonalities. Do this in just five minutes. If you don't finish the work in approximately five minutes, go on to the next study. After you work on all of the studies that follow, you may wish to go back and finish one or two. However, keep in mind that more benefit can be derived by capturing the essence of the scene quickly, than by overworking it. Your handling of the drawing tool is up to you.

FIGURE 7.7
IAN HORNAK
Sandbank and Tree (1970)
Pen and ink. 30¼ × 22½ in.
*Collection of the Corcoran Gallery of Art, gift
of Dr. and Mrs. Jacob J. Weinstein.*

Study 5. *Develop another compositional study in which your objectives will be related to aerial perspective. This should be done on the same sheet of paper, using pen (or improvised tool) and ink. Try to indicate at least four different tonalities to represent four different planes. Begin with the darkest area and work toward the lightest. Work vigorously, as before, using any technique that appeals to you. Limit this study to five minutes, also.*

Study 6. *Develop another composition on the same sheet of paper that will have one or two light foreground forms. This time, work with ink and wash, in any manner; your objectives should be related to what you have been doing in all previous studies. Though the foreground forms should be light, other areas of the composition should have varying tonalities to establish different depth levels and simplified tonal patterns. This drawing should be done in five minutes or less, since the use of wash is less time-consuming.*

Additional Studies. *In these studies, use any combination of pencil, ink, wash, and watercolor. Stress simplicity, tonal patterns, spatial depth (aerial perspective), directness, and a vigorous approach. These studies have no time limits. You may do compositional variations based on all previous work, or repeat a previous composition using a different medium. Examples of student work in Figures 7.8, 7.9, and 7.10 show imaginative, personal applications of these studies.*

FIGURE 7.8
JUDY HARNE (student)
Pencil and watercolor.

FIGURE 7.9
SUSAN HICKERSON (student)
Pencil and watercolor.

FIGURE 7.10
SHAFER TWINE (student)
Small study: Pencil.
Large study: Pencil and watercolor.

Composition

In the preceding section on landscape, very little was said about composition (how things are arranged within the picture plane). However, the various examples provided with those studies indicated compositional possibilities with specific objectives in mind; certain areas or portions of the composition were stressed to achieve certain results. They barely touched upon the many possibilities of pictorial organization that were considered more fully in Chapter 5. It would be profitable to review that chapter, relating some of the types of organization of pictorial forces that bear upon the study of landscape. For instance, the placement of trees or other forms in the foreground areas should be considered as shapes in themselves, which create tensions with the picture plane and with other, lesser forms in the composition.

The viewer is helpful in framing a composition, yet one often has to edit what is framed. It might, for example, be more effective to shift an image closer to another, or to regroup several forms to create a stronger composition. Figure 7.11 shows some compositional changes which improve upon what is found in the viewer.

FIGURE 7.11

Viewer shows this ↑

Compositional changes result in this ↓

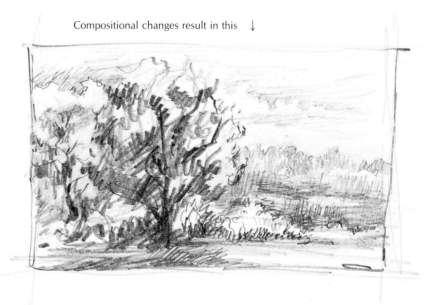

FIGURE 7.12

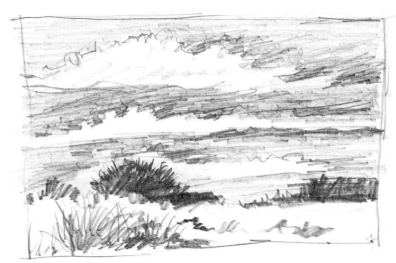

↑ Viewer shows clouds in ↓ Clouds have been placed for more
uninteresting manner. effective compositional quality, creating
 movement and *interaction* with
 landscape.

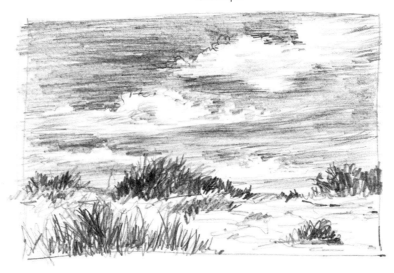

Tonal patterns have a strong influence in creating directional move-
ments. For example, in drawing clouds which dominate yet relate to the
landscape below, it might be better to select a particular formation (or invent
one) that strengthens the allover effect by creating movement. Figure 7.12
provides an example of this kind of selection, or invention.

Sometimes it is difficult for the beginner to accept that a drawing has
to be *structured* and not left to chance. An analytical approach (left brain
mode) is necessary in certain situations, where the learned material becomes
a part of one's expressive work (right brain mode). As we shall consider
more fully in Chapter 10, all of one's learning becomes integrated into a
precise, personal idiom, as individual as one's own handwriting, manner of
speech, or tone of voice.

It may be that there are no absolute rules for composition. Yet, some
forms of pictorial composition are better than others. All serve some pur-
pose, and the student should become familiar with various modes of com-
posing material within the picture plane. Preliminary studies, often called
"thumb nail sketches," are important before beginning a long study (or any
study, for that matter) that is meant to be a final statement. By making

several thumb nail sketches—each of which need not take more than a minute or two—the student can review several possibilities for pictorial composition, and may discover that one proves better than all the rest. It is possible to change scale, position, tonalities, patterns of tone, and other essentials in a few minutes in thumb nail form. In this manner, one will be more likely to have a stronger conviction of how to pursue a final study— and the chances for success are far greater.

Studying the work of artists whom you admire, or whose work moves you in some special way, can also be profitable, especially if you know what their *intent* is. Then you will more greatly appreciate how they have orchestrated their elements of composition to produce the results they wished to achieve.

Long Studies

Most of our work so far has stressed a rapid approach typical of short studies in which gesture and broad tonal areas are achieved as quickly as possible. This rapid approach is essential for the beginner, so that the totality of a scene or situation is captured as quickly as possible. This holistic approach is also critical for a long study. After all, a long study is a quick sketch that has undergone a more highly articulated development. The quick sketch is a visual shorthand, in which all of the meaningful elements have been telescoped into a few necessary essentials; it can be compared to a broad outline for a paper or book. The long study is built upon those essentials that should be captured within the first few critical minutes of the work.

Memory plays a critical part in the entire drawing process. When we "look" and then draw, we are actually memorizing what we see, bit by bit, and then putting such memory fragments on paper. This overly analytical, bit-by-bit process has many limitations: proportions can go off, parts may not seem convincingly related to the whole, or the entire work may take on a stiff, "dead" quality.

Instead of the bit-by-bit method, we have emphasized the concept of gesture. In this approach, the totality comes first—how the thing appears, what its action is, what it is all about, what it is trying to tell us. These are prime factors to grasp so that we may convincingly pass on the message in our art to others. Therefore, holistic memory is to be encouraged at every opportunity.

We all have holistic memory, but we must use it frequently in order for it to become an important working tool. Go back to some of your previous studies in this section, study them intently for a few minutes, then attempt to reproduce them from memory alone. You can glance at your original work from time to time, if necessary, but, if possible, try to eliminate those brief glances altogether. After making a drawing from memory, compare it with the original one. You may be surprised to find that your drawing from memory is superior to the one you made from life. I have found that many students using this method have been delighted with the superior results they have achieved. You can do it too, with practice.

The long study, then, is built upon a successful, general suggestion of the entire situation. Details emerge out of the generalized pattern, like a form emerging out of the mist; the closer it gets to you, the more you can see, although at first you can only see the bare outlines of form and mass. Let your long studies develop in the same way. Begin by spending only a few minutes establishing the foggy image, then devote approximately twenty-

five minutes to eliminating the fog by making your subject more detailed. Add some leaves, twigs, or other details that characterize your subject. Try to get the feel of textures, but only after you have indicated the general middle tone. Indicate the gritty quality of a gravel road, or the hard, uneven surfaces of stones and rocks. Empathize with these elements, much as an actor feels and experiences the role he or she is to play. *Become* what you are drawing, at least for the moment, and it will take on a special kind of reality, for you are recreating it within yourself.

Rather than plan a series of long studies for you, I suggest that you develop your own, using the considerations presented in the preceding pages. Set your own time limits, and use materials that appeal to you. Since you have now explored several drawing materials, you should have some preferences.

FIGURE 7.13
PETER BRUEGEL THE ELDER (CA. 1525–1659)
Landscape with a Mill and Two Walking Men (CA. 1552)
Pen and ink on brown paper. 8¼ × 10¹⁵⁄₁₆ in.
Medieval Institute, University of Notre Dame. Reproduced by permission.

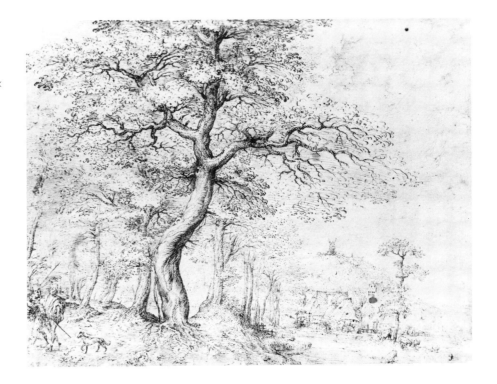

Figure 7.13 is an excellent example of the work of Peter Bruegel the Elder. Notice how this sustained pen and ink study maintains the freshness of a quick sketch, for instance, how the background has a tentative quality, establishing the general character and setting for the entire work. The figure and dogs in the lower left are somewhat detailed, but the major emphasis in the work is devoted to the large, majestic tree that dominates the composition. One can sense the texture of the bark, the evolution of larger branches, and the reaching out of the smaller branches and twigs. Thus, the detailed portions (the long study areas) are like extended gesture drawings. Study this work and others of a similar nature, and then develop some long studies of your own. Set up a schedule of work, lasting perhaps, for several days, in which your concern will be to work from a gestural, sketchy drawing into a fuller, more sustained study. If you are working alone, it is a good idea to make a short tape of half an hour or so, and analyze what you have done *after* you have done it. If you are working with a group (classroom situation, or otherwise), plan a discussion session of an hour or so (this, too, could be taped), in which the purpose is for each

person to explain how his or her work developed from its initial stages to the final, finished stage. It is helpful, especially in a group situation, to express any difficulties encountered. By this method, much can be learned from others. Faults, weaknesses, and mistakes are as valuable to discuss as successful achievements. I believe that the old cliché "we learn more from our mistakes than from our achievements" is true. We profit greatly by the verbalization process; by talking about what we have done *after* it has been done, we are using a left brain mode—a linear cognitive function which brings into focus some of the nebulous character of the creative process.

Photographic References

The use of photographs for drawing references has been discussed in Chapter 3; however, it deserves additional consideration in the present context and in relationship to our preceding examination of composition, long studies, memory, and group discussions.

Some purists object to the use of photographs as aids in the drawing process. They believe that life itself should provide the basis from which the artist makes departures and gets inspiration and subject matter. Let us consider some of the pros and cons concerning the use of photographs.

First, it is not always possible to work directly from nature if the weather is inclement.

Second, capturing the time of day, or the fleeting moment (moving clouds, crashing surf, brilliant sunlight on a patch of shrubbery) can be rather difficult for the beginner, and even for some seasoned artists, unless one's memory is developed to a heightened degree. The camera can be a valuable tool to help remind us exactly how the scene or object appeared at a particular moment which stirred us.

Your photograph will contain much more material than you need. This can produce a negative result unless you carefully edit. But nature is also like that; there is always too much there and one must edit, rather than slavishly copy all that one sees. So we are back to the problem of selectivity, whether we work from nature or from a photograph. However, a photograph is an item that we can keep, to refer to as needs dictate.

A photograph reproduces all the tones in a scene, if one uses the correct film and makes the appropriate camera settings. One can see complete tonal relationships in a vast scene very quickly, thus aiding the selective process and the easy recognition of broad relationships. Further, all this is reduced to the two-dimensional surface, which is also one of the prime objectives of the artist in making a drawing—to translate what is out there onto the flat surface of drawing paper. This also permits one to study positive forms (actual objects) in relationship to negative spaces (the sky and open areas around forms). This sensing of space and form, positive and negative, is right brain-oriented. One is making preliminary assessments with one's "mental ruler." This valuable process helps one to develop a much-needed faculty in the production of art, which is not mathematical or linear in quality but a holographic experience in which actual forms are sensed in terms of the spaces in which they exist.

Finally, since the artist tends to think in mental pictures, a photograph is quite like what the mind, itself, produces and not at all detrimental to the creative process. However, the beginner is cautioned to use a photograph only as an aid, not an end in itself. What you produce as a drawing is what counts, whether you work from nature or from a photograph.

Working from photographs that you have taken is better than working from the photographs of others, because one tends to have more insight into and empathy with what one knows by direct experience. Photographs that supplement quick sketches made on the spot can be extremely useful tools.

The beginner must cope with many forms found in nature: plants, shrubbery, trees, land, water, sky, and some man-made forms. Individual studies will be suggested to supplement the general landscape studies in the preceding portion. Such studies, which may be complete in themselves, will also serve to indicate how such forms can be treated for emphasis in the broader, landscape context.

Plants and Shrubbery

Greenery may comprise a good portion of a landscape study, and it is necessary to have an understanding of how such forms can be represented. When working with plants and shrubbery, the beginner tends to draw every leaf, every branch, —every detail—that is evident. This can be a tedious process that ends in a totally analytic and dead performance. Instead, one should utilize gesture drawing to capture the essence. Look for overall movements and masses first. You may wish to review Chapter 3, and we will also look at some examples before beginning to work.

Figure 7.14 represents a small plant. The first few indications of the drawing suggest *how* the plant is growing, how its stems and leaves are first seen as growth movements and then as shapes and masses. Gesture drawing and blocking in of masses are essential. After these have been established, some leaves are drawn completely, while others are partly drawn, or merely suggested by different tonal areas. Notice how awareness of the light source brings out the various forms; what is emphasized, and what is diminished. Figure 7.14 A reveals how the basic movements and masses were first established by a "scribble" technique, which is the basis for Figure 7.14 B.

Study 1. *Select a subject similar to the examples in Figure 7.14. Work with a grade B pencil, charcoal pencil, or conté crayon. Use a sketchbook or single sheet of paper, allowing for three to five drawings on a single sheet. These should fit comfortably on the paper, and should be larger than thumbnail sketches. Make several scribble, or similar allover gestural indications in separate areas, taking less than a minute each. Then, using the same approach, begin a study that will take about five to ten minutes. Essentials to consider: gesture, movements, masses, and tonal emphasis (be aware of your light source), bringing out some contours, while diminishing or merely suggesting others. Frame the work in your mind's eye before you begin to draw. Then, as you draw, let your eyes roam over the entire form, realizing how the parts are established within the totality. Shift your position slightly (or, if you are working from a photograph, select another portion of it), and repeat the performance in another, separate drawing. You may wish to make one or two additional drawings before moving to the next study.*

Trees

Figure 7.15, a close-up study of a portion of a tree and some foliage, indicates the importance of establishing major relationships first. The verticality of

FIGURE 7.14

"Scribble" study for longer study below.

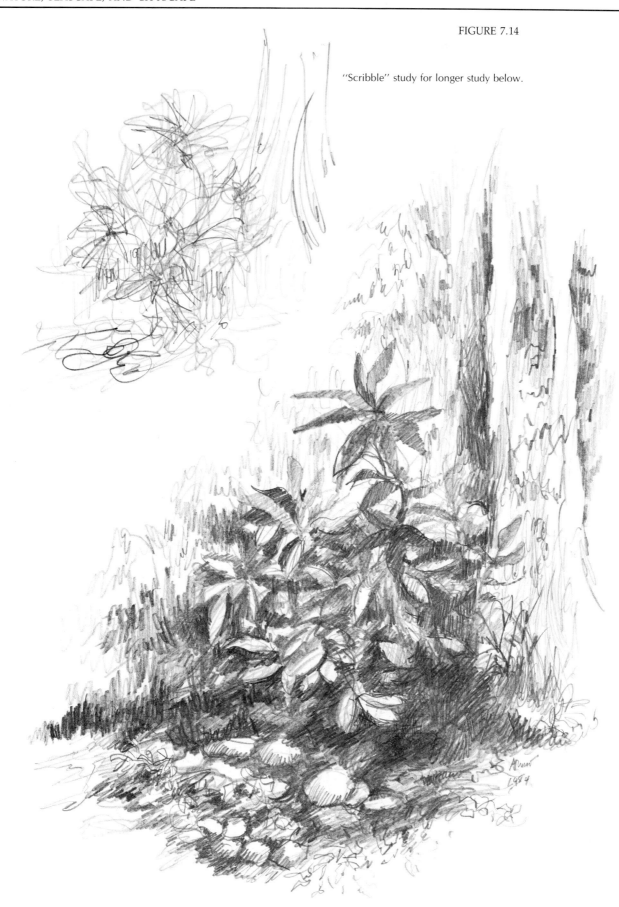

FIGURE 7.15

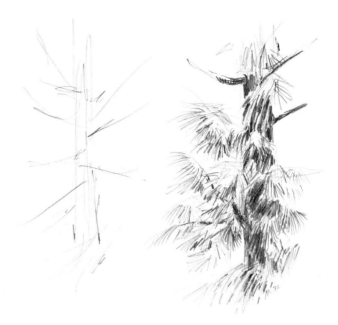

the trunk is complemented by branches which grow at angles to it. Foliage has top surfaces affected by light, and bottom surfaces affected by shade. Overlapping forms and tonal contrasts create strong form and depth relationships. Background elements have been eliminated to avoid cluttering this singular study.

Figure 7.16 is a fascinating study of a tree stump, a pen and ink drawing by the Dutch artist Jacques De Gheyn II. This carefully detailed work emphasizes the gnarled base of the tree and the plateau-like formations of the lower severed portions. Crosshatch and parallel lines establish a convincing three-dimensional presence and strongly unified massive structure. The technique employed creates the feeling of smooth-cut portions, as well as rough bark textures. The shadow cast by the stump serves to anchor it securely to the ground. Study this work and the Bruegel drawing shown earlier under *Long Studies* carefully before you begin the next exercise.

FIGURE 7.16
JACQUES DE GHEYN II (1565–1629)
Tree Stump (CA. 1600)
Pen and ink. 4½ × 8⅞ in.
Medieval Institute, University of Notre Dame.
Reproduced by permission.

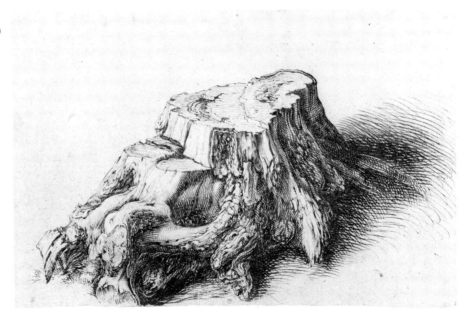

Select some trees that interest you and make some scribble gesture drawings. Suggested materials are soft lead pencil (B) or conté crayon. Use your sketchbook, or single sheets of paper that may later be placed in a pressure binder or portfolio for future reference.

Though gestural, these drawings may convey some aspects of tone in a very generalized way. Fill your first sheet of paper with such studies—about six or eight—spending no longer than two to three minutes on each. As you work, be sure that you observe the massive quality of the trees: shapes and masses affected by light and shade. Don't stop to concentrate on details that may cause you to tighten up. Instead, look at the entire mass of what you are drawing and keep your pencil moving all the time until you have completed each study.

This will be an exercise in the simplification of leaf foliage into basic three-dimensional masses. Use the same materials as in the previous work, making four drawings on a single sheet of paper. Since this study will be more analytical than the scribble approach, take about five minutes for each drawing.

(far left)
FIGURE 7.17

(left)
FIGURE 7.18

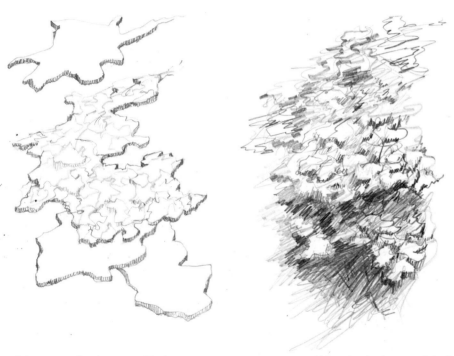

Oak leaves translated into simplified three-dimensional structures.

"Scribble" sketch of same oak leaf formation

Find two or three groupings of foliage that can be simplified into irregular, geometric masses (see Figure 7.17). First, indicate the top plane of such masses, then the shallow thickness of them. Look for overlapping formations so that you will achieve a sense of depth. Also, it is advisable to have a lighting situation in which the light source is primarily from above, either at a left or a right angle to the leaf formations. The best time of day for such studies is early to mid-morning, or between 3:00 and 5:00 P.M. If you are working from photographs, choose ones that have strongly contrasting relationships.

After doing a study from an analytical approach, make a few scribble drawings, as in Study 1, to carry you out of analysis and into a more dynamic statement of the subject matter. These may be done on the same sheet of paper or on a separate sheet. Refer to Figure 7.18.

Here, we will be making sectional drawings of a tree, using the same materials as in the previous studies. Make three or four drawings on a single sheet of paper. You may change the sequence of drawings, but be sure that you draw each kind.

FIGURE 7.19

Make a drawing which shows the lower portion of a tree, where the roots enter the ground. As before, establish gesture in a few seconds, then add contours and brief tonal indications that will convey the feeling of what the lower tree portions are doing, how they relate to each other, and how they enter the ground. Spend about five minutes on the drawing. Refer to the examples provided in Figures 7.13 and 7.16.

On another area of your paper, make a study of one or two large branches, showing how they emerge from the trunk of a tree and how they move and flow away from their points of origin. Follow the same procedure indicated above.

Make a separate drawing on another area of your paper which will indicate the upper, terminal areas of a few branches of a tree. Notice how the branches fan out, much like a flowering shrub. Follow the same procedure as indicated in the preceding study. Refer to Figure 7.19.

FIGURE 7.20
RENI COSTERIGES (student)
Ink and black spray paint on paper.

SPECIAL NOTE

All of the studies of plants and trees may be repeated, using different materials of your choice, *after* you have worked with the softer drawing materials indicated for each study. Try repeating the same drawings using pen and ink, ink and wash, and some other mixed media combinations. Also, try drawing the same subject matter from memory. See Figure 7.20, an imaginative study made with ink and black acrylic spray paint. A paper circle was used to mask out the moon shape when spray paint was applied.

Land

In drawing land, of which there is a tremendous variety, it is necessary to consider its importance in the total context of a drawing. Should it dominate, or should it be subordinate? What is its character, and how could it be best depicted? Studies made in the still life section suggested the possibility of using shallow paper forms, or "paper sculpture," to simulate various kinds of landscape terrain. While these studies can be valuable, actual terrain must be drawn in such a way as to convey its essential character.

Drawing land properly requires an understanding of its intrinsic qualities (smooth, rolling, jagged, mountainous, and so on), and how to establish simple geometric equivalents of these qualities in the process of making the drawing. The underlying structural feel must be there, and embellishments of tone and detail should enhance, not detract from, the essential structure. Careful, sensitive observation is needed to supplement drawing information that is included in the text. With personal application of such information, the student can cope with practically any landscape situation.

Figures 7.21, 7.22, and 7.23 provide examples of various types of terrain. The beginner is encouraged to make copies of these examples and then try developing original ones, adapting as needs suggest the various approaches given concerning gesture, line, tone, structure, composition, and other drawing elements and aids. It may also be helpful to study the texture of terrain. Notice how the quality of rocky, rough, smooth, flowing, and other kinds of surfaces are suggested in the figures noted above and in other examples throughout the book.

Study 1. *Review the section on the use of paper forms in drawing (under the still life section). If you have not made these studies yet, make a few now. What kind of landscape seems to be suggested, in terms of the surface qualities indicated in the manipulated paper form? What kind of terrain does it seem to indicate? Imagine the application of the result of the experiment and make a drawing of it, using any medium of your choice. Consider twenty minutes as your maximum time.*

Next, make another drawing on a separate piece of paper, preferably from nature, that resembles the first drawing. Emphasize the terrain portion, but give some indication of other components, such as sky or buildings.

Study 2. *Make a drawing that shows a completely opposite terrain than the one you developed in Study 1. Imagine what it would be like, then find such a situation, either actual, or a photograph. Spend about twenty minutes on this drawing. Use any medium you wish, but concentrate on the essentials.*

Study 3. *Imagine your ideal landscape. What kind of terrain does it have? How can you best depict such terrain in a drawing? What materials would be most suitable in developing*

FIGURE 7.21

FIGURE 7.22

FIGURE 7.23

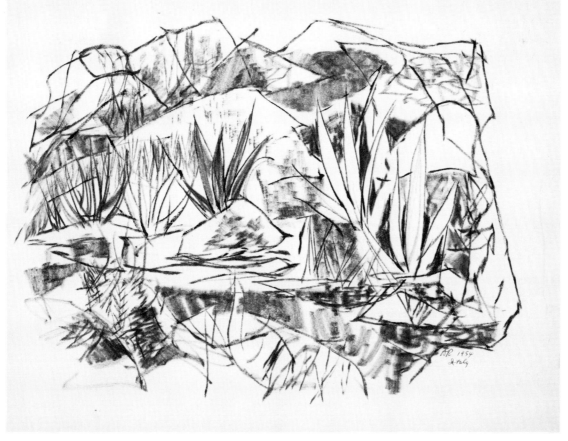

your drawing? Determine these aspects, then go to work. Spend about half an hour on this drawing, or possibly two drawings, if your first start is not up to your expectations. Spend some time visualizing your subject before you actually begin to draw, sensing what it is like (even touch the terrain in your imagination). This time you will be working from the inside to the outside, using your mental image as your reference.

Water

Water may be considered essentially a mirror which reflects its surroundings, taking on the same tonal aspects it reflects unless it is disturbed by winds or currents. It can be conceptually instructive to study small forms placed relatively at right angles to a horizontal medium-sized mirror. Try this, and study the results. Then tilt the object and notice how the image is reversed in position. When the object is tilted toward the mirror (or body of water), its reflection is *longer* than when it is tilted away from the reflecting surface. Some experiments in your studio with small objects and a mirror can be helpful in understanding phenomena that occur in nature when you are out on location. Photographs clearly convey these aspects.

Generally, tones will be somewhat lighter when they are reflected in water; the coloration of a swamp, for instance, will produce a reflected tone that lacks the clarity shown in a body of clear water, such as lakes or puddles after a rain. Intervening atmosphere, which may contain moisture, also influences the reflected forms, making them softer and blurred in outline. Height affects the length of reflected forms, too. The higher one's eye level is, the smaller the reflection will be. Water never seems to convey a perfect, undisturbed mirror image of the subjects its reflects, especially ocean water, as found in seascapes.

It is apparent that water, like terrain, has many aspects that produce countless variations. A few, essential studies of water are suggested in the following, and you may think of more variations to consider and work out on your own.

Study 1. *Try to find a location that shows the interaction of landscape with water—a pond or lake. Study the scene intently for at least five minutes and become aware of constants within the illusive patterns that form on the water's surface. Compare tones in the landscape with those that are reflected in the water. Are they lighter or darker? How long are the reflections compared to the actual forms in nature? Which reflections, or sections of reflections, seem broken or blurred? Which seem more like the objects or forms that are reflected? How can you represent the texture of water? How does that texture differ from the landscape? These are some of the questions to consider as you study your subject. Close observation may reveal other differences that you may wish to capture.*

It is recommended that you make your first few studies with an HB, B, graphite, or charcoal pencil. Work in your sketchbook, for it allows you to study your previous work and note your advancement, or problem areas that need to be corrected.

During your first work session, begin by capturing gesture of what is happening in your given situation, adding basic tones as you proceed. The first few drawings should be limited to five minutes or so.

After some preliminary work, begin a long study. Lay in general divisions of surfaces, evident movements, and any other particularly noteworthy effects (the way reeds form a curved pattern as they near the water, for instance, or the feathery formation of a clump of shrubs, seen against a darker background). Work on the long study for twenty or twenty-five minutes, taking a few minutes to look away and relax. When you return to your study you will see it with a fresh eye and notice what needs immediate attention. Figure 7.24 provides a typical example.

FIGURE 7.24

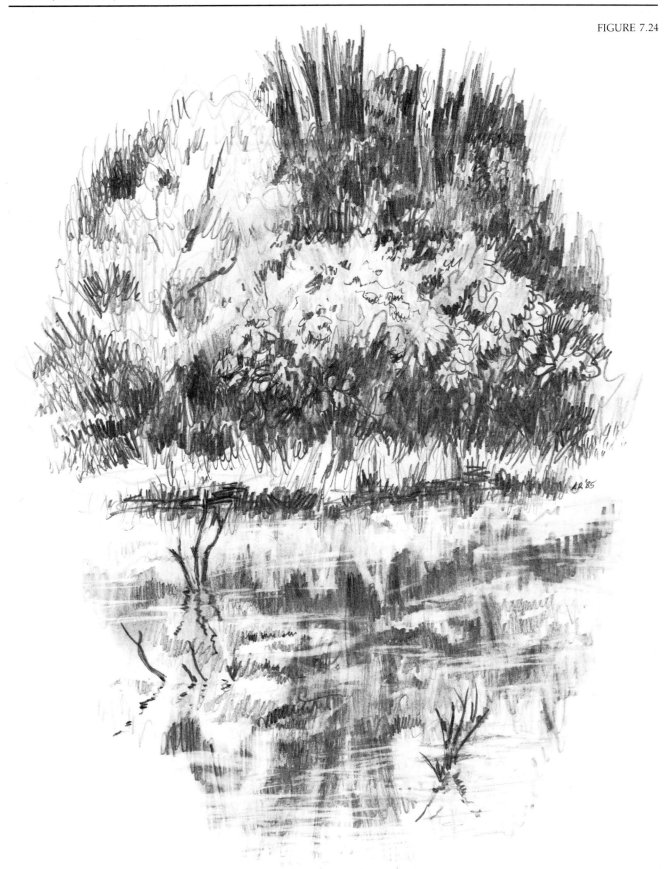

FIGURE 7.25

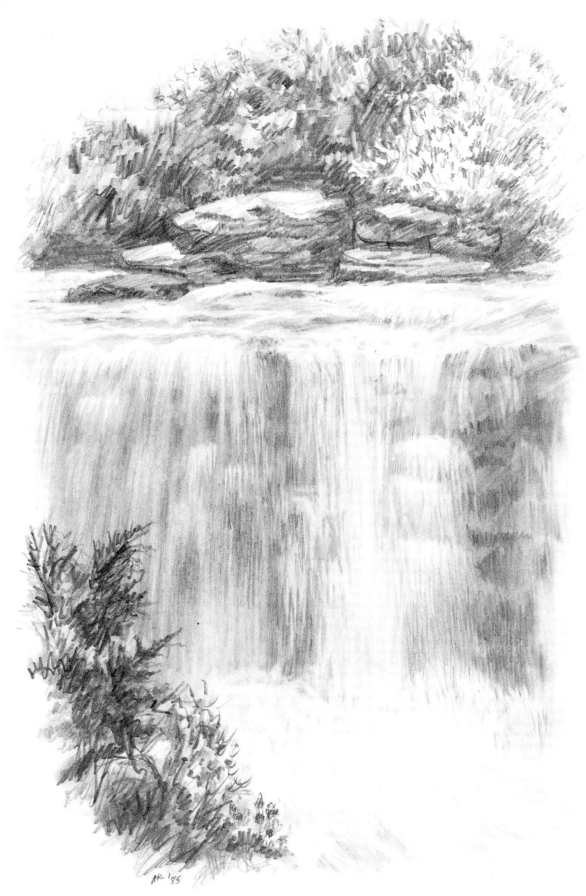

Spend a few days, or at least several work sessions of two to three hours each, to sharpen your perception of this scene. After you have learned to make generalized, broad indications of your subject matter, you will also become sensitive to what details to include, what clues are necessary to make your suggestions of reality more like reality. Don't forget that you have to suggest reality, not try to duplicate it. How you handle your materials in this regard is essential. Your earlier practice work has been a preparation for this stage.

Here, you will be concerned with making some drawings of moving water, such as streams, rivers, or waterfalls. An example is provided in Figure 7.25. Follow the same procedures as in the previous study. However, study your subject even longer, maybe eight to ten minutes before you begin to draw. Here are some observations to consider before you start to work: What characterizes the essentials in your subject? Is it movement, or pattern, or glittering light, or a staccato interaction of light and dark? Perhaps it is a combination of some or all of these. Notice what kind of shape the water makes, and how that shape relates to other shapes around it, both positive and negative. Careful, sensitive observation is the key. Some experimentation in quick studies before you prepare for a long study may be useful. Several sessions in which two or three long studies are developed are highly recommended. ***Study 2.***

Puddles or streets that are wet can be fascinating subject matter to draw. Although the subject matter is different, refer again to Figure 7.24, using it as an analogous reference. A puddle of water on a country road will take on the characteristics of its surroundings, often creating mirror-like images of small reflected sections of trees and other nearby objects. A large section of a city street can be equally fascinating in its varying subtleties of reflected portions of nearby, as well as distant, forms. Wet streets at night have interesting (often multilayered) effects created by traffic patterns, rough or slick surfaces, or other intrinsic phenomena. ***Study 3.***

Develop a variety of drawings, exploring the possibilities of puddles and wet streets available to you. Follow the procedures recommended in the two preceding studies. Observe, experiment, and explore, adding your personal insights whenever you can, thus extending the challenge to draw things you never have drawn before. Adventure and discovery are essential to the learning process.

FURTHER NOTE

A few studies have been suggested; you may find other kinds of water scenes that may interest you. You could devote a good portion of a small

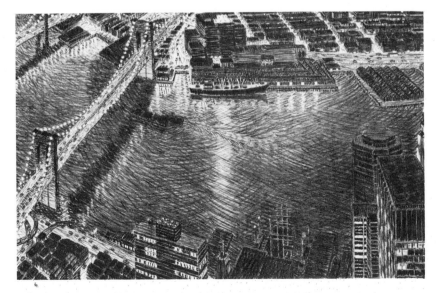

FIGURE 7.26
YVONNE JACQUETTE
East River View with Brooklyn Bridge IV
(1983)
Charcoal on cream paper. 65⅜ × 41 in.
Courtesy Brooke Alexander, Inc., New York.

sketchbook solely to this subject, going back to it for reflection and an awareness of where it has taken you artistically.

The works of such diverse artists as John Constable, Vincent Van Gogh, Rembrandt Van Rijn, and Claude Monet reveal their interest in and personal idiomatic use of water studies in a variety of situations. Figure 7.26 shows a charcoal drawing by the contemporary artist Yvonne Jacquette titled "East River View With Brooklyn Bridge IV." This work is discussed in Chapter 9. Study this example and those of other artists.

Sky

The sky, like other landscape elements, presents us with an infinite variety of possibilities. Here we cover some essential points, which incorporate both imaginary and real situations.

Elements in nature interact to produce moods or qualities that we associate with certain psychological states: A gray day is depressing; *stormy* weather suggests conflict; *dawn* suggests new beginnings; *sunset* suggests peaceful repose after a long day of work. In each of these varied situations, the sky helps to establish the required mood. The artist should know how to create these moods for full potential of expression.

The light and clarity of the sky, the shape, movement, tonality and texture of clouds—these are all important aspects that relate to the rest of the landscape and interact with it. Beginners may conceive of clouds as wispy things of an amorphous nature. However, we should think of them as three-dimensional forms, which may be wispy—or quite strong, yet constantly changing. Since they are three-dimensional, (although sometimes appearing quite flat), they can also be drawn in perspective. A cloud bank

FIGURE 7.27

that extends to the horizon or takes up a considerable portion of the sky will give the impression of forms that recede to some distant vanishing point. You do not have to draw the vanishing point, but have a *sense* of where it should be.

Clouds are affected by light, like any other three-dimensional form. Clouds usually have light tops and shadowy undersides, which may be more noticeable at a distance than when they are overhead. As the direction of the light changes, so do the light and shade portions of clouds, especially throughout the early morning and early evening.

The studies below should be made after careful observation of different cloud formations. You need not know the names of clouds, unless you wish to make a special study of them.

Study 1. *Sunrises and sunsets are usually dramatic and exciting to beginners. Using your sketchbook and soft drawing materials (a combination of charcoal pencil and soft vine charcoal is recommended for beginners), make some drawings of either a sunrise or a sunset. After you have established your main indications (gesture and simple blocking-in of masses, taking only one or two minutes), observe tonal differences within the masses. Getting the total structure of clouds is important before getting the edges, or contours, with any degree of accuracy. Look for essential movements (actually gesture), and try to frame in your imagination a particular formation, since it will likely change in a minute or two. Work rapidly, spending no more than five to ten minutes on each drawing. You should be able to judge how large the drawing will be from your previous rapid work. Refer to Figure 7.27 to remind you of essentials.*

Study 2. *Find some clouds which form a receding configuration in space. In this case, a sense of perspective is suggested by the diminution of cloud forms. Consider the essentials men-*

FIGURE 7.28

FIGURE 7.29

tioned above, and use the same materials and procedures in making your drawing. You may wish to refer to Figure 7.28 as an instructional aid.

Study 3. Try drawing clouds that indicate a storm. You don't have to wait for a stormy day. Think back to when you saw one, and try to remember how the clouds looked. Or, study a photograph, trying to project yourself into the stormy situation, sensing and feeling what it is like. Proceed as before. Figure 7.29 indicates a related example.

Additional studies. All of the studies of clouds and skies may be made using different materials—ink and wash, for example, or pencil. Consider how the strokes of pencil or pen can create the

FIGURE 7.30
Attributed to GAUDENZIO FERRARI
(1475/80–1546)
God the Father Surrounded by Music-making Angels (1535)
Brush, bistre wash, and white lead over black chalk on green paper.
17½ × 13½ in.
Medieval Institute, University of Notre Dame.
Reproduced by permission.

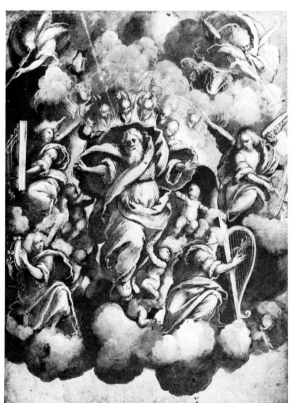

desired qualities. Make some drawings of your own invention. Do something fanciful, like a Baroque cherub flying through the clouds. It could be comical or serious, depending on your mood. Convey that mood.

Figure 7.30 is a bistre wash study, attributed to Gaudenzio Ferrari, which may stimulate an imaginative response. Study this and similar works by other artists to understand how they developed sky subjects and how they created their intended moods. Copy some, using the materials the artists used or improvised ones of your own. If you wish, spend a few days making an exhaustive study of clouds.

Man-Made Forms

It is often difficult to ignore man-made forms in nature, for they can be essential ingredients in a landscape. Beginners tend to leave out a building, a bridge, a fence, or other man-made constructions when making a landscape drawing because of difficulty in coping with such subjects. Of course, one's preferences are to be acknowledged; if you don't like the fence, leave it out. But it may work well if there are cows in the background. Use your judgment. The following studies indicate how to think of some man-made structures and how to draw them. You should review the section on perspective to fortify the essentials.

Study 1.

One of the most basic factors in drawing a man-made form in nature is the importance you wish to assign it. If it is to dominate the scene, it should take up a large portion of the picture plane. Find a scene, perhaps a bridge in a park, as shown in Figure 7.31. Note how a dramatic treatment of the bridge has been achieved. It dominates the space of the picture plane. It is centered in the composition. It is more strongly treated in tonal contrast than other forms. The eye level is low, creating dynamic convergence to the structure, thus indicating more importance from the very conception of the drawing (the first few indications should suggest the dramatic perspective approach). Background material merely supplements the protagonist, adding supportive suggestions of the setting.

Make your drawing using pencil or charcoal, and follow the procedures outlined for preparation (a few simple gestural studies) in previous work. Lightly establish all main forms, movements, proportions, and other basic essentials before you make your study more definitive. Make a long study of twenty or thirty minutes.

Study 2.

We will now reverse roles. The bridge, or other structure, will provide a subject of interest within the larger context of the scene, but will not be as dominant. It will add local color as part of the total environment. Sky and terrain will take up most of the picture plane. Refer to Figure 7.32 for additional clarity.

The illustration shows the same bridge viewed from a different position in which the perspective is more casual and less dramatic. It is not centered and is greatly reduced in scale, compared to the first illustration. The tonal treatment, though strong, becomes a part of a total tonal pattern. Your eye can move easily from the bridge to other elements, some of which have equal interest. The eye level, also, is not as low as in the previous work, so convergence of the bridge is minimized.

Select similar or related subject matter for your drawing, and work with the same materials as before. Assume the same distant view and a similar perspective. Approach the drawing in the same, searching manner, being aware of the new kind of orchestration you will create. The long study portion of the work should take about half an hour.

Additional studies may be made of the same or related subject matter using different mediums. Figures 7.33 and 7.34 parallel the bridge example, providing a dominance of man-made structures in the former, and a subordinate role for the same forms in the latter. Figures 7.35 and 7.36 show additional examples done by a student. Seek out others and study them. A program of several days of work or two to four sessions is strongly recommended.

FIGURE 7.31

Two views of covered bridge showing completely different perspectives and different emphasis.

FIGURE 7.32

FIGURE 7.33

Two different perspectives and different
views of Main Beach in East Hampton,
Long Island, New York.

FIGURE 7.34

FIGURE 7.35
JENNIFER MANLEY (student)
Pencil and watercolor.

FIGURE 7.36
JENNIFER MANLEY (student)
Pencil and watercolor.

Seascape

The seascape can be a totally absorbing subject area for an artist, since it conveys so many different moods. It is an intensely expressive vehicle. Drawing a seascape is challenging work. How can one capture the quality of a breaking wave? How can one convey the rhythmic pattern of wave formations, or the froth and spray of a crashing surf? Bright sunlight spar- kling over an early morning sea can be breathtaking, but how can one draw it? How depict the quality and texture of wetness in motion? Here we can only begin to learn how to think of the sea in basic pictorial terms.

When the sea is calm and viewed from a distance, it is unlike the mirror association we made when we studied water. The ocean's vast expansive- ness makes that analogy impossible and useless. Intervening atmosphere, wind patterns and water currents, sky that is in a state of transformation, and similar elusive elements create a continually changing and complex subject. Therefore, we must *look for* constants in the ever-changing material we wish to capture. Once we have identified these, we may discover how they provide important clues in the drawing process.

A passive sea, extending for miles, presents a restful situation. Its horizontality suggests stability and repose. It is relatively uncomplicated. Perhaps distant winds create changing, subtle, textural patterns that are not abrasive. This simple, planar surface can be drawn with ease. However, to make it convincing, we must pay close attention to how distant portions, at times, almost blend in with the sky. Other portions may have gentle transitional contrasts, almost imperceptible at first glance, until one views the scene with a slow but emcompassing vision that covers all that can be seen in the far distant horizon. This marvelous transition, with its subtleties and gentle tonal variations, can provide great interest if the artist's temper- ament is in tune with it. Figure 7.37 shows a passive sea vista. However, most beginners will be attracted to a more active situation, such as a sunrise or sunset, that provides much drama, mostly of texture and tonal interest. The sea interacting with the sky can make a fascinating study. Although the sea is still considered to be basically one horizontal plane, its surface takes on interest by the tonal patterns that result from the sun piercing the clouds, its rays playing over the water's surface in counterpoint to the shad- ows created by the clouds. Figure 7.38 suggests such a situation. The sun's brilliance is indicated by the paper itself. Surrounding tones create a feeling of light coming from behind. The far distant light source also makes the clouds near the horizon appear darker in character, adding to the dramatic quality of the event. Careful study of the illustration will indicate how the simple use of tones, which were applied at the outset of the work, become further articulated by additional tones that indicate minor changes within the broader surfaces. The white of the paper plays an important part in highlighting areas of the water, as it did to suggest the brilliance of the sun. Study this illustration and compare it with your memory images.

A less panoramic view, but one that still incorporates distant sky and sea, is illustrated in Figure 7.39. Here a midground jetty is prominent in the composition, with some small wave formations adding interest. The darker tones of the jetty, with its clinging seaweed and weathered surfaces, provide a horizontal passage that is interrupted here and there with the spray of small waves and salty mist. The sand at the shore has darker areas caused by the wetness of receding waves. Movements of clouds supplement the more active quality of the surf. Do you recall similar images from your own experience? Consider and compare.

FIGURE 7.37

FIGURE 7.38

FIGURE 7.39

FIGURE 7.40

FIGURE 7.41

The jetty scene provides new components. Let us examine some of the most important. First of all, we are aware that we can distinguish many planes, or surfaces, in contrast to the primary, singular plane of the two preceding illustrations. The rocky surfaces are multifaceted, and are affected by the light source from above (recall the paper experiment). Though basically darker than other elements in the composition, there are several tones that help to create the sense of volume and texture evident in the rocky formation. These, however, are highly simplified, with only minor tonal changes. Distance and the need for unification of the mass are important reasons for such simplification.

Waves and swells of water may also be considered as three-dimensional forms. Like clouds, they can change in a moment. Therefore, it is necessary to frame the impression of such forms in the mind's eye as quickly as possible.

Drawing waves from a direct frontal view is more difficult than drawing them from other views, because a direct frontal view is indicative of a large, curved frontal plane (once the action of the wave itself has been simplified). A side view conveys more dimensionality; one can more easily detect a side plane, top plane, and foreshortened frontal plane. Figures 7.40 and 7.41 present two basic views of waves, as described above. Study and compare the differences between the two.

Figure 7.42, a painting by Balcomb Greene, is a highly individual and interpretive work in which most objects are treated as integrated planes. The mystery of light is captured with rare sensitivity. Much of the work has been reduced to two-dimensional surfaces in which the play of color and tonalities recreates the subject in pure, pictorial terms.

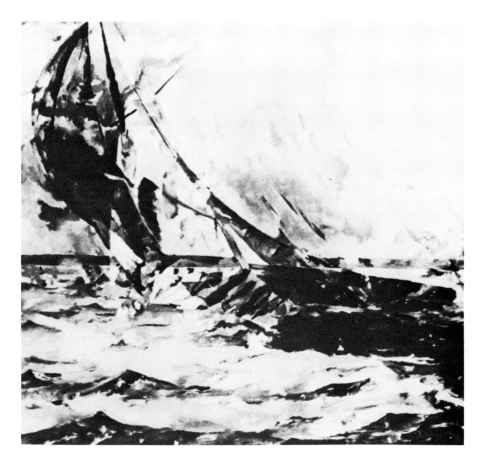

FIGURE 7.42
BALCOMB GREENE
The Squall (1969)
Oil on canvas. 46 × 50 in.
Photo by John Reed

Try the following studies, based on what we have so far learned.

Study 1. *HB and B-grade pencils are recommended for this drawing. Use your sketchbook so that you can keep all of your drawings together for study and review at a later time. Place your drawing on the paper so that you will have extra space for some side studies of portions that may require greater scrutiny and preparation for your main drawing.*

 Using a calm sea as your subject matter, make a long study that will take about twenty five to thirty minutes. Review the example provided in Figure 7.37; if there is a glittering light on the sea, or some unusual textural suggestions created by winds or tides, experiment on the side of your paper to achieve the best marks to represent such phenomena. Look at earlier experiments with materials for clues that may be applicable. Try to create interest in this distant view of the subject by trying to find patterns that will add movement. Study the sky for a continuation of tonal movements, or for contrast that will heighten interest. Although the subject may at first appear passive, look closer for those subtleties that will engage and hold your attention.

 It is suggested that you make a second drawing of the same subject matter, switching to vine charcoal and charcoal pencil. This will be especially helpful if you had some difficulty with the first pencil drawing. You can lay in tonal areas very quickly, smudging them with a paper stomp, or chamois. You can also lift up light areas with your kneaded eraser for light passages. Then you can accent some areas and indicate partial wave contours with the charcoal pencil.

 Study the subject for maximum compositional qualities and try to frame these in your mind's eye before you begin to work. Try to stay with your first, strong impressions as you continue.

Study 2. *If you are a beginner, consider whether pencil or charcoal worked best in your previous study. If you had difficulty with pencil—it might have taken too long to get the desired results—work with charcoal (perhaps combining compressed and vine charcoal). Continue to work in your sketchbook. This time, your subject matter will be either a sunrise or a sunset. These have something essential in common: a brilliant light playing through or over far distant background forms, reflecting patterns of light in sea areas. Consider ways in which the paper itself can be left to represent the lightest and brightest tones. Study other examples and make comparisons. Think deeply about how you can represent your subject matter with greatest effectiveness. As before, plan your drawing so as to allow marginal areas for special experiments in coping with difficult parts of the scene. Allow yourself about half an hour for this study.*

Study 3. *Having worked with some "soft" drawing materials, you may wish to switch to another medium, or a combination of mediums. Pen and ink, ink and wash, and pencil and wash are some suggested combinations. Use your sketchbook. This time your subject matter will resemble Figure 7.39, in which some land mass, such as a rocky jetty, figures prominently in the composition. Be aware of your eye level, and how waves or swells seem to diminish as they recede into the distance. Your drawing should take about half an hour.*

Study 4. *We have been working up to the most demanding of sea studies: waves (or wave formations), seen basically as dominant foreground elements. Experimental marks may be highly useful in drawings of such subject matter to suggest spray, foam, or forms that are the result of a very active surf. Allow sufficient space on your paper for experiments as you discover ways by which you can suggest such dynamic material. Don't allow yourself to become stiff and rigid. Keep a freedom of arm movement as you draw, to prevent a tightness that may deaden the entire result. Spend some time in preparing for this study. Review previous material and study Figures 7.40 and 7.41. Spend as much time as you wish, but try to maintain a sense of spontaneity. Make another drawing or two of the same subject matter, as seen from a different angle, or a farther or closer point of view. Use different materials for broader application and greater expertise.*

Do you have a particular feeling about the sea that was not expressed in any of your previous studies? How can you express such a feeling? What materials are best suited for the purpose? How long should you work? What are some other, personal considerations? Develop your own requirements for your drawing, then go to work. There is no time limit for this drawing. You may wish to look at the work of some well-known artists to serve as a stimulus for your own work. Several have been mentioned to which you may refer.

Cityscape

Here is another subject that has endless possibilities, such as rooftops, quiet streets in early morning, the rush of noontime traffic, small urban structures, and tall skyscrapers. Weather conditions add to the mood and should be considered a part of the total treatment. One's familiarity with cityscapes and one's intent are indispensable ingredients for the artists's expression, critically relating to the selection and use of materials.

The Renaissance artist often placed some portion of an urban landscape, perhaps a castle or a group of buildings associated with the donor (or patron) of the work, in the background of a portrait.

In the nineteenth century, Paris was immortalized by the Impressionist painters, such as Camille Pissaro, Edouard Manet, and Claude Monet.

In our century, Oscar Kokoschka's vigorous expressionist painting captured the buildings of Stockholm, while Lyonel Feininger translated European cathedrals and other structures into lyrical, post-Cubist essays. Charles Demuth and Charles Sheeler used the American city as a major subject. And Richard Estes, the meticulous Photorealist, has made small shops and streets his oeuvre. The principles of drawing are so apparent in Estes' work that a black and white reproduction of one of his screen prints looks like a carefully rendered drawing. (see Figure 7.43).

Perspective is a must in realistic drawings of cityscapes. Simple or complex structures have to be considered in terms of the perspective principles discussed in Chapter 5. Not knowing where one's eye level is in making a drawing of buildings would result in numerous inconsistencies.

FIGURE 7.43
RICHARD ESTES
Holland House (1984)
Screenprint. 48 × 72 in.
Parasol Press, Ltd., New York.

A sense of scale and diminution of forms is equally important. Hence, a good grasp of linear perspective is essential. Aerial perspective adds to the sense of reality.

We shall consider, in turn, one-point, two-point, and three-point perspective in the studies that follow.

Study 1. *Select a situation, containing one large building or several, which you can view comfortably from a frontal view. If you live in a city, you should have easy access to some such scene. Use your sketchbook and work with an HB pencil. Your objective is to make a convincing drawing of the scene using both line and tone. This will be primarily a one-point perspective drawing.*

Very lightly, indicate your eye level within the picture plane, since this will determine all other relationships. After doing this, draw the general contours of buildings and other subject matter in your scene. If you are not sure how much material to include in your drawing, use the cardboard viewer. This will frame your composition nicely, eliminating elements you do not wish to include.

Determine a sense of scale, which should go along with your general contour indications. How tall is a figure compared to a doorway? How high is a fireplug compared to the figure? Make assessments of this kind as quickly as you can, allowing your eye to roam over the entire scene.

Next, determine the various tonalities and textures. Do windows reflect the light of the sky? Are figures basically darker or lighter than the buildings against which they are seen? Are the buildings of the same or different tonalities?

Although your buildings will be seen essentially in one-point perspective, it is quite likely that small objects within the scene will present aspects of two-point perspective. People, automobiles, and other subjects may convey a sense of a top and two side surfaces.

Make your drawing sketchy, and as vigorous as you can. Do not spend more than twenty-five minutes on it. If the results are not up to your expectations, make another drawing, following the same procedure. Refer to Figure 7.44.

FIGURE 7.44

FIGURE 7.45

Study 2. Try a close-up view of a similar subject, eliminating all but a few, essential forms—perhaps including only a portion of a building and a few figures. Quickly establish the essentials: eye level, general contours, proportions, and tonalities. Work vigorously. Look for interesting tonal patterns and reflections in windows or glass doorways that will add interest. How do the figures move? Try to capture their gestures. Although we will consider the figure in more detail in our next section, do the best you can with what you already know. Refer to Figure 7.45. Spend fifteen to twenty minutes on this drawing.

Study 3. Change your view so that the same subject or a similar subject can be seen with convergences of a one-point perspective type. You might be looking down the street, at the same eye level as before. Lightly indicate your eye level and a central vanishing point to serve as a basis for all that you will draw. You will still be working with a pencil and a sketchbook, and the procedure will be the same. Spend about twenty-five minutes on this drawing. Figure 7.46 provides a useful example.

Study 4. Select a scene which presents a two-point perspective situation, which may have a higher eye level so that more of the scene is evident below eye level than in the previous studies. Use a vigorous approach. You may find it profitable to make several thumbnail studies before proceeding with a larger drawing. Use your sketchbook and pencil, as before. Spend about twenty-five minutes on the long study, and only a few minutes on each of the thumbnail preliminaries. Refer to Figure 7.47.

Study 5. Select a scene which will allow for a very low eye level, so that you can develop a frog's eye view drawing. Don't forget to quickly indicate your upper vanishing point and the general convergence of forms to other vanishing points at eye level. Follow the same procedures as before. Make one or two thumbnail studies before doing your longer drawing. An illustration relevant to this study is provided in Figure 7.48. Be aware that you are making a three-point perspective drawing, in contrast to all of the previous studies. You will probably not be able to indicate your vanishing points at eye level, since they

FIGURE 7.46

E.L. E.L.

FIGURE 7.47

E.L. V.P.

FIGURE 7.48

UPPER V.P.

TO
V.P.L.

TO
V.P.R.

FIGURE 7.49

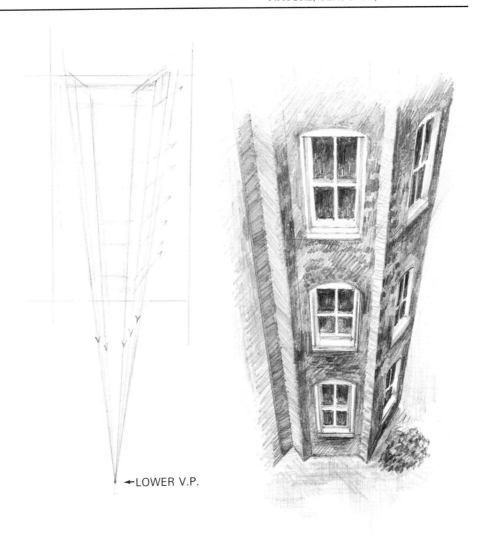

←LOWER V.P.

may very well extend beyond the surface of your paper. However, sense where such vanishing points would be.

Study 6. *You may have some difficulty in locating a real situation which presents a bird's eye view, unless you have access to a very tall building. Do not hesitate to make use of photographs. Remember to make some indications of essential vanishing points, including one below eye level. Imagine these if lack of space on the paper prohibits actual locations. Work in pencil, following all previous procedures. Refer to the example provided in Figure 7.49.*

ADDITIONAL SUGGESTIONS AND CONSIDERATIONS

The rather formalized presentation of studies on cityscapes may be supplemented by your own inventions and personal emphasis. You need not strictly conform to the sequence presented. Try repeating some of the problems, or invent some which allow you to work with different mediums. As before, look for examples of artists' work which have special meaning.

Fantasize, if you wish, and draw cityscapes which have reality only within your imagination. This can show you how much you have learned of the basic essentials that will make your fantasies convincing. It is not so much *what* you express pictorially as *how* you express it. The more you apply the principles of drawing, the more effective your statements will be.

8

THE FIGURE

The Figure in Action

The discipline of drawing the figure is a long and well established one. Figures incised on rocks in the caves of Spain around 10,000 B.C. depict the hunter's life in prehistoric times. Early Greek vases show inscribed figures assuming different attitudes and gestures, and later, the Romans adapted idealized Greek versions of the human form. Renaissance artists, rediscovering ancient sculpture, placed special emphasis on the figure. Even Impressionist color and light theories included the figure as an essential ingredient, while Cubism translated the figure into planar rhythms and arbitrary color. Figure drawing has thus persisted throughout art history.

Many present-day artists find inspiration from such works as that shown in Figure 8.1, an ink and bistre wash drawing by Federico Barocci, a study for a larger work. Reliance on capturing gesture is quite evident in this simple, but powerful study, characterized by economy of line, the critical use of parallel strokes, and massive washes.

Many beginners want to get into the subject as quickly as possible, forgetting that adequate preparation is essential. The desire to immediately capture representational aspects of the human figure, such as facial expressions, likenesses, and other physiological qualities often misleads the beginner to think that such aspects are ends in themselves. Such misconceptions are usually quickly demolished in art schools and art departments which stress basics first. We, too, will consider certain basics that relate to the figure.

PREPARATORY SUGGESTIONS

It is recommended that beginners devote a special sketchbook of medium size to figure-drawing work, which can be used as a reference for review, comparisons, and notations of progress. Although a model is preferable for all studies, the beginner who is not in a class, or who cannot afford a model, will find black and white photographs serviceable. Using one's self as a

FIGURE 8.1
FEDERICO BAROCCI (1526–1612)
Kneeling Draped Male Figure (Between
1588 and 1593)
Ink and bistre wash. 9⅛ × 6¾ in.
Medieval Institute, University of Notre Dame.
Reproduced by permission.

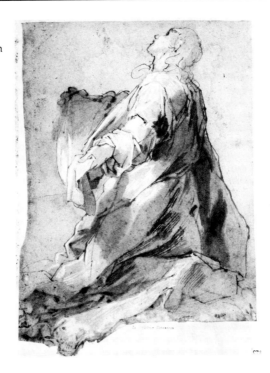

model with the aid of a mirror is also a good practice. Family and friends
may be willing to pose, too.

THE CLOTHED FIGURE

Drawing the clothed figure helps the beginner overcome inhibitions in draw-
ing the nude figure. Some beginners do have difficulty in dealing with the
nude at the outset, and working with the clothed figure serves as a good
introduction to figure drawing.

Some structural aspects of the figure may be understood in terms of
clothing—how it forms, its basic volume, and how that volume covers the
form. Many expressive aspects of the figure can be understood by reference
to the action and formation of clothing.

Here we will consider the *entire* figure. Capturing the gesture is our
primary objective. Also, we want to see how the individual parts of the
figure relate to each other as movements, rhythms, or configurations.

Since our first studies will concern people in a natural situation, consider
ways in which you can draw your subjects with them being unaware that
you are drawing them. Or you may ask a friend to take some natural poses
(bending, reaching, picking something up, tying one's shoe).

Study 1. *This is an instant gesture study. Look at your subject from a comfortable distance that
takes in the entire figure, and make continuous-line gesture studies taking a minute or less.
A magic marker, felt-tip pen, or a similar drawing tool should be used. Make these
drawings in your sketchbook, trying to get as many as you can on each single sheet,
allowing some space between each drawing so that you see each as a separate impression.
Don't take your drawing tool off the paper until you have completed each drawing. Let
your linear impression indicate the direction of each part you can see, and its relationship
to the direction of another part. Don't get involved in drawing contours, though some of
your action lines may naturally form contours. It is better if your action lines are centered
within the parts of the figure, much like a fluid wire armature. Make several sheets of
such drawings, and do not stop to examine them until you have worked for about twenty
minutes. Figure 8.2 suggests some results.*

It is a good idea to keep a small sketchbook with you, one that you can carry about with a minimum of effort—you should be able to slip it into a coat pocket or a purse. Make many similar quick-action notations when you are on a bus or other public conveyance, or while you are waiting to be served at a restaurant or post office. There are many opportunities available. After a few days or a week of making such drawings, you may include more aspects, such as masses and tentative contours.

This study involves movements plus masses. Repeat what you have done in Study 1, but add a bit more. Using the same vigorous technique and the same materials, state the essential movement by keeping your drawing instrument moving to scribble in the main masses. These drawings may build up to contours, but should not be attempts at precise definition. They may resemble tangles of wire or string that indicate action and masses. Don't spend more than a minute or so on these drawings. Superficially, such drawings may resemble people in underclothing. You may be inclined to laugh at them, but don't underestimate the value of such work. You are conceiving the total figure, gaining a holistic grasp. Refer to Figure 8.3. **Study 2.**

Keep working at these drawings until it seems quite natural. Avoid strain, or the tendency to analyze, for these are left brain deterrents that will hold you back. Also make some quick, one-minute drawings from memory. If your subject is moving, it is essential to remember the pose. Date all your work for future reference.

Here we are concerned with predicted movement. This study requires working from a model. You will use the same materials, and each drawing should not exceed two minutes. **Study 3.**

FIGURE 8.2

FIGURE 8.3

First draw the model in any given position (scratching her or his head, picking up a piece of paper). After making a rapid gesture drawing, massing in areas as in Study 2, consider what other action could follow. Ask the model to rest for a few minutes while you make an imaginary drawing of what you believe will be the next pose the model will actually take. Visualize the pose, as if you were actually drawing from the figure. Spend half a minute making your visualization as real as possible, then draw while the model relaxes. After completing your drawing, ask the model to take another pose that is related to the previous one. Compare the model's pose with the one you just finished drawing. Is it similar?

Next, draw the model as she or he actually is, spending only two minutes or so. Compare the new drawing with the visualized one. Is one better than the other? Does one express the essence of the model better than the other? Perhaps both are equally good statements, within the limitations assigned. If not, do a few more, following the same procedures.

As you probably suspect at this point, the visualization process puts you in an altered state of consciousness. You are viewing an image which you, yourself, have created and which has an actual presence. It should be as real to you as the model's actual pose. This exercise is often a catalyst for one who has previously not been able to visualize the figure. It is also a great aid in promoting mental images from which to work, a process that many seasoned artists rely upon. Later, when more information is absorbed by working from the model, it becomes much easier to make a visualized drawing with surprising accuracy.

The predicted movement studies may be supplemented with memory drawings. Ask

the model to take a pose, frame it in your memory, then have the model stop posing while you make your drawing. After a few minutes, ask the model to take the same pose. Compare your memory drawing with the actual pose, making a drawing next to the memory one for comparative purposes. Keep in mind that these early attempts should not be detailed; you are simply drawing movement and masses.

The quick contour drawing is closely associated with the previous two studies. Using the same materials, combine instant gesture with movements and masses. After your model has assumed a natural pose, make a few essential lines to indicate the gesture. Then quickly add to essential movements and establish masses (head, torso, legs, arms, hands, and feet). As these are attaining some degree of clarity, quickly state the outer contours that are most noticeable (tautness of clothing where a leg bends or an arm is outstretched, for instance). These are active contours, compared to those which suggest simple curves or relatively straight edges. As you make your drawing, compare contours with each other, looking for active and passive relationships. But work fast: The maximum time for these drawings should not exceed three to five minutes. ***Study 4.***

After completing a few drawings, emphasize the contour lines that seem most expressive by making them darker. Make at least five such contour drawings before you take a break. Figure 8.4 provides some examples.

Spend a week or so making quick contour drawings. This experience will prepare you for making extended, or slower, contour drawings, which are suggested in the following study.

The extended contour drawing is simply an amplification of the quick contour approach. In the first minute or two, capture action and simple masses. Then begin the slow contour work, which should be very tentative. The lines should be light and searching in nature. Make your observation more acute as you single out main folds and formation of clothing, how the head, arms, and legs seem to emerge from it (not tacked onto it). The flow of the figure should be maintained, and the eye should roam over the entire figure, as before. Also, it is a good procedure for the drawing to develop in an organic way. If you had to stop the drawing after four or five minutes, it should have a relative sense of completeness. ***Study 5.***

FIGURE 8.4

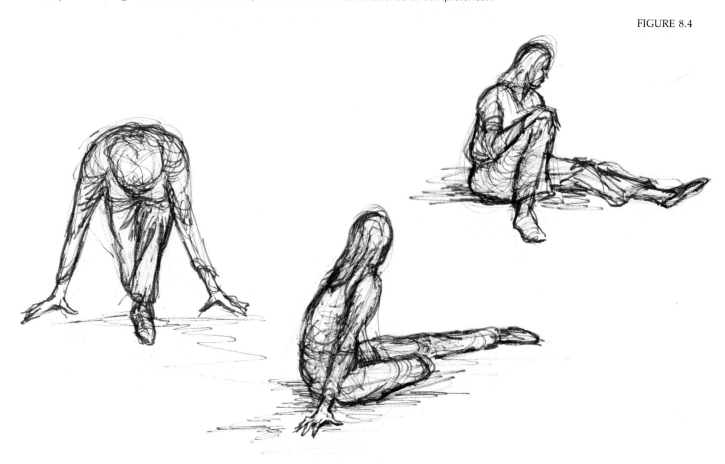

FIGURE 8.5

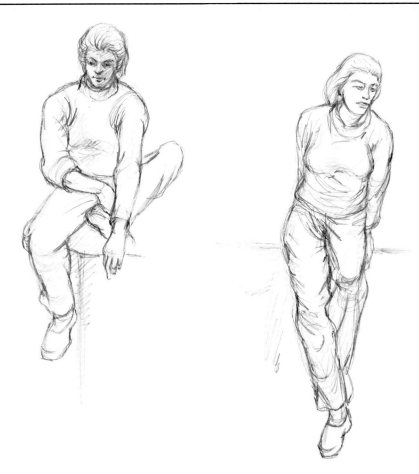

No part should be more developed than another. Use a soft drawing medium for this study. HB or B graphite or charcoal pencils are recommended. But don't use an eraser. Work from tentative to more affirmative contour indications, thus eliminating the need to erase. The drawing should take about ten minutes.

Since it is often difficult for beginners to maintain the kind of organic development described, it is recommended that the slow contour study be repeated many times. Several days or a week should be devoted solely to this work until the desired results are achieved.

Avoid old concepts such as drawing the head in a frontal position, where it actually is foreshortened and of a different shape. The same applies to other parts of the body, such as hands and feet. We tend to carry over some early, childhood ideas of how things are, when in actuality they may be different in a given pose. We must learn to see what is really there. Figure 8.5 provides some examples.

Sustained contour work improves with a sound grasp of structure. Therefore, it is imperative that one learn how to think of the figure as simplified three-dimensional forms. Before moving to the subject of structural analysis, an additional contour drawing is recommended for study: cross contour drawing.

Study 6. Use the same materials as for Study 5, and ask the model to take a natural, comfortable pose that can be easily maintained for ten to fifteen minutes.

In preparation for the study, make a few quick contour scribble drawings that should take only a few minutes (refer to Figure 8.6). After making a few flowing marks to indicate the allover gesture, scribble in lines that suggest the basic nature of the volumes of the figure. The legs and arms will resemble modified cylinders; the torso, a flattened cylindrical form; the head, an egg shape; and the hands and feet, truncated forms. Work vigorously, keeping your pencil on the paper as much as you can until you finish the drawing. Now you are ready for the longer cross contour drawing.

As the term implies, you will be using lines that go across the figure, at right angles

(far left)
FIGURE 8.6

(left)
FIGURE 8.7

to the long axis of parts of the figure. Each line is to be carefully and slowly drawn, beginning at one end of a form and ending at the opposite side. Each is an independent line, referring to the form, or part of the form, it represents. It will take several independent lines to indicate any portion of the figure, as noted in Figure 8.7. Study this illustration before you begin.

Do not rush this drawing. Note how each line represents some quality of the three-dimensional form of the figure, its elevations and depressions. Each line will tell you something about how the clothing is formed around the figure and the nature of the exposed volumes of the figure, itself. This is a good preliminary exercise to make you more aware of how the figure and clothing are structured.

Study 7. The next study concerns basic structure. All previous studies of the figure have been aimed at acquiring a grasp of the figure as a unit, with little or no concern for structure. A sense of volume, weight, and mass can be enhanced by the following study, which deals with strong black and white contrasts. Such simplification creates a powerful, convincing form. Parts of the form not drawn are implied. Many beginners are delighted with the results they achieve using this method. It serves as a valuable basis for the more demanding aspects of structural work.

The materials you will need are your sketchbook, a B pencil, several sheets of black construction paper, and white chalk, pastel, or conté crayon. If you wish, the black construction paper can be cut to fit your sketchbook, so that you can keep all of your drawings together (tape or clip the construction paper to your sketchpad).

Have the model take some natural, easy poses of from two to five minutes. Eliminate as much light as possible, using only one strong light source, preferably directed to one side of the model. Arrange your drawing setup so that you will see a large portion of the model in shadow, and an equal (or almost equal) amount in light.

Begin your first drawing using B pencil on the white paper of your sketchbook. You

should be concerned with the total figure, studying it intently for half a minute or so before you begin to draw. Let your gaze roam over the entire figure, framing the strong contrasts of light and dark in your mind's eye. Next, make a few light lines on your paper, establishing the height and placement of the figure on your paper. Then, shade in only those shapes that represent the shadows of the figure. You will not have to draw contours first, since the areas of the figure in light will be left as blank paper. Draw the dark shapes or portions as broadly as you can. Finish this in two minutes or less.

The first attempt may be way off in proportions and in shapes, so you will probably want to make another drawing of the same pose. It will be helpful as you make your next drawing to study both the light shapes and the dark ones, even though you will only be drawing the dark shapes. The dark shapes will represent positive shapes, the light ones negative shapes (where the white of the paper shows). Make at least five drawings, following the procedure described. These can all be on the same page in your sketchbook, but should not be too small. Keep in mind that you are after a total pattern of dark shapes, though you will be studying individual various dark shapes in the figure as you draw. Figure 8.8 indicates some results achieved by this method.

The next drawings will be made with white chalk, pastel, or conté crayon on black construction paper. This time, reverse the process and draw only the light passages or patterns that you find in the model. Study the model first and then draw in the light passages. This time the light areas will become your positive shapes, while the black of the paper will represent the negative areas. Fill one or two sheets of construction paper with these studies, asking the model to change the pose for each drawing you make. Figure 8.9 provides supportive reference.

After some two-minute studies, extend both the black and the white drawings to five

FIGURE 8.8

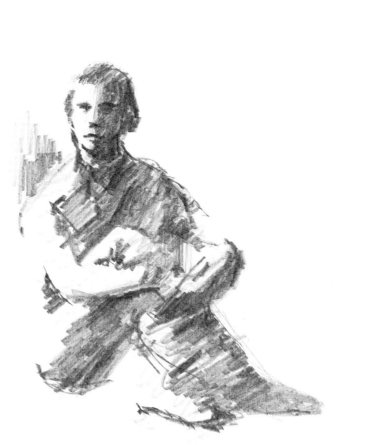
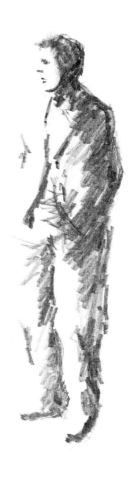

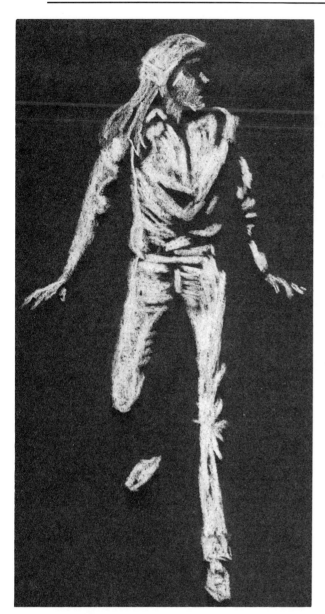

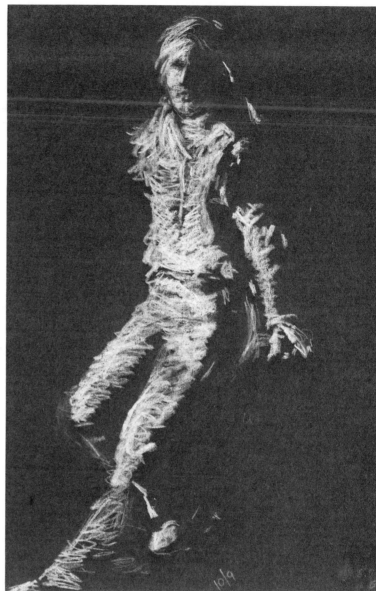

FIGURE 8.9
A. COOK (student)
White chalk on black construction
paper.

minutes, but no longer. The purpose is to achieve a strong, simple, allover impression, without any details or distracting elements. There should be no tonal variations: work with the blackest black you can achieve and the whitest white you can achieve.

This is an excellent preparatory exercise that you may wish to repeat (especially the black on white) in later work.

Study 8. *In this study, the basic structure will be amplified by combining aspects of both drawings made in Study 7. You will work with a soft, black medium that is compatible with a soft, white medium. A B grade charcoal pencil works well with white conté crayon, though any other combination of similar mediums will suffice. Instead of working on white or black paper, use a sheet of tinted stock: gray, brown, medium blue, or pastel.*

This should be a large drawing, taking up a good portion of your paper. Spend about twenty-five minutes on this drawing, making it slowly emerge. Figure 8.10 provides examples of this approach. Although our principle concern in this section has been with the figure in action, this study offers the opportunity to work in some detail. Besides the long study, make a two- or three-minute study in the margin of your paper to remind you of basic preliminaries.

FIGURE 8.10A
JOY MILLER (student)
White chalk and B pencil.

(facing page)
FIGURE 8.10B
ELLEN BARRIE (student)
Chalk and charcoal pencil on gray
paper

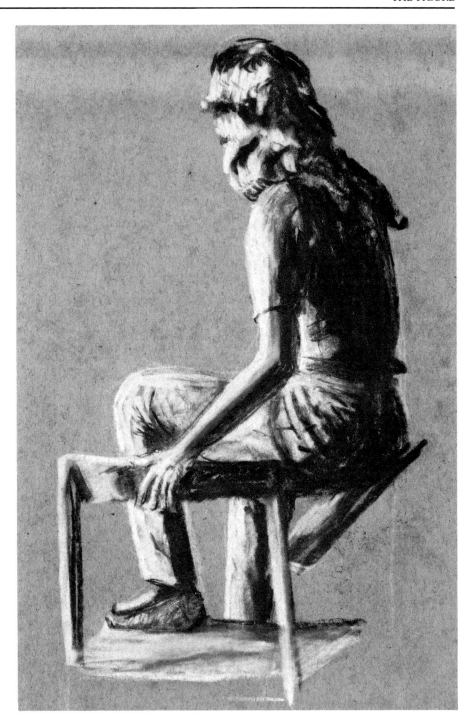

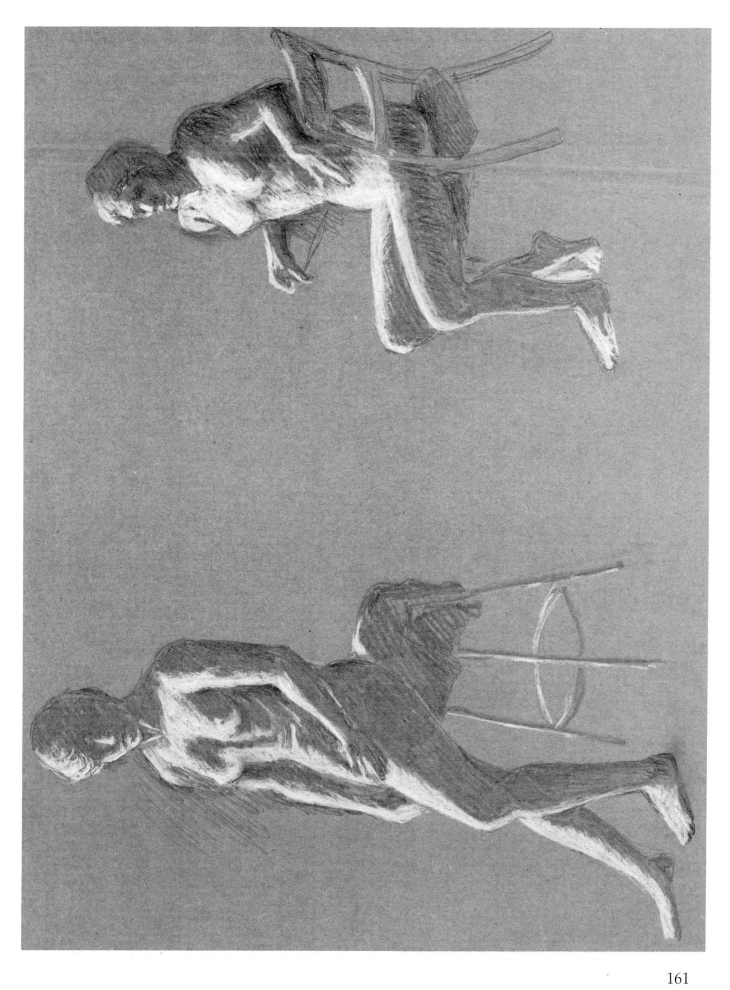

Here are some other essentials to keep in mind. Make sure your first indications include a comfortable placement of the figure on your paper. Be sure your model is willing to hold a long pose. If the model is not a professional, make sure that he or she takes a rest during the long study. Even a professional model may wish to stretch after five or ten minutes. Have one strong light source that will illuminate the entire figure effectively. Work from general things to the specific. Any details that you wish to suggest (keep at a minimum) should be the very last indications in the drawing. Details should find their places naturally, as an organic conclusion to the work, not as a superimposition on it. Draw simple shapes, instead of trying to draw individual parts. These are contained within larger structures that you should capture with minimal planes, toned areas, or light areas.

Making this study will alert you to your present stage of drawing ability. Many achieve surprisingly good results which serve to stimulate their enthusiasm for figure drawing. Others may have more difficulty. Therefore, think of this study as an experiment, whether or not it is as successful as you wish it to be. Those who wish to pursue figure drawing further will find the next section, "The Figure in Depth," useful.

FINAL CONSIDERATIONS

The sequence of work in this book provides a chronology for developmental experience, especially useful for the beginner. However, the more confident, exploratory individual may wish to include a composition of two or more figures; introduce backgrounds; or invent different settings for active compositions (ski slopes, the beach, swimming pools, and the like). There are many possibilities for individual departures. Think of ways you can make this section even more meaningful.

The Figure in Depth

In this section, we will work with the nude figure, discuss additional structural applications, touch upon essentials of anatomy, learn how to deal with sectional studies (such as the head, hands, and feet) and explore the total figure in long studies. Proportions will be dealt with in the section on anatomy.

This section is predicated upon a grasp of the figure given in *the preceding section*. Structural concerns precede anatomical ones. It is of little value to know all parts of the vertebrae, the various bones of the body, hand, leg, and so on, if one cannot see these as simple three-dimensional structures first.

Anatomy can be a life-long study, and there would still be much to learn. Anatomy for the artist is quite different than anatomy for the doctor or other health professional. Understanding the character and function of bones and muscles is a complicated process. And, although it is desirable to know as much as possible about such things, the process must be gradual. The analysis of certain poses in anatomical terms slowly becomes synthesized into *functional* knowledge. Memorizing the names of parts is not as useful as understanding how such parts move and relate to each other. Learning in context is essential. However, our ultimate objective should be to combine the linear (left brain mode) with the visual (right brain mode) for total comprehension of the figure.

STRUCTURE

In our study of the clothed figure, we found that shadows created patterns throughout the figure. We saw that one should not only be aware of

individual forms in shadows, but how such shadows, when connected, could form a unified relationship throughout the figure. Such shadows represent planes within three-dimensional forms. When we draw only shadows, the light surfaces are *implied*, and the observer tends to read in what is not actually drawn. Light surfaces also represent planes. When we reversed the process, working with white on black, we were suggesting planes, or surfaces in light, thus *implying* shadow surfaces, or planes that were not actually drawn. The exercises made us aware of how the three- dimensional form of the figure could be created using only one tone. Now we shall move a step further by considering how to create structural forms, highly simplified shapes that are basically geometric in nature.

Figure 8.11 is a red chalk drawing attributed either to Raphael or to Giulio Romano, his student. Notice how the ribcages of both figures are pronounced, but highly simplified three-dimensional shapes. Both are foreshortened three-quarter views. The legs and arms of both figures stress simple volumes and only slight musculature articulation. Neither head stresses anatomy; the emphasis is placed on expression within simplified three-dimensional volumes. This study provides a good example of how the artist stressed structure, rather than highly descriptive anatomical considerations.

The analytical structural drawing of the male figure in Figure 8.12 translates the human form into basic geometric shapes, in which flat planes dominate. Figure 8.13 represents the female figure by means of similar generalized structural indications. Figure 8.14 presents three related figure approaches. A depicts a gesture indication; B combines gesture with simple, two-dimensional blocked-in indications; and C represents both previous stages with final emphasis on simplified structure. These drawings are *progressively* related in a single work. This will be our aim.

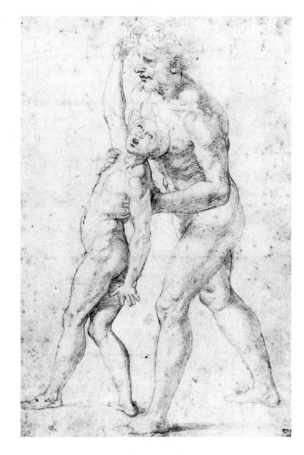

FIGURE 8.11
RAPHAEL (1483–1520) or GIULIO
ROMANO (CA. 1499–1546)
Father with Son Possessed by Demons
(CA. 1518)
Red chalk on paper. 11¼ × 7½ in.
Medieval Institute, University of Notre Dame.
Reproduced by permission.

FIGURE 8.12

(far right)
FIGURE 8.13

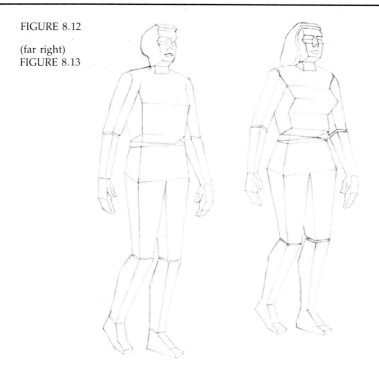

FIGURE 8.14

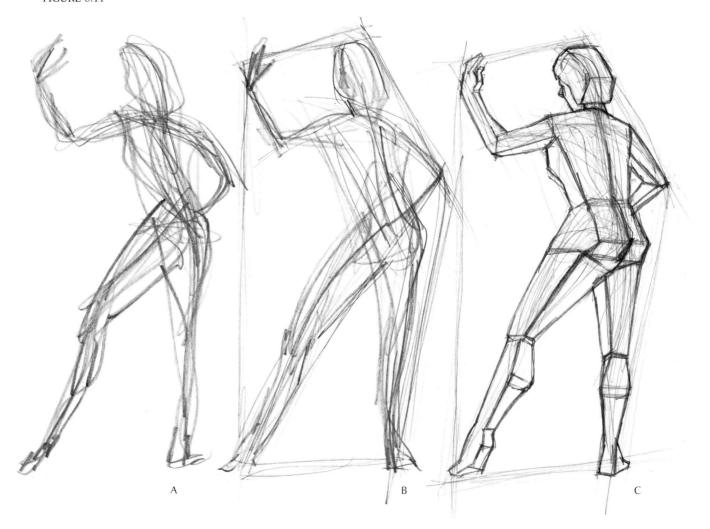

A B C

FIGURE 8.15

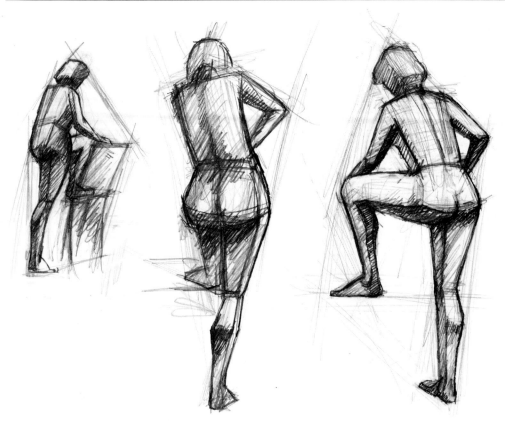

Let us now consider some work that will provide experience in relating these three approaches. A nude model should be used for these studies. If you cannot get a nude model, either ask a friend to pose in leotards (shorts if a male) or work from photographs.

Study 1.

Use a medium-sized sketchbook and an HB pencil. Ask your model to assume a natural standing pose that he or she can hold for five to ten minutes. Use a strong light source, as in drawing the clothed figure. Make all three drawings approximately the same size on the same sheet of paper.

In the first drawing, capture the gesture of the model as quickly as possible. This should take five to ten seconds. Review gesture as explained in "The Figure in Action," if you need a reminder.

Repeat the same process in the next drawing, blocking-in two-dimensional shapes that relate one part of the figure to another. Do this lightly, correcting allover relationships. This drawing should not take more than a few minutes.

The third drawing should be a combination of the two preceding studies, followed by more affirmative simplified structural indications. This drawing should take from five to ten minutes, and the final portion should be an attempt to indicate clearly the particular character of the figure in blocked shapes. Add some tone without getting involved in subtleties; one medium tone should suffice.

Study 2.

Use the same materials as in the previous study. This time ask your model to take a natural pose for about five minutes. This will be a study in which the model will rotate the same pose to present you with three different views to draw. Make three drawings, each of which should include gesture, two-dimensional alignments, and structural indications with minimum tone. Some related works are shown in Figure 8.15.

Although the foregoing drawings have included the entire figure, it is useful to make structural studies of separate portions. For instance, the head can be simplified structurally as shown in Figure 8.16. Notice how the eyes can be suggested by the notched-out

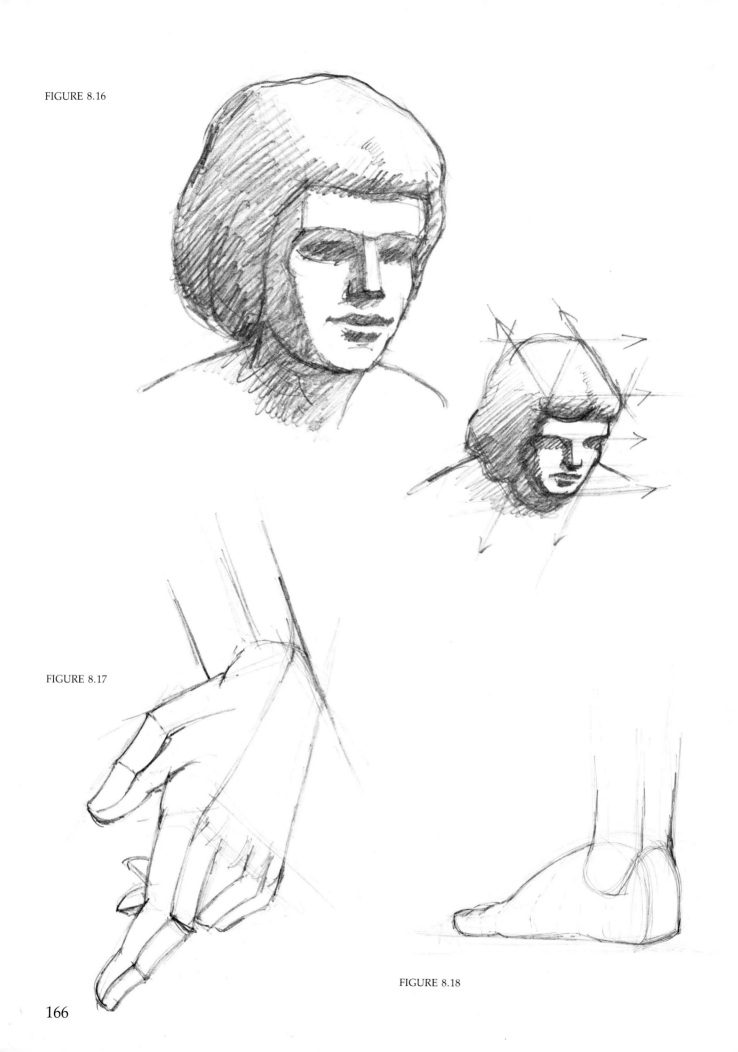

FIGURE 8.16

FIGURE 8.17

FIGURE 8.18

portion of a larger surface; how the nose emerges as a simplified geometric mass; and how the mouth is suggested as two planes, one in light, the other in shadow.

Hands and feet can be drawn in a similar manner, as seen in Figures 8.17 and 8.18. In Figure 8.17, the smaller units of fingers are part of a larger mass. Figure 8.18 shows toes in a similar manner, relating to the larger mass of the foot. Understanding detailed parts in this structural manner offsets a common problem beginners face: wanting to draw each finger or toe as a separate entity, while losing sight of the allover shape or mass of which it is a part.

Think of the simple shapes you use to block in portions of the figure in perspective terms, keeping in mind eye level and converging surfaces. Things below eye level (whether head, hand, or foot) converge to vanishing points that are above the object. Things above eye level converge downward to vanishing points.

Study 3.

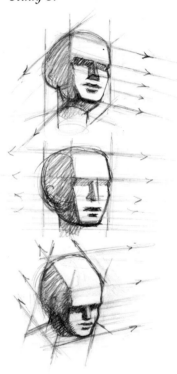

Ask the model to take a comfortable seated pose. You will be making five-minute head studies, using your sketchbook and an HB pencil. Make three drawings on one sheet of paper. As before, a strong light source from one direction is important. If you are drawing in a standing position, the model's head will be below eye level. Establish very light outer limits of the total shape. Then block in major masses which relate to the particular perspective situation. Next, indicate smaller, blocked-in masses (eye sockets, nose, and so on). Finish the work by adding one basic tone throughout all shadow areas of the drawing. Be aware of how parallel and near-parallel surfaces appear in shadow or in light. Use Figure 8.16 as a reference.

The second drawing should be exactly like the first, except for a change in eye level. This time, work from a seated position so that your eye level and the model's eye level will be the same (or nearly so). Try to capture the essentials in five minutes.

The third drawing should be similar in concept and execution, except that it should be drawn from an eye level which differs from the previous two drawings. This may be done by asking the model to stand while you remain seated; or you may sit on the floor while the model remains on the chair. In either case, the model's head will be above your eye level.

Figure 8.19 stresses a perspective orientation for the above three drawings, which you may wish to refer to as you develop your work.

Figure 8.20 shows two strong pencil studies by John Singer Sargent. Notice how the smaller study to the right completely eliminates the outer head contours, emphasizing only the play of light over certain features. The larger drawing to the left maintains outer contours, as well as definition of inner portions of the head. Although perspective is not explicit in these drawings, there is a definite application of it in terms of how the head is tilted, with corresponding parallel alignments of facial features (eyes, nose, lips, and chin). These features are interpreted in simple, structural planes that accent a three-dimensional quality. Only two tones are applied throughout these studies: a middle tone and a dark tone (the white of the paper serves as the lightest tone).

FIGURE 8.19

Study 4.

This study will be concerned with drawings of the hand, using the same materials as in the previous studies. A friend or relative may be an apt subject, or draw your own hand.

Make three drawings on a single sheet of paper in your medium-sized sketchbook. The objective will be to make structural drawings that basically follow the procedure for drawings of the head. Gesture and simple blocking-in of masses should be preliminary stages leading up to structural indications, as in Study 1. Therefore, the large mass of the hand should be correlated with the fingers seen as a unified mass (if fingers are spread apart, include the spaces between the fingers in the entire mass simplification). A strong light source is important. Spend about five minutes on each drawing. After you have decided on a pose, spend several minutes studying the hand before beginning to draw. Form a strong image of it in your mind's eye, then draw.

It is likely that portions of the hand, perhaps some fingers, may be foreshortened. If so, suggest such foreshortening by simple, blocked-in shapes. Compare the size of such foreshortened forms with those that are not. Also, look at open spaces that may exist between fingers, thumb, and other portions of the hand. Relate these to the solid masses as you make your drawing.

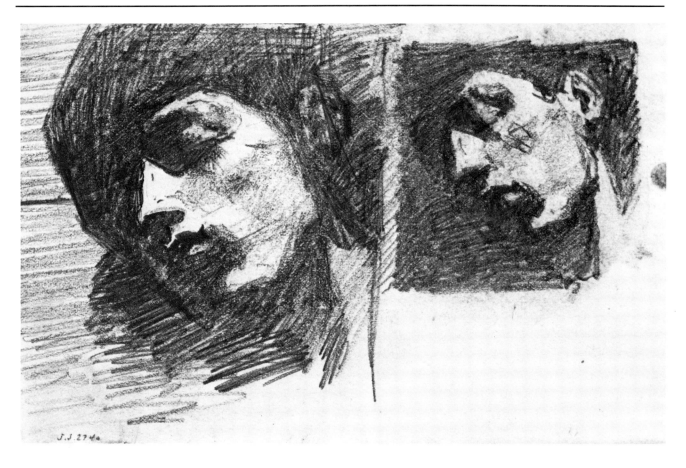

FIGURE 8.20
JOHN SINGER SARGENT (1856–1925)
Two Value Drawings of Man's (?) Head
(1875–80)
Pencil. 3¹⁵⁄₁₆ × 6⁵⁄₁₆ in.
*Collection of the Corcoran Gallery of Art, gift of Emily
Sargent and Violet Sargent Ormond.*

Another important observation is to sense how forms within the hand seem to be wedged into each other, and how the bulk of the hand toward the wrist seems to wedge into the wrist. After drawing for about five minutes, and achieving simple, broad tonal indications, switch to other drawings.

The second and third drawings should represent other views of the hand in different positions. Follow the same procedures as before. Figure 8.21 provides examples of structural studies of the hand that you may wish to study. As you make progress, give yourself greater challenges by drawing views that present greater foreshortening. Switch to another medium, but keep the same objectives in mind.

Study 5. *This study will be devoted to drawing feet. The principles outlined for drawing the hand also apply to drawing feet, therefore only a few additional suggestions will be offered.*

Make three drawings, using the same materials as in the previous studies. Later, you may switch to an HB or B charcoal pencil, or a conté crayon. Liquid mediums (wash, for instance) are not as suitable for the beginner. Limit each drawing to five minutes.

Look for the basic movement of the main mass of the foot and how the toes relate to it. Do not see them as separate entities, but as simple, blocked-in, related forms. Notice how the ankle forms a saddle over the upper arch of the foot; also note the distances of this arch from the back and front portions of the foot. Look for concave and convex formations: the under portion of the foot is concave (especially from an under-view); the upper portion is convex (or may appear to be several convex formations). Study the negative areas around the foot, as well, for these tell you something important about the positive masses. Keep the shading simple and direct; don't get lost in subtleties. Figures 8.22 and 8.23 provide supportive references.

We have so far considered some essentials about the structure of the figure, both as a whole and portions of it. However, the figure will be considered more carefully in the section on anatomy that follows. In one sense, it is arbitrary to study structure aside from anatomy, yet I believe it is helpful to make preliminary structural studies before proceeding

FIGURE 8.21

with anatomy. In the next section, some structural concerns will be repeated, but will be related to anatomy, especially with regard to portions of the figure not yet dealt with such as the torso, arms, and legs. Perhaps such study should be considered as "structure in depth," compared to the more elementary kind of structure we have worked with so far.

It is hoped that the student will find it profitable to relate the elementary work on structure with what will follow. The main objective is to assist the student in the learning process by going from the simple to the complex. However, you are encouraged to be flexible and to go directly to studies that interest you most, once basics have been studied.

ANATOMY

We will consider anatomy in simple, basic terms, incorporating structure and function. However, the material presented here can be amplified by references in the list of suggested readings.

Some contemporary artists do not consider anatomy an important area of study. Such artists, though they may utilize the figure in major works, are usually content to rely on photographic references, or other sources, not wishing to go beyond surface appearances. They are more interested in the figure's expression, than it's inner dynamics. They see the figure as simply a part of a larger design context. For instance, Figure 8.24 is a diagrammatic analysis of the work of Oscar Schlemmer. It illustrates the use of the figure in a highly stylized manner where anatomical concerns are minimized. These figures are highly simplified, and serve more as symbols for the figure than actual, realistic images. The same gesture of the figure is repeated, suggestive of the vertical dominance of figures ascending and descending a staircase. The figures emphasize the total structure of the composition, rather than individual movements they may assume. The interplay of curved and

FIGURE 8.22

FIGURE 8.23

straight forms of Schlemmer's figures tells us *less* about the anatomy of the figure, but *more* of his concern with pictorial structure. The human form has been simplified into volumes that resemble spheres and cylinders which conceptually relate to the stark, geometric background. To present realistic figures within his chosen context would be entirely inappropriate and not in keeping with the purist concerns of the Bauhaus, where he was a leading teacher of sculpture and scenic design in 1920.

Conversely, a diagrammatic analysis of a painting by Picasso, shown in Figure 8.25, shows a decided concern with the expressive state of the human figure. Note how Picasso used anatomy in the sensitive treatment of the heads of both the mother and child. Sensitivity in the treatment of

(far left)
FIGURE 8.24

(left)
FIGURE 8.25

the child's left hand should not be overlooked in relation to the age of the child and his pensive attitude. Picasso underwent years of rigorous realistic, academic study before he made departures into abstraction. He knew well how to apply anatomy for expressive purposes.

Other artists have relied on anatomy to an even greater extent. Leonardo da Vinci was among the first actually to dissect the human form and draw it. His insatiable desire for knowledge led him to acquire much information concerning the figure, which found its way into his many provocative studies.

Many artists today believe that a knowledge of anatomy can enrich their work, even if they treat the figure in an abstract fashion. Such a belief is generally predicated upon the assumption that the more one knows about the figure, the better one is able to abstract it. Sometimes to show less is to show more, if it is based on sound understanding.

THE SKELETON

We are considering the skeleton first because the skeleton is the structure which supports the rest of the body. Muscles are grouped around the bones, with attachments that provide the possibility for various movements. The bones are joined by ligaments, some of which allow for an astonishing degree of manipulation (as in the arm and neck, for instance). Others allow for less movement, as between the upper and lower leg—a simple hinge action. A considerable amount of twisting and turning of the torso is made possible by the various muscles that interrelate between the ribcage and pelvis, aided by the flexibility of the ligaments within these major bone structures. The skeleton also asserts itself in some surface areas. The skull shows through in the cheekbones (zygomatic bones), the forehead (frontal bone), the areas above the eyes (superciliary bone), the jaw (mandible), and the base of the skull (occipital bone). It is often evident in the "hunch" of the shoulders from the rear view (the scapulas), or in the frontal view in which the collarbones (clavicles) are prominent. The kneecap (patella) is almost always evident from several views of the figure, as are parts of its adjacent bones of the upper leg (femur) and the lower leg (tibia and fibula).

The edges of the pelvis in front (iliac crest) and in back (the sacrum) are almost always easily identifiable in a simple, standing pose.

Figure 8.26 presents three diagrammatic views of the complete skeleton. Study the parts and then associate them with your own body. Feel how your elbow protrudes, or how your kneecap may be gently moved sideways and up and down. Extend this identification process to other parts of your anatomy, noting correlations with the diagrams. If you are working in a classroom situation, or with a group, take some poses, yourself. Feel where the bones are positioned and how they move; note their importance in the pose.

In Figure 8.26, the torso consists of two parts: the ribcage (upper torso) and the pelvis (lower torso). These are connected by the spinal column, which terminates at the skull in the upper portion. Notice how the spinal column has been simplified into a flat "S" curve. The ribcage may appear as a modified egg, or basket shape. The pelvis may be translated into a basin, box, or two disk-like forms. The head may be translated into an egg and cone formation. The legs and arms are treated as cylindrical forms.

FIGURE 8.26

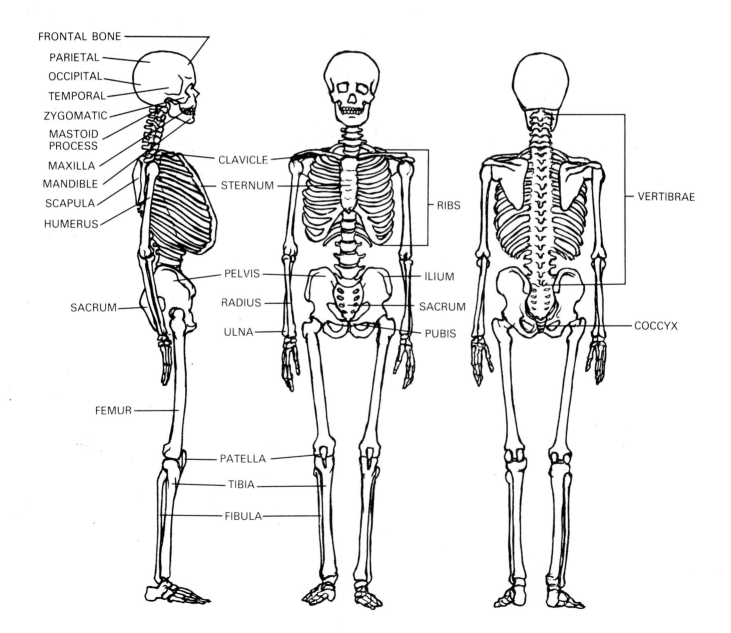

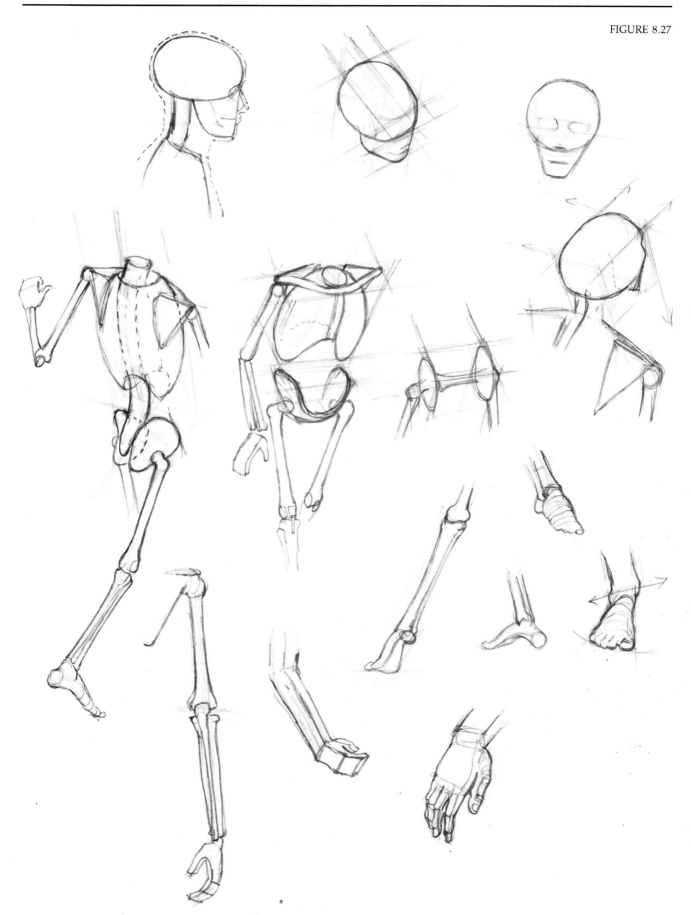

Hands and feet are also highly simplified forms which represent basic masses.

With some practice, it is possible to make drawings of these shapes with relative ease. First, make drawings of the examples provided in Figure 8.27. Then make additional drawings, *imagining* (visualizing) *how such forms would appear in different positions.* Once the concept has been grasped, it will form a sound basis for drawing detailed structures of the skeletal parts.

A useful aid recommended by some instructors (and used by numerous artists) is an inexpensive wooden mannequin. They are also available in plastic, and are about fifteen inches high. The mannequin is useful as a working tool to help one understand motion and form—how the figure would look in certain positions—or as a reminder of a previously modeled pose. Now let us turn to some studies, using the symbolic shapes shown in Figure 8.27.

Study 1. *Use a medium-sized sketchbook (or corresponding paper) and an HB pencil. You should have access to a model, or a variety of photographs showing a dozen or so different positions of the figure. Limit yourself to two or three minutes. If you are using a model, tell him or her to take twelve short poses in a series, demonstrating some normal action; for instance, picking up something by bending slightly, then more, then still more every two or three minutes until the action is completed. Explaining the intent of the poses to the model in this way will expedite the actual drawing process. If you are working from photographs, arrange them in an action sequence that shows relationships of gradual movements, similar to the bending sequence explained above. Do six small drawings on a single sheet.*

Your first indications should be of a gestural nature, drawn with a quick, continuous

FIGURE 8.28

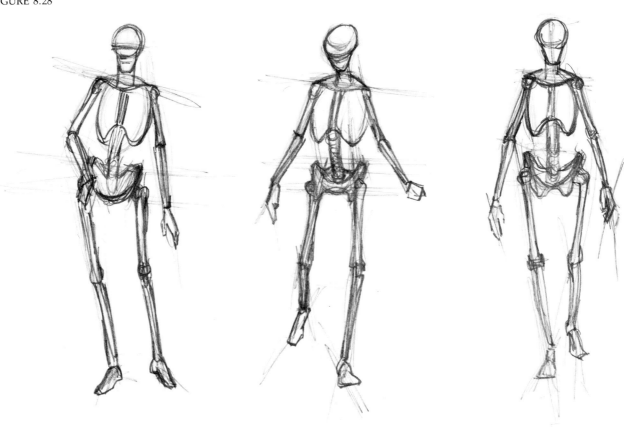

line. It should take only a few seconds. This should be followed by the drawing of the symbols that you have studied. As you draw, look for anatomical contact points, such as the crest of the pelvis, the edge of the ribcage, the kneecap, and the ankle. Identify the space between the ribcage and the pelvis. Is there a greater space on one side than on the other? Look for directional thrusts that will differ. For example, one leg may be angular (perhaps a side view of a bent leg), while the other may appear as a straight line (no bending action between the upper and lower leg is evident). If an arm or leg appears to be foreshortened, quickly indicate it by means of a foreshortened cylinderical shape. Figure 8.28 illustrates results you should work to achieve.

Make a five-minute drawing of the total figure, using the symbols you have studied in the **Study 2.**
previous work. Again, your sketchbook and an HB pencil are recommended. Include two or three drawings on each sheet of paper.

 Quickly indicate the gesture in continuously moving lines. Using straight, angular, and curved lines, draw the various aspects and proportions of the figure as they appear in the pose, looking for anatomical clues (elbow joints, kneecaps, clavicles, scapulas, and so on). Emphasize these more than in Study 1, making slightly darker indications where these occur. Draw in all of the anatomical symbols of the figure in single line contours, making the forms appear as three-dimensional as possible. Then, in the remaining minute or so, draw in the actual contours of the figure. In this way, you will be able to quickly relate the skeletal symbols to the actual contours of the figure. Keep all of your work in line only, without any added tonal indications. If you have difficulty completing the work in five minutes, try to speed up the process in the next drawing. Finish the four remaining drawings, changing the pose for each one. Figure 8.29 depicts the desired results.

 Often students complain that they cannot get enough done in five minutes to achieve

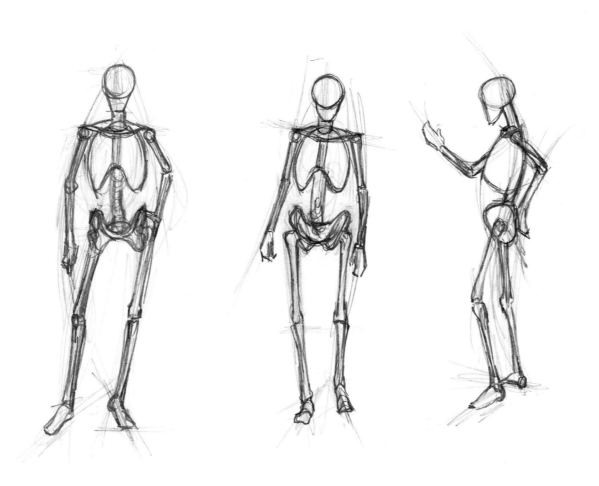

the planned objectives. This is to be expected, since the process is demanding and challenging. But, it can be done. You are urged to continue this drawing process until you can achieve the objectives within the five-minute time limit. If, however, you find this method too demanding, move on to the next study, which allows for more time. Then, having completed the longer study, try the five-minute drawings again.

Study 3. *Here, your objectives will be to draw three views of the skeleton from a three-quarter frontal position (the model faces you), followed by contours of the figure. The views should be (1) a simple standing position, (2) a standing position in which the model drops the left arm and raises the right, creating a dynamic relationship between portions of the figure, which also results in a natural opposition between the ribcage and the pelvis (the pelvis will remain stationary, while the ribcage will tilt downwards in the direction of the lowered arm), and (3) a standing position that is the reverse of the second. Your model may wish to rest his or her lowered arm on a chair, and the raised arm against the wall, for support during this fifteen-minute pose; or take several (one-minute) breaks, as the drawing proceeds. Work with the same materials as in the previous studies. Figure 8.30 illustrates the three views you are attempting to draw.*

Be aware of visible contact points (surface indications) of the skeletal structures as you make the first drawing. For instance, notice how the collarbones and upper arm bones (humerus) emerge above the ribcage. Look for some indication of the lower end of the ribcage and the portion of the pelvic crest. Sense where the upper leg bone (femur) emerges from the pelvis, and how the kneecap (patella) relates to it. If some of the skeleton symbols are obscure, imagine where they should be and continue to draw until you have established all of them. Then make a contour drawing over the skeletal indications, sensing

FIGURE 8.29

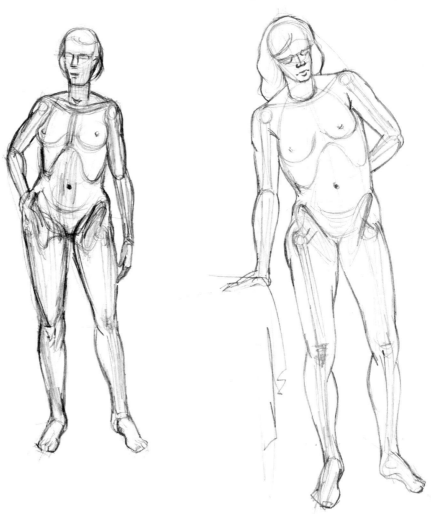

how overlapping formations of such contours correspond to the underlying structure. Many of the contours are considered "drapings" of muscles and flesh that cling to the skeletal armature of the figure.

The second drawing should be based on a pose in which the model lowers one arm and raises the other, thus creating oppositions. Follow the same procedure as in the first drawing. In this more active position, one clavicle will be raised in comparison to the other. The ribcage on the raised arm side will be farther away from the pelvic crest than the other side. The flexibility of the spinal column allows for this kind of action. Look for differences that occur between the present pose and the previous one.

For the third drawing, follow the same procedure as in the two previous studies, looking for complementary oppositions and dynamic aspects in the skeletal structure. Draw the outer contours. After making these three drawings, you will have attained a methodology that you can apply in successive studies of your own.

Make three views of the figure with the model facing away from you (the model's back faces you). Follow the procedure outlined in Study 3. Look for contact points that relate to the shoulder blades, the spinal column, and the back portions of the pelvis, as well as contact points of the skeletal parts you drew earlier. Finish your efforts by drawing the outer and inner contours. **Study 4.**

Draw three side views of the figure, following the procedure given. This time you will be aware of skeletal parts that were evident in the drawings of the front and back views. Study how these parts relate in creating the character of the side views that you draw. **Study 5.**

FIGURE 8.30

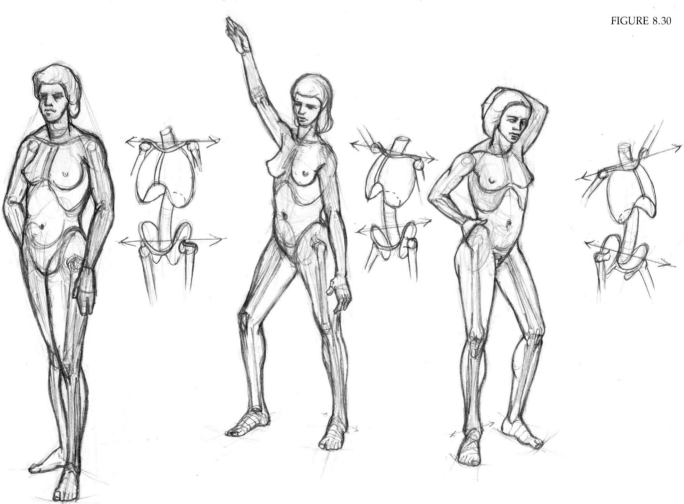

Notice the more pronounced oppositions between the ribcage and pelvis, even in the simple standing pose which you will start with. The ribcage has a natural tilt, or axis, that opposes the pelvis (refer to the earlier diagrams of the skeleton). Be aware of the "flow" of the figure, and how important the skeleton is in creating this quality. Do not draw the outer or inner contours until you have understood and clearly indicated the underlying skeletal structure.

PROPORTIONS OF THE SKELETON

It may seem unusual to present information on proportions of the skeleton at this stage, instead of at the beginning of this work. However, there are several reasons for doing so.

First, one may have made proportional comparisons automatically when studying the diagrams of the skeleton presented earlier. This might have been a natural tendency for some, but not for others. Some may have become frustrated, and consequently may have devised some personal method for establishing proportions. Self-effort of this kind is not uncommon, and often necessary in the course of one's studies.

Second, mention was made at the beginning of "The Figure in Depth" which emphasized that the beginner might be confused trying to get "correct" proportions when drawing a foreshortened view. Preference was given to careful observation and the making of visual, proportional comparisons. Proportions, or systems of measurement, after all, deal with material seen within the same plane, which is seldom the case when viewing the actual figure.

Third, proportions vary with various "systems," or "canons." For instance, El Greco elongated his figures well beyond "normal" proportions. Michelangelo made his figures of monumental proportions; Goya made his figures more earthy. A sculptor like Henry Moore disregards proportions in his drawings, which are aimed at creating essays of positive and negative forms and volumes. Although they have their origin in the figure, these are departures which greatly alter "normal" standards of proportions.

Perhaps the last and most important reason for not introducing proportions earlier is that "correctness" can lead to rigidity, which is the *antithesis* of our concern. Though much information has to be learned concerning the figure, it is essential to maintain, as much as possible, the concept of the figure as a *mobile, dynamic form*, expressive of many states, gestures, and attitudes. Hence, what follows concerning proportions should be considered in the light of helpful information, to be interpreted along with the drawing of the figure, adjusted to it. No slavish preoccupation with proportion (or with anatomy, for that matter) will produce good drawing.

Most instructors of anatomy use the skull as the basic unit of measure. The "normal" figure of an adult is approximately seven and one half heads in length. Sometimes an eight-head figure length is used, and in fashion drawing or for special elongated effects, a nine-head figure length may be established. Fewer head lengths are used in drawing children. This is best determined by making visual assessments, rather than following any preestablished system.

Refer to Figure 8.31 to see how the seven-and-one-half-head figure is established. Compare the skull to other parts of the body to judge their relative head sizes. For instance, the scapulas and clavicles, hands and sacrum are just about one head length. The ribcage is about one and one half head lengths, as are the humerus, the tibia, and the fibula. The femur bones are two head lengths. The bones of the lower arm, the ulna and radius, are slightly longer than a single head length. The midpoint of the

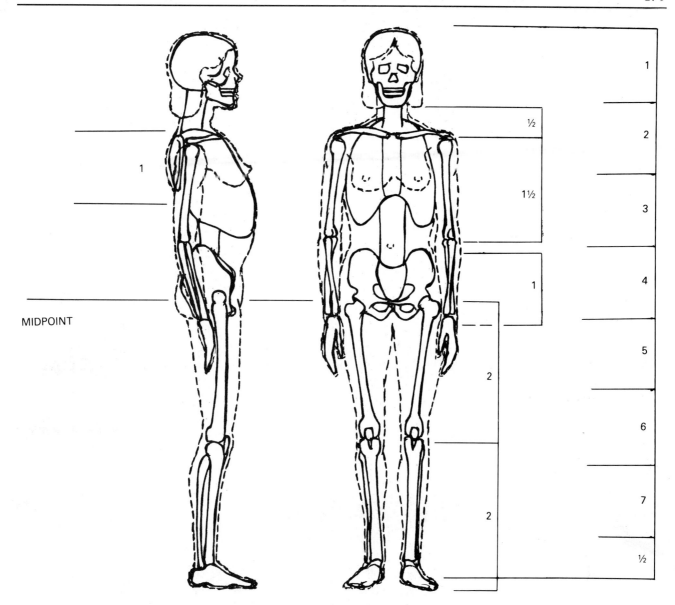

MIDPOINT

FIGURE 8.31

skeleton is at the pubic bone, though in the female it may be slightly higher. Notice, too, that the upper arm bone (humerus) ends between the ribcage and the pelvis. Also be aware of how the foot is included in the two head lengths of the lower leg bones (the tibia and fibula). Study the skeleton in this manner to familiarize yourself with such relationships of proportion.

Study 1.

Select a previous drawing of the figure, perhaps one you made of the clothed figure. Lay a piece of tracing paper over it and secure this overlay with masking tape. Using an HB pencil, draw the skeleton, establishing all of its parts. You need not draw every rib in the ribcage, nor the intricacies of the pelvis or the skull. Keep these forms simple; however, you may try for some articulation. For instance, you may show how the upper arm bone fits into the shoulder girdle, which consists of the clavicle (front) and the scapula (in back).

In a side view, the shoulder girdle will be foreshortened. Notice how the vertibrae of the neck relate to the shoulder area and the skull. Be aware of the angle of the neck; don't make it a vertical form, which is a mistake many beginners make. The neck follows the gentle "S" curvature of the spinal column, and should not be tacked to it. Try to get a feeling of the curvature of the arm bones and the leg bones. Notice how they emerge from the larger parts (ribcage and pelvis) and the general character they assume. Refer

FIGURE 8.32

to the previous diagrammatic indications of the skeleton, if necessary. Spend as much time as you need on this drawing (perhaps half an hour). Then finish the drawing by adding the contour of the figure, which may be only partially revealed in the clothed figure study which you are working from. An example of this study is shown in Figure 8.32.

Make several other analytical studies using previous drawings, photographs, and reproductions of other artists' work. An hour or two of such work over a period of one week will be very rewarding. Notice how this analysis differs from previous work with skeletal symbols. In the previous studies, the objective was to work up to indications of the skeleton, building your drawing over gesture and two-dimensional indications that resulted in more complete drawings of the skeleton. In the present studies, you are searching out the skeleton, trying to achieve proportions and relationships that are implicit. These two analytical works complement each other, resulting in a better understanding of the skeleton and its importance in drawing.

You may think of other ways of making skeletal studies. Try analyzing some of your early figure drawings that are obviously badly proportioned. Lay a piece of tracing paper over one of these and make an analytical study of the skeleton, correcting the proportions as you develop the work. Then lay another piece of tracing paper over the skeletal analysis and make another drawing which will be an improvement over the original drawing.

THE TORSO

The torso takes up most of the bulk of the figure, including the ribcage, the pelvis, and the stomach (epigastrium), forming a flexible, muscular area. Refer to Figure 8.33.

The ribcage appears wider when viewed from the front. It consists of twelve pairs of ribs, attached to corresponding thoracic vertebrae of the spinal column. The ribs arc slowly downward, then arc up in front to attach to the sternum, or breast bone. The seven pairs of ribs in the upper area are called "true ribs," since they attach directly to the sternum by means of cartilage. The five lower ribs are considered "false ribs," which attach to common cartilage in a band that extends up to the cartilage of the upper ribs, flowing into the lower portion of the sternum. The ribcage houses such vital organs as the heart and lungs. It is almost impossible to consider the ribcage without considering the shoulder girdle, since the two are totally interrelated through movements of the upper torso and arms. However, we shall consider the pelvis next, then the shoulder girdle.

The pelvis may be considered as a single bony mass, as shown in the close-ups in Figure 8.34. We are most familiar with its two portions that surface in the nude figure: the sacrum at the base of the spine, and the anterior superior iliac crests, observable in both frontal and side views. Figure 8.35 illustrates the male and female pelvis, which house the intestines and reproductive organs. Note, in the side view, the socket into which the upper femur bone fits (great trochanter). Later, we will study how the muscles interrelate with the pelvis and femur.

THE SHOULDER GIRDLE

As the term implies, the shoulder girdle consists of bones that relate in an elliptical sequence that girdles the upper area of the ribcage. The diagrammatic view presented in Figure 8.36, illustrates the bones of which it is comprised. Looking down onto the formation, we are aware of bones normally seen in a frontal view: the clavicles that attach to the sternum, and portions of the scapula, consisting of the coracoid process and the acromion process. The back view consists of the major portions of the scapulas. This marvelous formation allows for much flexibility. Raising one's arms, a simple action, depends on an unparalleled engineering feat performed by arm and shoulder girdle muscles.

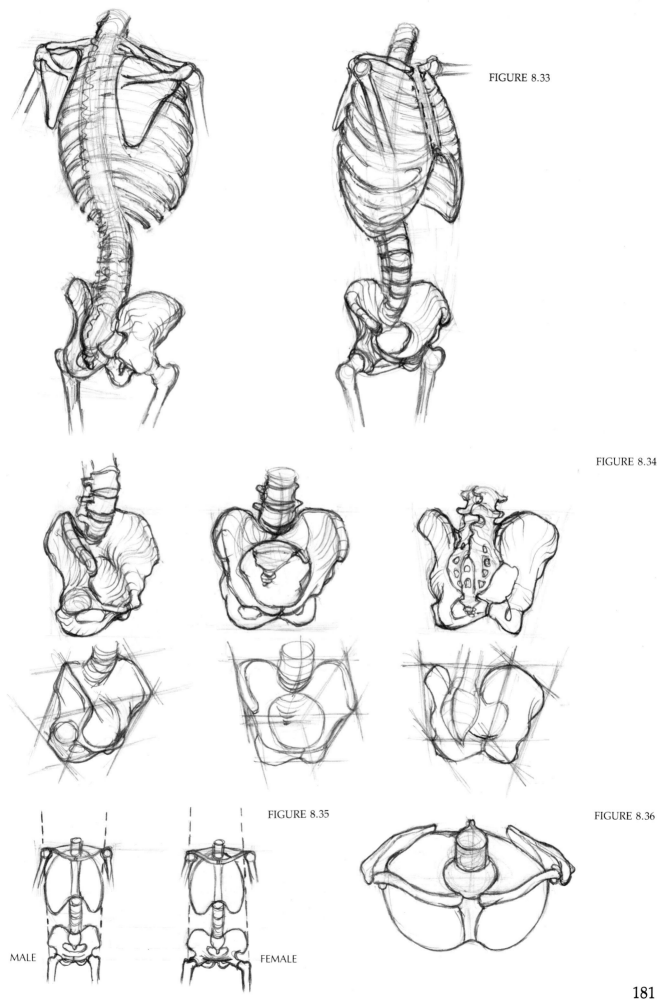

FIGURE 8.33

FIGURE 8.34

FIGURE 8.35

FIGURE 8.36

MALE

FEMALE

FRONT VIEW SIDE VIEW BACK VIEW INSIDE VIEW

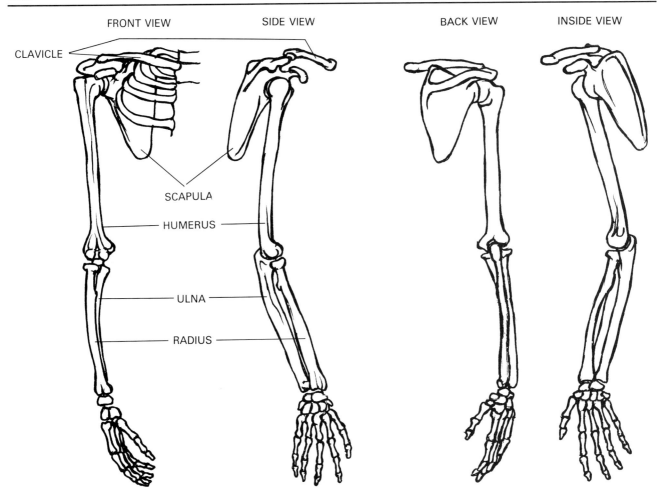

CLAVICLE

SCAPULA

HUMERUS

ULNA

RADIUS

FIGURE 8.37

THE ARM

The arm consists of three bones. The largest of these, the humerus, is the upper bone that relates to the shoulder girdle. The lower arm bones consist of the ulna and the radius. As the name implies, the radius rotates around the ulna in certain actions. When you turn your hand so that the palm is up, the bones of the ulna and radius are parallel. When you reverse the movement (palm down), the radius crosses over the ulna. The rotating action of the radius, combined with the hinged joint action of the ulna with the humerus, make possible a variety of movements. Investigate some of these movements as you read this explanation. Turn your hand so that the palm is up, then let it return to its normal position, palm down. Note what happens. Raise and lower your arm a few times, rotating your palm as you do so. Be aware of how it feels and what is happening. Doing so will give you some early insight into the functions of the muscles of this area. Figure 8.37 provides four views of the arm for you to study.

There are twenty-seven bones that comprise the wrist and the hand. The wrist has eight carpal bones. The palm of the hand contains five metacarpal bones, and the fingers contain fourteen phalanges, or finger bones. Study the diagram in Figure 8.38. Then move your hand in different positions, bending your fingers. Note how the normal action of extending the fingers creates a rake-like shape, fanning outward. When you bring your fingers together, they tend to form a cone-like formation in which all the fingertips touch.

THE LEG

The leg consists of four bones, the largest of which is the upper leg bone, the femur. The tibia and the fibula, the lower leg bones, parallel each other. And the patella (kneecap) is attached to the tibia by a ligament. See Figure 8.39 A.

The ankle consists of seven tarsal bones, which, in turn lead to the metatarsals and phalanges of the lower part of the foot. Notice how these bones form a gradual arch from a side view. The frontal view also presents an arch formation of bones. Keep these arches in mind when you draw the leg. They are relatively easy to draw as part of the total structure for the ankle and foot. Notice how the fibula relates to the ankle in a position that is lower than the tibia (frontal and back views), as shown in Figure 8.39 B. Compare the foot with the hand. Notice how the metatarsals of the foot correspond to the metacarpals of the hand; and how the phalanges of the foot relate to the phalanges of the hand. You'll find, however, that the range of movements of the hand far exceed those of the foot in the human figure.

THE SKULL AND THE SPINAL COLUMN

The skull is the most visible part of the skeleton, while the spinal column is mainly visible from the back view. The neck is an essential part of the spinal column, terminating at the skull. Although the skull consists of twenty-two bones, we shall simplify our study by being concerned with *only* the three bones constituting the mass of the cranium: the zygomatic and maxillae, the nasal bone, and the mandible or jaw bone.

Most of us are familiar with the zygomatic bones, or cheek bones, which are prominent in the total character of the head. The cavity created by these bones, with the front part of the cranium (superciliary bone), houses the ball of the eye. The mandible or jaw bone is the only movable bone of the skull.

The neck is comprised of seven cervical vertebrae of the spine. These vertebrae are responsible for the action of the head. The rest of the spine

FIGURE 8.38

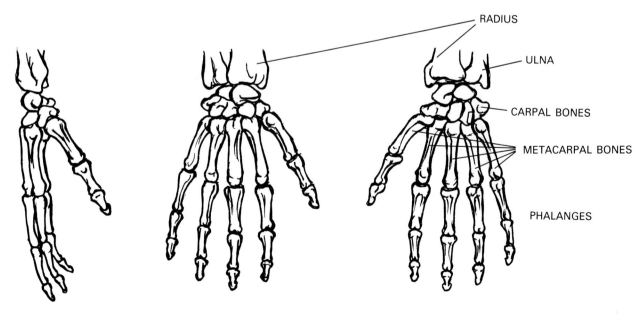

RADIUS

ULNA

CARPAL BONES

METACARPAL BONES

PHALANGES

THUMB-SIDE BACK INSIDE

FIGURE 8.39

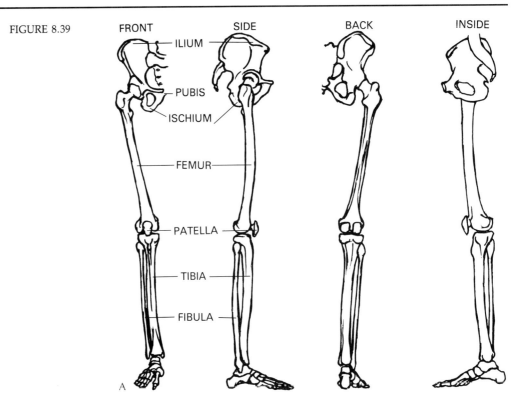

FRONT SIDE BACK INSIDE

ILIUM

PUBIS

ISCHIUM

FEMUR

PATELLA

TIBIA

FIBULA

A

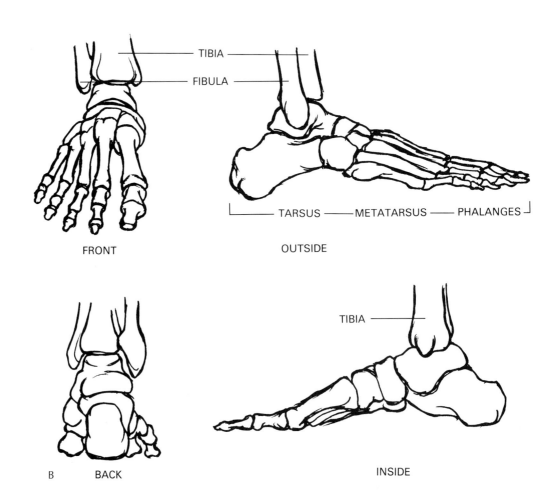

TIBIA

FIBULA

TARSUS — METATARSUS — PHALANGES

FRONT OUTSIDE

TIBIA

B BACK INSIDE

FIGURE 8.40

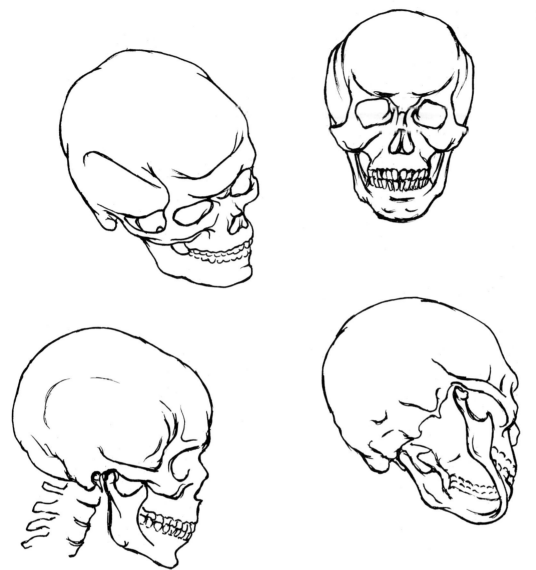

consists of twelve thoracic vertebrae, five lumbar vertebrae, the sacrum, and the coccyx. The ribcage has attachments to the thoracic vertibrae; the pelvis incorporates both the sacrum and the coccyx.

In addition to the diagram in Figure 8.31 (the total skeleton), you should study Figure 8.40, which shows several drawings of the skull. Become familiar with these different views and the main bones involved.

The spinal column is highly simplified in Figure 8.41. Note the various divisions of the vertebrae, and the curves which characterize the main divisions.

SUGGESTED STUDIES

The following studies are suggested mainly for the beginner. Most art schools have skeletons for anatomical studies. If a skeleton is not available, get photographic material that will permit the range of work suggested. It may be possible to make studies of a skeleton used in medical labs of colleges and other institutions. Call your local doctor or hospital for help in this regard. Work directly from the skeleton whenever possible.

Time limits will not be set, nor will materials be specified. These may

FIGURE 8.41

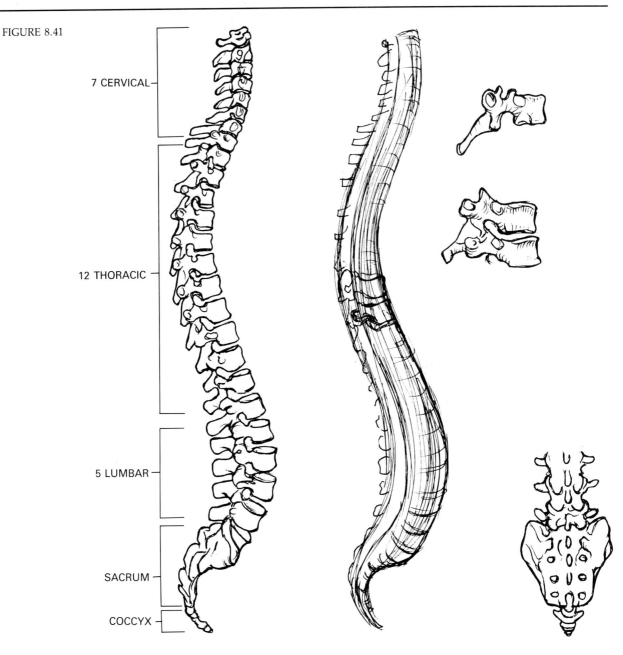

7 CERVICAL

12 THORACIC

5 LUMBAR

SACRUM

COCCYX

be determined by the individual. However, beginners are encouraged to work with an HB pencil on a smooth drawing stock, or in a sketchbook. Like other work, these studies can form a sequence of study for evaluative purposes.

Torso Studies. *View the skeleton in a three-quarter position (front and side). The forms of the ribcage and pelvis should be clearly seen in moderate light and dark effects, as well as in contours. Place the skeleton against a dark background surface to heighten allover contrasts, if possible.*

Use a large section of your paper for this drawing. After lightly indicating the general contours of the ribcage, pelvis, and portion of the spinal column that flows through them, make an exacting drawing. This should develop slowly. Use the skeletal symbols you studied earlier to create the basic structures. Carry these structural indications into more accurate delineations of each portion. Move gradually from basic, outer contours of the allover forms into inner contours, working up to drawing such specifics as the ribs, the sternum, the clavicles, and other visible portions of the ribcage. Do the same with the

pelvis and sections of vertebrae. This may take two hours or more, and should not be rushed. Erase when necessary, but your light, tentative, additive approach should minimize corrections of this kind. Take a short break (five to ten minutes) during your work session. You will return refreshed and more perceptive.

Repeat this study, drawing a three-quarter back and side view. Look carefully and articulate the subtle modifications of the scapula and the acromion process. Make the curvature of the spine so convincing that the drawing will appear as a sculptured form, all but leaping off the paper.

Make other drawings of this kind, studying sections such as the shoulder girdle or portions of the pelvis where the femur bone is attached. Intermittent torso studies over a period of one week will greatly sharpen your perceptions. Test yourself in this regard. Look at people as they walk by, or when you are waiting in line at the grocery store, and try to determine where their anatomical sections are. Imagine that you are drawing various parts in great detail. Then go home and draw a pose from memory. Refer to your more detailed studies, whenever necessary. This process stimulates the imagination and improves memory retention to a surprising degree.

Draw the bones of the arm at right angles, making the drawing as detailed as possible, using the method described in the torso studies. After finishing this drawing, prop the lower portion of the arm on a chair, or some other support. Draw this so that the ulna and radius will be foreshortened about half of their length. Use cylindrical forms in setting up the drawing, making the foreshortened aspects of drawing easier. Box in the wrist and the hand. Then draw simple forms within such shapes before drawing the details of the bones in the wrist and the fingers that are visible from your position. **Arm Studies.**

Rotate the radius so that the under surface of bones of the hand will face upwards. Make another drawing, following the procedure already established. Get a convincing effect of how the bones of the ulna and radius parallel each other, how the bones of the wrist emerge, and how the finger bones are aligned and interrelated.

Change your position to get a different view of the same upraised arm and make another drawing of a similar nature. Then switch your position so that you view the same situation from the back of the skeleton. Make another drawing. Seek out and draw the articulation of the lower portion of the humerus (epicondyles), and the end of the ulna (olecranon process) where it fits into the end of the humerus. Rotate the radius so that it crosses the ulna. Make some drawings that relate to the ones you have already drawn.

Make your drawings show how the femur bone emerges from the pelvic area. Include the other leg bones and foot bones, as well. Make the first drawing from any view that suits you, keeping in mind that you will make at least two other drawings of the leg and foot bones from different positions, showing different views. Pay particular attention to the drawing of the patella and how it relates to the upper and lower leg bones. Try a view or two that clearly indicate the relationship of fibula and tibia to the arch of the foot bones, noting that the fibula (outside) extends lower than the tibia (inside). Note carefully the formation and character of bone endings and their relationship in contact with other bones. **Leg Studies.**

Place the skeleton in a seated position and make some drawings of leg bones in a bent position. Supplement these drawings by detailed analysis of the drawing of joints at the knee and the foot. Change your position for foreshortened effects, and make a few more drawings. Draw the foot and ankle bones in various positions, some of which should show foreshortened views. As before, go from general, symbolic indications to more specific, detailed delineations.

Make three large drawings of the skull on a single sheet of paper. These should be aligned with each other so that comparisons can be made of the three views: the placement of the eye sockets, the zygomatic arches (cheek bones), the frontal bone of the cranium, and the maxilla and mandible. These views should not simply be diagrammatic and flat (front, side, and back), but should show several surfaces. In your drawings, convey areas that recede (hollowed-out surfaces) contrasted with areas that advance (extended surfaces). Use cross-contour or cross-hatched lines to create a heightened sense of form. Pay par- **Skull Studies.**

ticular attention to how the jaw bone (mandible) hinges to the larger portion of the skull, near the zygomatic bone and the mastoid process. Emphasize the three-dimensionality of the skull in these three views.

In addition, make some other studies of the skull from below and above eye level. Get the important foreshortened aspects from these different views. In drawing the skull from below eye level, make sure that you indicate the bones of the neck and how they fit into the under portions of the skull. Look for foreshortened relationships that will be different from those that you will find when you draw the skull from above eye level. In the latter study, notice how the dome of the skull dominates and other portions are subordinate, being highly foreshortened.

Make some additional small studies of the skull, if you wish. For instance, prop the jaw open (a short stick, or rolled-up piece of paper would work) and make a few drawings from different angles. These should be quick studies, simply to show the relationship of the jaw to the large mass of the skull.

THE MUSCLES

Like rubber bands, muscles work by contracting their fibrous bodies and act as levers in moving the bones to which they are attached. Throughout the body, when one muscle, or a set of muscles, contracts, muscles on the opposite side are activated, which result in coordinated movements.

Muscles taper to smaller areas, or points, where they are attached to bones. As children, we may have been asked to "make a muscle," and we immediately bent one arm up, making the biceps of the upper arm as large as we could. Try doing this now, slowly, and note how the muscle increases in size at the midpoint. Follow its taper up to the humerus, then down to the radius in the lower arm, where it terminates.

The names of muscles often indicate their actions. For example, extensors increase, or extend, parts, whereas flexors pull such parts together. We shall examine some of these muscles. However, we will discuss only the muscles that affect the action of the figure and its surface contours.

FIGURE 8.42
JOHN SINGER SARGENT (1856–1925)
Sketches of Arms and Knee (CA. 1891–95?)
Charcoal and stump. 23¹³⁄₁₆ × 18⅝ in.
Collection of the Corcoran Gallery of Art, gift of Emily Sargent and Violet Sargent Ormond.

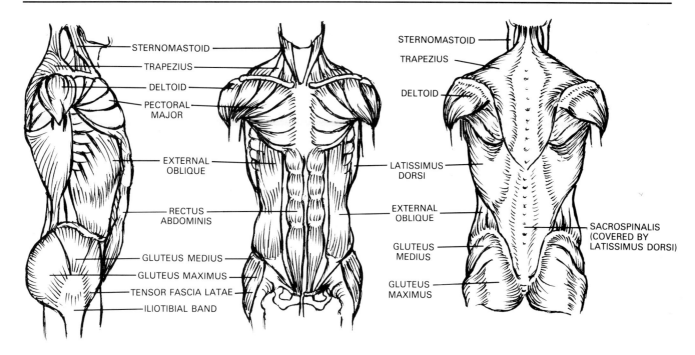

STERNOMASTOID
TRAPEZIUS
DELTOID
PECTORAL MAJOR
EXTERNAL OBLIQUE
RECTUS ABDOMINIS
GLUTEUS MEDIUS
GLUTEUS MAXIMUS
TENSOR FASCIA LATAE
ILIOTIBIAL BAND

STERNOMASTOID
TRAPEZIUS
DELTOID
LATISSIMUS DORSI
EXTERNAL OBLIQUE
GLUTEUS MEDIUS
GLUTEUS MAXIMUS
SACROSPINALIS (COVERED BY LATISSIMUS DORSI)

FIGURE 8.43

Figure 8.42 shows studies of arms and a knee by John Singer Sargent. Notice how certain surface muscles have been emphasized to give greater credibility to the actions of these parts. Can you identify these muscles from the various diagrams in the text?

Torso Muscles The muscles of the torso are schematized in Figure 8.43. Spend some time familiarizing yourself with these muscles, being especially aware of how some of the same muscles appear in different views; this will increase your awareness of their three-dimensionality and approximate placement over the bones or structures which they activate.

The muscles that activate the torso are the external oblique (side), the rectus abdominis (front), and the sacrospinalis (back—a deep muscle that affects surface form when active). These muscles exist within the flexible portion of the torso, permitting the torso to move in various ways (bending, twisting, flexing, and straightening the upper torso in relationship to the pelvis). The external oblique attaches to frontal and side portions of the ribcage and extends down to the iliac crest. The rectus abdominis attaches to the front of the ribcage (three lower ribs) and to the crest of the pubic bone (pelvis). The sacrospinalis muscles run the length of the spinal column on both sides of it; they are especially visible in the lower back portion.

Next, refer to Figure 8.44 and identify the torso muscles that are evident in each of the active poses.

The relationship of the torso with the upper and lower portions of adjacent anatomical structures requires that we look at some additional muscles. These will be discussed further in the appropriate sections.

In the upper portions, there are muscle attachments from the ribcage and the spinal column to bones of the shoulder girdle, the arms, and the skull. The pectoral muscles relate to the clavicles, the sternum, and the upper part of the humerus. The deltoid, a cap-like muscle, attaches to the clavicle, the scapula, and the upper portion of the humerus. Other muscles that attach to and activate the arm are the latissimus dorsi and the trapezius. The latissimus dorsi originates from the lower spinal area and the iliac crest. It curves upward to insert into the humerus. The trapezius resembles a cape that attaches to the last three thoracic vertebrae, the base of the skull

FIGURE 8.44

(occipital bone), the spine of the scapula, and around the top of the figure to the clavicle in front.

Another important muscle in the upper region is the sternomastoid, which runs from the clavicles to the base of the skull behind the mandible (mastoid process). Notice in Figure 8.43 how the two lower heads attach to the parts of the clavicles, close to the sternum.

In the lower portion of the torso, there are muscle attachments from the pelvis to the femur, two of which are very prominent: The gluteus medius and the gluteus maximus.

It is apparent that in considering some of the main muscles of the torso we have had to make reference to muscles that extend beyond it to other portions of the figure. The orchestration of the muscles of the total figure imply interrelationships that are difficult to isolate, and hence the divisions of muscles of the torso, leg, and so on, are useful as analytical aids that should be considered within the greater, holistic concept of the figure and to its various possible dynamic actions.

Arm Muscles Study Figure 8.45 which shows linear diagrammatic views of the arm. The heart- or cap-shaped muscle called the deltoid is responsible for lifting and pulling the arm forward and backward. The larger mass of the pectorals also assists the forward pulling action, while the latissimus

dorsi is responsible for pulling the arm back and downwards. The muscles in the shoulder girdle area assist in other arm movements, as well.

Other muscles in the upper arm control the movements of the lower arm. The biceps flex the forearm at the elbow, assisted by the brachialis. These are in the front portion of the upper arm, extending to the lower arm. The triceps, primarily visible from the back and side views, extend the forearm. Two other muscles that originate in the lower part of the upper arm and extend to the lower arm are the supernator longus (also called the brachioradialis) and the extensor carpi radialis. The former is used in turning the palm upward, the latter in extending the wrist. The pronator teres is a smaller muscle that extends from the humerus to the radius. It turns the palm of the hand downward and aids in other movements of the forearm.

The muscles in the lower arm may be simplified into two groups: flexors and extensors. Flexors are responsible for drawing the fingers together, as in making a fist. Extensors, as the word implies, extend the fingers. Flexors are identified by their attachments to the inner condyle of the humerus and continue along the inside of the lower arm. Extensors attach to the outer condyle and continue down the back of the lower arm. Figure 8.46 indicates some of these arm movements.

The large muscles (thenar and hypothenar) of the hand form the bulky masses of the palm side. The large thumb muscle (thenar) controls its actions, while smaller muscles activate the fingers.

Leg muscles The muscles of the leg are seen in Figure 8.47. Although they resemble those of the arm, their functions and actions are more limited. The muscles that move the upper leg are the gluteus maximus and the gluteus medius. These muscles originate in the pelvic area and attach to the upper portion (great trochanter) of the femur. The larger and more prominent of the two, the gluteus maximus, is visible mainly from the back and side views. It extends and turns the upper leg outward. The gluteus medius

FIGURE 8.45

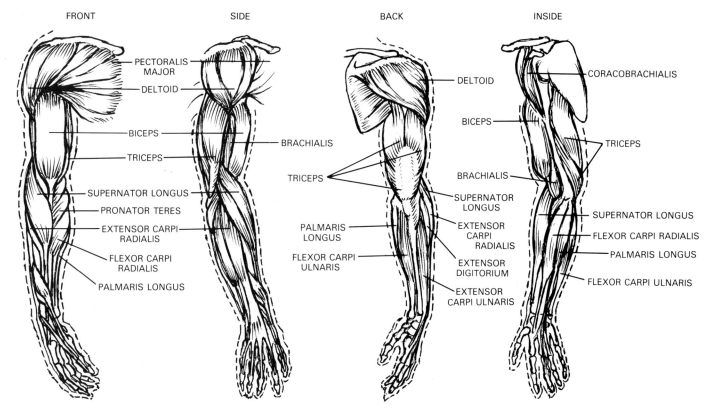

FRONT SIDE BACK INSIDE

PECTORALIS MAJOR
DELTOID
BICEPS
TRICEPS
SUPERNATOR LONGUS
PRONATOR TERES
EXTENSOR CARPI RADIALIS
FLEXOR CARPI RADIALIS
PALMARIS LONGUS

BRACHIALIS
TRICEPS
PALMARIS LONGUS
FLEXOR CARPI ULNARIS

DELTOID
BICEPS
BRACHIALIS
SUPERNATOR LONGUS
EXTENSOR CARPI RADIALIS
EXTENSOR DIGITORIUM
EXTENSOR CARPI ULNARIS

CORACOBRACHIALIS
TRICEPS
SUPERNATOR LONGUS
FLEXOR CARPI RADIALIS
PALMARIS LONGUS
FLEXOR CARPI ULNARIS

FIGURE 8.46

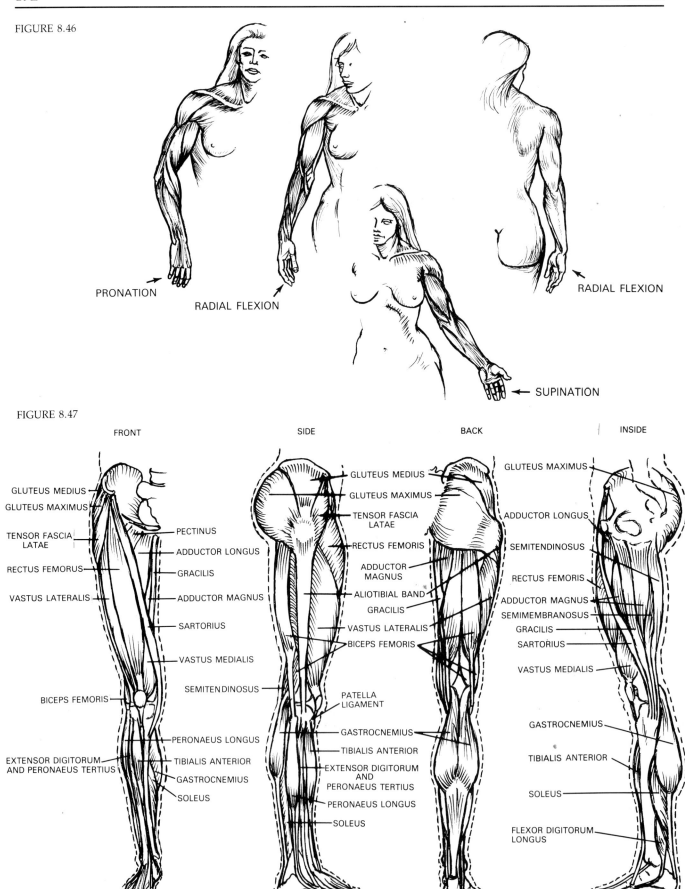

PRONATION

RADIAL FLEXION

RADIAL FLEXION

SUPINATION

FIGURE 8.47

FRONT

SIDE

BACK

INSIDE

GLUTEUS MEDIUS
GLUTEUS MAXIMUS

TENSOR FASCIA
LATAE

RECTUS FEMORUS

VASTUS LATERALIS

BICEPS FEMORIS

EXTENSOR DIGITORUM
AND PERONAEUS TERTIUS

PECTINUS

ADDUCTOR LONGUS

GRACILIS

ADDUCTOR MAGNUS

SARTORIUS

VASTUS MEDIALIS

SEMITENDINOSUS

PERONAEUS LONGUS

TIBIALIS ANTERIOR

GASTROCNEMIUS

SOLEUS

GLUTEUS MEDIUS

GLUTEUS MAXIMUS

TENSOR FASCIA
LATAE

RECTUS FEMORIS

ADDUCTOR
MAGNUS

ALIOTIBIAL BAND

GRACILIS

VASTUS LATERALIS

BICEPS FEMORIS

PATELLA
LIGAMENT

GASTROCNEMIUS

TIBIALIS ANTERIOR

EXTENSOR DIGITORUM
AND
PERONAEUS TERTIUS

PERONAEUS LONGUS

SOLEUS

GLUTEUS MAXIMUS

ADDUCTOR LONGUS

SEMITENDINOSUS

RECTUS FEMORIS

ADDUCTOR MAGNUS

SEMIMEMBRANOSUS

GRACILIS

SARTORIUS

VASTUS MEDIALIS

GASTROCNEMIUS

TIBIALIS ANTERIOR

SOLEUS

FLEXOR DIGITORUM
LONGUS

FIGURE 8.48

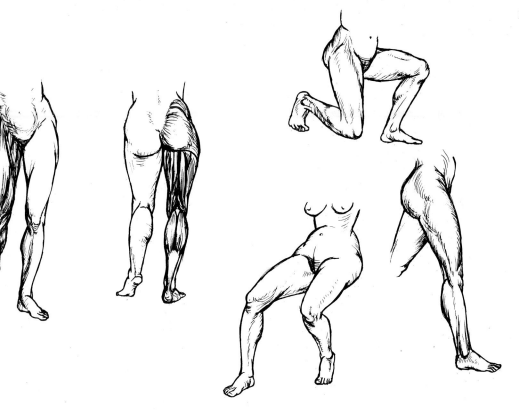

is visible from the back, the side, and partially from the front. It lifts and pulls the leg inward.

The inner upper leg presents us with the adductor muscles, which are not usually seen because they have a covering of fatty tissue. The most prominent of these is the gracilis, which creates the inner contour of the upper leg. It begins at the pubic bone and inserts into the lower leg bone, the tibia, on its inner side. The adductor group turns the thigh, or upper leg, and pulls it inward. A prominent muscle from the inner and frontal views is the sartorius. This long muscle divides the flexors on the front of the leg from the adductors on the inside. It originates at the upper tip of the iliac crest, moving inward in a curved direction down to the lower leg bone, the tibia, on the inner side.

The flexors are on the front part of the upper leg. The rectus femoris originates at the iliac spine of the pelvis. The vastus lateralis and the vastus medialis muscles originate close to the pelvic area near the top of the femur. These three muscles meet at the patella and share a common tendon.

Three major flexors of the lower leg are located opposite the rectus femorus, the back portion of upper leg. These are commonly called the "hamstring" muscles: the biceps femoris, the semimembranosus, and the semitendinosus. All originate from the lower pelvis. The latter two insert on the inner surface of the tibia; the biceps femoris inserts on the fibula. They are coordinate muscles that bend and pull the leg backwards.

The muscles that give much character to the back contour of the lower leg are the gastrocnemius and the soleus. The gastrocnemius attaches to the lower portions of the femur bone, between the hamstring muscles. These muscles flow into the Achilles' tendon, which attaches to the heel bone. They extend the foot at the ankle juncture.

Muscles in the front and side of the lower leg that help to establish its contours are the tibialis anticus (flexes foot and raises inside edge), the

extensor digitorum longus (extends the toes), and the peroneus longes and brevis (extends foot and lifts outside of sole). These are thinner muscles, compared to the gastrocnemius.

We shall not analyze the foot muscles. More important in the contour of the foot are its tendons, bones, and fatty portions.

Some actions of the leg can be seen in Figure 8.48 and should be studied.

Head and neck muscles We shall be concerned here only with the muscles that are primarily responsible for the movement of the jaw. Other muscles of the face relate to facial expression, and students who are interested in portraiture or caricature should seek out reference works on those subjects.

One of the largest muscles of the face, the temporal muscle, begins in a fan-like shape at the temporal bone. It moves down under the zygomatic arch to the upper portion of the jawbone. The masseter, another large muscle, begins at the zygomatic arch and inserts at the back of the jawbone. Together, these muscles perform the various opening and closing actions of the mouth, and are responsible for chewing, biting, and grinding.

Among the principal neck muscles are the sternocleidomastoid and the trapezius. The sternocleidomastoid has attachments at the top of the sternum, at an inner portion of the clavicle, and further up and back at the mastoid process (base of skull near the ear), which produce forward and downward actions. Portions of the muscle also relate to side motions. The muscles of the throat that relate to movements of the tongue bone (hyoid) are lodged between sternocleidomastoid muscles, which flank it. The thyroid cartilage, which is more popularly known as the Adam's Apple, is slightly below and in front of the hyoid bone.

The trapezius muscle creates contours of the neck seen from several views. Its attachments to the base of the skull, and the manner in which it moves forward to the front portions of the clavicles, make it particularly interesting when drawing the neck and head. It also attaches to the scapula and to the thoracic vertebra, and pulls back and inclines the head.

Three less visible muscles are the splenius, levator scapulae, and the scalenus. These, however, are seldom emphasized in drawing, though they do affect movements of the neck.

The head and neck muscles are illustrated in Figures 8.49 and 8.50.

Musculature studies The studies need not be followed in strict sequence. The work will begin with applied considerations and relationships with previous studies, after which other types of problems will be suggested for study. Materials and time limits are optional, unless otherwise specified.

Study 1. *Refer to the two- or three-minute drawings you made when first studying the skeleton (See Figure 8.28). Lay a piece of tracing paper or layout bond over the previous drawings and tape it into place. Then, make quick gesture indications of the muscles that relate to each of the quick, skeleton drawings. Do this as vigorously as possible, without being too precise. These drawings could be made with a B graphite or charcoal pencil for massing in muscles. Limit yourself to two or three minutes for each drawing. (See Figure 8.51.)*

If you experience difficulty in making these quick, gesture drawings of muscles, repeat the study until you feel more confident. You will realize how essential it is to stress muscles that convey the action of the figure, while minimizing others. You will also become familiar with those muscles that can be seen in a given position, and those that cannot.

Study 2. *Work from the three views of the skeleton you made previously. These were fifteen-minute studies of a standing pose and two bending poses. Tape a piece of tracing paper over the drawings, and make a study of the muscles that are associated with each pose.*

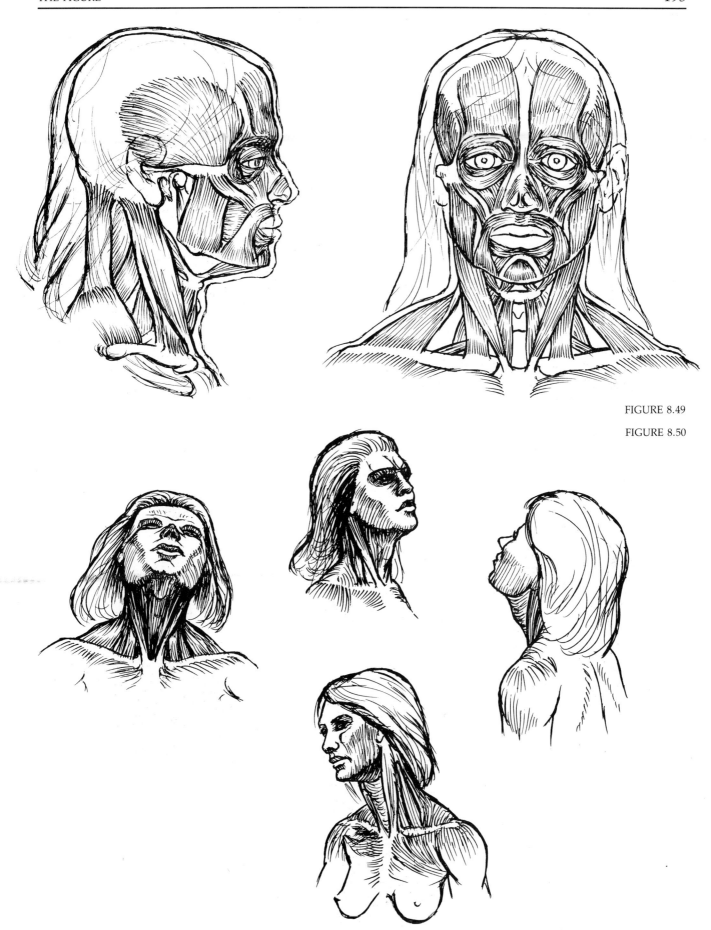

FIGURE 8.49

FIGURE 8.50

FIGURE 8.51

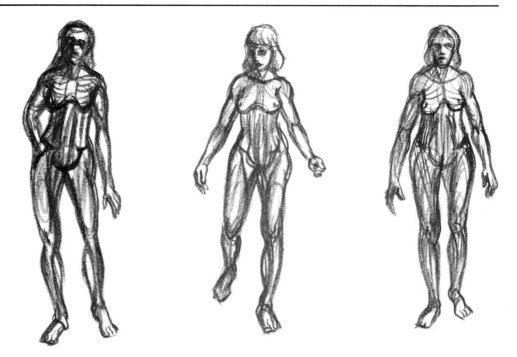

You may devote as much time as you wish to these studies. Finalize the drawings by adding contours (outer edges of figure). If the three views are frontal views, select a previous study of back views and make an analysis of the muscles. After finishing the back views, develop a similar muscle study using the previously drawn side views of the skeleton.

In these studies, hands and feet should be developed in simple, structural terms, with some suggestion of bones and muscular bulk, and how tendons from muscles flow into such forms.

Study 3. Take one of your previous studies of the clothed figure. (If possible, one that you have already developed in terms of a tracing overlay depicting the skeleton.) Now draw the muscles on a second overlay, making additional corrections in proportion. Work out to the final contours, imagining where the skin would overlay the muscles.

Study 4. Refer to previous skeletal drawings you made concerning the torso. Select one of these and make a detailed study of muscles on an overlay. This detailed study should take an hour or so. After completing this drawing, make another one showing a different view of the torso muscles, using the overlay technique. After finishing the second drawing, select another view of the torso which differs from the previous two. Repeat the study. Finalize these drawings by indicating outer and inner contours that seem essential in creating a convincing three-dimensional character.

Study 5. Using the procedures described in the previous exercises, select several skeletal drawings of the arm and leg muscles and make detailed analytical studies of each. Two or three analytical drawings of each part will make you aware of the action of muscles typical of the gestures assumed. Foreshortened views will present a challenge. Sketch the simple, planar, and geometric masses first, before drawing the actual muscles.

It may be difficult to imagine the actual appearance of the muscles in these studies; therefore, ask your model to take poses that relate to your drawings of the skeleton. You may also use yourself as a model with the aid of a mirror, or employ photographic references. Take as much time as you need for these studies.

Study 6. Referring to any of your previous drawings of the skull, ask your model to take a related

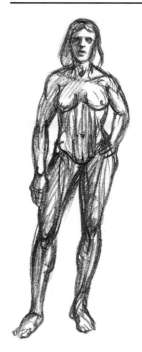
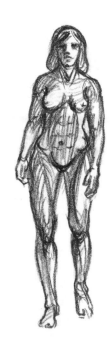
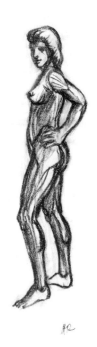

pose (preferably seated), and make a drawing of the masses of the skull and neck, including the upper ribcage. Do this very lightly and tentatively, so that you can make a more emphatic study of the contours of the head and neck later. Be aware of any muscles of the head and neck that have surface interest. The drawing should develop slowly, taking an hour or so. If the model is a female with long hair, seek out the underlying anatomical structures and lightly indicate them, as if they were X-Ray portions. Finalize the drawing by adding tone. Fit eye details into the eye sockets before drawing the actual eyes. Make the lip planes that fit over the mandible before trying to capture their unique character. Gradually construct the drawing so that final applications of superficial effects will be anchored within a sound anatomical structure.

Make three or four smaller head studies which show different views, including looking at **Study 7.**
the model at eye level, above eye level, and below eye level. Use previously drawn studies of the skull as a basis for this work. Spend about fifteen to twenty-five minutes. Pay particular attention to foreshortened views, and create simple structures before you get into complex considerations. Find contact points of muscles that span the neck region, locating their placements in the skull, scapulas, and clavicles. Getting a likeness should be a byproduct, rather than a prime consideration. Examples of strong head studies are seen in the mixed media drawings of Enoch Wood Perry in Figure 8.52. Notice how form has been subtly modeled in pencil and charcoal, highlighted by Chinese white.

Find sources that show an extremely thin figure and a rather full figure. Make complete **Study 8.**
figure studies of each in which you first indicate the skeletal structure, then the muscles. You can also modify previous drawings, or refer to the work of El Greco for thin, attenuated figures, and that of Rubens for fuller, more ample figures. These drawings should be made in ten or fifteen minutes. Then, develop a few in larger scale, with greater definition.

Select an example of some artist's figure study that you particularly like, and use this as a **Study 9.**
basis for an anatomical study. First draw the skeleton, and then add the muscles. Several studies of this kind will help you determine if the artist has either conformed to the natural proportions of the skeleton and musculature, or has made departures, based on a particular expressive idiom. After making such a drawing, conceive one of your own and develop it.

FIGURE 8.52
ENOCH WOOD PERRY, JR.
*Six Sketches: Five Heads of an Old Woman
and a Hand*
Pencil, charcoal, and stump, with
Chinese white.
*Collection of the Corcoran Gallery of Art, gift of J.
William Middendorf II.*

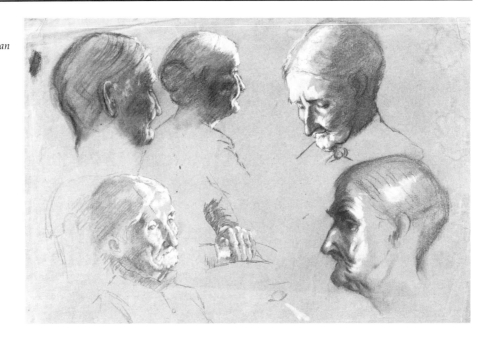

SUMMATION OF FIGURE STUDY IN DEPTH

The preceding study explored the structural, skeletal, and musculature aspects of the figure. Various analytical studies were outlined to help you acquire a sound orientation upon which to build and develop your own particular concerns in more personal work later. For further study, concentrate on the figure in emotional states such as anger, dejection, aspiration, or joy. Or work with specialized figure subjects such as dancers, acrobats, or athletes, applying the essentials of this study. There are as many possibilities as there are individual differences and interests.

Certain long studies were suggested; however, you may wish to devise long studies of your own, as a natural consequence of this work. For example, make a large study of some friend or relative, trying to capture the person's character and physical qualities. Applying the principles you have learned, your drawings should please both you and your subject.

Experiment with materials that you have not used. For instance, repeat some of the studies using pen and ink, or try mixed media of various sorts. Reworking drawings in this way can lead to new discoveries and possibly new interests. If you are studying oil painting (or have studied it), you may wish to reinterpret a drawing using acrylics, or vice versa. Or use a previous drawing as a point of departure for a large, expressive painting.

If you are interested in sculpture, rework some drawings in clay or plaster. Relating the two-dimensional character of drawing to the three-dimensional character of sculpture reinforces the total concept of the figure, which, in turn, enriches your creative potential.

Inventing compositional studies is another creative adaptation, either in drawing or in painting. Use some of your gesture work to suggest a compositional theme relating to a contemporary political or social issue of interest. Or, if you are of a contemplative nature, develop a theme concerning meditation, or "the inner landscape."

9

SPECIAL DRAWING PROJECTS

Preliminary Considerations

Most of our study has focused on the basics of the drawing process. We have also considered the importance of the creative attitude and some expressive possibilities inherent in pictorial forces and in the use of certain methods and materials. In this chapter, we shall explore analytical studies of the work of some artists. We shall try to determine the quality of expressive meaning and how such meaning is brought about. This will help the beginner to recognize applications of much that has been covered in earlier chapters. By means of this study we hope to gain some grasp of artistic intent and how it is manifested, which will serve as a basis for further study and application.

Analytical Studies

It is appropriate to begin with the work of an artist who relies heavily on the importance of gesture at the inception of a work and throughout. One such artist is Elaine de Kooning. In Figure 9.1, we see how the artist has developed several gestural studies on the theme of basketball. Directional lines form the skeletal structure for the compositions. Figures have been reduced to linear energy forces that convey movement, rather than realistic forms. However, as the work progresses, the artist often builds upon preliminary gesture by making separate drawings that do suggest individual figures, as you will note in Figures 9.2 and 9.3. The artist may make several studies which vary between gestural and contour compositions before one or two final statements are made in paint or in a mixed media composition. In Figure 9.4, we see how one of the final statements incorporates both

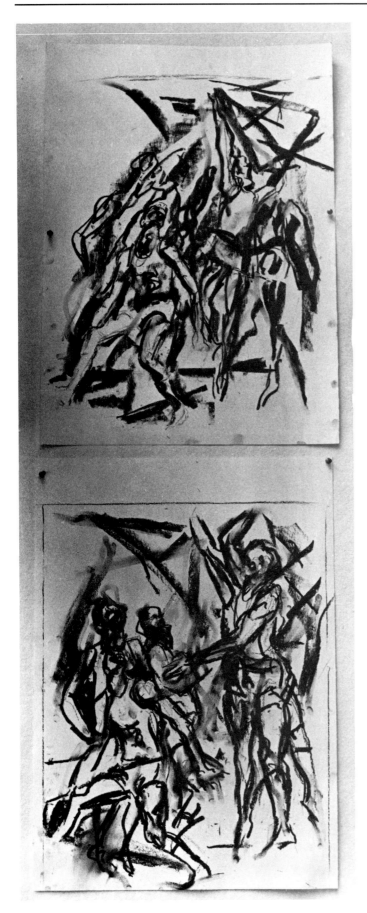

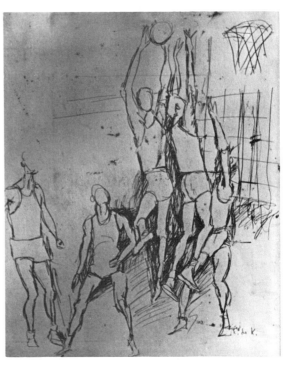

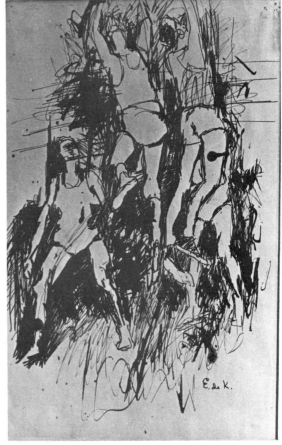

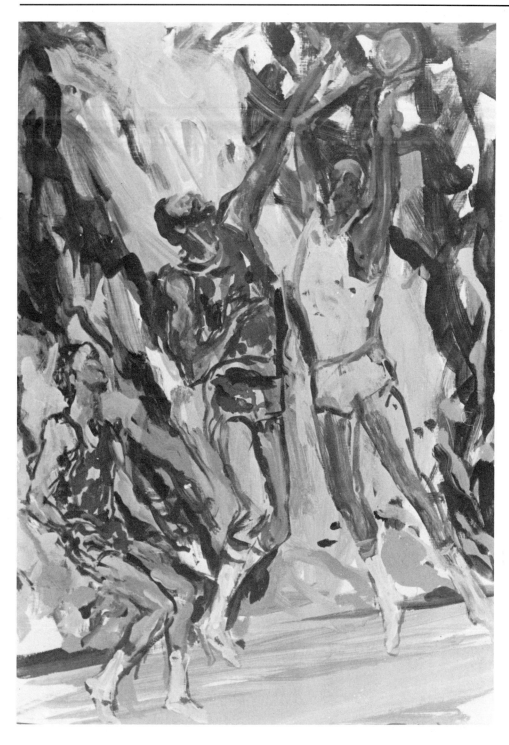

(opposite, far left)
FIGURE 9.1
ELAINE DE KOONING
Basketball Players (1979–80)
Charcoal. 28 × 22 in.
Photo courtesy A. Russo.

(opposite, top right)
FIGURE 9.2
ELAINE DE KOONING
Basketball Players (1979–80)
Ink. 28 × 22 in.
Photo courtesy A. Russo.

(opposite, bottom right)
FIGURE 9.3
ELAINE DE KOONING
Basketball Players (1979–80)
Ink. 28 × 22 in.
Photo courtesy A. Russo.

(left)
FIGURE 9.4
ELAINE DE KOONING
Basketball Players (1979–80)
Acrylic on canvas. 30 × 24 in.
Photo courtesy A. Russo.

gesture and figurative suggestions. The use of a nervous line, applied in a staccato fashion, conveys movement and an intense sense of energy. Although several leaping figures are suggested in the central portion of the composition, the sense of action is really created by the activation of linear patterns and movements. That is, the artist has relied on the action and movement that are brought about through the expressive use of materials and the manner of their application, more than through depicting the action of figures, per se. It is important to note, then, that not only are her preliminary drawings devoted to capturing the meaning of action by the use of appropriately activated linear structures, but that the final painting, as well, depends on the carry-through of such linear structures.

However, not all of Elaine de Kooning's work is of such a generalized abstract nature. She also has an intense interest in portraiture, reflecting her concern with sound principles of draftsmanship. For instance, Figures 9.5 and 9.6 are charcoal studies of the late President John F. Kennedy. The study of Kennedy in a seated position tells us something essential about his habitual posture and intense nature. The close-up head study shows how the artist captures likeness and character with a minimal use of lines. These concerns find a fusion in the larger-than-life acrylic portrait of Kennedy (Figure 9.7). Note how the nervous, energy-producing lines of the background enhance the vitality of the total work.

Alice Neel devoted much of her life's work to portraiture, for which she received much acclaim. Let us compare two of her works. One is an ink drawing (Figure 9.8); the other is an oil painting (Figure 9.9). Although these are contrasting works from an expressive point of view, they have much in common from a technical point of view.

The ink drawing of poet Adrienne Rich shows the figure in a frontal position. The hair, dark at the upper portion and light at the lower (in

(below, left)
FIGURE 9.5
ELAINE DE KOONING
The late president, John F. Kennedy (1962–63)
Charcoal. 28 × 22 in.
Photo courtesy A. Russo.

(below, right)
FIGURE 9.6
ELAINE DE KOONING
Head study of the late president, John F. Kennedy (1963)
Charcoal. 28 × 22 in.
Photo by John Reed.

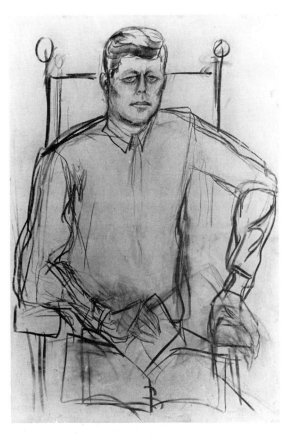

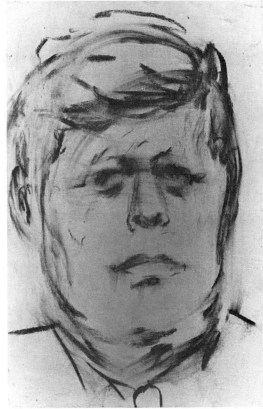

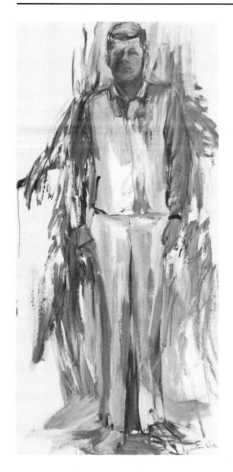

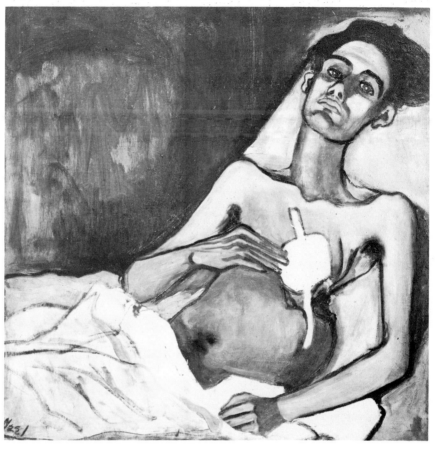

(above, left)
FIGURE 9.7
ELAINE DE KOONING
J.F.K. (1963)
Oil on canvas. 116 × 59 in.
Photo by John Reed.

(left)
FIGURE 9.8
ALICE NEEL (1900–1984)
Adrienne Rich (1973)
Ink. 29¾ × 22¼ in.
Courtesy Robert Miller Gallery.

(above, right)
FIGURE 9.9
ALICE NEEL (1900–1984)
TB Harlem (1940)
Oil on canvas. 40 × 40 in.
*Courtesy of Wilhelmina and Wallace Holladay,
Washington, D.C. Photo by Eric Pollitzer; Courtesy
Robert Miller Gallery.*

contrast to the dark blouse), frames the intense and somewhat amused expression of its subject. The drawing is done with great economy, relying more on careful delineation of contour than on elaborate tonal indications. Notice how the raised arm emphasizes the bony structure of elbow and wrist, conveying some basic physiological characteristics of the subject. The artist is concerned with directness, rather than with superfluous details. The intensity of the facial expression dominates, accented by the dark tonal masses that surround it. Each contour line, each form and texture, tells us something important about the subject; nothing could be left out—or added.

At first glance the oil painting in Figure 9.9 resembles the ink drawing. The black and white reproduction of the painting also resembles a work in charcoal, done with minimal tones that are simply modeled, except for the left back portion, which has more vigorous brush work. Comparing the painting with the ink drawing, it is obvious that the artist treats contour in both with the same kind of directness and simplicity. However, the expressive content is very different. While the portrait of Adrienne Rich shows a provocative subject, with an almost Mona Lisa-like combination of amusement and penetrating gaze, the man in the painting expresses a sense of hopelessness, a state of resignation and lassitude. The latter work is a social protest statement against conditions that created a high incidence of tuberculosis in New York City's Harlem district in the mid-twentieth century. Compare the different qualities in facial expressions and figure gestures, and note the difference between the healthy torso of the woman in contrast to the emaciated torso of the man. Study the visual clues which tell us essential information about the contrasting moods and qualities of these works.

Near the opposite end of the scale is the work of Larry Rivers (Figure 9.10). There is a cool intellectualism to his study of Julia Robinson, done in pencil and carbon paper. The study in the right-hand portion is more

FIGURE 9.10
LARRY RIVERS
Carbon Color of Julia Robinson (1976)
Pencil and carbon paper. 19½ × 30 in.
Courtesy Marlborough Gallery, New York.

FIGURE 9.11
CALVIN ALBERT
Apocalypse (1980)
Charcoal. 60 × 48 in.
Courtesy of the artist. Photo by Martha Albert.

emphatic and descriptive of the gesture and attitude of the woman's figure, compared to its lighter counterpart to the left, which emphasizes a diagonal passage of darker tones, and pays less attention to portions of the figure and background elements. It is an intellectual performance in which one's vision goes from left to right, or from right to left, much like a Ping-Pong game. This creates a sense of ambiguity, of unrest, causing the viewer to question which is more real—the image to the right, or the one to the left. Obviously, both are "real" in their individual ways. Maybe that is what the artist wants to tell us. Also, the pictorial quality of the drawing process, as an integral act in itself, presents a foil to the descriptive aspects of the figure drawing. Preference is given to pictorial structure, and the "echo" effect of images, and inventive ingenuity.

The work of Calvin Albert, shown in Figure 9.11, conveys still another kind of visual statement. Titled "Apocalypse," it portrays in charcoal a strong image of a woman's figure. At first, it may be difficult to "read." This statement expands across the paper, and with its strong chiaroscuro effects tell us something about a light source we normally associate with realism. But this is not realism; it is expressionism of a highly individual nature. The charcoal technique is handled in a masterful manner. The admirable nuances of shading are life-like in some passages, but the artist has created purposeful distortions to suggest emotion that could not be conveyed equally in terms of sheer realism. Though Albert is a master draftsman, well-schooled in traditional academic disciplines of figure draw-ing, he has chosen to develop a personal idiom that challenges the observer. It is not surprising that the same idiom is reflected in the sculpture of Albert,

FIGURE 9.12
CALVIN ALBERT
Standing (1975)
Fiberglass. 68 in. high.
Courtesy of the artist. Photo by Martha Albert.

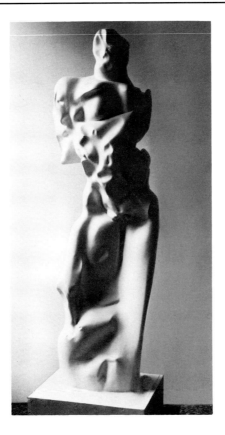

as in Figure 9.12. Here, the play of light over forms reveals the artist's concern for distortions that provide visual excitation of a plastic nature. Concave and convex formations interrelate in a total three-dimensional work that has a sense of both subtlety and power. The figure appears entangled in an environment from which it cannot escape, and of which it is an essential part. The metaphysics of his statement encourage close study and intense involvement.

A suggestion of a classical approach, reminiscent of late Medieval and early Renaissance art, is evident in Figure 9.13, a work by Audrey Flack. This ink and wash study, titled "Death and the Swami," requires careful reading. Unlike her super-realistic works (also known by the term "photo-realism"), for which she is better known (see Figure 9.14), this drawing tells us something about her involvement with spiritual issues. It's scale is small, almost minute. Yet, it presents strong, macabre references to death (the skeleton beating a drum). It also presents a cool, collected figure (a Swami) who seems not to be disturbed by the noisy presence of Death (the agitated skeleton). Contemplative, meditative figures in the foreground also counter the presence of Death, and seem indifferent to it. The simple, direct manner of the drawing, its almost sketchy quality is done without embellishments, without the seductive qualities that her super-realistic works employ. And there are some interesting innovative aspects. One is the extension of the hand and foot of the skeleton into the area of the frame. Another is the highly realistic fly on the right-hand portion of the frame. These innovations attest to the involvement of the artist in making the conceptual more immediate, more closely related to the actualities of dimensionality one associates with actual life objects. The contemplative, meditative aspects, the "inner" involvement combined with the actualities of the "real" world, make for a subtle, but powerful statement, despite the small scale of the work (9″ × 12″).

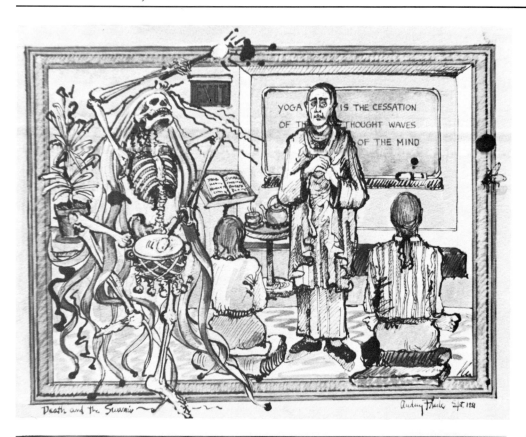

FIGURE 9.13
AUDREY FLACK
Death and the Swami (1981)
Ink and wash. 9 × 12 in.
Collection of the artist.

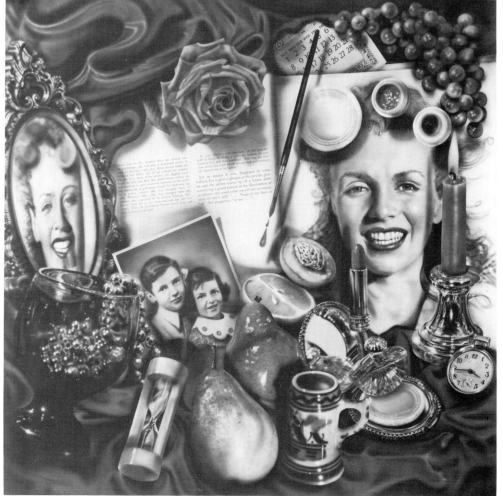

FIGURE 9.14
AUDREY FLACK
Marilyn (Vanitas) (1977)
Oil over acrylic on canvas.
96 × 96 in.
Courtesy of Louis K. Meisel Gallery.
Photo by Bruce C. Jones.

Figure 9.15 is a figure study by Jim Dine titled "Model on the Gloucester Road," done in mixed media, charcoal, and pastel on paper. Many of us associate Dine with the Pop movement, because he singles out such things as coat hangers, bath robes, and other mundane objects as a focus of his concern. Here, one cannot help but be impressed with the subtle power that the drawing conveys. The figure is like an encounter, a sudden revelation of a woman, full-breasted, poised, and mysterious. The upper head area is toned down, with only a small passage of light playing across her cheekbones, nose, lips, and chin. A minimum of modeling reveals the skeletal structure of ribcage and pelvic crests. The figure's left arm is incomplete, merging with the white surface of the paper. The pubic area seems scrubbed out, further heightening the pectorals and shoulder girdle area. There is a "Rembrantesque" effect to the head, most of which is obscure; however, the light background behind accents the mass of hair, creating a striking contrast with the light torso and arms. The study takes liberties with the light source to create a quality of mystery.

FIGURE 9.15
JIM DINE
Model on the Gloucester Road (1976)
Mixed media, charcoal, and pastel on
paper. 42 × 36 in.
Courtesy Pace Gallery, New York.

A sound understanding of academic drawing is conveyed in the portrait study, "Frank," (Figure 9.16) by Chuck Close. What superficially appears to be a conventional tonal study, perhaps made with charcoal smudges, or varying tones of wash, is *not* conventional at all. The striking, realistic head study was improvised using a stamp pad and ink on paper. A strong light source from the right creates a dramatic effect of form. The soft texture of hair and the brittle refractive quality of glass (in the eyeglasses) have a naturalness that is at once disarming, and not at all indicative of the ingenuity the artist has exercised. It is only after some scrutiny, that one realizes that what appears to be a conventional study is really a virtuoso performance. It demonstrates an anchor in the past, but a vision of the future, so that what might have ended as a trite experiment resulted in a product of strength and dignity. The penetrating gaze, the natural simplicity of the pose, the forthright look—these all attest to the humanness of a work done by a highly unusual process. It's bigger-than-life size gives the work a monumental scale, which further strengthens the power of the visual statement. The

FIGURE 9.16
CHUCK CLOSE
Frank (1980)
Stamp pad ink on paper. 42¾ × 30¼ in.
Photo by Al Mozell. Courtesy Pace Gallery, New York.

artist does equally well with conventional charcoal on paper, as we may note in Figure 9.17, a self-portrait.

Marisol Escobar takes us into a world of fantasy in her complicated, surrealistic drawings, one of which is shown in Figure 9.18. Perhaps the artist is better known for her unusual genre of sculpture, yet her drawings are expressive statements in their own right, and not studies for sculpture. ''Christopher'' is done with colored pencils and crayons on black paper. The artist developed her personal method by first tracing herself in a lying position on a large piece of paper. This large work has a stunning and eerie quality. The torso seems mummified, or like some creature from outer space. The drawing has been done in rhythmic patterns that both delineate the figure and related forms and give movement and vitality to the entire work. The placement of the hands creates visual tensions that carry the eye around the composition. There is an inner light and a quality of vibration that makes the work entirely different from a figure study dependent on natural light sources, such as we found in the works of Dine and Close. The texture of the drawing, which is not related to the human figure, heightens the surrealistic effect. It has a presence and an integrity of its own, making the surreal real in a convincing manner.

While the landscape in Figure 9.19 is not surrealistic, it has a visionary quality that sets it apart from a factual study. The work of Balthus (Balthasar Klossowskide de Rola), this pencil study has a pronounced textural emphasis brought about by the medium, itself, that adds an impressive sense of form to the subject matter. The composition, divided roughly into three sections, has an unusual cup-like format. Whereas the sky, portions of the mid-ground in side areas, and some of the foreground are only hinted at, the central portion is carefully modeled and more fully developed, creating strong three-dimensional references for the objects. Each tree, each portion of cliff,

(below, left)
FIGURE 9.17
CHUCK CLOSE
Self-Portrait (1980)
Charcoal on paper. 43 × 30½ in.
Photo by Al Mozell. Courtesy Pace Gallery, New York.

(below, right)
FIGURE 9.18
MARISOL ESCOBAR
Christopher (1974)
Colored pencils and crayons on black paper. 42 × 30 in.
Courtesy Sidney Janis Gallery, New York.

and each landscape mound has a convincing presence, as if distilled from "out there," into an inner vision that is illuminated by the artist's private sphere of being. The forms interlock, creating a sense of organic unity. Variations in simple divisions of subject matter are given added interest by rhythmic devices, such as the diagonal cliff formation in the lower left. The allover even tone in the central portion negates aerial perspective, but reinforces tonal pattern, which also increases the sense of unity and visionary quality.

In contrast, the work of Christo shown in Figure 9.20 relies on linear perspective to make a dramatic statement. This is a collage using pastel, charcoal, and pencil, engineering data, and a topographical map. It is actually a study for Christo's "Running Fence Project for Sonoma and Marin Counties, California," for which he made many studies. It is a means to an end, not an end in itself. His drawing is a visualization of how his idea can be manifested in an actual landscape. This drawing, and others of this type, take a relatively short time, compared to the months and even years that are required to complete his engineering projects that literally transform, and sometimes package, a landscape. He claims that he has made up to three hundred drawings for a project titled "Surrounded Islands." Clearly, we are into another dimension of artistic intent in which *conceptualization* necessitates data not usually associated with drawing. The work tells us something about *process:* what is yet to be has taken shape in the artist's mind, but requires resolution by additional effort and application. The drawings also serve as a belief structure that sustains the artist through trying times (getting the permission required to execute the project, raising

FIGURE 9.19
BALTHUS
Landscape (c. 1974)
Pencil on paper. 18¾ × 26¾ in.
Collection of Federico Quadrani, New York. Photo by Geoffrey Clements.

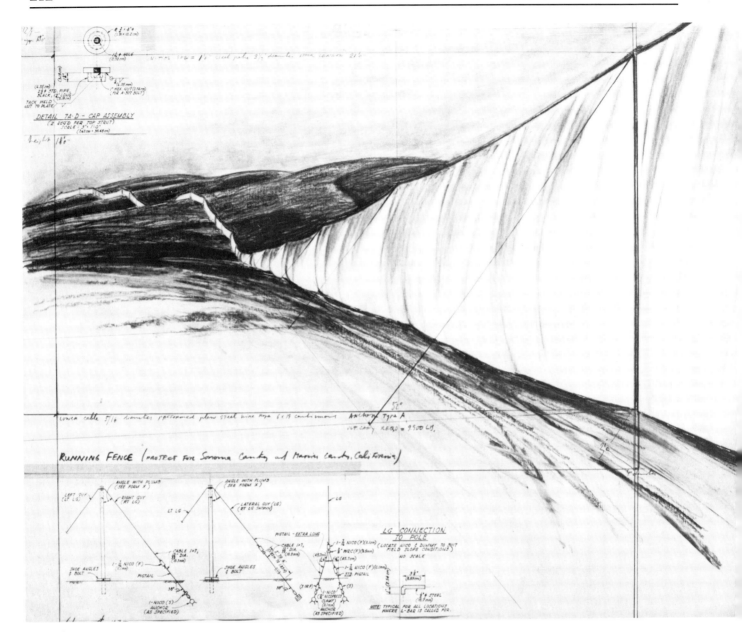

FIGURE 9.20
CHRISTO
*Running Fence, Project for Sonoma and
Marin Counties, California* (1975)
Collage: Pencil, fabric, pastel,
charcoal, crayon, and technical data.
22 × 28 in.

*Collection of the Rothschild Banak, Zurich. Photo by
Eeva-Inkeri.*

the funds). They are both a reminder of what is possible and a record of what has been accomplished.

From a purely technical point of view, it is fascinating to compare the artist's use of various textures. The soft, smooth quality of cloth activated by a slight wind is convincing as it moves into a point far back into space. Earth and hill formations are suggested by dark masses that accent the white, billowing, snake-like movement of white screen. Visual tension is created by the data in the left foreground with the typology of the map in the upper area. Both serenity and surprise are coupled with daring innovation.

Typology of a different sort is seen in Figure 9.21, "East River View with Brooklyn Bridge," by Yvonne Jacquette. It is done with charcoal on cream paper and is quite large in scale. Jacquette makes small preliminary studies from an airplane or high buildings. These are then developed in the studio on a larger scale, which allows for more detail. Various lights become focal areas in the composition. They also provide a sense of movement by means of rhythmic patterns that help to unify the surface, while adding essential interest. The complex texture of the water is set off by the more simplified treatment of buildings and bridge. Some areas are almost totally obscure, as in the right-hand middle portion. The allover effect is one of fantasy within realism; the artist has caught the "magic" of the situation with poetic feeling and insight. Additional study reveals a dominant passage of reflected light in the center, creating a sense of stability within the active circular movements of the large body of water. To the left, buildings and bridge combine their light patterns to create a semicircular movement, leading the eye from the lower mid-section to the upper areas and on to the right-hand

FIGURE 9.21
YVONNE JACQUETTE
East River View with Brooklyn Bridge IV
(1983)
Charcoal on cream paper. 65⅜ × 41 in.
Courtesy Brooke Alexander, Inc., New York.

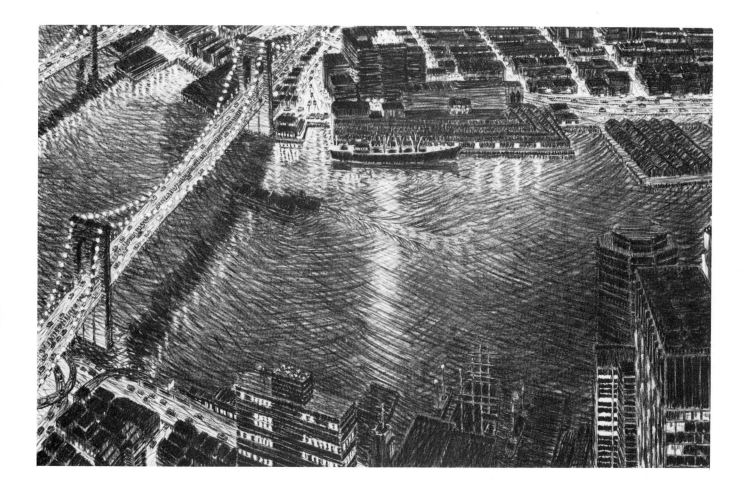

portion. The reflection of the bridge creates a tension with the bridge itself, which also adds to a sense of space and depth.

We are brought down to earth again by "Ale Cans," a work by Jasper Johns (Figure 9.22). This drawing, done in ink on plastic, shows us how mundane objects can take on special significance and dignity. "Pop" art like this should interest students who find still life a rather drab subject. One is moved by the dramatic effect of light and dark, the powerful feeling created by linear and wash applications, and the mysterious effect of confrontation. Objects that one normally discards after use take on an almost jewell-like quality and brilliance. We see the objects with the fresh, uncluttered perception of their creator, made new by their transformation. To be able to see the beautiful in the mundane, to be able to continue one's child-like curiosity and sense of wonderment are qualities artists cherish and wish to pass on to others.

FIGURE 9.22
JASPER JOHNS
Ale Cans (1978)
Ink on plastic. 15 × 16½ in.
Private Collection. Photo Courtesy Leo Castelli Gallery, New York.

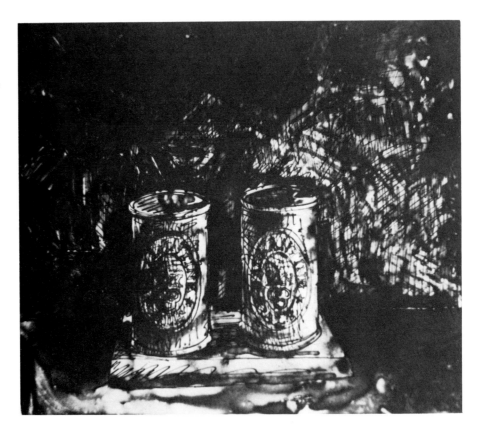

This seeing of mundane objects in a special way is also apparent in the work of JoAnne Schneider. Known primarily as a painter, she believes, nonetheless, that drawing has a special power and quality equal to painting. She finds the intimacy of small drawings particularly rewarding. Figure's 9.23 A and B provide two contrasting examples of her work. "A" (titled "Apple") is done in colored pencil, pastel, and graphite pencil. The form of the apple dominates the entire 16" × 13" picture plane and is a tonal study in which the play of light and shade creates a painterly quality, a loosely structured prismatic break-up of planar forms contained by the apple itself. The apple thus becomes a self-contained iconographic structure. It is not difficult to imagine a painting done in an almost identical technique.

In contrast, "B," which is a pencil study, titled "Electric Cord," is totally linear; the minute shading is hardly noticeable. The cord becomes a winding pattern that plays into and extends beyond the picture plane, like a meandering ribbon. It is both serene and playful, accented centrally by the plug and attachment structure. Although the two drawings present contrasts between the use of tone on the one hand and line on the other, they have something in common. They both represent the artist's concern with mundane forms that become translated into vehicles for poetic pictorial essays of form, space, texture, light, and composition.

Finally, the work of Eunice Golden is a departure from all the previous work we have considered. It is difficult to "put a tag" on her work, since it is often a combination of many complex concerns. For instance, Figure 9.24, titled "Dreamscape," is a work done in acrylics and graphite on canvas. It shows a figure which melts into its environment; the pattern of the rug

(below, left)
FIGURE 9.23A
JOANNE SCHNEIDER
Apple. (1980)
Colored pencil, pastel, and graphite pencil. 16 × 13 in.
Photo by Edward Peterson.

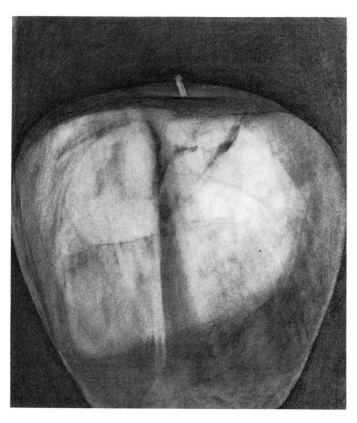

on which the figure rests is echoed in the figure itself, creating a mysterious illusion of metamorphosis, as if the figure is in a state of change and transition. The patterned effects of rug and figure blend into a subtle amorphous whole that provokes and holds one's attention. This quality of metamorphosis is again evident in a series of three drawings titled "Pas de Trois du Chats–a Study," shown in Figure 9.25. These charcoal on paper studies seem to represent "humanized" cats, whose agitated gestures remind us of boxers or combatants in defensive positions. Quick contour drawing combined with a scribble technique heightens the frenzied attitudes of the images, whose anatomical portions have a striking resemblence to human anatomy.

(above)
FIGURE 9.23B
JOANNE SCHNEIDER
Electric Cord (1975)
Pencil. 16 × 13 in.
Collection of the Metropolitan Museum of Art, New York. Photo by Edward Peterson.

FIGURE 9.24
©EUNICE GOLDEN
Dreamscape #5 (1980)
Acrylic and graphite on canvas. 24 ×
48 in.
Collection of the artist. Photo by Jacob Burckhardt.

FIGURE 9.25
©EUNICE GOLDEN
Study for *Pas de Trois du Chats* (1983)
Charcoal on paper. 17 × 35 in.
Collection of the artist. Photo by Jacob Burckhardt.

Concluding Comments

Our analytical concerns have carried us through an odyssey of some of the possibilities of expressive meaning. Such expressive meaning has been correlated with the elements and forces that help shape it. Of the many possibilities offered to the artist in terms of methods, materials, compositional possibilities, and other considerations, each artist, by some selective process, determines which is best for his or her own individual expression. The final results usually have some universal reference with which we can identify. Sometimes the enigma of art is the result of paradox and contradiction: doing something in a manner or with a material that is unconventional, yet resulting in strong, expressive results. The history of art has developed in just this way, with new modes of expression rising, like the Phoenix, from the ashes of a previous period, to produce new visual metaphors expressive of the human involvement in process of development.

The beginner, armed with the basics and having acquired some skills in using them, is prepared to face the adventure and challenge which expressive drawing requires. Like the poet, the adventurous artist may think of academic disciplines as a base from which to make departures for the purposes of personal expression. How and to what extent should one use the information and knowledge gained in this book requires personal decision-making; what may be adequate to some may be inadequate to others.

One individual may find it profitable to review problems in tone or structure before, or in conjunction with, some of the expressive drawing problems that follow. Another may choose to switch to materials that are different from those indicated in the problems. There are many possibilities for personal interpretations.

In pursuing the drawing projects, it is suggested that each be studied carefully. It may be prudent to review all of the projects that are presented before beginning your work. In this way, one may select a project that has immediate appeal, thus providing strong motivation. It is better to get intensely involved than to proceed with too much caution and trepidation. Since the projects involve different expressive states, they may extend over a considerable amount of time, perhaps several weeks or longer. Therefore, the work need not be rushed, and you may decide on your own deadlines.

It is best to take each project to a state of completion. If you are not satisfied with the results, spend some time analyzing possible lacks. You may find it helpful to review some earlier portions of the book, especially "The Creative Attitude," if you feel bogged down. You may also wish to refer again to some of the illustrations for possible inspiration, or clues that might be useful.

Drawing Projects

In some cases, materials and time limits will be suggested, but may be modified in terms of personal preferences. If some projects do not appeal to you, do them at a later date when you might perceive them with a different perspective. Feel free to invent a project. Each project will have an expressive theme to provide a focus for subject matter, materials, composition, and other critical considerations.

Project 1.

The theme is energy. Figures (nude or clothed) are suggested as subject matter, possibly related to a sport, a strike, or a gathering that allows for dynamic movements and vigorous linear and tonal treatment. A suitable paper of approximately 18" × 22" and soft drawing materials such as crayons or charcoal are recommended for the final drawing. Preliminary studies may be made in your sketchbook.

Make a few quick thumbnail studies to indicate essentials of the composition, keeping figure indications to a minimum. These preliminaries may also include structural aspects, perhaps as separate studies in which you translate primary action and configuration into simple, direct active lines (curved, jagged, angular, or diagonal).

At some point in your preliminary considerations, determine tonal relationships. Do you want a contrasting background or is the reverse preferable? Should the figures be light, moving masses against a dark background, or should they be dark forms seen against a light ground? Consider an interplay of both. Visualize what you think would be most effective, then make a quick, graphic statement of your visualization. To what extent is environment important? How much or how little should you include? How does it relate to your energy theme? For inspiration in developing your concept, refer to the work of Elaine de Kooning. Take your time in developing your material until you feel convinced that the particular situation is suited to your energy theme, and that all the supportive studies suggest a successful outcome. Review your materials before you begin the final work and perhaps make a few more experiments or review some earlier studies to assure yourself that your expressive language will be suitable and powerful.

Once you have started the final drawing on the large sheet of paper, pursue it with intensity and empathy. Feel yourself acting out the roles of action you are depicting. If you are doing a sport scene, jump into the air, or catch the ball, or otherwise "live" what you are drawing. Internalize as fully as possible what you are drawing. Get as many aspects of yourself involved with the creative development of your work—your imagi-

nation, your powers of visualization, your emotions, your tactile sensitivities—even your body. The materials of expression (paper and drawing tools) are there in front of you, but you must internalize the experience of what you are drawing to make it real for yourself and for others. The core of meaning is in intense personal involvement, and whatever aspects that involve you increase the possibilities of effective visual communication.

Project 2. *The theme is contrasting expressions. You may use the entire figure or a portion of it, clothed or nude. You may use a model, friend, or yourself as subject matter, and, if you wish, use a different person for each of the two separate and distinct expressions.*

Here are some contrasting expressions you may consider: elation/sadness; health/ sickness; powerful physique/weak physique; active gesture/passive gesture; the look of the winner/the look of the loser; and repose/action.

Prethinking and planning of the work might include the following:

(1) Position of the figure within the pictorial surface (picture plane): Should it expand to the outside margins, or should it be contained in a more compact fashion within the established limits of the work surface?

(2) What medium or combination of mediums are best for the work? Would a smooth paper be more suitable than a rough type? Is a soft medium (conté crayon, charcoal, and so on) preferable to a rigid one (hard graphite, pen and ink)?

(3) What kind of gesture seems implicit in the particular expression you are dealing with? How can that gesture form the essential core for descriptive data you use?

(4) What portions of the figure should be emphasized and which minimized? Is it more important to concentrate on facial expression, or on some other portion of the figure?

Review these and other aspects that relate to the particular quality you wish to achieve. Naturally, you should relate such concerns first to one of the selected expressive states, and then to the other, finally developing each as individual drawings on separate pieces of paper. Each drawing could be made on the same piece of paper for more apparent contrasts; however, determine whether or not they should be drawn in separate picture planes. If the type of paper seems crucial, it is best to make each drawing on the most suitable surface.

Works by Alice Neel and Jim Dine are examples that may appeal to you in making your initial decisions of theme, materials, and composition. Consider other preparatory stages mentioned in Problem 1. Would they help to maximize your final results? As before, after you have considered as many essentials as you can (left brain, analytical mode), get intensely involved in the expressive theme (right brain mode). Focus on one of the contrasting drawings before becoming preoccupied with the other. Only after you have done both should you become critical of the results. Compare them, evaluate them, and make the necessary changes that reinforce the expressive contrasts.

Project 3. *The theme is intellectual-expressive. Choose some situation, perhaps invented, in subject matter that has the possibility of several overtones of meaning in the same work, on the same pictorial surface. This may derive from some provocative situation, such as representing the same subject matter in two different ways using two different techniques, two different lighting situations, two different modes (one complete, the other fragmentary), or some other kinds of existential involvement. Refer to the work of Larry Rivers, or other examples. Use whatever subject matter seems most appropriate personally. It could consist of the full figure, part of a figure, still life, or landscape. For instance, Claude Monet developed several paintings of haystacks seen at different times of day to capture the reality of each successive impression brought about by a change of light and color, using the same haystack for each work. He extended this approach in a series of studies of Rouen Cathedral. It is not so much the subject matter that is crucial, but the way you might conceive it in different circumstances, different conditions, or with different inner perceptions. The same subject matter treated in different ways on the same drawing surface: that is the challenge and the objective. Decide which materials would be most appropriate, and review suggestions offered in the two preceding problems.*

Project 4.

The theme is philosophical. Consider some philosophical value issue: women's rights, the atomic threat, a political issue, or some theme that has pros and cons. This may call for imagery not usually found in an everyday life situation, perhaps symbolic in nature. For example, in the Audrey Flack drawing were a skeleton, a fly, and background references incorporating written material. This work may serve as a stimulus for your own efforts, though the philosophical content may be entirely different. Do some research, if necessary. Look for images that can best express what you have in mind. Get involved. The world is teeming with all kinds of humanistic issues. Make the visual statement bold and simple. All graphic elements and compositional devices should be selectively considered to produce the desired results. This drawing may take as long as you like. It might be large or small in scale. You may wish to try variations on the same theme. Your personal commitment will determine the extent of your involvement.

Project 5.

The theme is expressive distortion, the opposite of uncontrolled distortion. One distorts to achieve a desired response, not an accidental one brought about by inaccuracies or lack of knowledge. In one sense, almost everything one draws is a distortion, since it is a transference from one kind of reality into another. Even a simple drawing of a tree may not include all of its branches, or may minimize its foilage, or may otherwise modify, and therefore "distort" the image. The drawing of a figure in action may stress some aspects and minimize others. This, too, is a distortion based on selective preferences, in contrast to plain "bad" drawing. Distortion can take on many different forms for many different kinds of expressive purposes. Here we shall consider the possibilities of distortion for a singular expressive intent.

Determine your theme and how it could be represented by a single figure: nude, draped, or fully clothed. It could be a full figure, or part of a figure. After determining a theme, consider how you could best use the figure visually to create the work with maximum effectiveness. For instance, if the figure is to represent aspiration, consider how the figure could be translated (distorted) to produce the desired quality. El Greco's figures, for instance, were distorted for just such purposes. He elongated the figure far beyond its normal height, endowing it with an ethereal lightness and heightened spiritual effect. The gesture of the figure, its placement within the picture plane, the paper on which it is drawn, the materials with which it is drawn, the manner in which the materials are applied—all of these are essential considerations. If the figure is a nude, the manner in which its anatomy is represented is equally important. Is it advisable to stress all anatomical parts in a given view, or is it better to stress some and minimize others? How will the treatment of light and shadow relate to the theme? Does the light have to be consistently from one direction, or could it perhaps come from several directions? Perhaps there should be an "inner" light?

The analysis of the work by Calvin Albert may give you some clues to your purposive distortion drawing. Some other artists you might review are Leonardo Da Vinci, Michelangelo, Rubens, Käthe Kollwitz, Rouault, Daumier, and Dürer. There are, of course, many others that offer examples for the study of purposive distortion. Spend some time in a good art reference library reviewing as many possibilities as you can, especially if you have difficulty selecting a theme. Consider also some light theme, something humorous or whimsical. For instance, William Hogarth's work reflects satirical and whimsical aspects of eighteenth century England.

After determining your theme, make some small studies and experiments before developing your final statement. Review the suggestions given in other problems of this section, if necessary.

Project 6.

The theme is innovative portraiture. Here, the term "innovative" refers to the manner in which materials and techniques are used. It may also refer to the surface on which the drawing is made. For instance, though the Jasper Johns' study of ale cans is done in a conventional pen and wash technique, it is developed on a sheet of clear plastic, not usually employed for such work. Then there is the Chuck Close drawing made with a stamp pad using ink on paper; here the surface was conventional, while the technique and tools were innovative.

Portraiture could be a head study or a head and torso study. Such determinations should be predicated upon some personal aesthetic rationale. You may wish to explore

possibilities in preliminary experiments before deciding which allows for the most effective application. It is suggested that your preliminary considerations directly involve innovative tools, techniques made possible by such tools, and innovative surfaces on which the drawing can be made.

In addition to the examples of innovative works noted above, here are a few experimental situations that may stimulate your imagination.

Perforate a piece of material with small holes, made with a punch or some sharp instrument. Then place the material on a sheet of paper and rub graphite through the openings, transferring the shapes of the perforations onto the drawing surface. Shift the perforated material around, so as to build up the transferred tones gradually to create a portrait study.

You could also use applications of spray paint or other materials, transferred onto the surface by paper, cloth, or some other means. Pieces of wood (toothpicks, matchsticks, and the like), plastics, glass, metals, sponges, and cardboard provide innovative possibilities. The fact that such diverse materials could be productive tools for various kinds of techniques could greatly influence you in your final selection of the kind of portrait you want to make. Of course, some of these materials may also be surfaces on which you may make your drawing.

Set your imagination going. Be daring. Don't settle for an easy solution, but continue to experiment until you find some combination of unusual materials (both tools and surfaces) that is particularly satisfying. This can be a "fun" problem. During a lecture at the Albright Art Gallery, James Johnson Sweeney once remarked that art was "play." Some members of the audience did not realize that he meant that playful experimentation can lead the artist into new discoveries, new manifestations of expression not otherwise possible. Sometimes fun can lead to profundity. Don't underestimate the expressive possibilities of innovation.

Project 7. *The theme is wonderment. As explained in the preceding analytical studies, "wonderment" refers to seeing the mundane with a fresh vision. It is seeing some mundane object for its aesthetic quality, not its utilitarian value or purpose.*

As young children, we tend to see objects with a fresh vision. Gradually many of us lose that surprise and newness that we experience visually when younger. We become sophisticated and jaded in the process, until only certain "acceptable" objects are considered capable of eliciting an aesthetic response. As we have seen, an artist like Jasper Johns did not lose his sense of wonderment. He derived inspiration from common objects. Overtones of meaning welling up from deeper levels of consciousness can enrich the mundane, making it the vehicle for philosophical or mystical outlets. Reflections in a drop of water can become universes. A patch of muddy soil can echo Cleopatra's barge crossing the Nile. A common label on a can may suggest a coat of arms, a shield, or battle armament.

Take some time to reflect upon the opportunity afforded by this theme. Right now, wherever you are at the present moment, get into a state of relaxation. Take a few deep breaths and then gradually let your gaze roam around your environment until you find some object that tends to hold your attention more than others. Let your gaze search out the purely aesthetic qualities of the object. Are other overtones suggested in the process? Does the object assume greater importance as you study it? Spend some time utilizing this procedure until something happens that attracts your attention, and presents a freshness you missed before or tantilizes you with some mysterious aspect you wish to explore more fully. If nothing happens, try again, either now or later. At some point the sense of wonderment may dawn upon you. Seize this opportunity and make some brief notes and sketches. Then follow up when circumstances and time permit to develop your inspirational subject further. Make some preparatory drawings that need not take very long, but that help to objectify the "newness" of your associations.

Finally, sift through all of the preliminaries until you can focus on one that holds the most promise. Determine the scale for its development, the materials that will be most suitable, and the structural qualities that seem most useful. Make some mental or actual notes of these and other aspects before you go to work. Then get totally involved in developing your drawing. Spend as much time on it as you wish. Perhaps make

several detailed finished works of the same object until you have explored its full potential. Consider further the possibilities of developing your fresh vision by means of innovative materials suggested in Project 6.

The theme is fantasy. Fantasy and wonderment have much in common, especially in terms of imaginative excursions that may develop by contemplating some object or scene. However, fantasy, as we shall consider it here, is a surrealistic concept, involving the use of imagery not usually associated with normal life situations, (monsters, fairies, and the like). Fantasy of this kind may consist of a merging of several levels of consciousness. An artist once remarked that another person's fantasy was her reality. Perhaps she meant that what she fantasized about was extremely real to her, and she was capable of transferring her fantasy into a creative statement with the same ease that she experienced while drawing something from life. We all have fantasies of one kind or another, so the subject should be familiar. ***Project 8.***

Use the figure as a basis for your fantasy. You may use your own body as a starting point, as Marisol did, or use a photograph or drawing of a figure as a starting point. As in our previous work, materials, surface, and format are essential considerations which should be related to the core of meaning you wish to explore.

Since the theme may incorporate many complexities, it is useful to make some preliminary studies with a linear medium that will clearly identify the imagery. This will also help to make less conscious imagery more conscious. It will help to clarify fantasy associations on the fringes of your consciousness, objectify them, and make them three-dimensional realities. Visualization will be important and highly beneficial in this process, therefore, it will be helpful to enter deep states of relaxation as you proceed with this work. However, maintain an alert state that will permit you to sketch images that emerge quickly. With some practice you should be able to remain both relaxed and alert. Consider the gestural significance of everything you draw to make it easier to translate your images onto the surface of the paper. Spend as much time as you need on this procedure.

After you have gathered sufficient material, begin to orchestrate your theme in a large, preliminary study. This study should be tentative, allowing for changes in scale of imagery and shifts in compositional placement. If you work on thin bond or tracing paper, it is quite easy to tear or cut out separate items and recombine them in different ways. You should be able to develop various separate compositional possibilities, which you can later consider for a final study. However, if you cannot determine which of these is the most promising, it may be possible to combine images, or portions, from your studies in a manner that will result in a better total concept, which you can then develop in a final drawing.

The theme is contrasting landscapes. In some ways, this problem relates to Project 2 of this section, using different subject matter. One of these drawings should be a close-up study of some portion of a landscape, while the other should be a panoramic view, possibly of the same landscape. Therefore, each of the final drawings should be made on a separate piece of paper. The paper, materials, techniques, and other aspects of the work should vary with each drawing. ***Project 9.***

Two examples which we considered in the analytical portion of this chapter (the Balthus and Jacquette drawings) may serve as prototypes, but not rigidly so. Make your own identifications, choosing your own subject matter.

For the close-up study of a portion of some landscape, seek out source material that appeals to you, perhaps from some previous drawing you have made for another chapter of this book. Photographic reference can be used. It is essential that your reference contain some special quality that moves you deeply. For instance, tree patterns, the rhythm of hills, the texture of earth, jagged cliffs, rock formations, or sand dunes may capture your attention and imagination. You may wish to rearrange some of the elements found in a particular situation to heighten and further dramatize your initial impression. However, use only material found in the particular situation that has provided the initial stimulus, not fantasy materials as in a surrealistic approach.

After studying your subject, make some small preliminary drawings that will more clearly state what has moved you. Try to pinpoint, in graphic terms, what that is. If it

is a textural pattern, think back to earlier studies to find some expressive clues that may seem suitable. If not, try some experiments with materials that will produce the basic quality you associate with the subject. Keep working in this way until you achieve the identification that will serve your expressive purpose.

It is also necessary to determine the nature of the composition. We found in the Balthus work, for example, that his subject was composed in a cup-like format. What kind of compositional character would best typify your situation? How much of the paper should it occupy? Where should emphasis be placed? If a textural pattern should dominate, what supportive elements are necessary? How much should you include? How much should you eliminate? What kind of surface should you use? Would a toned paper be preferable to white paper? These and other decisions should be considered in early stages. Keep in mind, however, that all graphic determinations should be aimed at achieving a total effect that visually objectifies your particular vision.

The second, panoramic drawing presents other contrasting elements. Again, seek material that may develop out of previous drawings you have made, or from other sources. Pursue your search until you find subject matter that appeals to you. It may contain a variety of elements not found in the close-up study. It is probable that deep space will be essential, compared to the more limited space characteristics of previous work. What other differences can you find? How are you moved in a way that is different from the previous experience? What special magic moves you in this situation, and how can you go about capturing it? Use, as necessary, materials, surfaces, and compositional aspects you have already used as you refine your statements from preliminary studies to the final drawing.

Project 10. *The theme is process/conceptual. This drawing will involve a combination of drawing elements (line, tone, texture, form, space) and drawing principles (unity, variety, contrast, emphasis, and so on). It may be further complicated by the addition of diagrams or other data.*

This project relates to Christo's work, but does not require packaging of your material. You may be irritated by the architecture and physical planning of buildings in a mall, town center, recreational area, or similar environment. You may wish to reconstruct such environment imaginatively, conceiving new structures and an entirely different physical setting to avoid the visual pollution or static that you find oppressive. If you have plans of these structures, use them. Or, if you have a background in mechanical or architectural drawing, draw a plan and elevation studies to incorporate with a large perspective study of your intended improvements.

Integrating several different environments is another possibility. You may wish to take a severe group of buildings in a mall or other location and combine them with the softer features offered by shrubbery, trees, sculpture, fountains, and other aesthetically appealing forms. You could make a simple plan study (top view and elevation) in line, and combine it with a perspective study, indicating how the additions would create a more appealing total affect.

You might also utilize photographic or diagrammatic material found in architectural magazines for various combinations (architectural, sculptural, and nature forms). Such material could also be combined with drawings. With some imagination and research, you can explore many possibilities. For example, the addition of writing could add more specific references to your project. These could be established in strategic compositional areas to supplement the visual material of diagrams, photographs, other possible data, and your drawings.

Though you may not wish to relate to Christo's concept, it is useful to know that he used such diverse materials in his drawing projects as pastel, charcoal, pencil, engineering data, topographical maps, photographs, fabrics, enamel, and photostats. Such diversity of materials may stimulate your imagination and help you to produce your own personal expressive statement. This problem could be done over an extended period of time or, if you use fewer elements and a basically simple drawing approach, a much shorter period. The choice is yours.

FINAL CONSIDERATIONS

The preceding drawing projects have presented a variety of themes for expressive possibilities. Running the gamut from emotional through intellectual concerns has provided the possibility of many new drawing experiences. A variety of subject matter was considered, along with a wide range of materials, methods, and techniques. It is apparent, then, that one's concept of drawing need not be static; it should allow for the inclusion of unconventional materials, ideas, and methods.

Being aware of many new learning experiences can extend one's limited personal perspective. One may tend to pursue or prefer only *one* kind of expressive concern, rather than many, thus creating self-limitations that can restrict one's creative potential. It is natural for many to perform so as to elicit applause or praise for one's efforts; this is drummed into us from childhood, and extends into much of our later life. It is difficult to accept the challenge of the new and the untried. Yet, the student can greatly profit from exposures that at first may not seem compatible, nor ensure instant approval and reward. It is important to realize that some accomplished artists deliberately create new challenges for themselves in order not to stagnate, not to fit into the restricted mold or idiom for which they have become recognized. Picasso once claimed that success was his worst enemy, which could be interpreted to mean that he was not content to continue to work in a manner that had won him public acclaim. His various styles and idioms, and his exploration of media and materials, attested to his continual search for new means of expression for his developing consciousness and multilevel concerns.

It might be rewarding for you to review some of the projects that at first might not have had much appeal. You may discover new potentials or a new means of applying what you already know, coupled with an awakening to what you might yet do. We are now touching upon the subject of personal development, which we will consider in the next and final chapter.

10

PERSONAL DEVELOPMENT

This chapter is addressed to some important issues concerning personal development: practice and skills, the development of a personal style, or idiom, how to overcome creative blocks, and the relationship of drawing to various professional goals. Developing a personal drawing program will be dealt with in the Appendix, which may be studied for adaptation. Teachers who are interested in adapting material in the book for a one- or two-semester drawing course will also find references in the Appendix. Correlating drawing with the disciplines of painting and sculpture is another subject that will receive attention in the Appendix.

Practice and Skills

Much of the material presented in this book cannot be digested and put to use immediately. The learning process of drawing is experiential, not linear. A simple reading and minimal application will not suffice. Therefore, the student will most likely want to go back over some portions for further consideration and practice.

Various circumstances will help to shape one's focus for practice and skills development. For instance, if one begins to study the book during the summer months, it would be expedient to focus on sections dealing with nature, landscape, and seascape. Working with the figure, still life, and cityscapes may be done at almost any time. Also, personal preferences play an important part in developing one's focus. Preoccupation with the figure, or with portraiture, may motivate the student to concentrate on such subject matter almost at the outset, though practice with still life is recommended before facing the demands that figure work requires.

The sketchbook was emphasized in an early chapter of this book, and

it is not possible to overstate the value of keeping one. For instance, if one is interested in knowing as much as possible about figure drawing, it is not only important to review and apply the material on figure work given in this book, including searching out related texts and studying artists' works in galleries and museums, it is also extremely helpful to keep a sketchbook as a running "log" for drawing people in one's immediate environment. This practice of close and direct observation and quick recording of actions, gestures, forms, and tonalities of the figure reinforces one's basic concept of the figure, trains one to see essentials, and increases one's motor skills. Drawing other subject matter is equally important, and the sketchbook can be a useful means through which one can achieve a high degree of skill development in several areas.

Making written notes along with visual ones can also serve a valuable purpose. Perhaps if the drawing projects given earlier captured your imagination you may find that ideas come to you at odd times of the day or night. The sketchbook serves as a vehicle for making notes and sketches about such ideas that you may develop further at some later, convenient time.

Another essential use of the sketchbook is in exploring expressive directions. We considered some possibilities in the last chapter. Expressive concerns are by far the most sophisticated of all other considerations. Of course, conceptual concerns are aimed at expressive considerations of one kind or another. I refer to exploration by means of various media, pictorial composition, and possibly other strategies and devices. Pursuing an expressive concern by means of your sketchbook enables you to come to grips with many issues in a relatively short period of time. I have found, for instance, that some students engage in lengthy projects, only to discover later that they are on the wrong track. The materials they have chosen, or the major thrust of the composition, is not the best suited to their expressive intent. Much time and effort could have been saved by some experimental work in sketchbook form prior to engaging in such elaborate projects.

Still another valuable aspect of the use of the sketchbook is to determine the value, or importance, of a particular theme, mood, or concept. By means of quick, thumbnail indications one is able to evaluate a projected result. Is the initial inspiration suitable for visual expression? If it seems unsuitable, would it be better expressed in another medium, perhaps totally unrelated to drawing? These aspects of decision-making can be clarified in sketchbook indications.

The value of using a tape recorder has been mentioned. We stated that one could record one's reactions to one's work after its completion as a form of self-evaluation, a verbal analysis of steps taken and results attained. We emphasized that this should be done *after* completing a work, rather than during the act of creating it. This interaction of a right brain mode with a left brain mode is highly beneficial in personal development. It not only helps one understand some otherwise mysterious working of the creative process, it also heightens the potential of human consciousness by making one more aware of what goes on at deeper levels of consciousness, usually associated with the area of right brain cognitive functions. This self-analysis, this deeper understanding of the self, its motivations, and its coping mechanisms can help one understand and improve one's drawing performance.

The value of working with others is also an important consideration. Although personal development can be at times a lonely performance, it can also be strengthened by interaction with others, in formal and informal situations. For instance, artists often get together for "bull sessions," in

which they eagerly exchange their ideas and perhaps come to some interesting and edifying conclusions concerning aesthetic directions. They may also argue about such issues, finally going in separate directions. At the student level, such get-togethers offer opportunities for beneficial exchanges, especially when working toward common objectives. For instance, if several individuals decide to work together—let's say in renting a studio and hiring a model—they can share common concerns in group critiques and evaluations. The similarity of concerns often engenders a sense of camaraderie in which an easy rapport leads to broader perceptions of one's work. Such situations can result in the awareness of the need for improvements and additional practice and skill development, an awareness which may not be as obvious when working alone.

The value of comparative evaluation is certainly one of the strengths of working in a formal situation offered by classes in art schools and art departments. I have found that students can be quite verbal in classroom critiques, especially after overcoming inhibitions to verbalize what they have done in a more private sector of themselves. Sometimes students have to be reminded of problem objectives before making more subjective excursions concerning likes and dislikes that may be predicated upon interests having little to do with problem-solving objectives. However, such excursions may result in information, observations, and views worthy of group discussion and consideration. A wise instructor will serve as mediator, or guide, in class discussions and critiques, carefully steering the discussion back to its main concerns. Perhaps the instructor can add some meaningful observations that will further stimulate students to pursue more critically a problem-solving approach. However, the authoritarianism of some instructors can very well turn students away from a desire to pursue their subject. At best, the capable instructor should serve as a source of information, a bridge between the subject and students in order for effective communication to take place. The instructor can learn from his students, too, though that is difficult for some beginning instructors to accept.

Development of a Personal Style or Idiom

Developing a personal identity is perhaps one of the most crucial concerns the artist faces. How can one make the general specific in terms of one's individuality? During the early, formative period of learning, we establish identities that are rewarding. Though many may engage in problem-solving approaches in a drawing course, the results inevitably bear a personal stamp, an element undeniably one's own. Yet the artistic handwriting at this stage is often not rewarding enough. One wishes to be more significantly *different*, to be unique. If this need to be successful leads one to accept a current aesthetic cliché, an easy way for acceptance, the results are usually short-lived, and consequently limit the possibilities for a more mature, personal statement. Adopting someone else's mode, though it may have appeal, has not been earned by one's own evolution. The seed has not yet blossomed. Don't force it! Fortunately, each of us has a built-in natural mechanism that will produce its own kind of individuality—in time.

To avoid possible confusion concerning the issue of style and adopting a cliché, let me stress that working with artistic influences can be beneficial in some cases. For instance, as you begin to develop and make progress in your drawing program, you may be moved by the work of some master or contemporary artist. You may admire how the artist has dealt with a

subject, capturing its expressive quality. You may wish to pursue a similar method, and emulate the "master." This is a positive stance, since you are consciously working in the direction of a Michelangelo, or a Christo. This activity can produce a positive learning experience, especially if based on the kind of sympathetic reactions described. One may work through many such influences before finding one's personal style. In fact, being moved by the work of other artists and studying their methods and styles can lead to the development of your own style, especially if one is seeking visual means by which to express a strong motivation. You may discover several visions that are compatible with your own, which may lead you to unfold and build upon the perceptions and the solutions of others. Synthesizing influences and information of all sorts is an essential part of the learning process. This is far different from latching on to a cliché that may be currently fashionable.

In my student days at Columbia University, while taking a course in twentieth century art, I scrawled in my notebook "the artist with sticky fingers," a phrase the professor had used to describe Picasso at some stage of his development. I later quoted the phrase in an examination, only to be reprimanded by the professor for repeating the statement. I was stunned by this reaction, since I thought his observation, which I had quoted accurately, was insightful. Certainly Picasso had absorbed many influences, but had made them his own by his own ability to synthesize. His complex nature demanded the absorption of much data which became grist for the mill of his own creativity.

Ultimately, the development of a personal style is a personal matter. How one achieves it may be circuitous and probably different for various individuals. Pursuing one's main motivations, conceiving of one's own reality and a meaningful way of representing that reality, is the core of the matter. Knowing one's craft, learning the possibilities of an expressive visual language, and developing one's sensitivity to expressive content will eventually lead one to the individual stamp that is the crowning point of the journey. This is the challenge.

How to Overcome Creative Blocks

The problem of creative blocks is a common one for mature artists, as well as for students, though it would appear that there are some essential differences between the two. This is a complex topic, and we can consider only a few aspects of it here.

Many times I have heard from students "I'm just not with it today. I just can't seem to get anything done. It all goes wrong." These sentiments, or similar ones, usually result in wasting of time through an inertia from which it is difficult to escape. If the condition is due to fatigue, obviously the individual should get some rest. A more serious situation results when one cannot identify the reason for not being able to resume work, whether one is working alone or working in a group or classroom situation. What can one do? How can one get back into a creative state of mind? The following suggestions may help you to cope with creative blocks.

If you are working alone and can't seem to pick up where you left off, first consider your physical and psychological states. Usually these are interrelated. If you are upset by a problem in some sphere of your life other than drawing, your mind may be out of focus, perhaps tuned in to your problem and not to your drawing. Your breathing may be short and irregular. You may be physically tense, your muscles strained. Sometimes the

subtlety of the situation may be such that you are almost completely unaware of your condition until you become attentive to your thought patterns and physical state. The first thing to do is *consciously* to set about to physically relax. But don't force this state. Gently slow down your breathing. Take a few deep breaths, then allow your breathing to slow down in a natural way. Relax your muscles by tensing them and then letting them go limp. Slowing down your breathing and relaxing your muscles will naturally slow down your thoughts. Your state of mind will become less agitated and much calmer. At this point, try to establish some connection with your work. Review what you have already achieved in your work. Mentally relive the creative process you experienced when you were last working. Remember how you applied your drawing medium, the way you felt, the attitude you had when you were deep into the problem. By doing so you will activate thoughts, feelings, and motor responses that went into your work. It is almost like rewinding a movie film of what you have done, replaying it, and then anticipating by visualizing future action what the rest of the film will be like—or what you would like it to be. Frequently this method alone can get you back into the creative state you wish to reassume.

If you are working with a group or in a classroom, the above procedure will still apply. You may wish to verbally review the objectives of your problem with your classmates or your instructor. Don't be reticent. Use the verbal, linear mode of analysis to help you clarify objectives and provide the springboard for the more subtle, holistic right brain mode where creativity takes place.

If you get back into your work, but it still seems to go wrong, perhaps you should reassess what you have already done and how you have accomplished it. One normally encounters a stumbling block of this kind; it is quite natural, especially for beginners who are still coping with expressive issues, trying to find the right combination of materials, composition, and expressive intent. Sometimes what one has done earlier may suddenly seem all wrong, and a new block results. What can one do in such a case?

There are several solutions. Finish the work, especially if it is a drawing of a single form or figure. Carry it to a state of completion, as best as you can, according to your own previous objective, or one given in a classroom situation. This may go against the grain and create a kind of inner friction that may make you feel uncomfortable. But the carry-through process is a good discipline, and the results may prove better than you had anticipated.

If, however, the work is an obvious disaster, don't lose heart. If the work involved only a single form, ask yourself some of the following questions: Was the subject's gesture captured effectively? Was the subject placed in a suitable position on the paper or working surface? Was the medium used appropriate for the expressive intent? Was the technique suitable? Was it consistent? Were you sufficiently motivated by the subject, or was your approach too mechanical, too formalized? These questions may reveal weaknesses in the work that you may not have been previously aware of. The positive aspect of such inquiry is that by identifying some weakness, you may get a fresh start. You can then make corrections or another drawing with the prospect of greater success.

If the work involves more than a single element, further analytical study may be useful. A composition meant to be expressive may become stale, confused, or too busy. Try to detach yourself from the work and to see it objectively. Ask yourself some of the same questions that were suggested for identifying faults in the single study. Don't forget that gesture can apply to many compositional elements, as well as to one. The manner in which *all* elements are orchestrated implies the *total* gesture, the visual "gestalt,"

which, if *not* successful, will lessen the total impact, harmony, and expressive quality. Often a student becomes preoccupied with a single element in a composition, paying attention to that element (whatever it might be) rather than to all of the elements. That element might thus take on a preciousness that one is reluctant to disregard. Hence, an allover objective perception of the work is necessary, and the letting go of favorite parts is required. Sometimes simply standing back from your work and viewing it from a greater distance makes one aware of such faults. Another device is to look at your work in a mirror. You will see it with a fresh vision, which may make its lacks very apparent. Another method is to stop work, relax, and turn your attention to something else for a few minutes, then return your attention to your problematic composition. You may suddenly realize what is off and what needs attention, and then make the necessary corrections and adjustments.

Let us summarize some ways of coping with creative blocks:

1. If you can't work, determine whether the reason is due to fatigue. If so, get some rest and let your work go until another time.

2. If you can't work for some other reason which you cannot identify, consider the following:

 - Get into a relaxed state. Put other problems into the background, at least for the present, so that you can develop a creative focus.
 - Review the goals and objectives of your work and what you have already achieved.
 - Try a visual playback of your efforts, and then visualize what further steps you can take to continue your work. Get your mind, your emotions, and your materials involved.
 - If you are working in a group situation, verbally review objectives with your classmates. Call upon your instructor for additional clarity, if necessary. Link the verbal mode with the holistic mode.

3. If you begin to work, but things do not seem to go well, consider the following:

 - Discipline yourself to complete the work, even though it may "go against the grain." The work may turn out better than you expected. Or, you may be able to detect your shortcomings.
 - If the work is a total disaster, be as objective as you can. Review the core of meaning of the expressive intent. Reconsider all aspects that are involved in creating your expressive intent: materials, composition—including gesture, or "total gestalt"—pictorial forces at your command, the feasibility of the idea as a pictorial statement, and whatever else comes to mind. Use a mirror, take a long view of your work, take a break, or consider any other strategy that may enhance your objectivity and the possibility of finding a fresh vision of what you are doing.

This summation of how to cope with creative blocks often experienced by students may provide some clues to personal problems. You may invent some of your own methods that might be equally effective. You are requested to refer to the suggested readings which contain important related references. For example, Win Wenger provides some useful and fascinating techniques that have not been mentioned here. Jean Houston, a pioneer humanistic psychologist, has tested and developed many techniques for

creative individuals in such disciplines as the visual arts, music, and writing. Her methods for overcoming creative blocks are based on an enormous amount of study and research, providing unique and effective solutions, and are worthy of intensive consideration.

Before turning to the subject of professional goals, let us touch upon another type of creative block experienced by some students and artists. And since artists often consider themselves to be in the process of continual learning, the separation of the two may be entirely arbitrary. However, the kind of block we shall consider usually surfaces after one has attained some mastery of essentials and has already made steady progress in a personal direction. Perhaps to define the phenomenon as a block is too extreme. This block is often simply termed a "rut," a kind of expressive groove that one has fallen into, and from which one has difficulty getting out of. It is more subtle than other blocks, because it is predicated upon the premise that one wishes to change, to go further, and create additional challenges which make the creative experience more rewarding.

A teacher involved in the creative process who is concerned with the development of his or her students often encourages them *not* to pursue goals that are easily attained. They are prodded into considering new means of expression, which facility in a medium, or technique, may limit, and stimulated to take a leap into the unknown to broaden their expressive horizons. Students who are reluctant to follow such challenges often find greater difficulties later on, when they do wish to get out of a rut. Having little or no preparation, they have reason to be apprehensive. How can one get out of a rut and make advances in new directions? How can one overcome the inertia of past exposures, the security of the known, and its tempting rewards? These are philosophical and practical issues which we will consider briefly.

An example comes to mind. An extremely talented and gifted student was developing his M.F.A. thesis but had gotten into a rut, a way of working that proved to be totally inappropriate for what he was trying to achieve. He knew it, and I knew it, since I was his thesis adviser. I felt the obligation to help him with a solution. It was not an easy matter. The student had undergone intensive work in all basic and advanced courses: painting, drawing, design, sculpture, mixed media, anatomy, and other subjects. He had mastered all of these, and had, in the process, developed a personal style. However, when he was developing his thesis, his style did not seem to work. Everything seemed to be frozen, prosaic, and lacking in vitality. Although his concept was vital, his manner of dealing with it was much too static: everything seemed to be passive, overworked, and drab. Although he was applying everything he knew—and no doubt this was one of the reasons for the lifelessness of his work—the results lacked vitality and the insightfulness of his concept. After several unrewarding attempts to come to grips with the problem, I suggested that he forget all about his original intentions and simply begin to experiment with some "printing off" techniques. By this, I meant that he should work with two mediums, one that would dry quickly (acrylics) and the other that would take longer to dry (oils). I suggested a random approach, whereby the fast-drying medium could be applied first, and then, after it had dried, the slower medium could be applied on top of it. I also suggested that he look for pictorial relationships that might be stimulating. Some, I suggested, might even relate to his concept. The next week at his critique, he spread out some of his various experiments. The excitement that they conveyed and the possibilities of adaptation to his concept were obvious. By the following week he was deep into an entirely new manner of working that inevitably led to a personal,

new stylistic development. He had found a way to incorporate his need for representational imagery with abstract passages of color and form, fusing the two in such a manner as to provide a unified, unique, and impressive visual statement. His thesis was an outstanding success.

This example clearly indicates the possibilities of discovery that can come about by working in a random fashion, and letting the materials "talk to you." "Chance" configurations can set the imagination moving in new, expressive directions, which can stimulate new compositional approaches that analytical intent may not afford. Formal approaches, useful in previous stages of development, can be stumbling blocks to further progress. The possibilities of the discovery of new metaphors, new visual ways of expressing figurative imagery, is equally enhanced. New techniques can also emerge by which new metaphors are given added vitality. Personal control, one's individuality, comes into play in orchestrating all of these expressive possibilities into one cohesive visual statement. Previous, formal approaches, even though *not* used, can serve as a disciplinary springboard for the recognition of what might yet be. Nothing is lost in the process, and much is gained.

Although the above analysis deals with the development of an expressive concern in painting, one can, by analogy, extend the procedure to drawing. For example, one may begin with watercolors, and while the surface is still wet, one may then "print off" some of the applications with a paper towel, soft cloth, or paper. Configurations may emerge, which can then be clarified by drawing with ink, or charcoal, or a combination of media.

Applying ink washes, and then working over them when dry with wax crayons or colored pencils, or both, and then scratching out portions is another means by which discovery becomes possible. There are many other combinations that one might try.

In the process of such experimentation there is always the danger of settling for the dazzling effects one may achieve, while ignoring the more important issues and concerns, the in-depth involvements. Philosophical issues emerge at this point regarding integrity of intent. These are personal matters, which only the individual can determine. However, the playful experimentation with materials is not be be underestimated because of such admonitions. It is the personal focus of the individual, not the experiment, that is at question. One can be equally superficial with the most traditional materials and accepted formal procedures. Let us briefly enumerate some other possibilities for overcoming blocks that prevent developing in new directions:

• Examine nature. Look for unusual configurations in patterns of sand, water, clouds, rocks, and other natural elements. Once a meaningful configuration emerges, latch on to it and explore it as fully as possible. Apply your expressive concern to it. If you don't have one, let the configuration suggest one to you.

• Using your sketchbook and a conté pencil or some soft drawing medium, close your eyes and begin to draw without any specific intent—just draw until you fill the surface of your paper. Then open your eyes and see what you have done. Does it stimulate your imagination? If not, continue the same procedure on additional sheets of paper until something emerges that sets your imagination to work.

• Read a poem or some prose that appeals to you. Does it evoke some imagery that you could work with? Could such imagery be expressive in its own right, without the literal reference? Could the imagery stand on

its own by means of its own visual potential, rather than by being an illustration requiring accompanying text for its expressive meaning? Of course, you may wish to develop an illustration. Or you may wish to create a new visual metaphor for the descriptive content, or "flavor" of the words that moved you. Both are creative experiences that are worthwhile to pursue.

- Take some previous drawings, preferably unsuccessful ones. Tear or cut them up in a random fashion, then place them on a clean sheet of paper. Move them around in various positions, overlapping them in different ways. Continue to do this until some configuration emerges that stimulates your imagination. Add whatever lines, shapes, or additions that clarify what you have discovered. Or, block out portions with clean paper, over which you may draw suggested forms, or connective links with other, existing drawing indications.

- Examine a work of art that you *don't* like. What is wrong with it from your point of view? What could make it better? The work could be a painting, drawing, or sculpture. If its expressive resolution seems all wrong to you, how could it be improved? After determining such issues, make *your* drawing version of a more successful solution, using whatever materials seem most appropriate.

These are a few examples of what one might do to get out of a rut and explore new territory. Whatever stimulates the imagination serves as a key to the process. Think of other situations and experiments that might provide you with the needed means to break new ground, to see things with a new vision, and perhaps, to lead to new discoveries with methods and materials. By doing so, the rich reservoirs of the subconscious can be brought into *conscious* play. The right brain mode can be assisted by the analytical probings of the left brain mode, resulting in a total fusion of well-integrated performance.

Drawing and Professional Goals

There is much to be said about the relationship of drawing to professional goals. There are also a number of perspectives by which such relationships can be considered. Let us examine a few.

THE ART SCHOOL SITUATION

Art schools, including art departments in colleges and universities, still maintain a two-pronged type of art program: one called the "fine arts," and the other called the "applied arts." Students have the opportunity for options in either involvement, and may sometimes combine the two, as a major and minor, in terms of concentrations, or in special programs tailored to meet individual needs. Institutions offering the opportunity for various combinations of the fine and applied arts present the flexibility that relates to the reality of what can be termed crossovers in the professional world. For often one finds a so-called "fine artist" engaged in applied art pursuits, and vice-versa. Though some institutions maintain an archaic distinction between the two types of art, many now offer opportunities that suggest the gradual lessening of such rigid definitions.

A basic drawing course that all students have to take, whatever their

art emphasis might be, offers the opportunity for the development of native skills and the exploration of a wide spectrum of drawing possibilities. Out of such diversified experiences, students can gradually determine their own potential to pursue either the fine arts or the applied arts. Other courses, usually given in a foundation program, further help to clarify aptitudes and potentials.

In subsequent years, the student has the opportunity to pursue a professional direction which calls for specialization. Such specialization requires one or more drawing courses, (advanced or specialized) in either fine arts or applied arts. Some programs rigidly conform to two or three years of drawing, while others are less restrictive. Thus the student, by means of professional guidance, can determine how much drawing experience is necessary for a chosen profession, at least in a minimal sense. However, many art teachers (including myself) urge the student to take as many drawing courses as possible. There are important reasons for stressing drawing preparation in relationship to professional applications.

PROFESSIONAL APPLICATIONS

The student wishing to pursue the profession of a fine artist (printmaker, painter, or sculptor) will profit by developing a high level of proficiency in drawing. More advanced work in structural drawing, figure, anatomy, rendering, and related courses prepares one for the creative demands intrinsic to fine arts.

The printmaker (etcher, serigrapher, and lithographer), by nature of the craft, is deeply involved in the process of expressive drawing. The various avenues of printmaking are complicated by certain processes, techniques, and methods, but expertise in drawing is essential in all stages of the printmaking process. Preliminary work in drawing (sketches, basic composition, and format) is necessary, as well as later work, when changes or corrections have to be made on a plate or screen.

The painter also employs drawing in many critical situations, from the inception of an idea throughout its various stages. Drawing sometimes dominates a finished work, as in Elaine de Kooning's work in which she literally "draws with paint," or by actual drawing maintained in the painting, itself, as we found in Larry River's work.

The sculptor usually employs drawing as an aid to conceptualizing ideas in graphic form. Some sculptors, Henry Moore, for instance, develop complete sketchbooks that indicate such a process. These sketchbooks not only relate to the sculptors' various concepts, they are often important drawing statements in their own right. The drawing process enables the sculptor to get into a theme before or in conjunction with small studies in clay or some other medium. Like the printmaker, the sculptor can edit such studies and make important changes in sculptural form to anticipate the visual effect of the final work.

TECHNOLOGICAL ADVANCES

The fine artist can profit from technological advances. Much that the fine artist does is achieved by materials, methods, and techniques that have their origin in some previous or current technological development. For instance, oil colors, used by the printmaker and painter, were once laboriously prepared by the lengthy process of grinding pigments by hand, using mortar and pestle. The development of industrial mills made it possible to prepare such colors in a fraction of the time it previously took. Acrylic paints, of

more recent origin, enable the artist to make a fast-drying underpainting, over which he can then work in oils. Chemical experiments suggest that paintings done completely with acrylic paints avoid the dangers of cracking and separation that often come about by using older underpainting and overpainting mediums (egg tempera and oils, for instance); each application of acrylic paint (paint film) adheres to any successive layers, to provide one total film of the same substance. Drawing materials, such as pencils, pastels, and crayons may employ new binders that have working qualities that equal or surpass those of earlier times. Papers are now being made using synthetic mediums instead of wood pulp or linen, as are canvases and other supports for drawing and painting. Even fixatives and varnishes have been developed using new synthetics that have certain advantages over previously used substances. The gradual depletion of natural resources has made such technological advances necessary; in addition, such advances have added to, and enhanced, the materials and technical means available to the artist.

Advances made in lithography, formerly employed solely for commercial purposes (such as offset lithography), are now being used by such artists as Robert Rauschenberg and Roy Lichtenstein. Transfer methods and the practice of drawing directly on a plate have increased the range of expressive possibilities.

The serigrapher has also benefited by new advances in technology. He or she may now employ special adhesive sheets of plastic film for certain drawing techniques and stencils. New photo-silkscreen materials and techniques enable the serigrapher to transfer photo images directly to the printing screen, which can then be modified or combined with drawing materials.

The spillover of commercial media into the realm of the fine artist is evident in the possibilities offered by television and film making. Some art schools have experimental programs that afford the student the opportunity for creative, noncommercial applications. Such programs make it possible for the fine arts-oriented student to experiment with the film process as an expressive form. The process can also incorporate methods of drawing with special inks and dyes. The still shot offers another expressive medium, as does the sequential visual action essay.

The full potential of computer technology has yet to be determined. However, it is already being explored by some institutions and artists. Advances in technology extend, not diminish, the artist's potential creativity.

THE APPLIED ARTS ISSUE

New technologies and commercial media are presently being adopted by the fine artist. We may be entering an era in which distinctions between the fine arts and applied arts are becoming increasingly blurred. We noted many crossovers in our consideration of the art school situation.

The philosophy put forth in the early teachings of the Bauhaus (turn of the century) may be taking on new significance as the artist comes in contact with expanded commercial media. Artists' increasing involvement with contemporary issues remind us of the Renaissance when art had no distinctions between fine and applied, when art was an expression of the issues of the day: religious, political, economic, philosophical, and psychological. Its aesthetics developed out of such interrelationships and the artists' sensitivity to them.

Throughout many periods of art, the artist worked on a commercial basis, in which the product—portrait, landscape, mural, and other manifestations—was developed in terms of the client's demands or to meet specific needs and was not solely determined by the artist. However, late in

the nineteenth century, artists became more concerned with art for its own expressive potential, free of other demands. It became a vehicle for "self-expression," leading to various new movements: Abstract Expressionism, Op, Pop, Minimalism, Photorealism, and Conceptual Art are some of its more recent manifestations. A study of advertising art, especially of the last few decades, will reveal the commercial application of such art movements. What was once an expression of fine art has found a secure place in commercial art, serving a completely different purpose in magazines, newspapers, television and film productions.

The issue should not be defined in terms of application, fine as opposed to applied, but in terms of artistic intent. The equivocal nature of an art form and where it is found is less the issue than its expressive quality. A fine arts drawing can be as trivial or inept as a commercial drawing for a book, magazine, or newspaper, while a commercial work can be admired for its strong expressive merits. Established categories of aesthetics break down under such considerations, especially in the light of current concerns. It all rests with the individual artist's intent and capabilities. Therefore, although students are encouraged to specialize soon after their foundation year, they should be careful not to limit themselves by such early specialization. They should allow for the possibilities of various career applications after they leave art school.

Since drawing underlies many forms of artistic expression, its value should not be underestimated in either fine or applied arts. A sound orientation to drawing and a personal application of it to some chosen profession is an enormous asset, especially a dynamic concept of drawing which permits one to adapt it for many expressive possibilities. New media and technology expand one's potentials and add fresh vision and insights that the artist can build upon. As the artist's vision changes, so does his or her particular idiom or style. Changes in politics, culture, and commerce bring about new demands on artists. Therefore, draw, draw, draw.

11

CONCLUSION

There are several broad issues that this book has attempted to address, and it may be wise to review them.

A general overview of drawing was presented at the outset, related to objectives and methods. The value of experimentation has been encouraged throughout, and stress has been placed on learning to see creatively.

The creative attitude and the creative process were considered, along with some suggestions of how these could be maximized. It is easy to read such material; it is more difficult to apply it experientially. One who is unwilling to examine the psychology of creativity and who accepts the romantic notion of working by means of unpredictable spurts of inspiration creates severe self-imposed limitations. It would be more prudent to explore techniques that have helped others and may prove to be beneficial in one's own creative attempts. Recent research on creativity is becoming more and more prevalent. Books, workshops, lectures, and courses on pyschological aspects of creativity offer many options for personal adaptation.

Several chapters of this book were devoted to information and exercises dealing with basic drawing, including materials, concepts, and the application of pictorial forces necessary for composition. Various kinds of subject matter were explored to allow for the greatest possible personal identity and expressive interests.

More advanced work in the form of drawing projects involved analytical studies of some leading artists, with emphasis on their expressive intentions and how they were resolved pictorially. A section on personal development emphasized how to overcome creative blocks and how to evaluate your relationship to the professional world of art. The value of strong preparation in drawing was stressed, whatever your professional preference. Above all, drawing as a conceptual attitude was emphasized in relationship to expressive intent on many levels of meaning. Expressive intent can range from the subjective-oriented, as in one's personal self-expression, to the objective-oriented, as in problem solving to meet the demands of commerce. We noted that these, though different in intent, can be the concern and product of the same individual. Much depends on one's range of interests and

236

talents. To limit one's efforts to established aesthetic standards may result in disappointment. Personal experience will help you to develop your own standards.

The challenge of drawing, therefore, is multifaceted. It makes demands in terms of one's willingness to grow and develop, to delight in the new and untried, and to expand, not contract, one's inner potential.

APPENDIX

Developing a Personal Drawing Program

Plan I may be used by an individual working independently, or by someone who is also taking a formal drawing course or working with a group, to supplement such study. It may also serve as "independent study" in a college program.

The drawing problems are planned to span approximately four months (sixteen weeks), and are therefore equal to an average art school, college, or university semester. However, the plan is flexible and can be adapted to your personal preferences.

Plan I: A Four-Month Drawing Program

TOTAL 96 HOURS (6 HRS. PER WEEK)

Drawing Problems	Time Element	Materials
1. Gesture drawing (various subjects)	2 hours a week/16 weeks	2B pencil or conté pencil; newsprint or bond paper
2. Still life drawing Linear studies	2 hrs. a week/2 weeks	HB pencil and pen and ink; bond paper or sketchbook
Tonal studies	2 hrs. a week/2 weeks	Charcoal, ink, and water-color; charcoal paper or bond paper
3. Perspective drawing (various subjects)	2 hrs. a week/4 weeks	Pencil and pen and ink; sketchbook
4. Nature drawing	2 hrs. a week/4 weeks	Various media; sketchbook or heavy bond paper

5. Clothed figure drawing	2 hrs. a week/4 weeks	Various media; sketch-book of various papers
6. Nude figure drawing (full figure, sectional studies; structure, anatomy)	2 hrs. a week/8 weeks	Various media; sketch-book or various papers
7. Optional problem	1 hr. a week/10 weeks	Any media; various papers

PLAN II

The following plan may serve as a typical Drawing I syllabus, which can be used as the basis for a one-semester drawing course in art school, college, or university art programs. It may be expanded by the instructor to extend over a two semester period if desired.

Since most one-semester drawing courses meet two or three times a week for a total of 6 hours a week (96 hours a semester), the plan may be adopted as is or used with modifications that emphasize other instructional needs.

Plan II: A One-Semester Basic Drawing Course

96 HOURS (6 HRS. PER WEEK)

It is recommended that an *orientation session* preceed the work; this may include a lecture (using slides, film, or other aids) and a review of the working syllabus. This should take one to three hours.

Drawing Problems	*Time Element*	*Materials*
1. Exploratory, linear exercises	3 hours/first week	Ink and improvised drawing tools; sketchbook
2. Critique Problem 1, assign Problem 2— gesture and contour, drapery and still life	6 hours/second week 3 hours/third week	Pencil; sketchbook or bond paper
3. Critique Problem 2, assign Problem 3— negative space studies	3 hours/third week	Pencil and ink; construction paper, bond paper
4. Critique Problem 3, assign Problem 4— perspective drawing, small objects; one and two point perspective	6 hours/fourth week	Pencil; sketchbook or bond paper
5. Critique Problem 4, assign Problem 5— perspective extended to room and interior subjects	6 hours/fifth week	Pencil; sketchbook or bond paper
6. Critique Problem 5, assign Problem 6— large still-life study	6 hours/sixth week	Charcoal; charcoal paper

7. Critique Problem 6, assign Problem 7— pencil experiments, mood or imaginative composition	6 hours/seventh week	Various pencils; bond paper
8. Critique Problem 7, assign Problem 8— form study, crumpled paper	3 hours/eighth week	HB and B pencils; bond paper
9. Critique Problem 8, assign Problem 9— outdoor perspective drawing	3 hours/eighth week 6 hours/ninth week	Pencils, pen and ink; sketchbook, bond paper
10. Critique Problem 9, assign Problem 10— gesture drawing, figure	6 hours/tenth week	Conté crayon and soft pencils; newsprint
11. Critique Problem 10, assign Problem 11— figure, contour and tone	6 hours/eleventh week	Charcoal pencil and graphite stick; bond paper
12. Critique Problem 11, assign Problem 12— figure, skeletal gesture and structural studies	6 hours/twelfth week	Pencil and felt-tip pen; sketchbook, bond paper
13. Critique Problem 12, assign Problem 13— figure, structure, long studies	6 hours/thirteenth week	Pencil and charcoal; appropriate papers
14. Critique Problem 13, assign Problem 14— develop own optional problem	6 hours/fourteenth week	Any media; any choice of papers
15. Continuation of Problem 14, critique at end of period	6 hours/fifteenth week	Any media; any choice of papers
16. Final critiques, discussion, presentation of portfolios for final grade	6 hours/sixteenth week	

PLAN III

The following plan is a multi-media program for figure study. It incorporates drawing the figure (including anatomy), painting the figure, and sculpting the figure. These interrelationships (actually three courses combined into one) increase the possibility of developing a *concept* of the figure in a one-semester offering. For a college with limited resources, this kind of plan has many advantages. Ideally, it is best adapted to a two-semester situation. Interpretive adaptations, depending on a particular focus, may allow practical modifications. By analagous interpretations, this basic plan for multi-media involvement can serve many other needs, especially in reference to foundation programs.

Plan III: A Multi-Media Program for Figure Study

96 HOURS (6 HRS. PER WEEK)

Concept	Problem	Time Element	Materials
Linear Development	1. Gesture drawing—full figure	3 hours	Magic marker and felt-tip pen
	2. Gesture projection in space—full figure	3 hours	Aluminum wire
	3. Calligraphic brush drawing	3 hours	Japanese watercolor; brush
	Critique	3 hours	
Line and Mass Head Studies	4. Linear contour head studies	3 hours	Magic marker and conté crayon
	5. Gesture/volume mass	3 hours	Clay
	6. Tonal mass	3 hours	Black and white acrylic
	Critique	3 hours	
Structure and Anatomy Emphasis	7. Articulation of planes—head	6 hours	Clay
	8. Shoulder girdle and head	3 hours	Pencil
	Critique	1 hour	
	9. Monochromatic study head and shoulder girdle	6 hours	Acrylic
	Critique	1 hour	
	10. Gesture and contour ribcage & pelvis	4 hours	Conté crayon and pencil
	Critique	1 hour	
	11. Mass/volume study torso	6 hours	Clay
	Critique	1 hour	
	12. Anatomical analysis skeleton/muscles	5 hours	Pencil, colored pencils
	Critique	1 hour	
	13. Monochromatic study torso	5 hours	Acrylic
	Critique	1 hour	
	14. Gesture studies, arms and legs	3 hours	Conté crayon and pencil
	Critique	1 hour	
	15. Mass/volume studies arms and legs	6 hours	Clay
	Critique	1 hour	
	16. Anatomical analysis arms and legs	6 hours	Pencil, colored pencils
	Critique	1 hour	
	17. Monochromatic studies arms and legs	6 hours	Acrylic
	Critique	1 hour	
	18. Final critiques/optional work	6 hours	Optional materials

GLOSSARY

Abstract art. An invention or form of expression (drawing, painting, and so forth) that usually has a basis in reality (object or experience). When based on reality, essentials are stressed, and superficial or changeable aspects are removed. See *nonobjective*.

Abstract Expressionism. A movement that developed in the 1940s and 1950s in which action techniques of painting and emotional expression predominated, usually resulting in nonobjective results.

Achromatic. Tonal combinations that do not employ color.

Aerial perspective. A method used by the artist to indicate that forms appear less distinct the farther back they exist in space due to the greater density of air.

Aesthetics. Formerly a theory of the "beautiful" and a traditional branch of philosophy, it now encompasses psychology and sociology as well. Thus a more contemporary definition would relate to the origins of sensitivity to art forms within a given culture.

Analytical line. A line that is used to search out forms in relationship to each other and to the space they occupy.

Asymmetrical balance. The opposite of symmetrical balance, achieving a state of equilibrium within the pictorial field by unequal forms or arrangements. See *Symmetrical balance*.

Awareness. A state or states of consciousness in which cognition is possible; in drawing often related to the seeing process.

Balance. The harmonious relationship of units within the whole which results in the sense of organic unity.

Calligraphy. A form of writing or drawing characterized by flowing, rhythmic qualities. For instance, Oriental calligraphy is a noted form of writing that exhibits those qualities. Vigorous brush and ink drawings are often referred to as "calligraphic."

Cast shadow. A shadow, usually the darkest tone, caused by the relationship of how light on an object causes a shadow (cast) to occur on an adjacent surface or object.

Central axis. An imaginary line through the center of an object which may be vertical, horizontal, or any angle which the object assumes.

Chiaroscuro An Italian term relating to the use of light and dark tones to model forms in the drawing and painting process.

Chroma. Color; chromatic refers to the use of color.

Classical. In art history, the term refers to the art of ancient Greece and Rome. In contemporary terms it suggests something of high order or of first rank importance.

Collage. The use of materials applied or attached to the pictorial surface.

Composition. An orderly relationship of parts to the whole; the use of elements of art within a given work.

Conceptual. In reference to drawing, that which is conceived in the "mind's eye," rather than directly from external sources.

Content. The meaning or subject matter of an art work. Various levels may be involved in "meaning," such as emotional, intellectual, psychological, and so on.

Contour line. A line that describes the outer and inner portions of a form or object; i.e., their surfaces or planes. See *Outline*.

Creativity. The formation of the new; the ability to arrive at new solutions or new modes of expression.

Cross contour. In reference to lines that describe the interior or three-dimensional character of a form.

Crosshatching. The use of lines that are parallel and intersect to produce tone or shading in a drawing.

Cubism. A style of artistic representation developed in the early 1920s, originated around 1907 by Pablo Picasso and Georges Braque, characterized by breaking down forms into geometric planes.

Dadaism. A form of art that rejected all past art forms after the dislocations of World War I. Considered nihilistic and antiart, it paved the way for surrealism.

Decorative. That which features two-dimensional or surface aspects, hence decorating or enriching such surfaces.

Diminution. The apparent illusion that objects seem smaller as they recede in space.

Distortion. When purposeful, a change made in the general character of forms (size, position, and so on), usually to stress some artistic aspects. Distortion can also be an accidental result.

Dry brush. The marks made by a brush, characterized by being broken or uneven due to the small amount of medium on the brush when applied; usually related to ink drawing, watercolor, and some additional mediums.

Elements of art. The constituents, such as color, texture, line, shape, and value, which represent the visual language of the artist. Thus, the basic visual signs used to express or to communicate creative ideas.

Empathy. The sense of identification with another individual, animal, form, or phenomenon which results in greater understanding of such subjects.

Expressionism. An expressive style that incorporates distortion of forms and intensification of color for specific artistic intent or meaning. In art history, associated with the style that developed in Germany at the turn of the twentieth century, attributed to such artists as Enrst Barlach, Ludvig Kirchner, Franz Marc, Edvard Munch, and others.

Eye level. Synonymous with horizon line. The actual height of one's eyes when viewing an object or scene. Knowing one's eye level is essential in perspective drawing, since it relates to how things are represented on the pictorial surface.

Fantasy. A departure from realism; free interpretation or invention for psychological purposes in a drawing or other work of art.

Foreshortening. The controlled illusion of depth in figures or objects related to the pictorial surface; forms may appear to project or recede from the two-dimensional surface.

Form. Arrangement of all visual elements to produce organic unity in a work of art; may also relate to a single three-dimensional object, or aspects thereof.

Format. The general shape a work assumes, such as rectangular, square, or oval; proportion of width to length.

Genre. Artistic expression that deals with domestic, everyday objects or situations.

Geometric shape. Mathematical shapes, such as a circle or square.

Gesture. A quick representation of the actions or movements of a form or a composition; rapid linear or tonal indications of such actions or movements that characterize the essence of what is to be represented. An essential, basic consideration in drawing.

Graphic. Relating to marks or representations on a two-dimensional surface.

Harmony. The sense of unity of visual elements, whatever the art form. In drawing, harmony is brought about by consistency of medium and surface so as to produce a totally integrated expression.

Highlight. The drawn portion of an object that receives the most light.

Hue. The name of a color, indicating its position in the color spectrum.

Icon. An image of special importance or religious veneration.

Illustration. Drawing of a narrative nature which helps to support a text (novel, technical work) or a theme.

Imagination. The ability or faculty to combine past imagery into a new pattern.

Implied line. A line that exists by means of the viewer's participation in connecting a broken line.

Impressionism. A painting movement that developed primarily in France toward the end of the nineteenth century. It is characterized by its concern with light on forms and its suggestive, rather than highly descriptive, indications of subject matter.

Intensity. The strength of a color resulting from the quality of light reflected from it. A strong color has high intensity; a dull color, low intensity.

Intuitive. Instinctive rather than reflective thinking; a sensing or feeling, often without a specifically known rationale.

Kinesthetic sense. An individual's awareness of one's body and movements, or the empathetic awareness of another. A useful sense to develop in learning to draw.

Light pattern. The collective effects of light passages over forms to be drawn, indicative of the kind and direction of light.

Line. The mark of a moving point made by a drawing tool across a surface.

Linear perspective. A system of linear drawing in which forms get smaller as they recede into space. Surfaces which are not parallel to the picture plane converge to vanishing points (by means of parallel lines). Linear modes consist of one- , two- , and three-point perspective.

Lyrical. Synonymous with poetic, refers to a special aesthetic quality in a work of art which may be characterized by spontaneous drawing or brush applications that result in graceful rhythms.

Mass. In drawing and the graphic arts the term refers to the bulk, weight, or density of a body or object.

Matting. A process of presenting a drawing or other work in a frame cut from matboard; matboard margins help to set off and protect the work.

Mediums. Materials used by the artist to objectify his or her particular form of visual communication, such as pencil, charcoal, watercolor.

Modeling. A technique or means of tonal gradation in drawing objects which presents them in a three-dimensional manner.

Motif. The dominating feature in a work of art; the use of an element or elements that present a thematic character to the work.

Narrative art. Art that tells a story. See *Illustration.*

Negative space. The unoccupied space surrounding a positive shape; also called void, ground, field.

Nonobjective. A form of art that intends no reference to the world of objective reality, hence a synonym is nonrepresentational art.

Objective. Relating to the way things are before subjective reflection takes place; factual rather than subjectively expressive.

One-point perspective. A mode of linear perspective which creates a three-dimensional illusion on a two-dimensional surface. All lines of convergence relate to a single vanishing point on the horizon line.

Opaque. In reference to paint, a layer or application that obliterates whatever is underneath. A surface that cannot be seen through.

Organic shape. Sometimes referred to as biomorphic or free-form; irregular in shape.

Outline. Outline delineates only the outer edge of a form, whereas contour extends to delineation of planes, as well.

Overlap. The sense of one object or form being in front of another in terms of a single line of vision.

Pattern. A connective organization of similar elements (tones, lines, shapes), actual or implied. It may also refer to elements that are repeated or combined in some form of systematic organization.

Perception. The act of awareness; taking notice of objects or phenomena directly seen or imagined.

Perspective. See *Aerial* and *Linear perspective.*

Pictorial space. Various forms of space created on a two-dimensional surface, such as flat (two-dimensional), three-dimensional, deep, ambiguous, or others.

Picture plane. The defined area on which the artist creates his or her pictorial image.

Plane. A two-dimensional shape. Planes or surfaces may suggest three-dimensional forms, depending on the pictorial context.

Plastic. In drawing and the graphic arts the term refers to the three-dimensionality of a shape or form.

Positive shapes. The actual shape of some object or form, real or imagined, drawn or depicted on the pictorial surface. See *Negative* space.

Proportion. The relative comparison of parts to each other within the whole and between the parts and the whole.

Realism. The concern to depict objective reality, attentively perceived.

Reflected light. Light that is reflected from one surface to another; it is never as light as the highlight in conventional drawing.

Repetition. The use of an element or form any number of times, often creating harmonious relationships and obvious patterns.

Rhythm. Usually associated with repetitive elements; a measured type of movement, flow, or continuance.

Scale. Relative comparison of one form (size, weight, and so on) with other forms within any given context.

Scumbling. A rubbing in or somewhat uneven application of one layer of medium (paint, pastel, etc.) over another, allowing the under surface to show through to some extent.

Shadow. Portion of a form that does not receive light. See also *Cast shadow.*

Shape. A form that exists in terms of a real or implied outline, or by means of contrast of tone, color, or texture.

Sighting. A means of assessing relative sizes, using a measuring device such as a pencil that is constant; assessing distances by the same means.

Space. Measurable distances used in various contexts such as (1) interval between preestablished points, (2) two-dimensional, (3) three-dimensional, (4) four-dimensional (includes time), (5) infinite (suggests endless space), (6) shallow (minor or limited), and (7) deep space.

Stipple. A technique of drawing achieved by a pattern of dots.

Structural line. Line used to make assessments in developing an object, or in determining relationships between objects and/or the spaces they occupy, often tentative in nature.

Style. With reference to the artist, a personal stamp or idiom developed in terms of medium and expressive content. In art history, a specific character or trend of an art movement.

Subjective. The artist's individual focus or manner of interpretation. Compare with *Objective.*

Surrealism. A movement developed in the 1920s and 1930s that emphasizes fantasy and symbols, relating to the functions of the subconscious mind and theories of psychoanalysis.

Symbol. Representation or image that stands for something else, such as a lighted bulb to suggest "idea." "Symbol systems" developed during early childhood may persist throughout later years, making the drawing process more difficult.

Symmetrical balance. A state achieved by the use of similar compositional elements or units placed in relationship to a vertical or horizontal central axis.

Tactile. Having to do with the sense of touch. Texture in a work of art heightens this quality.

Technique. The manner in which materials and tools are used to create an expressive effect.

Tension. The dynamic relationship that results from the interplay or movements of forms or elements in a composition. Tensions exist between one form and another as well as in their relationships to the picture plane. The eye relates to these implied energy patterns.

Texture. The tactility of a surface or object; its "felt" quality. Textures are of three general types: (1) actual—the use of real materials, (2) simulated—the representation of an actual texture, and (3) invented—freely created textures without objective references.

Theme. A motif or topic; the result of the development of a series of works that have a common subject matter, image, or idea.

Three-dimensional. A form having height, width, and depth; a solid existing in space.

Three-quarter view. Usually related to portrait or figure drawing and painting in which the model sits halfway between a frontal and profile view.

Tonal drawing. A drawing in which tone or value is used; a drawing using shading or modeling.

Tone. Synonymous with value. A constituent of color. A particular degree of lightness or darkness.

Tooth. The intrinsic texture or grain of a given surface.

Trompe l'oeil. A term in painting which refers to the exactitude of representation of objects to the point of seeming like actual forms.

Two-dimensional. Possessing height and width.

Unity. The successful combination of parts to produce a whole or total effect in a work of art.

Value. Synonymous with tone. The quality of lightness or darkness.

Value pattern. The totality of effects achieved by means of value distributions throughout a given work.

Value scale. A reference which indicates gradations of tone from the lightest to the darkest.

Visual energy. The sense of energy derived from an emotional response to the imagery used by the artist. The kind and placement of forms within the picture plane have much to do with the degree of energy generated. Refer also to *Tension*.

Visual reality. Close accordance with that which is observed; visual objectivity; naturalism of the physically observed.

Visual weight. The visual representation of the actual weight of the drawn object. The weight sensed in observing various forms or objects in a relative relationship to each other within the picture plane.

Volume. In two-dimensional representation (drawing or painting as opposed to sculpture) the illusion of a three-dimensional form existing in space.

Wash. A transparent layer of a tone or color applied to a surface. Various inks and painting mediums (watercolors, acrylics, and oils) can be applied using a wash technique.

SUGGESTED READINGS

The texts listed below provide useful references in several categories, both general and specific, related to the concerns of this book.

GENERAL READING: CONCEPTUAL, PHILOSOPHICAL, AND PSYCHOLOGICAL

Albert, Calvin and Seckler, Dorothy G. DRAWING COMES TO LIFE. New York: Reinhold, 1957.

Arguelles, Jose A. THE TRANSFORMATIVE VISION. Boulder, Colorado: Shambhala Publications, 1975.

Arnheim, Rudolf. ART AND VISUAL PERCEPTION. Berkeley, California: University of California Press, 1954.

Blakemore, Colin. MECHANICS OF THE MIND. Cambridge: The University Press, 1977.

Capra, Fritjof. THE TAO OF PHYSICS. Boulder, Colorado: Shambhala Publications, Inc., 1975.

Collier, Graham. FORM, SPACE AND VISION, 3rd. ed. Englewood Cliffs, N.J.: Prentice-Hall, 1972.

Dewey, John. ART AS EXPERIENCE. New York: Minton, Balch, 1934.

Ferguson, Marilyn. THE BRAIN REVOLUTION. New York: Taplinger, 1973.

Frank, Frederick. THE ZEN OF SEEING. New York: Vintage Books, Random House, 1973.

Ghiselin, Brewster, ed. THE CREATIVE PROCESS. Berkeley: University of California Press, 1952.

Henri, Robert. THE ART SPIRIT. Philadelphia, Pa.: J.B. Lippincott, 1923.

Houston, Jean. LIFEFORCE: THE PSYCHO-HISTORICAL RECOVERY OF THE SELF. New York: Delacorte, 1980.

————— . THE POSSIBLE HUMAN. Los Angeles, California.: J.P. Tarcher, Inc., 1982.

—————, and Robert Masters. MIND GAMES. New York: Viking, 1972.

Jaynes, Julian. THE ORIGIN OF CONSCIOUSNESS IN THE BREAKDOWN OF THE BICAMERAL MIND. Boston: Houghton Mifflin, 1977.

Kellogg, Rhoda, and O"Dell, Scott. THE PSYCHOLOGY OF CHILDREN'S ART. New York: Random House, Published by CRM, Inc., 1967.

Lowenfeld, Victor. CREATIVE AND MENTAL GROWTH, New York: Macmillan, 1947.

Ornstein, Robert. THE PSYCHOLOGY OF CONSCIOUSNESS. 2nd ed., rev. New York: Harcourt Brace Jovanovich, 1977.

Paiget, Jean. THE LANGUAGE AND THOUGHT OF A CHILD. New York: Meridian, 1955.

Samuels, Michael, and Samuels, Nancy. SEEING WITH THE MIND'S EYE. New York: Random House, 1975.

Tart, Charles T. STATES OF CONSCIOUSNESS. New York: E.P. Dutton, 1975.

Wenger, Win, and Wenger, Susan. YOUR LIMITLESS INVENTING MACHINE. 3rd ed., Gaithersburg, Md.: Psychegenics Press, 1979.

GENERAL DRAWING

Chaet, Bernard. THE ART OF DRAWING. New York: Holt, Rinehart & Winston, 1970.

Edwards, Betty. DRAWING ON THE RIGHT SIDE OF THE BRAIN. Los Angeles, California: J.P. Tarcher, Inc., 1979.

Goldstein, Nathan. THE ART OF RESPONSIVE DRAWING. Englewood Cliffs, N.J.: Prentice-Hall, 1973.

Hale, Robert Beverly. DRAWING LESSONS FROM THE GREAT MASTERS. New York: Watson-Guptil, 1964.

Janis, Harriet, and Blesh, Rudi. COLLAGE. Philadelphia, Pa., and New York: Chilton, 1962.

Mendelowitz, Daniel M. A GUIDE TO DRAWING. New York: Holt, Rinehart & Winston, Inc., 1975.

Nicolaides, Kimon. THE NATURAL WAY TO DRAW. Boston: Houghton Mifflin, 1941.

Sachs, Paul J. MODERN PRINTS AND DRAWINGS. New York: Alfred A. Knopf, 1954.

Simmons, Seymour, and Winer, Marc S.A. DRAWING, THE CREATIVE PROCESS. Englewood Cliffs, N.J.: Prentice-Hall, 1977.

ANATOMY AND FIGURE

Bridgeman, George. LIFE DRAWING (1924). New York: Dover, 1973.

_____ . CONSTRUCTIVE ANATOMY (1920). New York: Dover, 1973.

_____ . HEADS, FEATURES AND FACES (1932). New York: Dover, 1974.

_____ . THE HUMAN MACHINE (1939). New York: Dover, 1972.

Goldstein, Nathan. FIGURE DRAWING. Englewood Cliffs, N.J.: Prentice-Hall, 1976.

_____ . A DRAWING HANDBOOK. Englewood Cliffs, N.J.: Prentice-Hall, 1986.

Peck, Rogers S. ATLAS OF HUMAN ANATOMY FOR THE ARTIST. New York: Oxford University Press, 1951.

Perard, Victor. ANATOMY AND DRAWING, 4th ed. New York: Pitman, 1955.

Rubins, David K. THE HUMAN FIGURE. New York: Viking, 1953.

Schider, Fritz. AN ATLAS OF ANATOMY FOR ARTISTS. New York: Dover, 1958.

PERSPECTIVE

Burnett, Calvin. OBJECTIVE DRAWING TECHNIQUES. New York: Van Nostrand Reinhold, 1966.

Norling Ernest R. PERSPECTIVE MADE EASY. New York: Macmillan, 1939.

Turner, William W. SIMPLIFIED PERSPECTIVE. New York: The Ronald Press, 1947.

Watson, Ernest W. HOW TO USE CREATIVE PERSPECTIVE. New York: Reinhold, 1960.

MEDIA AND MATERIALS

Herberts, K. THE COMPLETE BOOK OF ARTIST'S TECHNIQUES. New York: Frederick A. Praeger, Inc., 1958.

Mayer, Ralph W. THE ARTIST'S HANDBOOK OF MATERIALS AND TECHNIQUES (rev.). New York: Viking, 1970.

Watrous, James. THE CRAFT OF OLD MASTER DRAWINGS. Madison, Wisc.: University of Wisconsin Press, 1957.

INDEX